2004

The Child's Creation of a Pictorial World

The Child's Creation of a Pictorial World

SECOND EDITION

Claire Golomb
The University of Massachusetts at Boston

LEA Lawrence Erlbaum Associates, Publishers
2004 Mahwah, New Jersey London

Editor:	Bill Webber
Editorial Assistant:	Kristin Duch
Cover Design:	Kathryn Houghtaling Lacey
Textbook Production Manager:	Paul Smolenski
Full-Service & Composition:	UG / GGS Information Services, Inc.
Text and Cover Printer:	Edwards Brothers, Incorporated

This book was typeset in 10/13 pt. Aster.
The heads were typeset in Aster.

Lawrence Erlbaum Associates, Inc., Publishers
10 Industrial Avenue
Mahwah, New Jersey 07430
www.erlbaum.com

Library of Congress Cataloging-in-Publication Data

Golomb, Claire.
 The child's creation of a pictorial world / Claire Golomb.—2nd ed.
 p. cm.
 Includes bibliographical references and index.
 ISBN 0-8058-4371-X (alk. paper)
 ISBN 0-8058-4372-8 (pbk. : alk. paper)
 1. Children's drawings—Psychological aspects. I. Title.

 BF723.D7G64 2003
 155.4—dc21

 2003056125

In memory of our father Chaskel Schimmel,
1899–1943, who perished in the Holocaust

FOR DAN

Contents

Foreword to the Second Edition ix

Acknowledgments xi

Introduction 1

1. From Action to Representation: The Origins of Early
 Graphic Forms 8

2. The Puzzle of the Tadpole Man 37

3. Differentiation of Forms and Early Graphic Models 57

4. Space: In Search of the Missing Dimension 98

5. Color, Affect, and Expression: The Depiction of Mood
 and Feelings 133

6. Composition: The Creation of Pictorial Space and the
 Communication of Meaning 169

7. Gifted Child Artists 201

8. Art, Personality, and Diagnostics 279

9. The Child as Art Critic 322

10. Reflections on Cultural Variables 340

References 363

Author Index 375

Subject Index 378

Foreword to the Second Edition

A decade has passed since the publication of the first edition of *The Child's Creation of a Pictorial World*, and it seemed time to reassess the status of child art and review studies that were published in the intervening years.

The outcome of this review has been to expand the earlier version and to incorporate new findings in the current book. The basic philosophy that underpins the first edition continues to serve as a productive framework for an assessment of the available literature. In addition to updating references in all the chapters, I decided to expand those in which significant new findings have become available. In chapter 4, which deals with the problem of how to represent solid, three-dimensional objects and their spatial relations on the flat, two-dimensional space of the paper or canvas, I have included a more detailed review of Piagetian and neo-Piagetian research on the representation of spatial relations in drawing. I also report on some of my recent research that is of special relevance for our understanding of spatial and compositional strategies. In chapter 5, which is devoted to color, affect, and expression, I highlight sociocultural and individual differences; some children are "color dominant" in their use of bright, contrasting colors and their preference for expressive forms that ignore rules of realism, while other children are motivated to represent the world with utmost fidelity and thus opt for a more naturalistic style. Chapter 7, which is devoted to gifted child artists, is considerably expanded in its review of recent research on children talented in the visual arts and in its discussion of talent as a cultural construction. This chapter provides updated information on the case histories previously presented and includes an expanded section on the art of savants, the gifted autistic children and adolescents whose work presents a serious challenge to theories of child art as an index of conceptual development. Chapter 8 provides a more extensive presentation of the art of mentally retarded children, and chapter 9 includes a new section that reports on the child's changing conceptions of the nature of art and the role of the artist. Chapter 10 provides a more comprehensive review of the impact of cultural variables on drawings, and includes an extensive discussion of the art of preliterate children and of the role played by tradition and teaching practices on the evolution of child art.

—*Claire Golomb*
The University of Massachusetts at Boston

Acknowledgments

The Child's Creation of a Pictorial World summarizes a large body of research conducted over many years at the University of Massachusetts at Boston. This work represents a collaborative effort with many students whose active participation in my representational development course sparked our joint interest and led to thesis and independent study research projects. I would like to express my deep appreciation for their keen interest, lively discussion, enthusiasm, and hard work! Special thanks go to my research associates who devoted much thought, ingenuity, and effort to our enterprise, and whose commitment was essential to the execution of our projects: Jill Dennehey, Gordon Dunnington, Debbie Farmer, Frank Gallo, Anath Golomb, Judy Helmund, Maureen McCormick, Jill Schmeling, Kate Sullivan, Patty White, and Linda Whittaker.

I am also grateful to the directors and staff of the child care centers, schools, and institutions, and to the parents of the children who gave us permission to engage their youngsters in our studies. Above all, I want to thank the children for the tolerance they showed for our often "dumb" questions, and for teaching us so much about their drawings.

My intellectual debt to Rudolf Arnheim is clearly evident in all the chapters of this book, but I am especially grateful for his willingness to read and comment extensively on all the early and late versions of the chapters. His generosity to give so readily of his time and energy provided me with a much-needed dialogical framework. It was wonderful to find a receptive ear that does not tolerate conceptual ambiguity or fuzziness.

My warm thanks go to my friend Marianne Simmel, who read all the chapters and whose editorial comments were much appreciated; and to my daughter Anath Golomb, who critically reviewed the whole manuscript and helped to sharpen my vision and pen. Her clinical knowledge and insight were of special help on the chapter "Art, Personality, and Diagnostics," to which she made major contributions. In the field of clinical psychology, I am especially indebted to my mentor and friend, the late Shlomo Kulcsar, who inspired my interest in the art of the mentally ill. I also want to express my sincere appreciation to friends and colleagues who read chapters that are especially relevant to their own work and who were willing to share with me their insights: Dennis Byrnes, Norman Freeman, Malka Haas, John Matthews, Patricia Shilo, Pat Tarr, John Willats, and Ellen Winner. I

was very fortunate to have access to several important collections of children's drawings. I want to express my deeply felt appreciaton to Malka Haas, the Shiloh family, and Amnon and Tamar Kessel for their permission to reproduce the drawings. Permission to reproduce selected drawings from the collection of the State Jewish Museum in Prague, which also provided the photographs, and Yad Vashem, the Holocaust Martyrs' and Heroes Remembrance Authority Museum in Jerusalem, is gratefully acknowledged. I also wish to express my appreciation for the permission to reproduce drawings from Rudolf Arnheim, *Art and Visual Perception* (The University of California Press), Sylvia Fein, *Heidi's Horse* (Exelrod Press), Claire Golomb, *Young Children's Sculpture and Drawing* (Harvard University Press), Rhoda Kellogg, *Analyzing Children's Art* (National Press Books and Mayfield Publishing Company), Lorna Selfe, *Nadia: A Case of Extraordinary Drawing Ability in an Autistic Child* (Academic Press), and Wang Shiqiang, *Yani. The Brush of Innocence* (Hudson Hill Press). I also wish to thank John Willats, Susanna Millar, Dale Harris, Ingrid and Sven Andersson, and Max Klaeger for permission to reproduce illustrations from their published works.

My research was supported by several faculty development grants from the University of Massachusetts at Boston, and benefited from the technical assistance provided by the Department of Psychology. Thanks to Michael Pollard for his skillful handling of the reproduction of some of the illustrations, and thanks to the production team for the excellent collaboration and the effective handling of the many illustrations to the text. Above all, I am especially grateful to my editor, Bill Webber, for his generous support of this book and for the expert assistance he has provided for its publication.

—*Claire Golomb*
The University of Massachusetts at Boston

Introduction

For over a hundred years, the drawings of children have enchanted a rather diverse audience of psychologists, educators, art historians, and artists. It is not surprising that over this period of time child art has been examined from a number of different perspectives and significant shifts have occurred in the views of students of child art.

Over the years, two major orientations have come to dominate this field of inquiry. The first one can best be described as the cognitive deficit view of child art. Children's drawings are seen as revealing the child's immature conceptions of the world, as graphic statements that provide the investigator with a kind of cognitive map or "printout" of the child's mental life. The second position emphasizes the projective significance of drawings, which are said to mirror the child's emotional concerns. Within a broadly conceived psychodynamic perspective, the drawings are viewed as reflections of the child's feelings.

Both positions bring to the study of child art ready-made conceptions that derive from other domains of psychology. They merely confirm already well-established views. Jean Piaget is a major representative of this approach to children's drawings. He focused his attention on a limited aspect of children's drawings and interpreted his findings in terms that support his theory of the growth of intelligence and logic in the child. The study of child art per sé did not engage Piaget's interest, nor was he concerned with the visual arts as a domain of adult artistic achievement. Much the same may be said about Karen Machover's interpretation of children's drawings. Insights won from psychodynamic psychology led to her analysis of children's drawings as a projective test of the "body image" or the "inner self." In neither case were children's drawings studied with the intention to discover the laws that determine development in the graphic domain; drawings were treated as evidence for an accepted theory of the child's mind.

In these approaches, and other variants thereof, there is little awareness that art is a unique symbolic domain that needs to be

investigated in its own terms before one can establish similarities to other symbolic domains, for example, to language, mathematics, or music. The tendency to apply to the analysis of children's drawings concepts and methods that derive from other domains has led researchers to overlook some of the disparities that exist between data and theory, and it has placed undue constraints on the research conducted in this field.

It is to the credit of Rudolf Arnheim that students of child art have been able to free themselves from the conceptual straitjacket that narrowed our vision of the nature of child art and how it can be studied. His work has laid the foundation for a new psychology of the arts and provided the necessary conceptual tools for analyzing child art as a symbolic domain that has its own intrinsic rules and developmental coherence. Bringing to the field of his inquiry a genuine understanding of the artistic process and a dynamic conception of visual perception, he taught us that the visual arts, even in childhood, are grounded in a graphic logic and that the language of drawing can and ought to be studied in its own right.

Once we concentrate on the child's unique way of representing objects and events, we are faced again with two different approaches, of which one reflects the negative view mentioned above. It considers the childish forms and their spatial arrangements as primitive deviations from reality and from the projective retinal image. Here again, children's drawings are seen as symptomatic of a deficit, whether it be perceptual, conceptual, or due to executive and working memory constraints—defects that are overcome in the course of development. A second approach sees image-making positively as an effort to create "equivalences" in a given medium, as graphic statements that are quite independent of the nature of the optical retinal image and of realism as a higher order of artistic achievement. The first position leads to an analysis in terms of an idealized standard of accuracy and detail and to an assessment of graphic achievement based on standards of realism or naturalism. The second position offers an account of development that finds meaning and a measure of completeness at each level of graphic achievement. It accounts for the increasing sophistication of the representation in terms of a better understanding of the medium and its potentialities that, in turn, enhances understanding of the nature of the objects in the world.

Drawing is a uniquely human activity whose complex syntactic and semantic development can be studied systematically. It represents one of the major achievements of the human mind. While all symbolic forms testify to a universal attribute of the human mind, drawing presents the investigator with a special challenge. Perhaps more than other symbol systems, representational drawing is a truly creative activity of the child, who invents or reinvents in every generation and across different cultures, a basic vocabulary of meaningful graphic shapes. It is a remarkable feat because there are no real "models" available to the young child that might lend themselves to imitation. Unlike the spoken language, which offers a ready-made model for the child who is learning to speak, neither the natural nor

the man-made environment provide the child with a comparable model for drawing. The flat paper and the tools for making lines, dots, and circles do not correspond in any strict sense to the objects in the real world.

I mentioned that earlier accounts of children's drawings attributed to the child the unsuccessful intention to copy nature. Children as well as adult artists were seen as aspiring toward realism in art. Therefore, it was the task of the investigator to identify the factors that led to the typical "faulty" imitations exhibited, for example, in the "tadpole" man and in the transparent, so-called X-ray figures.

Such a view, if developed consistently, would have recast the history of Western art as a linear progression toward realism. In actuality, of course, there is little support for such a copyist version of the artistic process. The history of art reveals a diversity of mature and sophisticated artistic styles, and modern art in its manifold expressions has totally undermined whatever credibility the copyist notion of art may have had. Instead, we have come to view artistic activity, in the child as well as the adult, as a process in which lines and forms merely "stand" for objects that differ vastly from the materials with which the artist works. At the heart of representation, as Arnheim argued, is the urge to create equivalences of form in a particular medium; forms that correspond structurally or dynamically, but not literally, to the object.

Representation does not aim for a one-to-one correspondence between the elements that constitute an object and the depicted image, nor does it aspire to copy the original. If symbolization is at the core of the artistic enterprise, children's drawings ought not to be viewed as being either more or less representational than the works of more accomplished artists because artistic representation, by its very nature, rests on a system that excludes objective priority for any one level of form.

It is this conception of the nature of representation that inspired an earlier book, *Young Children's Sculpture and Drawing: A Study in Representational Development.* In this work, I traced the development of the human figure in two different media—modeling and drawing—with a special emphasis on the evolution of the modeled human figure, which had never been adequately documented before. Systematic comparisons between the drawn and the sculpted figures revealed significant differences in their construction and highlighted the impact of the medium on the nature of the representation. These findings provided a serious challenge to theories that considered graphic representation as a direct indicator of the child's level of concept formation.

As in the earlier work, it is this conception of the nature of representation that has guided the present study in its more extensive search for the principles that underlie the graphic mode of visual symbolization. Within a broad framework of human development, I have tried to address the problem of children's drawings as a creative search for meaning. I have attempted to articulate the rules that determine the development of drawing as a predominantly cognitive

problem-solving activity, but I have also tried to capture the passion that motivates this childhood endeavor. My overall aim has been to broaden the field of inquiry into child art beyond narrowly defined questions and to situate this inquiry clearly within the field of developmental psychology.

My research has focused on a set of issues that are at the heart of the representational enterprise. I have raised fundamental questions about the course of graphic development, the nature of the changes in drawing style and competence, the extent to which a universal rule system underpins early graphic development, and the impact of cultural models. I have considered the role of "stages" in development and how the constraints of the two-dimensional medium affect the representation. Using Arnheim's representational theory as a general framework within which to formulate questions and to design empirical studies, the book provides new information regarding children's representational concepts and competencies. There emerges a new understanding of child art and its relation to symbol formation and cognitive development in general. My questions have had a dual purpose: to reexamine the conceptions that have guided the study of child art and to formulate the issues so that they can be addressed empirically. Inevitably, this approach is selective in its focus on some topics. It reflects my assessment of what constitutes core questions. The results of this work have led to a reevaluation of some long-held and cherished assumptions about the meaning of children's drawings.

The first chapters explore the antecedents and origins of representational development in the child, the invention of early forms, and the first graphic models of humans, animals, and man-made objects. Chapters 1 and 2 address the question of how representational drawings come about. Do the early motor scribbles hide early representation in what we might call an abstract fashion, or does representation come about only when the scribble patterns transform into recognizable shapes?

Once clearly defined forms are created, they become the basic units for the construction of animate and inanimate objects. Chapter 3 explores the laws that determine the orderly differentiation of forms and the evolution of early graphic models. Shape, however, is not to be considered in isolation, and in chapters 4 and 5 I examine how the child solves the problems of two-dimensional and three-dimensional space, and how color and form can be used for the expression of affect. Although at first the child's ability to convey emotions is limited, expression is not an "added" quality, but resides, from the very beginning, in the forms, the colors, and their arrangement.

This raises the problem of composition. The meaning of a pictorial theme lies in the arrangement of all the elements that make up a drawing, and thus chapter 6 explores new ground as it examines the development of compositional principles in children's drawings.

The problem of the development of gifted children is taken up in chapter 7. Do they "skip" the stages identified in the development of ordinary children, or move through them more rapidly, or grow in unique ways? Fortunately, longitudinal records of several unusually

gifted children, some of whom are in fact precociously talented graphic artists, provide an insight into some of the universal principles that direct graphic development. These records, which I cherish as a rare find, highlight the originality of the young artists' vision and the uniqueness of their development.

Chapter 8 considers the relationship between art, personality, and diagnostics. Its major contribution is of clinical significance in that it systematically examines the drawings of mentally retarded and of severely emotionally disturbed children. Once again, as was the case with gifted child artists, the question of "atypicality" is considered. Are the drawings of these children different, do they deviate from the normal course of development, or do they follow the general principles established for normally developing children? The results of these studies affirm the essential humanity of these children. They are found to develop the same graphic language and, in general, perform very similar to their normal counterparts. Drawing emerges as a very robust language that, in a formal sense, is not easily affected by mental disturbances.

Thus the validity of using drawings as a diagnostic tool is reconsidered, and criteria for such an evaluation are more clearly spelled out. That drawings can be emotionally charged and packed with meanings is also demonstrated in this chapter, which provides some insight into the usefulness of art therapy. Within the therapeutic context, the activity of picture making can bring forth feelings and knowledge that otherwise are not easily accessible to the child. Moreover, the concrete reality of graphic expression presents the therapist with disclosures that a purely verbal account might not be able to provide.

The young artist's own view of child art, a perspective that is often ignored, is taken up in chapter 9. It illustrates the child's criteria for art making and also the gap that exists between pictorial competence and performance. But even here we detect a fundamental order in the expression of the child's judgments and preferences, a lawfulness that underlies his evolving representational logic and aesthetics.

In chapter 10 I address the perplexing problem of universals in graphic development and the role of social and cultural variables. Can one insist on general laws in the face of the phenotypical variability in children's drawings? My examination of the cross-cultural literature of children's drawings and the considerable variations I have noticed in the thousands of drawings in my collection lead me to affirm a position that stresses a universal graphic logic. I am persuaded that a universal rule system underlies the orderly course of early graphic development. Underneath the aforementioned variability there are general structures that appear in a stage-like progression in all the drawings of young children. But the variability is also real, and any notion that children create in a social vacuum is quite untenable. No doubt children are influenced by what their peers and their siblings can do and by the tools made available by their culture. One can even trace some of these influences in early child art. However, they exert only a limited effect on what ordinary children can and tend to do. Children are likely to incorporate features they can understand best because

they are closest to the graphic schemas they themselves have developed. In my view, child art, at least in its early stages, is an autonomously guided problem-solving activity that is shot through with affect and reflects, most commonly, the child's interests and concerns.

My references to a stage-like progression of representational development do not imply a fixed timetable nor do they specify ages for certain achievements. I do not subscribe to the existence of immutable graphic schemas that dominate all of a child's drawing activities. The concept of "stage" or "phase" is a useful device when we consider the orderly changes that characterize all children's drawings—changes that are largely propelled from within, determined by the child's own and active experimentation with the medium, as well as by the nature of the objects she wishes to depict. A phase may be drawn out or short-lived, depending on the motivation, practice, and talent of the child.

Although I frequently refer to children's ages or classroom grades, these are merely convenient ordering devices and do not suggest objective standards by which to assess a child's work in relation to his or her mental development.

To fully understand child art, we need to attend to the general principles as well as to the many individual and cultural variations on the common themes of humans, animals, plants, machinery, and the like. The many illustrations that accompany the text document the diversity of graphic styles on an underlying structure or theme. The individual variations, the phenotypical diversity, are the actual data, and the rules, laws, or principles we formulate are abstractions that elucidate the representational process but do not capture the full flavor and vibrancy of child art.

There is an essential tension between the formulation of general laws and the description of the phenotypical variability that characterizes the actual drawings. Both description and the formulation of laws have a legitimate place in the account of child art, and I have tried to move between these two poles, recognizing that only illustrations can capture the excitement and pulse of child art.

As the chapters attest, I devised my studies in order to elucidate the rules that guide development and determine the particular form it takes. I have probed children's conception of the task and of their accomplishments and tried to discern the complex relationship between motivation, intention, and production. Taken together, the empirical studies and their theoretical interpretation support a new vision of the child artist; one who explores a medium in ways not basically different from what is found in the early drawings of inexperienced adults. Rather than viewing child art as evidence of the child's deficient cognitive capacities, a closer examination of the child's work reveals unsuspected competencies. They suggest a problem-solving mind eager to explore the possibilities and constraints of the two-dimensional medium. The child invents a new world of meaning literally from scratch. As we follow the child's pursuit, a pictorial world emerges that is complex and multifaceted but does not stand in a simple one-to-one correspondence to the child's intellectual conceptions

or emotional concerns; this world is not simply a print-out of the mind. Above all, my aim has been to understand the child, at each level of development, as a feeling and thinking person for whom drawing is a favored, or indeed a compelling, activity. To understand the child's graphic language from this perspective has been my overriding goal.

1 From Action to Representation: The Origins of Early Graphic Forms

The first drawings of a child that evoke a smile of recognition usually take us by surprise. Figures appear quite abruptly, born as it were out of scribble chaos, and we wonder how the preschooler has acquired the unsuspected ability to create a meaningful figure. Our curiosity aroused, we search for the origins and antecedents of pictorial representation.

We might begin our exploration of child art by taking a look at the earliest marks toddlers make and ask whether the traces left in mud, sand, or paper are the first steps on the road to pictorial representation and herald the onset of children's drawings. In our search for the origins of early graphic forms, we shall focus on two different sets of assumptions about the antecedents of representational drawing. One position asserts that refinements of motor movements and elaborations of scribble shapes will eventually lead to the drawing of recognizable forms. An alternative view identifies specific points of transition at which scribble actions are transformed into symbolic actions that yield meaningful figures.

A review of the literature indicates that most students of children's art have not attributed much significance to the early scribble ventures. The toddler's scribbles have been identified as a motor activity that is largely devoid of visual guidance and that elicits in the child only a fleeting interest in the product of his actions (Burt, 1921; Goodenough, 1926; Luquet, 1913, 1927; Munro, Lark-Horowitz, & Barnhard, 1942; Piaget & Inhelder, 1956). From this perspective the scribble pictures appear as unintentional and unanticipated visual records of movements, largely determined by the mechanical structure of the arm, the wrist, and the hand. To the extent that the hand with pencil or crayon acts independently of the eye, the incidental marks that ensue from the gestures do not carry graphic meaning. Whether or not the scribble picture evolves accidentally, once it is made the child is quite proud of having left a mark where none was before. Although initially awareness and planning may have been absent, with their scribble marks the children have created an "existence," they have left a record of their actions and made a statement of "having been there."

Despite children's evident pleasure in making marks, their early scribble productions have received only scant attention since neither children nor adults can easily decode their message or attribute meaning to the scribble pictures. This state of benign neglect is beginning to be rectified, and recent years have seen several attempts to analyze the scribbles as potentially useful graphic elements destined, perhaps, to play a role in later development (Haas, 1984, 1998, 2003; Kellogg, 1969; Matthews, 1984; Smith, 1972). Let us examine more closely the views of two authors, John Matthews and Rhoda Kellogg.

Antecedents: Mark-Making and Scribble Ventures

John Matthews (1984, 1999) bases his account of the earliest phases of graphic development on carefully documented longitudinal observation of his three children. He alerts us to the often-forgotten fact that long before they discover paper and pencil, infants and toddlers leave many traces of their gestures. With an attentive and caring eye, he reports on the visual-motor explorations of his six-month-old infant, whose glance is caught by a patch of regurgitated milk on the carpet. The baby first reaches for the puddle and then modifies his reach as he scratches the puddle, an action that changes the substance markedly. Undisturbed by the milky invasion of the carpet, Matthews describes this process as a first instance of "mark-making." He lists three basic mark-making movements that he considers essential to later drawing activity. The first is a downward stabbing motion of arm and hand that collides with its object at a near-right angle. This movement he calls the "vertical arc." The second is a sweeping or swiping motion directed at a horizontal surface; it encounters its object as it sweeps across the floor, the table, or the tray of the baby's high chair. This motion, well-suited to smearing and painting, is called the "horizontal arc"; it yields knowledge of the body space that surrounds the infant. The third motion to qualify as a basic mark-maker is called the "push-pull" action. The toddler grips a pen or a marker, pushes it as far as the arm can reach, and then reverses the direction and returns to the starting point. This action creates a line that travels the length of the paper away from the child, and back toward him. Push-pull actions consist of a series of forward and return motions. Unlike the child's ordinary push-pull actions that displace real objects but do not leave a visible trace of its movement, the pen creates a distinctive visual mark. These three types of body action performed with marker or brush leave, in Matthews' phrase, "a trace of their passage through space and time."

Beginning with the second year of life, the Matthews children—all of whom are fortunate to have access to their father's studio—explore and handle brushes and paints and discover the effects their vertical stabs and horizontal swipes can have on various surfaces. The photographs of these activities show infants interested in their actions and in the marks they leave. The running commentaries of the sensitive adult observer inform us that the hand adapts to different kinds of reaches. For example, the handle of the brush can be grasped in a

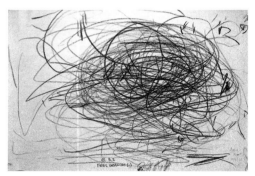

a.

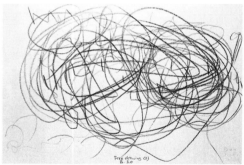

b.

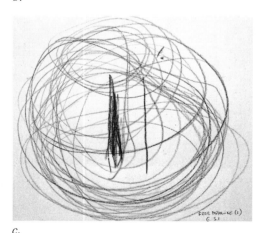

c.

1. *Scribble Whirls*
a. Girl, 3;2.
b. Boy, 3;0.
c. Girl, 3;1.

palmar or a pincer grip; that is, the palm of the hand can enclose the handle or two fingers can grip its endpoint. Just as the hand can adjust to the tool held, so the child's posture adapts to the action. We see the toddler crouching while he swings the paint-dipped brush in a semicircular arc and splatters the paint by centrifugal force; we see him standing when he makes vigorous up–down gestures in space and thus disperses the paint droplets by inertial force. At this time, markings are not yet limited to floor and paper surfaces, but are also made on the child's own person. These varied explorations with paint and brush reveal to the child his normally invisible movements in space. Thus, the temporal sequence of ongoing activities is given visible shape in a manner that calls attention to itself. The child's body serves as the center from which these actions in space ensue, with the horizontal arc describing a continuous motion around the body's vertical midline, the push–pull action following a linear axis to and from the self, and the vertical arc aiming at discrete targets. Although these three mark-making actions are merely recorded gestures—and one might add bang-dots to this repertoire of actions (Smith, 1972, 1983)—Matthews suggests that these gestures underlie all later drawing activity and play a role in establishing a spatial signifying system.

From the middle of the second year we can see further explorations as new combinations are tried out and a newly won control over the motor action facilitates the separation of formerly continuous motions. For example, pull lines can now be separated from push lines, and horizontal arc sweeps can combine with pull lines to yield the familiar continuous rotations best known as scribble whirls (see ills. 1 *a, b, c*). These newly combined action patterns also yield interesting right-angular structures, the outcome of an active visual attention to the marker, the movement, and the mark. The author's illustrations show a young two-year-old absorbed in his own mark-making actions. To the extent that these line configurations manage to stay within the frame of the paper surface, the notion that these actions demonstrate some degree of visual guidance is quite plausible; other observers have noted the child's search for "empty spaces" in which to place their marks (P. Tarr, April 19, 1987, Tarr, 1990), and Malka Haas (1998) has called attention to what appear to be individual differences. She documents how some young two-year-olds, in their focused attention to the emerging lines, show an early visual-spatial orientation to the marks and their spatial surround, carefully staying within the paper's boundaries. Such control, however, is not always the case. Other examples of two-year-old youngsters indicate that despite daily scribble experiences, the lines tend to bounce off the edges of the page, and such crossings do not seem to alarm the child. Clearly, we need to distinguish between visual guidance and mere interest in observing what the hand with its marker produces. On the basis of her extensive collection of longitudinal data from 892 children, Haas has provided a very detailed account of the graphic development that proceeds from mere gestures that leave marks on the paper to the creation of lines, shapes, and an understanding of pictorial space, a highly ordered development (2003).

Beyond observing what his marks look like and how he can vary them, how does the child relate to the marks he creates? What—if any—meaning does the child attribute to his scribble pictures? Fortunately, when the child draws in the presence of an adult, he tends to accompany his actions with verbal utterances that shed some light on this question. At 2;1,[1] Ben Matthews creates continuous overlapping spirals and comments, "It's going around the corner." As the paint lines vanish under additional layers of paint he remarks, "It's gone now." In this instance the child condenses several meanings into the single undifferentiated rotational action. The child's own bodily movements, the trail of the brush on paper, and the movement of the imaginary object are all compressed into the visual-motor act of creating circular whirls. It appears that motor action and representational intuition are as yet fused, a state that Matthews identifies as "action representation." We are witnessing a newly found freedom to label the action-in-progress. As the child creates his circular whirls, the motor rotation and his image of a moving and perhaps roaring object merge. Depending on the context, the child may identify the action-representation as "airplane" or "lawnmower" (see ills. 2; Arnheim, 1974, p. 173). In real life airplanes usually vanish along a straight path; in the two-dimensional plane the imaginary airplane is rendered by a continuous circular path, a gesture that captures the roar of the engine, as much as the actual ongoing motion of flying. The rotational motion attempts to make the path as well as the sound of the airplane visible. Matthews (1999) points out that actions in diverse domains tend to be synchronized; thus, for example, the pretend gesture of climbing a mountain and coming down is captured in the ascending and descending lines drawn on paper, accompanied by corresponding vocalization and changes in pitch. Such correspondences across diverse domains of action highlight an intrinsic synchronization that has its source in the sociobiological structures of the organism, and represents the beginnings of drawing as a meaningful and representational activity.

While Matthews interprets these action-verbalizations as "symbolic" behavior, from the point of view of graphic representation such actions indicate an early and primitive stage of development where space, object, flight trajectory, sound, and the child-as-actor are as yet undifferentiated (Werner & Kaplan, 1963). To the extent that symbolization rests on a differentiation between the graphic symbol and its referent, such fusions do not qualify as genuine symbolic actions. Above all, a graphic symbol must sustain its meaning after the motor action has ceased so that the child who inspects the finished drawing can recognize its intent and relate to its meaning. The differentiation between the symbol and its referent does not diminish the child's involvement in the making of a drawing or a painting. The pleasure in the motion, the visual surprise, and the mental images and associations that empower the action with the affective meanings that underlie various impersonations and identifications, ensure an intimate link between action and symbol.

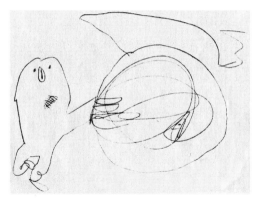

2. *Action-Representation*
"Man mowing the lawn." Artist is a four-year-old girl who depicts the action, the lawnmower, and the noise of the motor as a whirl. (Courtesy, Rudolf Arnheim, *Art and Visual Perception*, 1974).

[1]Ages are given in years and months (e.g., 2;1 = two years and one month).

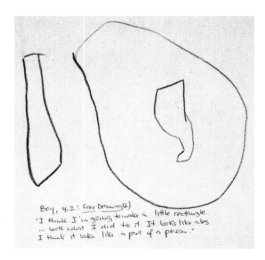

3. Free Drawing: Reading Off
Boy, 4;2: "I think I'm going to make a little rectangle . . . look what I did to it, it looks like a leg. I think it looks like a part of a person."

At this stage, the scribble lines tend to be drawn without lifting the marker from the paper surface, which yields dense line formations. In addition to the circular whirls, the child now also practices right-angular ones that may yield, among others, cruciform structures that tend to be interpreted according to their resemblance to known objects. The meaning of a configuration is determined *after* inspection, as if the child "reads" the meaning suggested by the finished product (Golomb, 1974).

During the third year of life, the drawn lines tend to release story images that in turn prompt the drawing of additional lines. Drawing can now serve as an outlet for fantasies and also substitute for a symbolic play act. The dual function of drawing at this stage can be seen as the child "romances" about the meaning of his graphic line-actions and associates them with seemingly unrelated fragments derived from actual life-events or borrowed from fairy tales. Soon thereafter, purposefully practiced closed shapes appear that invite dot-markings both inside and outside the shape. With these closed shapes, the child is ready to construct pictorial space. Line movements now lose their action-compulsion; the lines can be better controlled and can thus attain new meanings as configurations begin to emerge. Reading off what the figure stands for intensifies as the lines come to represent edges of objects (see ills. 3). This account brings us to the point of transition when the possibility of representation emerges as a new force that reorganizes the child's graphic actions. Before I explore this transitional phase with its exciting discoveries, I shall review Rhoda Kellogg's rather different account of the early antecedents of drawing development.

The search for the roots of graphic representational activity has engaged Kellogg, a preschool educator, for many years; on the basis of her extensive collection of young children's drawings she has formulated an interesting thesis (Kellogg, 1969). She views the child's early scribble-pictures as important and even meaningful productions that hold the key to the development of an extensive graphic vocabulary. Kellogg proposes the existence of an orderly progression that begins with relatively simple marks that are quickly extended to form scribble-patterns and eventually lead to nonpictorial designs.

In an effort to document this steady progression, she has analyzed the scribble-formations that children produce between the ages of two and three years. Her analysis yields a series of 20 elementary scribble-units that she considers as the building blocks that underlie all graphic development (see ills. 4). The lines that comprise the basic scribbles can be grouped on the basis of their directional characteristics and defined as either vertical, horizontal, diagonal, or circular patches. The 20 basic units serve as elements to be combined in various ways to form higher-order units at the next stage, in which the line patches are viewed in relation to the whole drawing surface. Unlike the basic scribbles, which can be produced *without* any eye control over the movement of the marker and without eliciting much visual interest, the placement of scribble-patterns across the page is seen as a deliberate action that may require some visual attention and perhaps even a limited degree of visual guidance of the activity. Kellogg lists 17 different

Scribble 1		Dot
Scribble 2		Single vertical line
Scribble 3		Single horizontal line
Scribble 4		Single diagonal line
Scribble 5		Single curved line
Scribble 6		Multiple vertical line
Scribble 7		Multiple horizontal line
Scribble 8		Multiple diagonal line
Scribble 9		Multiple curved line
Scribble 10		Roving open line
Scribble 11		Roving enclosing line
Scribble 12		Zigzag or waving line
Scribble 13		Single loop line
Scribble 14		Multiple loop line
Scribble 15		Spiral line
Scribble 16		Multiple-line overlaid circle
Scribble 17		Multiple-line circumference circle
Scribble 18		Circular line spread out
Scribble 19		Single crossed circle
Scribble 20		Imperfect circle

4. *Rhoda Kellogg's Twenty Basic Scribbles* (Courtesy Rhoda Kellogg, *Analyzing Children's Art,* 1969).

placement patterns, and she contends that the marks are distributed in a manner that suggests such shapes as half- and quarter-circles, rectangles, triangles, circles, and odd shapes. This patterning process reflects a greater visual interest on the part of the child who positions marks in relation to the delimited shape of the page or paper. As this process of placing scribble-marks in "patterns" continues, potential shapes emerge more clearly, and the distribution of scribble-patches, according to Kellogg, suggests more strongly the shapes of circles, ovals, triangles, rectangles, and crosses. Since these shapes are merely suggested and not clearly delineated, the author labels these scribble-constellations "emergent diagrams." At the next stage, outline figures and crossed-line patterns become part of the child's repertoire of shapes and are identified as "diagrams." Altogether, the author lists six diagrams that comprise the stage of shapes: the rectangle, the oval, the triangle, the Greek cross, the diagonal cross, and the odd shape, which is a closed though irregular shape. The diagrams are drawn quite clearly and deliberately, often with single unbroken lines. Once these shapes have emerged—and Kellogg assigns to the memory of emergent shapes a specific role in this development—they lead to further practice and

tend to be combined into more complex configurations. When a shape incorporates two diagrams it is labeled a "combine," and when it incorporates three or more such units it is called an "aggregate." Kellogg has identified 21 combines and 22 aggregates that occur with varying degrees of frequency during the ages of four to five years. Aggregates usher in a stage of "design" during which the child uses these graphic formulas to create figures that are as yet devoid of pictorial intention or likeness to objects in the real world. Only after the development of an extensive repertoire of forms and figures does the child use these familiar configurations to represent known objects. These graphic figures reflect their nonrepresentational origins, and while they lack true likeness to the object, they are nevertheless able to represent it in some fashion.

Kellogg emphasizes the universal propensity to perceive as well as to create shape. The child's ability to make shapes can be seen in the earliest scribble formations. These need to be exercised until eye control combines, alters, and recombines the forms. Through repeated practice, the child discovers shapes that are hidden or implied in its scribbles, and thus guides his or her own development in the graphic domain. This account describes a linearly ordered sequence of development, an innately determined progression that is quite independent of the impact of the visual world. The evolution of graphic forms proceeds in a somewhat piecemeal fashion, analogous to block-building, beginning with simple forms that are eventually combined to yield more complex ones. Thus, Kellogg considers the nonpictorial scribbles and the emergent pattern formations as the immediate precursors of the forms drawn later, when the child deliberately and intentionally represents objects.

In summary, the longitudinal study of Matthews describes how gestural patterns develop into mark-making activities, a process that yields rotational swirls and culminates in the drawing of closed shapes. En route, and before the child attains the visual-motor control for the drawing of true shapes, Matthews sees in action-representations an indication of the emergence of symbolic skills. It is the child's active visual-motor explorations of the medium of markers, brushes, and paint that yield spatial knowledge and a repertoire of open and closed shapes, of crosses and circles that form the basis for further representational development. The early awareness of symbolic possibilities motivates and guides this self-taught drawing ability.

Like Matthews, Kellogg considers the earliest scribble patterns as necessary precursors of the later drawing activity. However, her cross-sectional study is designed to isolate the basic elements, the universal building blocks that constitute shape. In order to elucidate the steps by which motor scribbles evolve into intentionally controlled shapes, Kellogg constructs an extensive graphic vocabulary. In contrast to Matthews, meaning is absent from this account in which the child at first creates the scribble elements and only later combines them into shapes. In this view, the child creates pure forms and delights in their combinations and permutations. According to Kellogg, symbolization and the search for likeness are as yet alien to the child artist, and they intrude into his awareness only at the persistent urgings of the adult.

Transitions: The Discovery of Shape

Both Matthews and Kellogg stress the visual-motor component of drawing and consider experience in mark-making essential for the development of line patterns. The question I now wish to address concerns the transition from marks and scribble-patterns to the drawing of relatively clear outline figures. Both authors arrive at the "closed line" shape via the cumulative process of experimentation with paper, pencils, and brushes. The child, after extensive experience with the graphic medium and its mark-making tools, discovers, sometimes quite accidentally, that he has made a closed line or loop. This shape captures his attention and leads to further attempts to reproduce it. Whether or not the circular whirl is a combination of earlier practices—for example, of horizontal or vertical arcs that merge with push–pull lines, as Matthews suggests—or an elaboration of previously perceived shapes that were hidden in the implied diagrams—as Kellogg contends, between the ages of two and three years most children discover the closed form and create a circle.

Drawing a single line that encloses an area and arrives back at its starting point demonstrates a remarkable visual-motor control. It speaks of an effort to subdue the impulse to make rotational whirls and thus to subordinate a preferred motor gesture to visual dictates. The successful drawing of a contour illustrates a new degree of mastery and the deliberate use of lines to create a stable and meaningful shape.

Many authors have commented on the significance of clear outlines for graphic development, and Rudolf Arnheim (1974) and Henry Schaefer-Simmern (1948) have pointed to the figure-ground characteristics that the circle on its paper background represents. According to Arnheim (see also Koffka, 1935; Rubin, 1921), the contour is not impartial; the circle bounds the *inside* area, which attains a solid-looking and figural quality that makes it useful for representational purposes. Once the clear outline figure has emerged, it draws attention to itself in a number of ways and elicits interpretation of its meaning. The child tends to label the form according to a perceived likeness to a known object, she interprets the shape, which is a mental activity best described as "reading off" what the figure refers to (Golomb, 1974). At the same time as the child infers the meaning of the drawn shape by searching for a resemblance between it and an object in the real world, he also tends to place marks inside the contour. Apparently, the figural quality of the shape invites further action on the part of the child, which sets graphic development firmly on its course. From this perspective, it makes good sense to begin the story of child art with the discovery of the circle because it represents an early shape that is both visually expressive and representationally useful. It is a form that can carry symbolic meaning and thus lends itself to representational purposes.

At this point, it is important to make a clear distinction between drawing as pure action on the medium and drawing as representation. At the heart of representation as a symbolic activity lies the differentiation between the symbol and its referent, the knowledge that a

drawn shape points beyond itself, that it can "stand" for an object and thus represent it in some fashion. While infants and toddlers can recognize photographs and line drawings of a familiar object (Bower, 1966; DeLoache, Strauss, & Maynard, 1979; Hochberg & Brooks, 1962), this kind of understanding, which identifies the structural features both items have in common, is not by itself a symbolic action. Only when the child recognizes that her lines and shapes carry meaning that is independent of the motor action that produced the shape can one consider the drawing as a representational statement. Almost from the moment the clear circular form emerges it becomes endowed with internal markings that usually represent a human; indeed, in the spontaneous production of young children, humans are one of the first figures drawn intentionally or labeled retrospectively after inspection of the figure.

Among students of child art there is considerable agreement in the singling out of the oval-circle for special representational status. No such accord, however, is apparent concerning the route by which children reach this milestone, or the role assigned to the early scribble-practice. The description of the orderly progression from marks to scribble-patterns to the closed shape offers an attractive account of development from simple skills to more complex ones. However, the predominance of the circle over other closed shapes, which is evident in the early drawings, presents a somewhat puzzling finding not fully accounted for by the previous scribble-exercises. Keeping this reservation in mind, I shall consider findings that raise some questions about the adequacy of these descriptions for the beginnings of representational activity.

The results of two independently conducted investigations of the development of drawing ability in previously inexperienced "naive" subjects suggest that lack of drawing experience need not present a serious handicap. Children as well as adults in the studies conducted by Dale Harris (1971) and Malka Haas (April 9, 1978) progressed in only one to two trials from uncertain scribble-marks to the representation of humans that are very similar to the ones children arrive at after extensive scribble-practice. Harris reports on children in a remote village in the South American Andes whose first experience with paper and pencil began when the experimenter provided them with this material and asked for the drawing of a person (see ills. 5). The earliest trials yield a very restricted scribble-repertoire consisting of circular whirls or loops, separately distributed over the page. The next step already produces simple but recognizable human figures. Similarly, Haas' collection of drawings by Bedouins from the Sinai peninsula illustrates rapid progression to representational status. The investigator provided children and adults with paper and pencil, items hitherto unavailable to them. The results for children and adults alike indicate a quick transition from scribble-marks to the typical early representations of a human by young children. Similarly, Elsbeth Court (1982) reports that Kenyan children and adults who previously had no access to paper and pencil produced, on first trials, and within the same drawing, circles and zigzag patterns that quickly developed into simple humans. Similar findings are reported by Ingrid and Sven

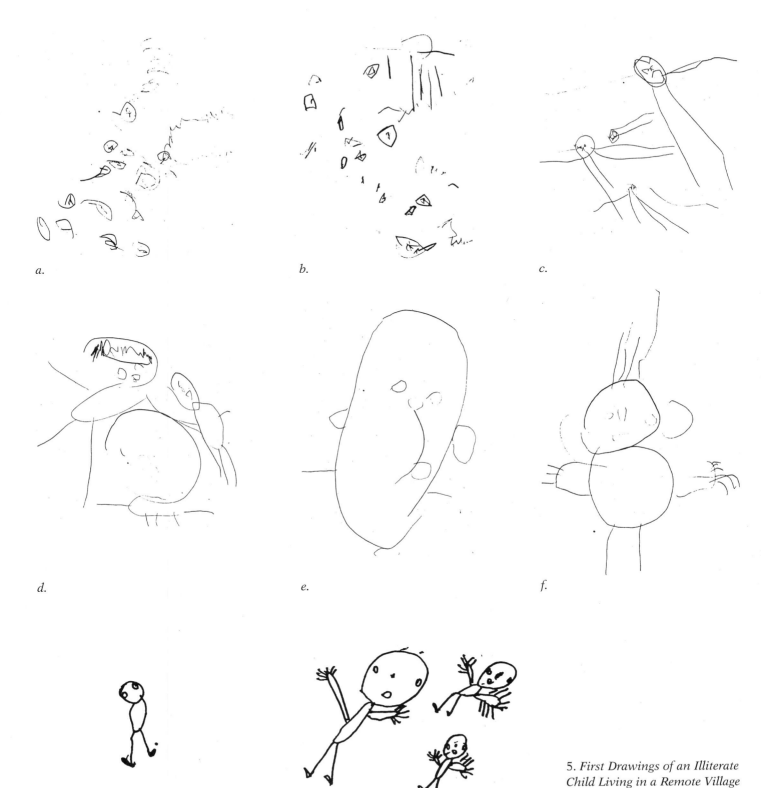

5. *First Drawings of an Illiterate Child Living in a Remote Village in the South American Andes* The artist is a five-year-old boy. (Courtesy Dale B. Harris, National Art Education Association, 1971).

a.

b.

c.

d.

e.

f.

g.

h.

Andersson (1997) on first drawings made by members of the Himba tribe from Namibia (see chapter 10). In these instances, the familiar drawing patterns emerge very quickly, without prior experience and without any training. Impressive though these findings are, we cannot claim that cultures deprived of paper and pencils lack all marking experience. Certainly, play in sand, carving on rock, and using berries to mark stones are activities that can be explored in the absence of paper and pencil. However, the incidence of such activities is likely to be more restricted, and the marks made in sand or mud are easily altered or destroyed. The relative permanence of a scribble-pattern made on paper is not easily duplicated on other surfaces when fingers or sticks are used as mark-making tools. It is the relative permanence of marks on paper that promotes a visual response to the marks and facilitates, via labeling and reading off, the process of exploration.

Additional evidence of representational activities that may be somewhat independent of previous scribble-practice comes from studies of the blind. Both Susanna Millar (1975) and John Kennedy (1980, 1983, 1993) provide startling evidence for the ability of congenitally blind children to create lines and shapes that represent humans and other objects. These blind individuals can invent relatively pertinent graphic forms in the absence of previous scribble experience and without any visual input (see ills. 6 *a, b, c*). Although these drawings fall short of the standards achieved by sighted individuals, they are representational in nature and capture some of the basic structural properties of the object they intend to portray, which facilitates their recognition by an observer. This remarkable achievement of the blind cannot be linked to experimentation with scribble-forms.

Another set of data that may also require a somewhat different account of the transition from scribbles to the invention of first forms comes from studies that use a dictation method. In an earlier investigation (Golomb, 1969, 1974), I asked children who only drew scribbles to draw a person as I named the various body parts—a method that can be described as drawing-on-dictation. I asked the children to draw the following parts: head, eyes, nose, mouth, ears, hair, neck, tummy, legs, feet, arms, fingers. The names of the parts were dictated one at a time, in an order that shifted direction at several points—for example, upwards for ears and hair, and downwards for neck and tummy—and the child was encouraged to draw each part as it was

a.

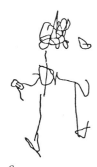

b.

6. *Drawings of Congenitally Blind Children* (Courtesy Susanna Millar, *Perception*, 1975).
a. Girl, 11;4.
b. Boy, 9;3.
c. Children, mean age 10;4.

c.

mentioned. Children had to figure out how to draw a body part and where on the page to place it. Thus, the child had to determine the shape as well as the location of the body parts. The results of the dictation procedure are quite startling. To the amazement of the child as well as the adult observer, recognizable forms emerged. These forms displayed a certain degree of graphic clarity and were correctly ordered along a vertical axis. Thus, for example, hair was scribbled above the head, the tummy below it, whereas the legs were indicated underneath the tummy (see ills. 7 *a, b, c, d*). When several trials were

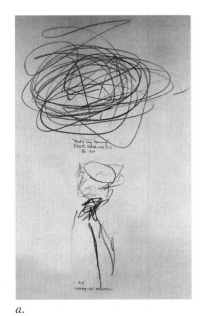

a.

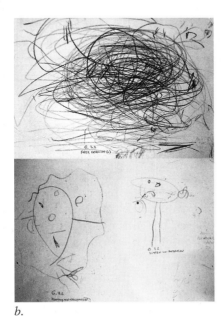

b.

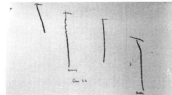
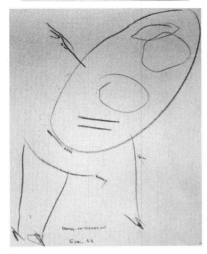

c.

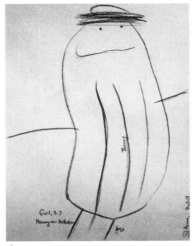

d.

7. *Drawing-on-Dictation*
a. Boy, 3;4. On the free drawing task, the mommy is drawn as a circular whirl; on dictation she is drawn as a scribbly but representational figure.
b. Girl, 3;2. The free drawing yields a circular whirl, while dictation elicits representational figures—a mommy on the left, a kitten on the right.
c. Girl, 3;3. The request to draw a mommy and a baby produces verticals; on dictation, the major parts of the human figure are represented and fairly well organized.
d. Girl, 3;7. The free drawing consists of scribbles; dictation elicits a clearly representational human figure.

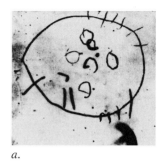

a.

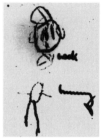

b.

c.

8. *Drawing-on-Dictation*
In short succession, this four-year-old boy evolved a coherent representation of the human figure consisting of a head with facial features, neck, body, arms, hands, legs, and feet.

observed on a single session, progress could be charted clearly, beginning with a crude and graphically ambiguous formation, and ending with a clearly recognizable figure of a person. Illustration 8 *a* presents the work of a four-year-old boy who, on dictation, drew a large circle for "head." With the exception of the hair, all the parts are drawn inside the circle that, while it encloses them without much regard for their orientation, indicates that they belong together. Thus, the major distinction in this drawing concerns marks drawn on the inside versus the outside of the circle, while their orientation within the boundary is ignored. On a subsequent trial, immediately following the first one, he drew the major body parts outside the primordial circle, creating a separately drawn neck, body, and limbs. While the overall organization of the figure along a vertical axis presents a great improvement over the first drawing, the various body parts are detached from each other, with "gaps" or open spaces that separate the parts (ills. 8 *b*). On the third trial, the same child drew a circle large enough to encompass all the facial features, he attached the neck to the head, and while he still left a gap between the neck and the body, he aligned the parts very appropriately along the vertical axis (ills. 8 *c*). Moreover, the orientation of the marks corresponded to the orientation of the features of the object. This drawing on dictation over three trials lasted only a few minutes and illustrates that meaningful shapes can be forged without the benefit of prolonged scribble practice.

Similarly, my studies indicate that when scribblers are presented with a figure-completion task consisting, for example, of a head and facial features, and instructed to complete the drawing of a man that someone else started but left unfinished, they draw the outline of a trunk, legs, and sometimes arms. Other data from the same study indicate that in a single session some prerepresentational scribblers can progress from lines and nonrepresentational shapes to the drawing of a recognizable figure (see ills. 9). Three-year-old Sarah's first response to the request to draw a person was a pear-shaped oblong, a form that may well represent a failed attempt to draw an oval. The second and third trials yielded similar shapes. The fourth attempt produced a

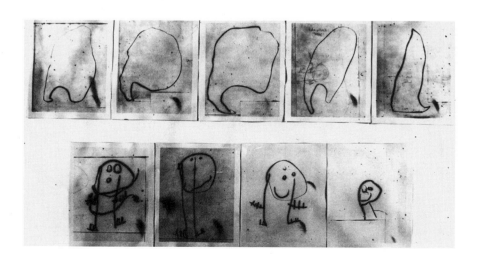

9. *First Representational Drawings*
Girl, 3;8. Within a short time span, Sarah progressed from a relatively undifferentiated closed shape to a clearly recognizable human figure.

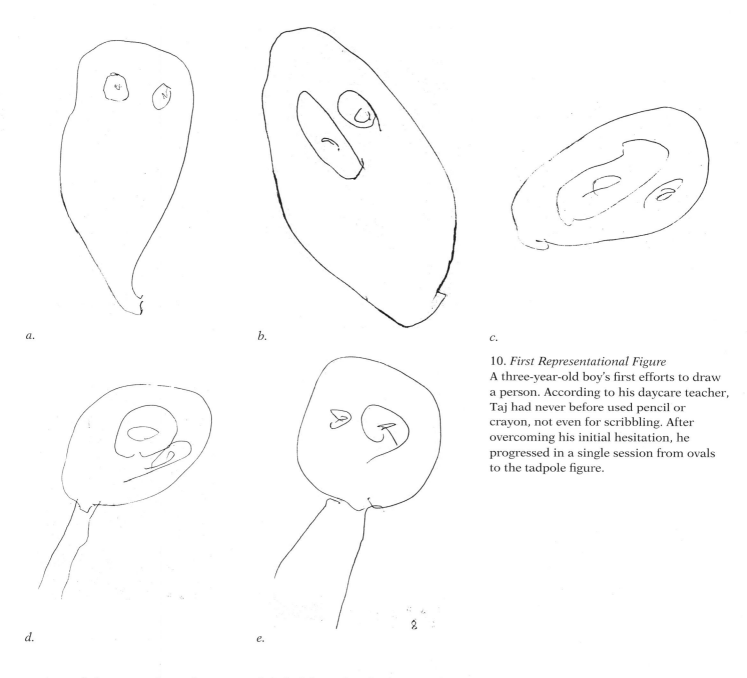

a.

b.

c.

d.

e.

10. *First Representational Figure*
A three-year-old boy's first efforts to draw
a person. According to his daycare teacher,
Taj had never before used pencil or
crayon, not even for scribbling. After
overcoming his initial hesitation, he
progressed in a single session from ovals
to the tadpole figure.

variant of the same shape, but it was labeled "a turkey." The next fig-
ure, a somewhat triangular-looking closed shape, was interpreted as
"a ghost," and apparently facilitated the transition to the series of rec-
ognizable humans that she drew next. A similar progression over a
limited time period can be seen in illustration 10. These findings have
been replicated in several additional studies that engaged children be-
tween ages 2;0 to 3;4 (Golomb, 1981). Once again, children who on
the free-drawing task produce only scribble-patterns are able to draw
recognizable figures on dictation (see ills. 11 *a, b, c*). Lack of practice
can yield rather scribbly looking figures. However, the ordering of
parts along a vertical axis tends to support a primitive unit-formation

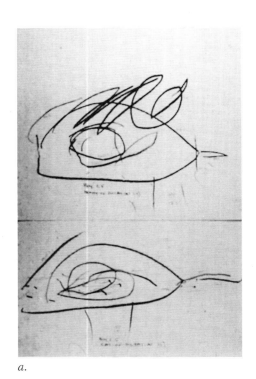

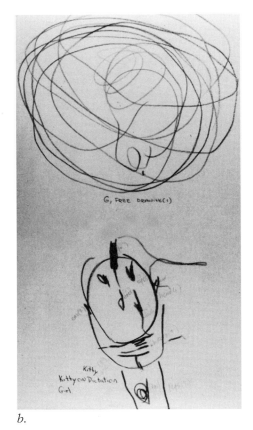

a.

b.

c.

11. *Drawing on Dictation*

a. Boy, 2;5. A scribbly but representational figure emerges on dictation.

b. Girl, 2;9. The free drawing consists of circular whirls; dictation yields a representation of a " kitten."

c. Boy, 3;0. The first drawing consists of an array of open and closed shapes which are identified as "cookies," a form of reading off; the second drawing consists of circular whirls. On dictation, recognizable representations of a mommy and a tree emerge.

that places this kind of drawing in the representational category (see ills. 7 *a*).

How can we account for the remarkable improvements in the drawing of recognizable figures over such a short time period? Do these data support the previously mentioned conception of an incremental step-wise progression from marks to scribbles to shapes? Or do they suggest that the scribble stages can be abbreviated or even skipped? At this point, the evidence suggests that the scribble experience is neither a sufficient nor a necessary condition for the development of early drawing; it does not support Kellogg's emphatic and Matthews' more implied view of the role of this presymbolic activity as a precursor of representational drawing. However, though not essential for drawing development, it might well be useful as it acquaints the child with the "tools"—that is, the paper, the crayon—and how he or she can manipulate them to produce a visual result that progressively can be linked to meaningful objects or people. In order to gain greater clarity about the transition from nonrepresentational scribbles to the emergence of clear and useful contours, prerepresentational two- and three-year-olds were first asked to draw a picture of anything they wished (Golomb, 1981). The request was stated in very general terms, and the choice of a theme or of a design was left to the child. After completion of the "free" drawing, the child was asked to

a.

b.

c.

12. *Drawing on Request*
When faced with a request to draw a person or an animal, scribbling 2- and 3-year-olds tend to produce clear contours.
a. Girl, 2;2.
b. Girl, 2;11.
c. Boy, 3;4.

draw, one at a time, a series of items: a mommy, a baby, a giraffe, a kitten, a snake, a worm, a tree, a flower, a bird, a fish, a car, and a house. The results were enlightening: Whereas on the free-drawing task, children between two and three years of age drew only scribble-pictures, on being asked to draw specific items, they drew, with few exceptions, clear outline figures, usually ovals for each one of the requested items (see ills.12 *a, b, c*). An exception can be seen in the responses to the snake and the worm. These were drawn as single lines, most commonly in a horizontal orientation. These results suggest that the nature of the assignment—namely, the imposition of an intention to draw a specific and known object—leads to a different conception

of the task and elicits a new graphic strategy. The instruction seems to mobilize the child's efforts, the unruly swirls come under careful visual-motor control, and clear contour formations emerge, one for each of the requested items. These forms seem to have little in common with the preceding scribble-patterns produced on the free drawing and do not clearly relate to the scribbles practiced by many young preschoolers.

The dramatic transition from scribble-patterns to clearly delineated graphic shapes requires a special account. The freely ambulating scribble-lines are somewhat antithetical to the controlled shape that emerges when the child intends to represent an object. Although the prerepresentational child may well profit from experience with mark-making and may be able to draw upon a varied repertoire of scribble-patterns, when he struggles to create a figure on request, this repertoire is not very useful. Let us consider the dictation task with its instruction to draw specific parts that demands on-the-spot solutions. Under the pressure of this assignment, the child's graphic inventions appear to short-circuit the need for lengthy practice with scribble-patterns, implied shapes, or emergent diagrams.

How then are we to construe the transitional stage that links the early nonrepresentational scribble-patterns with the emergence of clear graphic shapes? Careful investigations using dictation and completion strategies can help detect a short-lived transitional phase that precedes the evolution of clear contours. Already Herman Lukens (1896) described certain localization skills in preschool children who could draw scribbles in a top-to-bottom order, pointing to the upper part of the scribble-picture as head, for example, and the lower one as legs. I noted a distinction between scribble-pictures that are merely the product of recorded gestures and do not point beyond themselves and those that accompany an imaginary event and lead to "romancing" (Golomb, 1974). Romancing can take the form of a free-running interpretation of the scribble-action and occurs quite independently of the scribble-configuration. Despite the chaotic lines on the page, the child imposes meaning on her scribbles as she identifies parts of the scribble-picture according to an imaginary vertical top–bottom axis. Thus, for example, a scribble can be identified as a person whose face is located above the body, whereas the legs are presumed to lie below the body. In a more detailed study of localization skills, Carolyn Fucigna and Dennie Wolf (1981) found that the ability to map marks in a top-to-bottom order is quickly followed by the placement of marks on either side of a major axis, either a vertical or a horizontal one, which indicates some understanding of the referential function of the marks. Closely connected with these localization skills is the ability to depict the correct number of the parts—two eyes, one nose, and two legs, for example—and to orient these parts in a relatively consistent fashion.

These findings point to the existence of a brief transitional phase, an interlude between the purely visual-motor exercises that yield the various scribble-patterns and the spontaneous emergence of closed circular shapes. During this transitional period, the child appears to

have a vague understanding that the location of marks on paper can correspond to the location of the features of an object. The romancing child who can, however fleetingly, maintain a top-to-bottom order when interpreting his scribble-picture intuits the existence of correspondences between the two-dimensional surface of paper and the three-dimensional mass that defines an object. A new order is established that extends beyond a particular domain, an order essential for representational purposes. The dawning awareness of the sheer possibility to represent a complex three-dimensional object with paper and pencil marks the transition to representation proper. However, the cognitive skills that permit the short-lived localization of scribble-parts as well as the depiction of the correct number of parts do not yet mark the true beginnings of graphic representation, since the scribble-lines on their own cannot sustain meaning. Scribble-localization is a relatively transient phenomenon, one that is often induced by the adult. Graphic representation is the process of creating meaningful correspondences that rest to a large extent on the ability to invent shapes that signify, and thus point beyond themselves to another realm of meaning.

The foregoing account of the transition from scribble-patterns to representation suggests that as the child evolves basic forms beyond the scribble-patterns and controls the impulsive scribble-motions, the forms become immediately useful for the representation of objects. Closed contours lend themselves to meaningful portrayals, and these forms are in turn transformed by the meanings they evoke. The transition from scribble-patterns to representation is characterized by a transformation of a motor action that represents only itself to a form that can become a symbol for another reality. We have examined some of the precursors of this transformational process, and we have seen that when shape emerges with relative clarity it can be used in an intentional fashion by the child, who thus reaches the representational stage.

Before we explore the beginnings of representational drawing, let us turn once more to the positions articulated by Matthews and Kellogg and consider them in the light of the data I have presented. The startling finding that representational forms and figures can emerge without previous scribble practice (Andersson & Andersson, 1997; Court, 1982, 1989; Golomb, 1969, 1974, 1981; M. Haas, April 9, 1978; Harris, 1971; Kennedy, 1980, 1983, 1993; Millar, 1975) provides a serious objection to Kellogg's account of the evolution of forms through an almost invariable sequence of scribbles, placement patterns, emergent diagrams, and diagrams to a design stage of combines and aggregates. Clearly, as the drawings of inexperienced children and adults— of the sighted as well as the blind—indicate, representational forms can and do emerge independently of such practice. Kellogg's formal description of the child's construction of a seemingly abstract graphic vocabulary ignores the meaning children attribute to their scribbles and designs. An examination of the finished product on which Kellogg's taxonomy is based, of necessity eliminates the interpretive comments children make while drawing or when they inspect their finished work.

Kellogg's taxonomy of shapes, and her emphasis on the nonpictorial or nonrepresentational nature of complex configurations does not provide an insight into the representational origins of drawings. Her orientation betrays a preference for abstract forms, an appreciation of shape independent of meaning that determines her choice of units of analysis, and, ultimately, imposes an adult's vision on children's drawings.

Matthews' account of the infant's developing visual-motor coordination and of her interest in the marks she leaves behind does not specify the extent to which such practice is a prerequisite for the discovery of the closed shape. His emphasis on action-symbolism as a major motive for representational development ignores the distinction between action-symbolism as a prerepresentational activity of only fleeting significance and the ability to draw a meaningful shape. Long before the toddler draws recognizable forms, she engages in symbolic acts in speech, imitation, and symbolic play. However, symbolic actions in these domains do not by themselves insure the invention of a graphic symbol system; the laws that govern the pictorial medium have to be discovered independently of other domains. I now turn to a closer analysis of the beginnings of representational drawing.

Beginnings: The Invention of a Representational System

With the beginning of representational drawing, a noticeable change occurs in the child's attitude toward the shapes he has created. While the mark-making toddler frequently inspects the drawings of his peers, and shows a lively interest in his own ongoing brushwork, once he leaves the painting easel, he seems indifferent to the marks he has left behind and does not object when another child adds her brush strokes to the painting (P. Tarr, April 19, 1987; Tarr, 1990). This non-possessive attitude reflects the absence of a personal relationship with the shapes the child has drawn. Such mark-making is not unlike the footprints left in sand that elicit our fleeting interest until they are covered up by other footsteps. Once the child uses shapes to represent objects, they tend to elicit feelings of ownership, a personal and more enduring interest in the product, and a desire to preserve it.

In the previous section, we have seen that localization of scribble-parts and the correct number of features cannot by themselves sustain the child's representational intention. Graphic representation requires the use of shape, and it is shape that constitutes the basic unit for the depiction of objects and, later on, of more complex ideas and feelings. Shape does not exist in isolation but as a contour in relation to its background, which imparts a figural quality to the enclosed area. Moreover, shapes are never truly "neutral" and it would be misleading to conceive of them as empty vessels that need to be filled to attain meaning. In Arnheim's words (1974, p. 97), all shape is semantic; that is, intrinsically meaningful and expressive of such qualities as roundness, sharpness, straightness, fragility, harmony, and discord. Further illustrations of the power of abstract line patterns to express psychological attributes come from studies on symbol formation by

Heinz Werner and Bernard Kaplan (1963). Their work demonstrates that the shape, direction, color, lightness, or heaviness of a line can suggest such characteristics as mildness, harshness, goodness, and evil.

Such considerations strongly suggest that shapes are the carriers of basic—not explicitly taught—meanings. In marked contrast with graphic representation, the relationship between the verbal phoneme and what it signifies is generally considered to be of a conventional and somewhat arbitrary nature. In the domain of drawing we are faced with shapes that are endowed with an expressive power that is not primarily derived from conventional usage, a finding that leads to a major distinction between the linguistic and graphic systems.

What are the earliest shapes children employ when they begin to represent their favorite subjects? In the previous section we have seen that in order to sustain a pictorial image and to express graphically the child's intention, lines must be used to create a relatively clear and perceptually readable configuration that exists beyond the child's momentary association. The child's memory of an image, and his or her association to a scribble-picture, are short-lived, and scribble-patterns that comprise the correct number of parts in their appropriate location cannot sustain a meaningful interpretation. The latter requires visual supports that are independent of fleeting memories. The first truly representational shapes that meet this specification are usually circles and ovals. They are the heirs to well-established perceptual and motor preferences. Visual perception singles out the circle for its simplicity as well as its perfection. The circle is a shape characterized by its centric symmetry; it does not specify any direction and it possesses the fewest individual features. According to Arnheim (1988), these attributes are well-suited to first efforts to represent objects in a general and abstract way (see ills. 12). Thus, when the circle is employed as the earliest available form, it does not yet represent the figural quality of roundness but signifies the general "thingness" of objects—that is, the solid property of three-dimensional things. The undifferentiated use of the circle in early drawings defines this first representational system as "topological" in that it depicts the general quality of an object as a bounded surface and is unconcerned with properties of shape, size, and distance (Piaget & Inhelder, 1956; for a more detailed discussion, see chapter 4). The priority of the circle in the development of perceptual-motor coordination can also be seen in the copying of geometric figures, which is first accomplished with the circle at approximately three years of age, one year before the child can copy a square. Given the construction of arm, hand, and fingers, which tends to favor curved paths, the circular motion is easier to perform than the deliberate drawing of straight or angular lines that requires greater motor control (Arnheim, 1974). Thus it appears that perceptual as well as motor processes favor the use of the circle in an early phase of representational development.

Evidence for the graphic usefulness of the circle is abundant in children's drawings. I shall examine the early phases of representational development by focusing on the drawn human figure. The

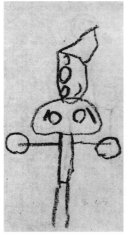
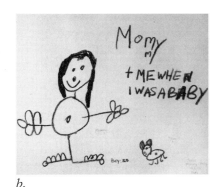

13. *The Circle as a Representational Shape*
a. Boy, 4;7. Imaginative use of circles.
b. Girl, 5;5. The circle is useful for the representation of many different body parts.

a. *b.*

human figure provides us with a prototype of the emergence of representational forms and their differentiation, and lends itself to a closer analysis of the rules that guide this development. It is a much-favored subject of young children's drawings and one that has been most extensively studied by many authors (Cox, 1993; Goodenough, 1926; Harris, 1963). Other subjects and themes will be taken up in the succeeding chapters, especially chapters 3 through 7.

Inspection of some of the earliest figures indicates that these drawings make liberal use of circles for head, eyes, nose, mouth, ears, and body (see ills. 13 *a, b*). Indeed, many of the first drawings, usually of humans, tend to consist of a large oval with roundish facial features drawn on its inside (see ills. 14 *a, b, c* and 15). Soon after the drawing of these global humans, additional features make their appearance, and the global unit tends to sprout legs, hair, and frequently arms (see ills. 16 *a, b, c*). How are we to interpret these odd-looking creatures? From the adult's conventional viewpoint, such figures appear primitive and incomplete, lacking the photographic realism we have come to expect of a drawing. If, however, we consider

14. *Global Humans*
a. Girl, 2;10. Picture of her mommy.
b. Girl, 2;10. Person
c. Girl, 3;3 and boy, 3; 8. People.

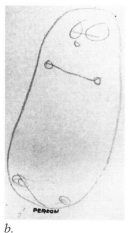

a. *b.* *c.*

the early drawings as first explorations of a pictorial world whose language is still unknown, we might well marvel at the ingenuity of these inventions that specify that graphic units can stand for more complex units of the three-dimensional world and that makes the basic distinction between thing and empty space.

Let us examine more closely the child's first depictions and try to infer the rules that guide his or her drawings. As we have seen, the child's first drawings of humans and of most animals consist of global units that encompass the facial features. These figures, which portray human and animal characteristics in a generalized and very similar way, are original productions in the sense that they are not derived from an existing model. If we contemplate this surprising finding, we wonder where the peculiarly childish forms originate. Even on first reflection, we are struck by the observation that humans do not consist of circles, lines, or dots, and that the child's rendition is purely his own invention. Given the three-dimensional character of the model that is made of organic stuff, the child's drawn version clearly does not bear a simple relation to it. The discrepancy between what the child perceives and what she draws offers us an insight into the representational rules that she develops.

According to Arnheim, who extols the logic of the child's graphic solutions, the early drawings demonstrate a spontaneous awareness that invented forms can "stand" for the object and represent it in some fundamental way. Representation rests on the invention of forms that are structurally or dynamically equivalent to the object. It does not aim for one-to-one correspondence, nor does it aspire to "copy" the original, which is altogether an impossible task given the intrinsic differences between the properties of a two-dimensional and a three-dimensional medium. By its very nature, the drawing medium with its specific tools and demands for graphic concepts tends to encourage shapes made of lines. Thus, the flat surface lacks the condition necessary for imitation proper. The child who draws an oblong, equips it with facial features, and calls it "a man" does not mistake it for a human of flesh and blood; he merely views his figure as an acceptable equivalent. The child seems to evolve a rule that states that a unit on paper, for example, the circle with facial

15. *Global Animals*
a. Boy, 3;11. Drawings of a giraffe (left) and a kitten (right).

16. *The Global Human Sprouts Legs, Arms, and Hair*
a. Boy, 3;3. Armless tadpole figure
b. Boys, 3;6 and 4;7. Tadpoles with arms. Approximately one third of the early tadpoles are equipped with arms.
c. Girl, 3;9 and boy, 4;0. Tadpoles with arms and ears.

a.

b.

c.

features, is equivalent to another unit, a human or an animal. This conception of equivalence does not reflect an inaccurate percept or a faulty concept of the object. On the contrary, it indicates the symbolizing propensity of the human mind to establish correspondences on the basis of general qualities. Representation does not rest on an identity of elements, but on prototypical or abstract properties (Arnheim, 1974; Rosch, 1973, 1975). The ability to abstract out of the myriad details that comprise a human some general characteristics that define its animate nature, to declare that a highly simplified and unique version can "stand" for something without being it, is a true hallmark of a symbolizing intelligence. The human child invents this basic rule of representation on its own.

In summary, Arnheim's (1969, 1974) orientation to child art focuses on the invention of two-dimensional solutions to an essentially intractable problem—that of representing three dimensions—and views the child's simplistic graphic forms as genuine acts of intelligence. Implicit in this position is the assumption that the drawing child does not have recourse to suitable "models" because our three-dimensional world does not directly provide children or naive adults with a graphic language that can be imitated. Drawing is an act of translation; it requires a radical transposition from the perception of a solid object extended in space to a representation that uses lines and dots on a two-dimensional surface. The invention of a meaningful graphic language rests on an understanding that symbols "represent," and that they are not to be mistaken for the actual object they refer to; that is, that symbol and referent are to be distinguished. Unlike spoken language, which presents the child with a ready-made symbol system essential to his survival as a social being, early drawing requires an individual act of creative invention that most children between ages three and five years attempt in a fairly autonomous fashion. This view of child art stresses the symbolic capacities of the young child who actively engages in creating a pictorial statement and discovers the particular possibilities and constraints that are unique to the drawing domain.

Having viewed the child's first representations as inventions, we are now ready to examine more closely how he utilizes his newly won discoveries. In his first trials, the circle-oblong stands for the totality of the object, for example, a person. While this "unmarked" symmetrical figure represents the object only in a general and undifferentiated manner, the arrangement of the facial features begins to obey a principle of spatial ordering that specifies the placement and orientation of eyes, nose, and mouth from the top down and manages to confer a degree of specificity and clarity onto the figure. Within this new context, lines are further explored and used to indicate facial features, hair, and limbs. The child quickly discovers that lines have multiple uses and that their length can be controlled. Lines can be dot-like or extended, which makes them useful for the drawing of pupils, tears, or limbs. When they are curved, lines depict hair, lips, and teeth. Indeed, a simple change in orientation renders the same line suitable for the portrayal of either nose or mouth. A set of tentative rules for

a.

b.

17. *Contourless Human*
Verbal labels identify the parts and thus
give meaning to the contourless figure.
a. Girl, 3;2.
b. Boy, 3;1.

graphic depiction is being developed by the child who uses the closed
contour in conjunction with the multiple functions of the line to con-
struct her first representational system.

The invention of the circle does not always precede the internal
differentiation of the figure. Some children employ, for a short time,
the contourless model, which demonstrates the difficulty of depicting
a meaningful figure in the absence of an enclosing line. A figure that
portrays facial features and limbs in the correct location and orienta-
tion without the benefit of the contour line lacks the perceptual cohe-
sion necessary for recognition to occur (see ills. 17 *a, b*).

Early representational systems employ highly economical forms
that are marked by an intrinsic order and symmetry. According to
Arnheim, a rule of simplicity governs such representations, which ex-
hibit the simplest possible relationship of contour and inner mark-
ings. The early figures are based on the simplest possible structure
that can denote its object. Arnheim calls attention to the general de-
velopmental course that proceeds from simple to complex forms, a
developmental principle of differentiation that characterizes all cogni-
tive processes. (For a more detailed discussion, see chapter 3.) Given
this view of development, the global human represents its object in a
rather general sense. In its overall characteristics, the figure merely
portrays an animate object that, due to its lack of graphic differentia-
tion, yields only very limited information about its subject matter.
The figure's ambiguity or lack of definition raises basic questions: Is it
a human or an animal? Is it young or old, female or male? The simple
outline endowed with a few facial characteristics places severe con-
straints on the meaning that can be conveyed to an observer. Al-
though the global human represents a tremendous achievement over
the scribble-patterns of the transitional phase, which lack unity of
shape, it also exemplifies the limitations inherent in such simplicity.
It is the ambiguity of the early model that now impels the child graph-
ically to differentiate his figure so that it portrays the object with
greater clarity. The child first accomplishes this by appending limbs
to the global man, and next by shrinking the global primary unit and

18. *Tadpole Figures*
a. Boy, 3;7. Mommy and baby.
b. Girl, 4;4.

a. b.

19. *Human and Animal Tadpoles*
a. Boy, 4;2. This child intended to draw a
cat, but upon inspection of the figure (left)
he renamed it a "cat-boy." The next figure
(right) is endowed with four legs, a tail,
ears, and fuzzy hair that distinguish it
from its human counterpart.

lengthening the verticals that extend downward. This newly created
version of the human is a figure commonly called the "tadpole" man
(see ills. 18 *a*, *b*). The tadpole man is still an essentially "animate"
creature rather than an exclusively human representation. As illustra-
tion 19 indicates, this tadpole can serve with equal ease as a human
or an animal—in this case, a cat. The two drawings were made by a
four-year-old boy who, on discovering the similarity between the two
figures, renamed his man "a cat-boy." Such verbal correction is not
unusual, and we shall take a closer look at the role of verbalization to-
ward the end of this chapter.

As long as the global human represents the totality of the object, it
does not require the separate delineation of all its parts, and the body
(torso) of the tadpole man may reside in either the large circle or be-
tween the elongated vertical lines that stand for body-contour as well
as legs. These representational implications—that is, the implied body
parts that are "contained" within the contour—are easily verified by
asking the child whether her figure has a tummy, and if so, to indicate
where it might be (see ills. 20 *a*, *b*, *c*).

With the extension of the two verticals downward, we observe
that the primordial circularity tends to be transformed or compressed
into verticality, following a rule system that goes beyond the represen-

20. *Early Depiction of the Trunk*
The trunk may be represented by a
scribble, buttons, or a circle; it is
frequently "implied" in the area bounded
by the two long verticals.
a. Boy, 4;7.
b. Boy, 6;0.
c. Girl, 5;2.

a. b. c.

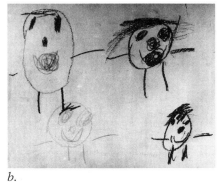

b.

c.

21. *Variety of Tadpole Figures*
a. Ages 3;6 to 5;1.
b. Girl, 3;6.
c. Girl, 3;10.

a.

tation of "thingness." This newly evolving rule system defines humans by their vertical uprightness, which in the drawing medium translates to the vertical length dimension and distinguishes the human from other animate creatures. A tension becomes evident between the desire to create simple structural equivalents and the need to create a visual likeness to the object, and thus to transcend the earlier graphic abstraction. At this juncture in the graphic development of the child, a structural equivalent must capture an essential visual property of the object.

The newly articulated graphic structures consisting of a circle and extensions are further endowed with embellishments. Beyond the basic facial features—eyebrows, pupils, nostrils, ears—hair and arms appear with increasing frequency. Despite the structural similarity of the two-unit figures (i.e., the circle and the extensions), we find seemingly unlimited variations on this common theme (see ills. 21 *a, b, c*). Among these, we can observe figures that are as yet deprived of the firmness and stability that the circle confers on the subordinate parts. We see the contourless model that organizes the facial features and limbs along the vertical axis and creates a humanoid figure that lacks the solidity of the enveloping contour. This model is perhaps the heir to an earlier strategy of marking the location of features that I described in the previous section (see ills. 22 *a, b*). We encounter rectilinear figures that, like the contourless model, create the human in the vertical order without the benefit of the closed shape. We also find

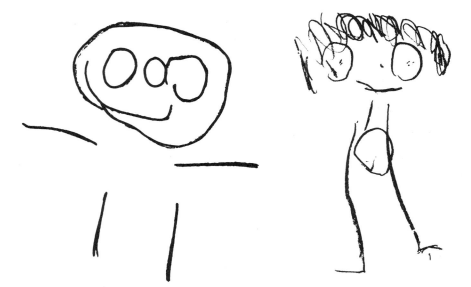

22. *Contourless Models*
a. Boy, 4;0. Arms and legs extend from an "unbounded area; the trunk is merely implied.
b. Girl, 4;2. Head contour is missing.

elongated tadpoles that from the very beginning consist of a tiny circular head with long downward extensions (see ills. 23 *a, b, c, d*). Generally speaking, the contourless and the rectilinear models are short-term and not entirely satisfactory solutions that will be abandoned in favor of the more solid-looking figure that uses the circle as a basic figural unit.

The route to the invention of graphic equivalents is never completely uniform and, as the ages of the young artists indicate, there is no strict age progression or timetable. Children struggle with the problem of inventing suitable forms of equivalence and their solutions may vary within a certain range of options. The contourless models, while short-lived, indicate the limitations inherent in a representation that lacks the embracing contour and merely relies on number (for example, two eyes), symmetry, and location-orientation cues. When the similarity of form, number, location, and orientation of parts yield recognizable "units," a representational figure may result, although it is deprived of the stability and cohesiveness that contours can impart and thus presents a less satisfying solution. Despite the impressive individual variation in the depiction of the tadpole man, it is relatively easy to detect structural commonalities.

How satisfying are the early tadpole drawings to the preschool child? Given her tendency to use graphic forms sparingly, to economize in the graphic delineation of parts, as well as her desire to finish a drawing rather quickly, the drawing is bound to fall short of what she knows and might wish to represent. The gap between the richness of her perceptual experience and her simple graphic rendition may call for additional efforts, particularly when the drawing fails to meet her standards of what it ought to look like. To correct this unsatisfactory state of affairs, she may have recourse to verbal interpretations and modifications. The notion that a drawing should present a self-sufficient statement is as yet absent from the child's mind, and she

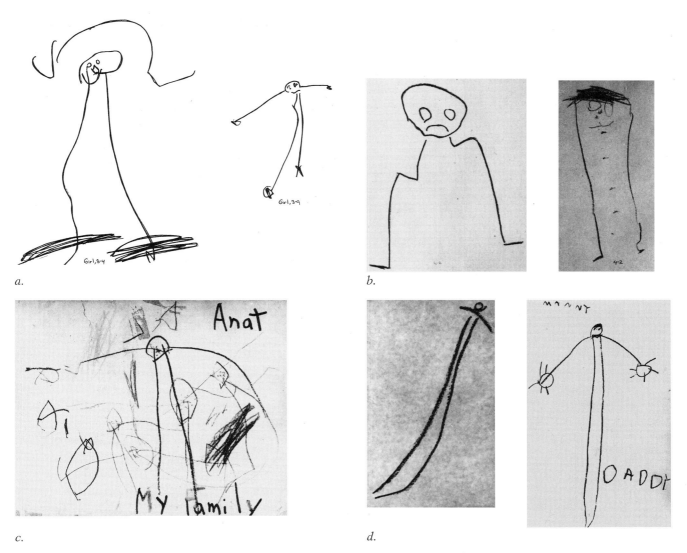

a.

b.

c.

d.

23. *Elongated and Rectangular Tadpole Figures*
a–d. Ages 3;4 to 5;2.

adopts the easiest solution available to her, namely, to verbally correct the imperfections. The child, for example, may legitimize an irregularity as "funny," or transform an uneven pair of legs into a "broken leg." Omissions are often redressed in a matter of fact fashion: "I just won't make it," or "It's there but you can't see it." There are many devices that can explain the imperfections, alter them, or elaborate upon them. They include the primitive forms of romancing—that is, making up stories that seem unrelated to the scribble markings, examining the accidentally created pattern and reading off what it might stand for, designating parts that are not graphically delineated in a verbal fashion, and various forms of criticism that express the child's dissatisfaction with the outcome. These verbal devices are means for bridging the gap between the child's aspirations and the simplistic drawing that he produces. But it would create the wrong impression to consider the child as a frustrated artist. He is frequently surprised by his achievements, delights in his unanticipated successes,

exclaiming, "Look what I made! It's a man!" Altogether, the child's verbal comments, justifications, and reinterpretations reflect his awareness that the drawing is not meant to be a copy, and that it is the best he can or wants to do.

Let us now summarize the account I have offered of the evolution of graphic depiction. Early marks and scribble-patterns are largely determined by the mechanical construction of the arm, wrist, and hand. The emergence of the first circles and ovals in combination with lines yield the early global humans, animals, and other items of interest to the child. Given the generality of this progression, we might say that we have witnessed the discovery of a universal graphic language. And indeed, the early depictions emerge quite independently of language, culture, history, and even chronological age as the drawings of children in previous times and of inexperienced adults indicate. The collections of children's drawings published since the end of the 19th century and the drawings of the blind further amplify the generality of the process I have described. Thus, a story of universal graphic propensities begins to emerge. The evidence for a fundamental, perhaps even biologically based, competence to perceive and recognize pictures is also quite impressive (DeLoache et al., 1979; Gross, Rocha-Miranda, & Bender, 1972; Hochberg & Brooks, 1962; Jahoda, 1981; Kennedy, 1980, 1983, 1993). My own analysis of the data on early drawing development suggests that this might also be the case in graphic representation, at least in its early phases. The utilization of preferred graphic patterns indicates the nature of the early representational conceptions that guide and constrain the drawing process and thus make for the remarkable similarity across individuals and cultures.

Although I have emphasized the dynamics of the early discovery of forms and the beginning of their differentiation, the gestural action component stressed by Haas and Matthews ought to receive adequate acknowledgment. The child's motivation is embedded in all the phases of the ongoing action and its satisfaction is intrinsic to the action. Gesture, the very early expressive communicative system of humans, remains active throughout the lifecycle, and art-making is rooted in bodily sensations that reflect intentions and individuality of a biological and psychological order.

Does this account of the early beginnings imply a rigid stage conception? I do not think so, as this analysis merely suggests the course that naturally developing abilities may take in predisposing humans for certain types of graphic formulation and experimentation. I have reviewed this course from the invention of form to the deliberate and intentional creation of meaning. With the global human and the tadpole man, the first milestone in figural representation has been reached. Next I shall explore in greater detail the rules that determine its unique structure.

The Puzzle of the Tadpole Man 2

With the tadpole drawing the young child has created a recognizable figure that can represent an object, image, or idea. It is one of the first representations that exemplify the child's basic grasp of the graphic medium.

Most adults tend to greet this tadpole creature with a mixture of wonder, bemusement, and uneasiness. There is first the moment of surprise when we discover and recognize this figure that bears so little resemblance to the picture-book humans and animals, or to the photographs that the child is likely to have seen. We marvel at the child's inventive mind that has produced this simple, visually meaningful figure. But beyond the initial surprise and appreciation, we feel uncertain about the representational status of the drawing, which deviates widely from the accepted norms of what a drawn human ought to look like. Most adults seem to rely on a standard list of items they deem essential for the portrayal of a person. This list usually includes a head with facial features, torso, arms, and legs. On first inspection, the tadpole figure is quite deficient in the number of its drawn parts. Most striking is the absence of a trunk, while fingers tend to vary from a few to a superabundance. Additional "faults" concern the misplacement of arms and legs and a disregard for body proportions. One could easily extend this list of peculiarities and "errors." When the figure is judged in terms of number, proportion, relations, and the depiction of essential body parts, the tadpole drawing presents a somewhat disturbing deviation from an hypothesized norm or standard. Indeed, the puzzle of the tadpole man has provoked a great deal of theorizing. Most students of children's drawings have seen in this simple figure the working of an immature mind whose errors can be identified as sins of omission and of commission. Thus, the tadpole drawing is said to reflect the primitive, prelogical mentality of the young child. Various processes have been considered that may predispose the child to such drawing "mistakes." At times blurred mental or memory images have been implicated (Eng, 1931) or the inadequacy of the perceptual analysis of the object (Piaget, 1951; Piaget & Inhelder,

1956, 1971). With a few notable exceptions, most writers have argued that the child's immature reasoning processes lead to the defective drawings (Goodenough, 1926; Harris, 1963; Kerschensteiner, 1905; Luquet, 1913, 1927; Piaget & Inhelder, 1956). This emphasis on faulty knowledge was captured in the popular phrase, "the child draws what he knows, not what he sees." Despite the widely held view that the young child is perception-oriented—that her attention is turned toward the outside world, captivated by the immediate appearance of objects and people—her knowledge was deemed inadequate, the product of prelogical reasoning that fails to do justice to the perceptual information. This emphasis on deficiency (Piaget called it "distorting assimilation") leads to the paradoxical view that the perception-bound child does not draw what she sees but draws what she knows, and that her conceptions are incompatible with the world as we adults know it.

With the passage of time we observe gradual changes in the child's drawings that can be interpreted as steady improvements in the ability to depict objects. Such findings seem to provide support for the notion that progress in drawing goes hand-in-hand with the growth of conceptual skills. As the drawn figure gains in detail and its proportions appear less idiosyncratic, we assume that this graphic achievement reflects the child's increased conceptual competence. This position has been taken by Goodenough (1926) and Harris (1963), and is embodied in their Draw-a-Man test, which credits each drawn part and the manner in which it is depicted with a score; the sum of scores is said to yield an index of the child's conceptual maturity. It is a position that comes close to considering the drawing as a print-out of the child's cognitive status. To make use of a contemporary figure of speech, the drawing provides a kind of X-ray or CAT-scan picture of the child's mental activity.

For many decades, the simplicity of this assumption has made it an attractive, albeit somewhat circular, proposition: we know that the young child is conceptually immature, and his drawings confirm this inferior cognitive status. However appealing this simple account of the relationship between drawing and concept formation might be, its adequacy was seriously challenged by Rudolf Arnheim in his book *Art and Visual Perception* (1974). Arnheim exposed the fallacy of adopting a stylistic, culture-bound convention—for example, realism—and measuring the child's graphic achievements by this standard. Psychologists, somewhat unwittingly, have elevated an era-specific accomplishment, characteristic of the period that extends from the Renaissance to Modern Art, to a near-universal principle and applied it to child art. If we follow this line of reasoning, we misconstrue art-making as a process of replication, and judge early art by its failure to establish a one-to-one correspondence between the object's realistic properties and its graphic representation. Arnheim's analysis of the nature of the two-dimensional medium, and of representation as a search for equivalences, has focused our attention on the *graphic logic* that determines the evolution of early forms and their gradual differentiation. As an example of graphic logic we might consider the huge circle of the tadpole figure to represent the head as well as the body,

to encompass both in its boundary. It is a simple, easily readable figure that captures an essential quality of the object. More will be said about graphic logic later.

From Arnheim's perspective, then, the tadpole man is not an incomplete or defective figure; it is a simple rendition of a human. Art is not concerned with a replication of all the artist knows about the object; it concerns itself with equivalences of a structural and a dynamic kind and obeys rules of a visual logic that has little in common with an enumeration of parts. In this conception of adult as well as child art, nothing is, strictly speaking, "missing" from the tadpole figure. The simple, relatively undifferentiated structure of the tadpole man is typical of an early stage in representational development. In this view, all cognitive development proceeds from a global, somewhat undifferentiated conception to one that is more detailed and discriminating.

This analysis, which stresses the meaningfulness of the tadpole figure and insists on its representational intactness and logic, rests on a sophisticated analysis of the psychology and history of art. Its position is in stark contrast to the conception of child art as an imitative activity where progress is measured in terms of approximations to "realism" in art. We are faced with two opposing conceptions of art and its relationship to cognitive processes. How do we choose between them? In an age that values empirical evidence, we tend to design experiments.

It is fortunate that the positions, briefly sketched above, lead to different predictions about the effects of media, task demands, and instructions. In the case of the "defect hypothesis" of children's art, we ought to predict that the child's representation of the human figure is determined as well as constrained by *what* she knows and *how* she knows; that is, by her concept of the object. It follows that the child's representation of the object as a kind of print-out of her conceptual status should be fairly uniform across a wide range of tasks. The same number of parts should be represented in two- and three-dimensional media, in tasks that demand completion or copying of figures, in drawings on dictation, and on form-puzzles that require the construction of a figure. In the case of Arnheim's representational theory, which assigns the medium a major role for the invention of forms of equivalence, we would predict that the properties of the specific medium and the demands of the task would lead to a considerable degree of variation in a child's representation of the human figure.

Such a reformulation of the theoretical issues enables us to marshal empirical evidence to support or to reject one of the two competing hypotheses. Accordingly, I set out to clarify the relationship between the child's drawing and his conception of the object (Golomb, 1969, 1973).

The Effects of Models, Media, and Instruction

To address the controversial issue of the status of the tadpole drawing, it seemed essential to select young children who are at the beginning

phase of their representational explorations; to assess developmental change it was also important to include older children. With this goal in mind, children ranging in age from three to seven years were presented individually with sets of tasks that differed in the choice of media and task properties, while holding the theme of the human figure constant. I was interested in children's performance when they are asked to draw a person, to model a person and a snowman out of Play-doh, to complete a series of incomplete drawings of a human, to dictate to me all the parts I would need if I were to draw a person, to identify a series of incomplete drawings and to select the "best" among them, to construct a puzzle-man out of a collection of flat wooden forms, and finally, to draw the human figure as I verbally dictated the various parts. The results were straightforward: the human figure varied as a function of the task, the medium, the instructions, and the provision of parts. For example, on the task that presented the child with an array of wooden pieces, of which some were familiar-looking and could be identified as head or coat, not a single child constructed a tadpole man. When the array consisted of relatively unfamiliar flat, wooden geometric shapes, only 2 out of the 27 three-year-old preschoolers constructed a tadpole man. This finding is noteworthy because the majority of these youngsters drew scribbles, global humans, or tadpole figures when asked to draw a person. On the completion task, the child was presented with a figure that consisted of a head with facial features. Almost all of the children completed this incomplete figure in greater detail than what they produced on the draw-a-person task, and 69 percent of the three-year-olds now included the trunk section. On the Play-doh modeling task, children modeled the trunk in 52 percent of their sculptures of a man and in 70 percent of their snowman figures, while only 33 percent of their drawings contained a separate trunk. Similar differences emerged when the results of the free-drawing task were compared with drawings made on dictation and with the child's selections from a series of incomplete figures.

Clearly, the results of this study indicate that the hypothesis of the print-out process and of the simple correspondence between an immature concept and a graphically simple drawing is no longer tenable. The old dictum that "the child draws what he knows" has not been supported, and thus we reject the notion that the tadpole drawing is a case of faulty imitation due to conceptual immaturity. We may now be ready to abandon simple-minded standards of realism and to reaffirm Arnheim's position that the tadpole man is a relatively undifferentiated figure that represents its object at a very basic level. From this perspective, the concept of "completion" is not very meaningful because various graphic models can adequately represent their object. Arnheim substitutes the concept of "differentiation of form within its medium" for notions of incompletion or errors of representation. This approach to early child art endows the young child with an intuitive problem-solving intelligence.

The child emerges as a creative image-maker, an appealing vision that may, however, lead us to underestimate the child's limitations.

Indeed, this is the position that Norman Freeman has taken and argued quite persuasively in his critique of the romantic vision of the child as creator (1980). Freeman begins with the assumption that a child's drawing does not directly reveal the nature of the mental image nor the child's internal representation of the object. The child's concept of the object, in this case the human figure, is assumed to be accurate and more detailed than her drawing reveals. The deficiencies of the tadpole figure are viewed as a problem of translating the child's knowledge into a linearly ordered, sequentially drawn series of parts. This translation requires a program of actions, it involves retrieval from memory, and it is also a decision-making process. Production requires a careful task analysis that yields the steps essential for a good performance. All performance requires planning and monitoring of a series of actions, and Freeman assumes that a major limitation on performance is the difficulty of conducting a search among representations held in memory. He points out that the drawing action is a highly complex performance that demands the simultaneous coordination of a temporal and a spatial order. In other words, the child must determine what part is to be drawn first, second, and so on, as well as the spatial ordering of the parts to each other in terms of their top-to-bottom and lateral directions. The major premise underlying Freeman's analysis of children's drawings is that the early figures demonstrate typical performance errors. Such errors are also found in other domains, and are suggestive of the selective forgetting of items learned in a specific order that, on retrieval of the series, tend to be omitted. According to Freeman, the child fails to meet her own criteria of what the drawn figure ought to include. Her errors are rule-governed and they demand an analysis of the drawing process in terms of the difficulties inherent in serially ordered performances. Freeman criticizes Piaget for his deficient analysis of task demands, which leads to his underestimation of the preschool child's cognitive abilities, and he takes issue with Arnheim's failure to consider performance factors, and thus to overestimate the child's graphic output.

The Serial-Order Hypothesis

Freeman considers the defects of the tadpole drawing a prime example of a serial-order problem. In his analysis of such peculiarities as the omission of body parts or their misplacement, he has recourse to models derived from the study of serially ordered material. When individuals are asked to recall a learned list of items, they tend to "end-anchor" on the terminal items of a series—that is, on the first and the last elements, which are easier to recall than the intermediate ones. According to Freeman, these findings are not limited to the retrieval of temporally ordered material from short-term and long-term memory storage to, for example, verbal sequences, but apply equally well to spatially ordered imagery (Olson, 1970). He generalizes from the experimental literature on recall in memory and considers it a general rule that people have a strong natural bias toward a linear ordering of

material. From this perspective, the omission of trunk and arms suggests a simple end-anchor effect, with young children anchoring on the head as the top structural unit, and the legs as the terminal structural item. If we think of the human figure as an assembly of parts that begins with the head, continues with body and arms, and ends with the legs, we could conclude that a serial position effect that gives preference to the first and the last items would yield the ubiquitous tadpole figure. While the child's knowledge of the basic body parts may well be correct, the specific biases that affect the drawing process yield predictable performance errors. Moreover, production problems are not limited to deletion of parts, and can also be observed in the misplacement of arms. Freeman provides evidence for the tendency of preschoolers to attach the arms to the larger of two vertically aligned circles that are presumed to represent head and body, and he has dubbed it the "body proportion effect." Size alone determines where the arms will be drawn, and if the top circle is larger than the bottom one, arms will be attached to the head, clearly a production error in this view.

Such an analysis in terms of production errors once again affirms that Freeman, and theorists sympathetic to his position, adopt certain representational standards by which the performance of the young child artist can be judged. These are not necessarily aesthetic norms; most likely they are criteria derived from an implicit conception of realism in art. From such a position, the omission of the trunk and the deletion of the arms are errors that in due course will be overcome. Freeman considers it essential that we adopt criteria that specify which are correct and incorrect solutions. Since children, apparently quite spontaneously, overcome the early limitations and biases, we may assume that the developmental progression implies a standard of "correctness" that can be applied to the earlier work.

Freeman's call for a careful analysis of the nature of the task, and his attempt to specify what the performance biases might be, presents a welcome challenge to psychologists studying child art. His desire to find general psychological principles that apply across a wide range of problems is appealing, and his admonition not to overvalue the child's achievements and to confront the production difficulties that drawing involves is worth considering. Let us now examine his arguments more closely and determine the fit between his model of analysis and the graphic data.

Let us begin with the strongest argument for a serial position effect; namely, the tendency of young children to omit the arms on the tadpole figure and on figures that are structurally more advanced and include a graphically differentiated trunk. The young child, approximately between the ages of three and five years, is described as a victim of faulty memory retrieval processes, not unlike the person who attempts to recall a newly learned list of perhaps unrelated items and omits some of the middle terms. We shall have to ask how useful this analogy is for an understanding of the demands that the child faces when planning a drawing. The preschooler's knowledge of the human body is quite extensive and when he draws a human, retrieval from

memory is aided by the presence of such concrete models as the body of the adult examiner and that of the child himself, which are in plain view. Moreover, once the drawing is completed, it can be inspected, and if the omissions are explicable in terms of performance rather than conceptual errors, the child who scans the figure ought to discover the glaring omissions and attempt some form of correction. If the circle stands for head-only rather than for a global human, inspection ought to "cue" the missing items, just as children spontaneously comment on missing facial features in their drawing. I shall briefly review findings from several separate investigations that provide data relevant to our discussion.

The observation, already noted by Edward Barnart (Munro et al., 1942), that children do not follow a simple linear progression from the top to the bottom—that is, from the head to the legs—but frequently inspect their drawing and return to the top or middle parts for the addition of features, was followed up in a systematic investigation of the serial order of figure construction (Golomb & Farmer, 1983). We tested three-to-eight-year-olds and ascertained that, with few exceptions, the human figure was initially drawn in a top to bottom sequence, beginning with the head. This finding was consistent across all age groups. However, even among our youngest children this sequence did not automatically end with the drawing of the legs. Frequently the child proceeded to backtrack to include facial features, hair, ears, arms, and even clothing. The incidence of such "return upwards" occurred in 40 percent of the three-year-olds and in 70 percent of the four-year-olds; that is, in those children whose drawings exhibit the presumed symptoms of faulty memory retrieval. Clearly, a process of visual inspection occurs after the legs, as the presumed end-anchor points of the figure, have been drawn, a finding that suggests that figure completion may be quite independent of preferred top-to-bottom drawing sequences. The many returns upward indicate that the serial order and the number of drawn parts are not closely related variables. Several of our additional studies using different groups of children affirm these findings. While the number of returns may vary from sample to sample, the phenomenon occurs with regularity and presents a consistent and robust finding. For example, arms, which appear on approximately 50 percent of the figures preschool children make, are often added *after* the legs have been drawn.

A second study was designed to take a closer look at the verbal and drawn order of body parts, and at the relationship between the serial position of the drawn parts and their organization. In order to determine the degree of correspondence between verbal and graphic series, we probed the child's verbal knowledge on two different tasks. First we asked each child to name the parts of the body, and then we instructed the child to dictate to the examiner the parts she needed in order to draw a person. The data pertinent to our question come from three-to-five-year-old youngsters (Golomb, 1981). The variability both within and between these two verbal tasks was high. Almost all of our young subjects (89 percent) offered a different verbal order on these two related tasks. While we note a general tendency to list as the first

item the head or the facial features and to proceed from the top downward, the incidence of favored sequences was rather modest. If we pool the data for the two verbal series and examine the order in which the major body parts were mentioned, we find that the most common strategy lists the head as the first item: 11 percent of the children used a head-body-legs-arms sequence, 13.5 percent employed the simplified variant of head-legs-arms, 11 percent adopted a head-arms-legs order, and 5.5 percent a head-body-arms-legs order. A considerable number of children, 24 percent, did not adopt a top-to-bottom order but named as the first part arms or legs. The remaining children adopted a wide variety of sequences; for example, starting in the middle—that is, with the body—and proceeding to arms and legs or the reverse. Such a sequence was used by 3 percent of the children. Facial features were inserted at many points in the beginning, middle, and end of the series. The number of parts named or dictated usually exceeded the number of drawn parts. Two items in particular, the arms and the trunk, appeared much more frequently in the verbal than in the graphic domain and were more numerous in the verbal task that was unrelated to drawing. In the case of the verbal naming of parts, arms were mentioned by 94 percent of the three-year-olds and by 84 percent of the four-year-olds. On dictation, arms were named 59 percent and 63 percent, respectively. The trunk or its equivalent was represented in the verbal series 65 percent of the time by three-year-olds and 84 percent by four-year-olds, and on dictation 59 percent and 79 percent, respectively. Thus, whereas both tasks called for a description of the human body, the major parts were more frequently mentioned on the loosely defined verbal-listing task than on dictation to the examiner that was explicitly linked to the domain of drawing. However, on both verbal tasks the incidence of arms and trunk by far exceeded the actual drawing of these parts by the same children. Arms were drawn by 50 percent of our youngsters, whereas the trunk appeared in only 28 percent of the drawings. The variable results of these three related tasks indicate that the proposed difficulty in accessing known body parts from memory cannot provide an adequate explanation for the presumed deficit of the tadpole figure. How then can we account for the differences in the frequency of the items either named or drawn? The highest frequency of body parts occurs in the task of free recall, where recall is essentially nonfunctional and unconstrained. Without adhering to a specific order, the child names the largest number of parts. On the drawing dictation task, the number of parts is significantly smaller, most likely constrained by the graphic model that guides the listing of parts. Indeed, the number of dictated parts is midway between the unconstrained—that is, free recall of items—and the constraints of drawing a readable graphic model. While the number of dictated parts exceeds that of the actual drawing, a similar graphic model seems to underlie both assignments.

On a second set of tasks I varied the usual drawing sequence so that the spatial and temporal order of drawing the parts no longer coincided. Each child was first asked to draw a person to establish her

preferred spatial-temporal pattern and to assess the structural characteristics of the figure. Next, she again was asked to draw a person, but this time she was instructed to begin with the legs. The same procedure was followed specifying the arms and the tummy as the first item to be drawn. Altogether, four drawings were obtained from each child. Changing the order in which a figure is drawn did not result in any specific difficulty for our youngsters; that is, it did not result in the omission of items or their misplacement. On these reversal tasks, 50 percent of our three-to-five-year-old children improved their performance; they included parts previously not drawn, while almost all of the remaining children maintained their customary level of graphic depiction. In some cases, varying the task demands by specifying a different starting point tended to improve the overall organization of the figure and encouraged the adoption of new forms (see ills. 24 *a*, *b*). The results of this study indicate that even young children can change the order in which they draw the human figure, and that this deviation from a preferred sequence is not detrimental to their retrieval of parts from memory, nor need it impede their drawing performance. In this case, successful retrieval of parts from memory seems independent of the previously hypothesized linear top-to-bottom order. Two additional replication studies with three-year-old children affirmed these overall findings.

24. *Varying Drawing Starting Points*
a. Girl, 3;8. When the instructions varied the sequence in which body parts were to be drawn, different graphic models evolved: tadpole figures; a stick figure; and a full-fledged person with head, circular whirl trunk, arms, legs, and feet.
b. Girl, 4;2. When head or legs were drawn first armless tadpoles ensued. Beginning a drawing with the arms or the tummy led to a more detailed representation of the human figure.

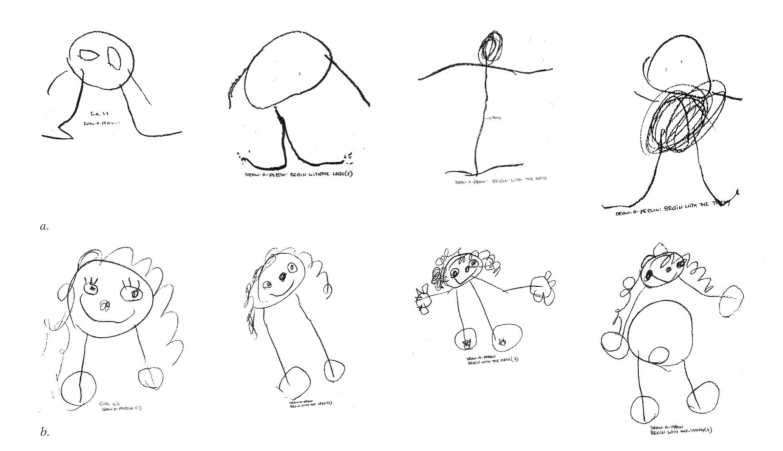

a.

b.

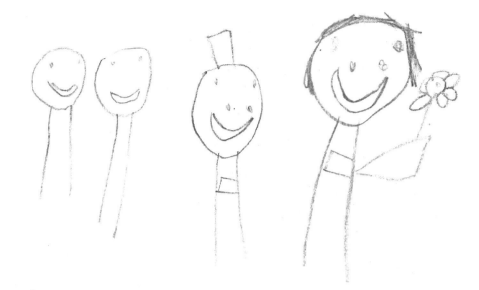

a.

25. *The Effects of Specifying a Body Part*
a. Boy, age four. The instructions call for the drawing of a person, a person with a tummy, a person with a flower. From left to right: armless tadpoles, figure with tummy and hat, figure with tummy and one arm holding a flower.
b. Girl, age four. From left to right: open-trunk figure, figure with tummy and one-dimensional limbs, figure with tummy, two-dimensional limbs and flower.
c. Girl, age four. The instructions are: draw a person, a person with a tummy, a person with a fat tummy, a person with a big coat. From left to right: stick figure, person with tummy, person with a rectangular and squarish trunk.

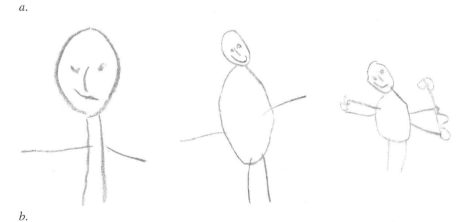

b.

DRAW-A-PERSON (5)

DRAW-A-PERSON: BEGIN WITH THE TUMMY (6)

DRAW-A-PERSON WITH A BIG TUMMY (7)

c.

DRAW-A-PERSON WITH A BIG COAT (8)

I continued to pursue the impact of instructions on the number of drawn parts, increasing the specificity of the assignment—for example, by requesting, "Draw a Person with a Flower," and "Draw a Person with a Big Fat Stomach." These instructions seemed to mobilize the child's efforts, resulting in the production of graphically more differentiated figures that conveyed their meaning with greater clarity (see ills. 25 *a, b, c*). In general, specification seemed to call for a reorganization in representational strategy. Whereas a general, and thus vague, request can be met with a global representation of the human, specification of an item focuses attention on it, thereby requiring a more complex solution. Our data show that improvement in the number of drawn parts as a function of task specificity occurred in 42 percent of the drawings, while an equal number of children maintained their usual performance level. Only 16 percent showed a decline in representational scores (Golomb, 1981).

The impact of task specification was most dramatically illustrated when thematic variations were introduced; for example, when the child was asked to "Draw a Family," to depict a "Teacher Reading a Story to the Children," or "Three Children Playing Ball." Under these conditions, arms were drawn in higher proportions on figures that "needed" them to fulfill their function. Accordingly, four-year-olds included the arms in 67 percent of their family drawings, in 82 percent of the children playing ball, and in 80 percent of the teacher reading a story, although only 60 percent of her listeners were endowed with arms. This distinction between the teacher who needs her arms to hold the book, and the listeners who, for the moment, can do without the arms, was frequently amplified by the greater structural differentiation of the teacher vis à vis the children, who were portrayed as simpler figures, global humans, or tadpoles (see ills. 26 *a–f*). A similar differentiation can be observed in some of the drawings in which the playing children are equipped with a single arm oriented in the direction of the ball while a fourth child who acts as a spectator to the

a.

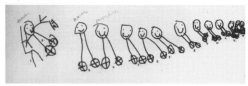

b.

c.

d.

26. *Teacher Reading a Story*
a–f. Ages, 4;0 to 6;5. The figure of the teacher is more differentiated than that of the children. The teacher is endowed with arms, the children are mostly armless. Also note significant size differences and a tendency to depict children as global humans or a stick figure.

f.

e.

a.

b.

27. *Children Playing Ball*
a. Girl, 5;1. Each of the children is
equipped with a single arm and hand
pointing in the direction of the ball.
b. Girl, 5;7. The three players are endowed
with a single arm reaching for the ball. The
fourth child, a mere onlooker, is armless!

game is armless (see ills. 27 *a, b*). For the five- and six-year-olds, the
percentages of arms depiction were quite similar: a modest increase
to 72 percent occurred on the Family theme, and on the Playing Ball
task the number increased to 93 percent. The gap between the inci-
dence of arms depicted on teacher and audience widened, with 85
percent of the teachers displaying arms compared with only 54 per-
cent of the listeners.

Two different though compatible principles seem at work here.
The inclusion or omission of arms according to "need" suggests that
the child's tendency toward simplicity of forms—his inclination to
economize and to represent what he considers the most essential fea-
tures of his figure—determines if and when such optional items as
arms are to be drawn. When the teacher is drawn in greater detail,
with a fully differentiated body, while the children are represented in
more primitive form as tadpoles, graphic differentiation becomes the
hallmark of adult status, of power and importance, whereas lack of
differentiation represents the state of the young and dependent child.
In this case, graphic differentiation serves as a metaphor for age, wis-
dom, and power—in short, for development.

Overall, I have demonstrated a relationship between task speci-
ficity or task instructions and figural complexity. When the instruc-
tions specify, either implicitly or explicitly, that an item ought to be
represented, they disrupt the usual drawing sequence and draw atten-
tion to parts that are frequently not yet graphically depicted. The sur-
prising finding is that varying the starting point does not seriously af-
fect the organization of the figure. Contrary to a "strong" version of
the serial position hypothesis, which states that seriation helps recall
because it provides a systematic retrieval strategy closely aligned with
the original encoding of the items, the organization of the figure im-
proved in many cases. Without prompts, the figure tends to be orga-
nized in the simplest possible manner, as a global human or a tadpole
man. With verbal prompts we see the appearance of graphically more
differentiated figures that hint at the transitional nature of the repre-
sentational system the child has developed. The graphic conceptions
are flexible, open to challenge and experimentation. Above all, these
findings suggest that if end-anchor biases can be overcome that easily,
and different figural formats are maintained at the same time, then
the serial-position hypothesis with its reliance on the end-anchor bias
seems to have little explanatory power.

An earlier study previously mentioned in this chapter (Golomb,
1969, 1973), sheds further light on the issues raised by Freeman. On
some tasks, arms and trunk depiction appeared with much greater
frequency than on the drawing assignment. This was the case when a
human figure was constructed out of Play-doh or geometric shapes,
on drawing-completion and on dictation-to-the examiner. Because
the request to make a person remained constant and the necessity to
access parts from memory applies to all tasks, the variable outcome
does not seem congruent with the serial-position account of the
source of the drawing error. When the child dictated the parts and
the examiner drew, only 3 out of the 57 three- and four-year-old

preschoolers dictated a tadpole drawing. Arms or trunk were rarely forgotten; the dictation followed the vertical top to bottom order, except that arms were usually named after the legs had been drawn. An interesting finding emerged on the identification of incomplete figures task that draws attention to the child's graphic conceptions (ills. 28 *a b, c*). Even the first graders, whose drawing of a man invariably included a separately drawn trunk, considered the figure with the open trunk (see ills. 28 *c*) a *complete* rendition of a man, with the trunk occupying the blank space between the two verticals. When instructed to complete a series of incomplete figures, only 54 percent of the first graders added a horizontal line between the verticals to indicate where the "tummy ended," and 46 perecent deemed it an acceptable graphic rendition. Clearly, these results raise the issue of "units" yielded by visual inspection of the object and of the drawing.

The Body Proportion Effect

The issue of units and their referential status emerges with urgency when we consider a finding Freeman has termed "the body proportion effect." Young preschoolers who are presented with an incomplete figure consisting of two vertically aligned circles and instructed to add the arms tend to attach them to the larger circle, independent of its relative position on the vertical axis. If the top circle equals the bottom circle or is the smaller of the two, arms are mostly located where they are "supposed" to be; namely, on the second circle that is meant to represent the trunk. If, however, the size-ratio favors the top circle, children tend to locate the arms on a part usually identified as the head. According to Freeman, we are faced with another example of a production error, a systematically biased response to the cue of relative size rather than of location. What does this type of production error have in common with the serial production problems considered earlier? Freeman suggests that the arms-trunk retrieval difficulty attributed to the serial position of the middle terms is also responsible for the body proportion effect. In this case the head or the trunk fails to serve as an adequate cue for the location of arms. Because, however, the examiner provides the verbal label for the part that is to be drawn, the problem has changed from one of retrieval from memory to the perceptual cue of "bigness" in the positioning of the arms.

Labeling the peculiar arms completion drawings a production error and incriminating the factor of relative size does not tell us much about the child's understanding of the task. Does he face a conflict when confronted with the disproportionate figures? Does she consider placement of the arms on the head equally acceptable as on the trunk? What meaning do these circles hold for her? In order to answer some of these questions a set of figures was designed to elicit the body proportion effect, and their order of presentation was counterbalanced (Golomb, 1981). The quantitative results are quite comparable to those reported by Freeman. When the top circle was considerably larger, in this case two inches in diameter versus one inch in

a. *b.* *c.*

28. *Incomplete Figures*
The figure with the "open" trunk (*c*) is considered a "complete" person; the space between the verticals is identified as the "tummy."

29. *Arms Completion Task*
A study of the Body Proportion Effect.

a.

b.

30. *What To Do About Disproportionate Figures*
a. Child adds a head and facial features, normalizing the figure.
b. Child "rotates" the figure adding arms to the "tummy."

diameter for the bottom circle, 72 percent of the three- to five-year-olds extended the arms from the top circle. When their placement was reversed and the one-inch circle was the top one, only 17 percent extended the arms from it. When both circles were identical in size, 78 percent of the children preferred to extend the arms from the second circle (see ills. 29). The comments and behavior of the children indicated that, regardless of location, the larger circle represented a "big belly." Several children turned the paper 180 degrees in order to rectify what they perceived as an upside-down figure and others indicated verbally that it was inverted. Several children added facial features to the larger circle, effectively transforming it into a global human, reminiscent of the primordial circle (see ills. 30 *a, b*).

The same children were also presented with a set of four drawings that only varied in the location of the arms (see ills. 31). They were asked to select the figure that looks best and the one that looks worst, and then to explain their choice. The results are simple to report. The great majority of the children, 70 percent, selected "conventional" figures whose arms extend either from the center of the second circle or from the intersection of the two circles (see ills. 31 *a, c*), whereas 85 percent agreed that arms extending from the head region (ills. 31 *b, d*) did not look right. The few subjects who selected *b* or *d* explained their choice in terms of "hair" or "ears." Thus, all the children responded to the set of prepared figures with what appears to be a graphically or anatomically reasonable judgment.

Next the children were presented with three sets of paired figures, each one composed of a top circle endowed with facial features, a bottom circle, and legs. The left figure in each set consisted of a large circle, three inches in diameter and a small circle one inch in diameter. The right figure in each set consisted of two similar circles, but their vertical alignment was reversed. In the first set, the arms extend from the top circle, in the second set they extend from the bottom circle, and in the third set from the intersection of top and bottom circles (see ills. 32 *a, b, c*). These sets of paired figures were also presented in a counterbalanced order, and the child was asked for her judgement of which looked best, which looked worst, and the reasons for the selection. The response to this task was quite enlightening in the resistance it elicited on the part of our participants. The children appeared conflicted, shifted their judgments, and required a great deal of encouragement before they offered their opinion. Indeed, the responses were equally divided among the paired figures, with a comparable number of subjects preferring the figure with the huge head or the huge torso. Very few children made consistent choices. Most children selected the huge head as the best as well as the worst figure over the series of tasks. As inspection of the test figures reveals, they are indeed grossly disproportionate and do not permit a reasonable solution to the task. Children seemed to experience a dilemma as illustrated in the comments of a youngster who, forced to make a choice, selected as the best figure the one consisting of a huge head and a tiny body with the arms extending from the top circle (see ills. 32 *a*) and exclaimed: "This is cuter, the arms are not on his head—almost!" On

the second figure of this set, composed of a tiny head and a huge body, he commented: "This is the worst because the arms are on the head."

Closer analysis of the responses indicates that the overall looks of the figure are important and that mere placement of forms along a vertical axis does not make for a pictorially meaningful statement. When faced with the disproportionate figures, children complained about heads that were too big or too little, and similar remarks were made about tummies. The completion and judgment data tell us an informative story. When the figures' proportions are grotesque, the children face an acute conflict. They do not look right; even though the experimenter defines the top circle as the head or face by virtue of its location and its facial features, and likewise defines the bottom circle as the trunk, again by virtue of its location (amplified by such a landmark as the navel), the child does not necessarily agree with these assumptions. Essentially, the figure completion and judgment tasks of this study and those used by Freeman do not have an adequate solution, and the child wavers, as most in this study did, or silently redefines the task. If she attaches the arms to the huge top circle, it tends to be seen as a head-belly conglomerate, even though the smaller second circle may be identified as the place where the belly-button ought to go. Drawing a belly-button does not make this location a more suitable place for arms attachment, and indeed, the distance from the navel to the place where arms are attached to the body is greater than from the head to the shoulders, whence they ensue.

If we summarize our findings from the body proportion studies, we can see that the "looks" of the figure carry great weight. If a unit is relatively large, it tends to be identified as a global human, and arms are likely to extend from it. Under some circumstances the extension of the arms from the global unit also coincides with a principle of balance and salience, which is the case in the classical tadpole figure (see ills. 16 *b*, *c*). When two circles of different sizes compete for the arms, the solution is not self-evident, and the top circle with the facial features as the salient and most familiar form may come into competition with the second circle. As long as the second circle is relatively large or a vertical oblong, the overall meaning of the figure can emerge with relative ease, which favors arms attachment to the second and larger shape. But in many cases, as the figures in illustration 32 indicate, there is no reasonable solution to the problem. In reality, arms do not extend from the middle of the trunk—the second circle in this design—and they also look odd at the intersection of the two circles. As long as the large primordial circle is paired with a second and smaller one, we provide conflicting cues and create a problem to which there is no adequate solution. The anatomically most correct depiction, in which arms extend from the intersection of the two circles, does not look right; the balanced figure with arms extending from the large top circle is anatomically incorrect; and the solution that seems acceptable to the examiner, namely, the figure with arms extending from the small trunk, is graphically ambiguous as well as unbalanced. The strategy that children adopt on this task as well as

WHICH ONE LOOKS BEST?
WHICH ONE LOOKS WORST?

31. *Varying Arms Location and Probing the Child's Preferences*
The majority of preschoolers selected the "conventional" looking figures *a* and *c*.

a.

b.

c.

32. *Disproportionate Figures*

33. Family
Boy, 5;8. The older members of the family are graphically more differentiated than the youngest child who is represented as tadpole figure.

a.

b.

34. Simple Figures with Arms
When an activity calls for arms, even simple tadpole figures are so equipped.
a. Girl, 4;5.
b. Boy, 5;5.

on their own free drawings is a transient one, determined by factors of saliency, familiarity, and also trial and error; in short, a tentative compromise solution.

The experiments briefly described above, and the arguments against the memory retrieval version of the production-deficit hypothesis, may seem contrived and remote from the drawings children make under more natural conditions. What additional evidence can we marshal against the view that the tadpole drawings are errors, symptomatic of inadequate monitoring of the production process? I shall review some findings derived from the child's free drawings that speak against the type of performance bias thesis that I have discussed so far.

Once we extend our inquiry beyond the single sample of a child's drawing repertoire, we often find considerable variability in the manner in which the human figure is depicted. For example, in a drawing of her family, we may find that the same child draws a graphically distinct trunk for a parent, whereas the child or the baby is portrayed as a mere tadpole (see ills. 33). The same child may draw an armless tadpole next to one more richly endowed and also mention parts verbally that are not portrayed graphically. As these examples indicate, arms and trunks are quite readily retrieved from memory, and we ought to consider alternative explanations. In the case of the arms it seems that they are "optional" items that do not add much to the basic visual definition of the human. Indeed, the absence of arms does not prevent the portrayal of graphically more complex figures that use the side-view to depict an interaction between two people . However, when the child intends to portray an action that requires arms, even simple figures include them (see ills. 34 *a, b*). These findings indicate that not all aspects of the human are given equal weight in the drawing of a figure; some parts are seen as essential to this task, whereas others serve a subsidiary function and might even hinder the process of creating a graphically meaningful figure. Support for such an interpretation comes from a careful study of early representational efforts.

On occasion, when we are fortunate to observe a child's very first intentional experiments to draw a human figure, we may find that a more detailed configuration precedes the tadpole man. This suggests that the latter's graphic simplicity is preferred over the realistic but more cluttered representation of an earlier attempt (see ills. 9). In 1921, Cyril Burt presented a pictorial account of the early stages in drawing a human; in his series a figure with a crudely drawn trunk precedes the tadpole and open-trunk models. This observation suggests that the young and inexperienced child explores the graphic medium and experiments with forms and formats until a graphically satisfactory solution is found. Additional evidence for such an interpretation comes from global figures that contain all the major body parts *inside* a comprehensive outline (see ills. 35).

Variability in the depiction of the trunk can be seen most clearly if we compare the child's drawing of humans and animals. Whereas preschoolers draw humans mostly as tadpoles or open-trunk figures,

the body of an animal is soon separately delineated (see ills. 36 *a, b*). Depending on the kind of animal that is intended, the trunk may be drawn as a one-dimensional horizontal line or as a two-dimensional unit in a horizontal or vertical orientation, which once again confirms our suspicion that the absence of a graphically delineated trunk for humans is not a simple function of a memory lapse. Finally, early art as seen in some samples of American Indian petroglyphs also seems to have employed tadpole configurations that apparently served a representational function.

As these examples of child art indicate, the drawings obey a visual graphic logic that dictates *what* parts need to be drawn for a specific figure and *how* this is to be done. Lack of graphic differentiation does not automatically signal an omission, as viewers of modern art have long since learned to accept. This brings us back to the problem of "units of analysis" that was raised earlier.

What are the "natural" units or elements of the human body that need to be portrayed in a drawing? From a functional point of view, a human being needs sense organs as well as organs for the intake of food and the elimination of waste products. While all functional units seem important, it is quite apparent that for a visual definition of the object, not all such units are equally significant; ears, for example, can be omitted without much loss of information, but the absence of eyes carries a greater penalty. Clearly, neither adult nor child artists are intent on depicting all they know about the object, and the selection rests to a large extent on medium properties and on the characteristics of the object. Graphic elements do not exist in isolation; they derive their existence by standing in relation to the object they represent, and their significance lies in the role they play as equivalents for a vastly more complex reality. While single dots and short lines dispersed across the page may not appear as meaningful units, once

35. *Global Figures*
Facial features, body, and limbs are depicted within the confines of the contour line.

36. *Depiction of the Trunk in Humans and Animals*
a–b. The artists are four-year-old boys. The humans are tadpoles or open trunk figures; the animals are endowed with one- and two-dimensional bodies.

a.

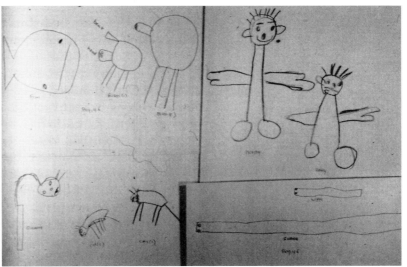

b.

placed inside a contour they become genuine elements that define a face. A graphic form is not an independent or fixed element; its meaning is determined by the total context. Even if we omit a line—for example, the one that stands for nose or mouth—the unity of the face is maintained. As long as we assume that one- and two-dimensional lines ought to stand in a simple one-to-one correspondence to all the relevant three-dimensional parts of the human, we are applying the wrong model to the analysis of drawing. The visual-graphic definition does not always coincide with a linguistic, conceptual, or functional definition. In the case of the human, the totality of the figure is the basic referent or unit despite the fact that drawing proceeds sequentially—a process that tends to favor a segmental construction. In the early global man we see a sweeping contour that represents its object as a single unit, a graphic conception that is temporarily abandoned in favor of segmentation as the simplest procedure to differentiate the figure in drawing. Only years later is the single comprehensive contour once again attempted (see chapter 3).

After this brief detour, which highlights the inadequacy of the production and cognitive deficit approaches to child art, we return to an issue raised earlier; the criteria we might wish to adopt to assess the child's drawing efforts, and how to determine when the child fails in her own terms.

In the earlier chapters I surveyed the orderly manner in which forms acquire representational significance. When we consider the progression in drawing from the first contours to the global man and its transformation into the tadpole figure, we discern a developmentally meaningful process during which graphic conceptions evolve, undergo revisions, and become differentiated. In light of this analysis, it seems most sensible to address child art in its own terms; to examine its logic and beauty by standards that are not derived from an adult model of perfection. The entrenched tendency to view child art as a symptom of prelogical reasoning, a view adopted by Piaget (1928, 1951; Piaget & Inhelder, 1956), has made psychologists insensitive to the graphic logic that underlies a child's drawing and that is characteristic of all early graphic conceptions (Andersen, 1961–1962; Arnheim, 1974; Schaefer-Simmern, 1948). Fortunately, the standards for the representation of the human figure in adult art have changed radically in the last 100 years, and we are not likely to hold Klee or Picasso to norms of realism. The notion that art copies nature is no longer a defensible position (Arnheim, 1966, 1969, 1974; Bernheimer, 1961; Gombrich, 1960, 1982; Goodman, 1968). These far-reaching changes in our understanding of the visual arts have made it easier for students of child art to abandon the simplistic notion of art as a faithful copy of the object (Golomb, 2002).

Now that we have firmly rejected copyist notions of art, we must protect ourselves from another temptation—viewing the child's drawings as if they occurred in a cultural vacuum. When we inquire into the child's judgments and preferences, we ought to do so with the understanding that he is surrounded by pictures and that his taste and conceptions evolve within a cultural setting. To consider the child's

own preferences, however, does not provide simple answers. When we present the child with various samples of drawn figures and ask for his judgment or selection of the best one, we discover that the preschooler prefers a drawing of greater complexity than he can produce on his own (see chapter 9), a finding that also holds true for adults. Thus, the child's standards for a good drawing differ when he is called on to draw a figure and when he makes a selection among figures drawn by others. Clearly, the production process makes different demands on the individual, and the outcome, in this case the drawn figure, needs to be judged by the degree to which the child's intention has been graphically conveyed. To what extent does the child consider his tadpole figure an adequate representation that conveys his intentions? While we do not yet have a comprehensive set of data that can answer this question, we can turn to observational evidence that demonstrates the transitional status of early graphic models and reveals the child's dual orientation toward his drawings. As is to be expected, the child is proud of his newly won command over the blank page, but also views his drawing as "child's" work that falls short of what adults can do. On various drawing, dictation, and completion tasks, for example, we have found that children who attach the arms to the head criticize the drawing and consider the arms placement an error. Krysa, at 3;6 years makes a tadpole drawing but dictates the following parts to the examiner, who draws as she names them: "Head, eyes, nose, mouth, hat, legs, arms (indicates that they ought to be drawn from the head), chin, tummy." She scrutinizes the drawing and suddenly exclaims: "The arms are wrong! they go here (points to the shoulders)." The examiner draws the arms at the point indicated by Krysa. She is still not satisfied and complains that now there are two sets of arms instead of one set. James, age 5;4, draws a tadpole man with arms extending from the head. He looks at it attentively and remarks: "Never seen hands coming from the head." Despite the criticism, he leaves the drawing unchanged. Jen, age 3;10, declares that she is going to draw "a daddy this time, is going to be looking up. . . . Has cheeks, chin, big body is in towel . . . big hand and weentsie hand is sticking out, legs and feet are in towel," yet she draws a simple tadpole figure. Such examples can easily be multiplied; they highlight the child's awareness that her figures are mere representations and that they have shortcomings. Perhaps we might specify what constitutes an error by considering the drawing system adopted by the child. If an early rule specifies a global unit, arms can be attached only to it, and within this system it is the only reasonable solution. However, the internal spatial ordering of the parts should be consistent, with eyes, for example, drawn above the mouth and not vice versa. When ears as well as arms are drawn, we expect the former to be located above the latter. When the figure consists of two basic units—for example, two vertically aligned circles—new degrees of freedom for decision making arise. As indicated earlier, a large top circle tends to attract the arms since it is reminiscent of the global human; given a figure that does not permit an optimal solution, factors favoring anatomical fidelity, balance, and salience may come into

conflict. When this is the case, we may observe amusing compromise formations in which the arms on the large top circle tend to descend below the mid-section. Likewise, arms placed on the larger second circle tend to move upward, away from their center.

Given the child's graphic rule system, these types of solutions do not constitute errors in the sense of a confusion regarding the existence and location of the body parts. However, the child's tendency to give a literal reading to the abstract forms that he has created gives us an insight into his own evolving criteria for judging the goodness of a figure. The tendency to represent a figure in the simplest way clashes with the desire for a closer resemblance to the object and creates the tension that leads to revisions.

We have come to the end of our review of the meaning of the tadpole form. A long line of serious researchers interested in child development (Freeman, 1980; Goodenough, 1926; Harris, 1963; Kerschensteiner, 1905; Luquet, 1913, 1927; Piaget, 1928, 1951; Piaget & Inhelder, 1956) have maintained that the child's attempt to draw what she *knows* yields the defective drawings or, more recently, that the translation from knowledge to production fails and results in the flawed product. We have reviewed the findings from a series of relevant studies and discovered that the problem does not lie in the child's deficient conceptual understanding of the object to be portrayed, nor in her deficient memory retrieval strategies. Our data indicate that the serial position of the parts, the sequence in which they are drawn, and the number of drawn parts are relatively independent factors at this early stage. The order in which a figure can be drawn is quite flexible and the meaning of a graphic figure is largely independent of the production process. The child's determination that a figure is complete is not solely a function of the sequence in which it was constructed. At this stage, the sequence of the drawn parts need not constrain representational meaning.

My analysis has not supported theories that stress conceptual and production difficulties as the major reason for the form early art takes. Instead, Arnheim's representational theory has provided a productive framework within which to reassess children's drawings and to interpret our findings. The data are most congruent with the view that considers the tadpole an undifferentiated form that is neither a distorted nor a defective portrayal of a human. This early form reflects the child's lack of experience with the medium and her limited graphic vocabulary. But lack of graphic differentiation does not imply lack of conceptual differentiation, nor does it speak of an impaired memory search. Art-making always involves simplification. In early child art this simplification is at an extreme.

In summary, the tadpole figure reflects the ingenuity as well as the limitations of early graphic reasoning. The invention of the tadpole as a structural equivalent for the human being is an act of creative intelligence, but its simplicity is also evidence of limited monitoring skills, of a relatively short attention span, and of a modest representational ambition. Let us now examine the development of more differentiated figures and the rules that guide this process.

Differentiation of Forms and Early Graphic Models

<div style="text-align: right">3</div>

In the previous chapter I focused on the tadpole figure as an example of early childhood drawing. I now turn to the broader question of how the child generates a graphic vocabulary that can serve his needs as he sets about drawing the diverse objects that hold his interest. What kinds of graphic model does the child create for the representation of people, animals, plants, houses, cars, and other items that constitute his immediately observable world? Does the child acquire these models by studying available illustrations and copying them as best he can or, alternately, does the child forge an original vocabulary of shapes that is organized according to a meaningful set of rules?

To address these questions we shall have to take a closer look at the changes children make in their graphic models as they develop greater familiarity with the drawing medium. Among others, we need to determine whether these changes are of an incremental order—for example, the addition of previously omitted parts—or whether the changes transform the figure as a whole. With these questions, we are considering whether representational development can best be described in qualitative terms, as a stage-like progression, in which case drawing development is seen as an orderly, meaningful and relatively autonomous process. In this view, children generate rule systems that reflect their understanding of the medium and guide the actual process of graphic representation. The issues raised above go to the heart of what constitutes graphic development and determines its future course. I shall attempt to specify the major principles that underlie change and pay special attention to the processes of differentiation that characterize drawing development and that occur across a broad range of graphic dimensions.

When I explored the beginnings of representational development (chapter 1), I invoked the concept of differentiation to account for the evolution of representational forms, and also referred to a general tendency characteristic of early drawings—namely, the tendency toward simplicity. I shall now restate the general law of differentiation that Arnheim proposed as the major principle determining developmental

change. In its most general formulation, it applies to all forms of organic development, which are viewed as proceeding from the simple to the more complex. The same characterization applies to the development of mental processes, which can also be described as beginning with simple or global perceptions and conceptions and striving toward greater differentiation and complexity. Arnheim elaborates on this general law in two additional statements that establish a more explicit link with the visual arts. First, "Any shape will remain as undifferentiated as the draftsman's conception of his global object permits." This statement asserts that representations tend toward the simplest visual form that will accurately capture the intended meaning, for example, circular or ovoid contours to depict the perceived roundness of the human head. Secondly, Arnheim maintains that "until a visual feature becomes differentiated, the total range of its possibilities will be represented by the structurally simplest among them" (1974, p. 181). Thus, the meaning of a particular form depends on the alternatives that are available to the artist at the time; that is, the extent to which his graphic vocabulary enables him to make distinctions—for example, between open and closed, circular and angular, symmetrical and asymmetrical shapes.

Given this definition of the concept of differentiation, how can this law elucidate the developmental changes that we observe in the use of shape, line, size, proportion, direction, and orientation? What predictions can we derive from it concerning the development of drawing competence? To begin with, this law calls our attention to qualitative aspects of development and predicts an orderly evolution of graphic conceptions and representations. This view of development is quite congruent with the theoretical positions of cognitive stage theorists such as Werner and Piaget.

The term differentiation refers to at least two outcomes: the addition of detail to an existing structure that, although it enriches the figure, does not affect its basic organization; and modifications that lead to its transformation or restructuring. An example of the former can be seen in the global representation of a person comprised of a large oval and facial features, to which are added "eyelashes" and a "belly-button." In this case, the figure is enriched by the added features, although its basic structure and representational conception remain unaltered. But when, for example, the simple rule that a single graphic entity can stand for or represent a three-dimensional object is modified, as is the case when the global man no longer stands for the totality of the human figure, we are faced with a restructuring of the representation. A new graphic conception is exemplified in the model of the tadpole figure. Thus, differentiation can occur by the addition of graphic elements to an existing configuration and enhance its meaning without having to discard a previously useful graphic model, or addition may lead to a more radical restructuring. The latter is the more interesting phenomenon in early development. Restructuring reveals how early conceptions are being transformed by practice with a medium, while the mere addition of parts is a somewhat more variable phenomenon, often subject to momentary interest and inspira-

tion. In early stages of this development, transformations in the graphic model occur mostly by a process of internal differentiation whereby the original global unit is subdivided and the several elements are drawn consecutively and linked one by one to constitute the figure. A somewhat later occurring and more advanced procedure consists of the drawing of a single and comprehensive contour-line that incorporates all or most of the prominent parts into a new configuration. As these examples indicate, the concept of differentiation also involves a process of integration whereby all the parts are organized within a new totality. Thus the concepts of differentiation and integration refer to the creation of representational units that are organized and meaningful from the beginning.

I now turn to a description of the course of graphic differentiation in several subject-categories. I begin with the early global representations and document the changes the child institutes as he aims for a more distinctive, detailed, and complex graphic rendition of the objects of his interest. My analysis highlights the child's changing representational conceptions and the non-arbitrary nature of this process. As in all beginnings, drawing starts with the very general representational conception of "thingness" that lacks distinctive features. From this common core, it branches out along a path prescribed by the principles of differentiation and pulled by increasingly demanding conceptions of how to create a satisfactory "likeness" to the object. Practice informs the child about the specific properties of the graphic medium, its possibilities and constraints. In this process the child discovers the "equivalences" that can be created in the graphic medium and which graphic model can most adequately represent the perceived characteristics of the object.

Given a conceptual framework that views development as proceeding from simple structures to more differentiated and complex ones, one would predict such a progression across a wide range of graphic aspects, most notably, line, shape, size, orientation, and direction. More specifically, we would predict a developmental course proceeding from general purpose and unmarked forms such as the circle to more varied and specialized ones. Straight lines would gradually begin to curve and bend, and the undifferentiated use of one-dimensional lines to denote extension would give way to more complex denotations of dimensionality, including the third dimension. The strictly right-angular relationship between the parts of a figure would no longer be the sole spatial axis along which the graphic elements are organized. As oblique directions are incorporated into an expanding graphic vocabulary, the possibility to portray movement and gesture will yield more dynamic representations. Likewise, the early standard orientation of a figure that is limited to a single view of the object will make way for more diverse orientations, including front, side, top, and rear views of the object. Finally, sizes and proportions that are relatively insignificant in early representational efforts will gain increasing importance for the depiction of objects and the relations that pertain among them. Indeed, such a progression can be observed as children begin to draw humans, animals, plants, and

man-made objects. In the following account, I pay special attention to the differentiation of the human figure, as it is an early and commonly preferred subject with much effort spent on its creation and perfection. Moreover, the human figure has been studied most extensively and some researchers consider it the single most revealing drawing index of developmental maturity (Goodenough, 1926; Harris, 1963; Koppitz, 1968). The principles of differentiation demonstrated in my analysis of human figure drawings, also apply to the drawing of other objects discussed later in this chapter.

Human Figure Drawing

As previously stated, the earliest shapes useful for the representation of any object and its parts tend to be circular. The circle is the simplest visual pattern, symmetrical in all directions, a stable and balanced form that calls attention to itself. It emerges early on as a useful shape and becomes the fundamental carrier of meaning. We observe global humans whose basic structure as well as subordinate parts are comprised of circles. The circle in conjunction with the straight line can be used quite effectively even as the figure becomes differentiated and richer in its detail. The straight line serves two primary functions: it indicates extension, and when combined with the circular contour, it also represents a figural quality or "thingness"—for example, limbs, eyes, nose, mouth, eyebrows, and hair. Together, the circle and the line create the sunburst pattern that is an early and highly favored configuration comprised of a center or circle with lines or loops radiating from its circumference. The sunburst pattern can represent such diverse items as eyes and eyelashes, hands, feet, suns, and flowers. Meaning, however, is not to be found in the separate elements; it emerges from the relationship that obtains between the parts and the whole. This is also the case for very simple figures whose internal features, for example, the face, are composed of the same one-dimensional lines, symmetrically arranged with but a change in the direction of some of the lines. This illustrates a very early phase in representational development in which a single shape, in this case a line, stands for the common property of thingness. While this property is best illustrated in the closed contour of the circle, one-dimensional lines too can perform such a function provided they appear in conjunction with the circle.

A word about the motivation that propels this graphic development; I see motivation embedded in the very curiosity that leads to the early, almost accidental, discoveries of figural characteristics, of shapes that are reminiscent of familiar objects and invite further experimentation. Drawing is a playful and inventive activity, engaged in at the whim and will of the child, for whom the magic of this medium and its mastery provides intense satisfaction.

Figural Differentiation

In the previous chapter, I introduced the tadpole man and the controversies that surround it without indicating how this figure comes to

a.

b.

37. *Early Graphic Models of Humans and Animals*
a. Girl, 3;2. A similar model represents a human (the experimenter) and a cat.
b. Boy, 4;8. Tadpoles represent humans as well as animals. The two figures in the center depict a mommy and a baby. On the right, a similar but elongated figure depicts a giraffe.

represent a human. Strictly speaking, the tadpole is a generic "animate" creature that represents humans as well as other animals. In the early drawings, humans and animals are much alike, and it is this lack of differentiation that prompts the child to alter his figures eventually (see ills. 37 *a, b,* and 19). Once the three- and four-year-old can draw the tadpole man with some degree of ease and competence, he no longer is content to capture the general animate characteristics of a pattern and aims for a better likeness to the particular subject. This engenders a major effort to differentiate shape and to create figures that can convey their meaning without the earlier recourse to verbal completion and interpretation. The many changes that the figures now undergo facilitate the distinctions the child wishes to make between humans and animals, male and female, young and old, and so forth. Once these basic aims of graphic differentiation have been accomplished, the child will also try to portray actions and feelings. The acquisition of such a complex graphic vocabulary will extend over many years.

As a first step toward eliminating some of the ambiguities of the tadpole figure, the human becomes differentiated along the vertical axis and is represented explicitly in the frontal view. This is mostly accomplished by shrinking the size of the primordial circle and extending the vertical lines downward. The parallel verticals come to stand for body dimensions as well as legs and create an open-trunk-human (see ills. 38 *a, b,* and 20*b*). When children are questioned about the presence and location of the tummy, they define the blank space between the verticals as the trunk. At times children will draw a scribble, a bellybutton, or a circle between the vertical lines to indicate graphically the existence of the tummy. When arms are included in the representation, they are drawn at right angles to the figure, which now acquires a distinctly human look. The right-angular relationship of the arms to the rest of the figure increases its symmetry and accentuates the dominant vertical axis (see ills. 39 and 13 *b*). Between the ages of four to six years, we find charming individual variations on the theme of the open-trunk figure, and we might well include the stick-figure among them (see ills. 40 *a, b*). Contrary to earlier opinions (Kellogg, 1969; Kerschensteiner, 1905) that considered the stick figure a purely adult solution imitated by the child, the stick figure is a genuine invention, derived independently from early experimentation with the straight line. It also makes its appearance in modeling with Play-doh and Plasticine (see ills. 41 *a, b, c*; Golomb, 2002). The next step in the differentiation of the human overcomes the ambiguity of the open trunk, whose lines serve the dual function of representing the body's contour and legs. This can be accomplished by connecting the two parallel verticals with a horizontal line or by drawing a separate part, usually in the form of a circle or an oval. Thus, the child arrives at the depiction of the trunk by two different procedures: by closing the outlines and creating a squarish-looking trunk and by drawing a circular shape under the head. For a while both forms appear with similar frequencies (see ills. 42 *a, b, c* and 13 *b*). Both are examples of the "transformation" of a structure. In the case

a.

b.

38. *Open-Trunk Figures*
a. Boy, 6;5. Mommy and baby.
b. Girl, 5;5. Open trunk figures with a small circle depicting the tummy.

39. *The Figure is Organized Along the Horizontal and Vertical Axes*
Girl, 4;8. Arms are placed perpendicular to the body contour. The large figure on the right is her mother: "My mommy is going to have a dress." Next to the mother she draws her father with an "open" trunk and herself with a dress.

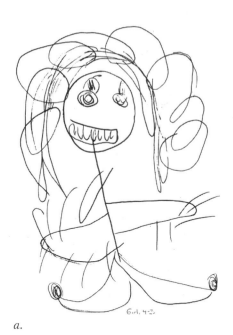

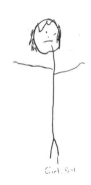

40. *Stick Figures*
a. Girls, 3;10 to 5;1.
b. Girl, 6;8. "Family."

a.

b.

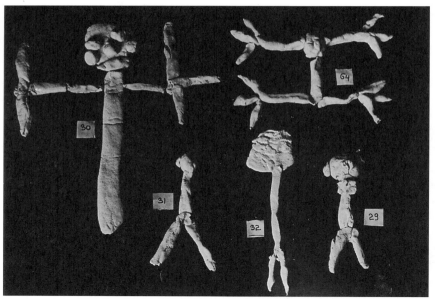

a.

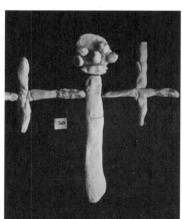

b.

41. *Playdough Stick Figures*
a–c. 4;7 to 5;4.

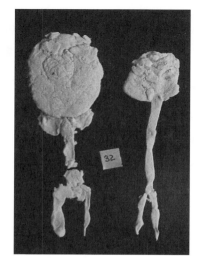

c.

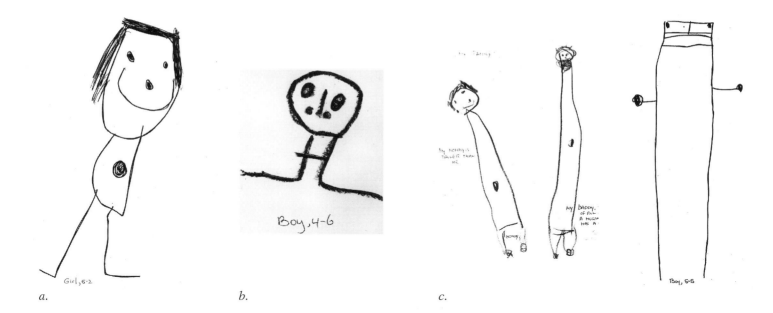

a. b. c.

42. *Graphic Differentiation of the Trunk*
a. Girl, 5;2. Trunk is drawn by adding an oval under the head.
b. Boy, 4;6. Trunk is drawn by adding a horizontal line between the verticals.
c. Girl, 4;4; boy, 5;5. Trunk is created by adding a horizontal line between the verticals.

of the addition of the horizontal line, we note that the ambiguity of the open trunk no longer is acceptable, that lines indicate edges, and that demarcation is necessary for a graphic description of the object's solidity. As the child has been able to draw straight lines all along, this is not the case of merely "adding" a line. It reveals the need to differentiate more clearly between the figure and its background; whatever is outlined belongs to the figure. It is also a statement that solidity requires demarcation and it reflects a major revision in representational concepts. Thereafter, the body tends to lengthen into ovalish or rectangular trunks, and somewhat later triangular shapes make their entry (see ills. 43 *a, b, c*). With the appearance of such differentiated shapes, the circle that until now served as a generalized representational unit useful for almost any object and its parts, gains in specificity and gradually becomes restricted to the representation of roundness. As differentiated forms become available for representational use, new constraints begin to dictate the choice of forms for specific parts.

Two seemingly contrasting tendencies can be observed. We see how the child's experimentation with forms yields new squarish, rectangular, and triangular shapes that increase the likeness of the figure to its referent. Along with the search for new forms, however, we also notice a conservative tendency—namely, to hold on to well-practiced and preferred patterns. Some forms continue to be used with only minimal adjustment, for example, in relative size. The only requirement for the circle-head seems to be that all the parts fit comfortably within its boundary; the torso undergoes more radical changes to indicate that the referent is human rather than an animal, and somewhat later, to specify the gender and age of the drawn person. There are clear benefits to what I have termed a conservative tendency. Unlike the fluidity of pretense play and verbal narrative, where characters can change at the whim of the actor and storyteller who has forgotten

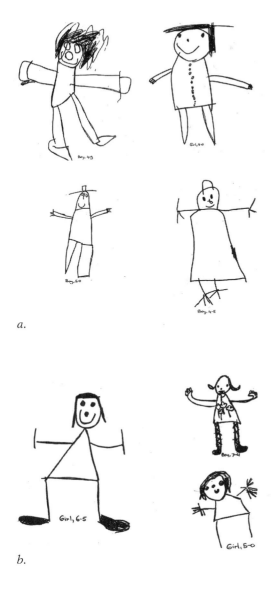

a.

b.

c.

43. *Rectangular and Triangular Bodies*
a–c. Ages 4;5 to 7;4.

the earlier characterization, the drawing presents stability. It is open for inspection, it facilitates an ongoing dialogue between intention and production, and it lends itself to all kinds of experimentation—for example, keeping some parts constant while varying others and assessing the outcome. Thus, it is not altogether surprising that more advanced figures do not automatically displace the earlier ones, and we may find an open-trunk human coexisting in the same drawing or in drawings from the same time period with a closed-trunk figure, depending on thematic needs and the mood of the child. This finding militates against too rigid an application of the concept of stages of graphic development.

As previously mentioned, when arms first make their appearance they are drawn as straight lines at right angles to the body. Even the inexperienced child usually considers the circular shape not optimal for the portrayal of arms and legs. As Arnheim and Schaefer-Simmern have pointed out, the right-angular configuration that organizes the figure along the two dominant axes of space, the horizontal and the vertical, provides the greatest contrast of the direction of lines. This configuration renders the relationship between arms and the body in the visually simplest manner. It is the simplest directional ordering principle, both in terms of the production and the comprehension of a figure. Just as the early shapes are as yet relatively unmarked—with circles standing for heads, facial features, ears, and at times arms, legs, and hair—so also the right-angular relation of arms to the body represents an early phase of differentiation, in which the contrasting horizontal-vertical directions are useful to indicate that the figure is endowed with arms. Indeed, the clearly differentiated arms provide an additional mark of distinction between humans and animals. Thus, this early directional differentiation is only of a general order that does not yet single out a specific angle, and the representation remains constrained within this horizontal–vertical framework.

Like the gradual differentiation of forms, the representation of direction is only slowly acquired. Just as the circle in the beginning represents the thingness of objects without indicating a specific shape, so it also lacks directionality. True, we can discern directional precursors even in the early phase of the global man whose facial features are arranged symmetrically around an implied vertical midline. But the use of location of parts to indicate a primitive top-to-bottom order does not yet imply a concern with lines as indicators of actions and intentions. Only when other directional possibilities have been discovered by the child and incorporated into his repertoire of forms and their orientation can we rightfully assume that right-angular and oblique relations are intended to represent specific directions and orientations in space. Oblique lines are important for the depiction of movement, gesture, action, and later, for the purpose of perspective suggesting three-dimensional space; they require a more advanced level of graphic differentiation and represent a relatively late achievement. The need for simple, well-ordered relations among the parts of a figure yields a relatively stable model based on horizontal and vertical directions, a model that resists change. Only when the differentia-

tion of forms has been firmly established does the desire to portray action and intention—for example, reaching, chasing, running, jumping, bending, or fighting—lead to the deliberate use of oblique lines that imbue the figure with greater tension and vitality. At that point, discontent with his somewhat static graphic formula will lead to the child's experimentation with oblique directions.

Even after the trunk has emerged as a separately drawn entity, arms are not yet consistently depicted and appear in only 50 percent of the human figures. To the extent that they are drawn, the one-dimensional limbs, which lack the self-evident solidity of the contoured shapes, are gradually transformed into two-dimensional ones. With the greater differentiation of the figure and the increased length of the trunk section, arms now extend quite consistently from the torso.

Supportive evidence for the impact of a lengthened trunk and its effect on restructuring the figure also comes from a figure-completion task that attempted to elicit the well documented arms location biases, in which arms tend to extend from the larger of two vertically aligned circles (see chapter 2). I presented preschool children with an incomplete man consisting of a huge head and two smaller vertically aligned circles with legs. In this study, only 19 percent of the three-year-olds and 14 percent of the four-year-olds attached the arms to the top circle, while the overwhelming majority appended the arms to the second, though smaller circle (Golomb, 1981). Clearly, figural differentiation that emphasizes the length dimension of the human tends to promote a reassessment of arms location on a predrawn figure and yields more conventionally acceptable solutions.

The inclusion of a separately drawn trunk signals a process of differentation that calls for greater detail of the figure. Graphic articulation can be seen in the drawing of a two-part torso, clothing, accessories, and a neck. The five- or six-year-old who draws his figures skillfully and with evident pleasure can afford to spend time and effort embellishing his human with hair, ribbons, barrettes, eyelashes, eyebrows, nostrils, earrings, neckties, pockets, socks, shoes, and laces. Clothing is used quite effectively to indicate gender, while hair and belts complete this phase of male-female differentiation (see ills. 44). It is amusing that despite the present-day tendency toward unisex hairstyles and clothing, females usually are portrayed with long, sometimes braided, hair and dresses, whereas boys follow the older tradition of short hair and pants with belts and buckles. A female kindergartener with short hair and dressed in pants may insist on the need to draw a girl with long hair and wearing a dress, "because that's the way they look." This seems to speak to a pervasive cultural influence that specifies some of the defining attributes of males and females despite the profound changes that have occurred in actual practice. Although I have placed special emphasis on what I perceive as universal and fairly autonomous processes of early representational development, these do not occur independent of the culture. Children are clearly affected by their social and pictorial environments. I shall return later to this issue of cultural influences.

44. *The Depiction of Gender Related Characteristics*
Ages 6;2 to 6;9. Clothing and hair are used quite effectively to differentiate between males and females.
Also note that the figures are drawn with a sweeping outline that fuses the parts into a unified whole.

My account of the evolution of the drawn human figure has demonstrated the orderliness with which graphic problem solving unfolds. It reveals the visual intelligence that guides the transformation of the early global models into more differentiated and informative figural statements.

Figural Orientation and Frontality

Earlier I mentioned that the differentiation of the human figure occurs in the frontal plane. In our three-dimensional world, the object can be seen, almost simultaneously, from the front, the rear, and the sides, which of course is not possible in the two-dimensional plane of the paper. The child's solution to this problem reflects her visual conception of the task. In the case of the human, the frontal aspect represents the object in a manner that captures its most characteristic attributes, maintains its symmetry, and provides maximal information with minimal effort. It is an intuitively successful solution to a spatial problem, and one that, with additional practice, also conveys the person's gender and age. Various authors have described the preferred orientations in which humans, animals, and inanimate objects are portrayed, and have termed it the canonical form of the object (Arnheim, 1974; Freeman, 1980; Ives & Rovet, 1979). Arnheim, however, warns us that frontality in children's drawings does not imply that the child intends to portray a specific aspect of the appearance. Children do not intend to draw the object from a specific viewing point; rather, their major aim is to capture its general characteristics (Arnheim, 1988; see also Matthews, 1999; Moore, 1986; Willats, 1997). Although the circular contours of head and body comprise only two dimensions, they represent or denote the three-dimensional quality of the human; that is, they stand for the totality or the volume of the object. Such a drawing that combines volumetric as well as two-dimensional frontal aspects involves a high degree of ambiguity (Willats, 1981, 1985, 1997). When children first aspire to go beyond the depiction of frontal features, they may turn the paper over to draw the "back" of the person on the other side, and even represent a rear view of the human if the assigned theme calls for such a solution (see ills. 45 a, b). Around the age of six or seven years, we may see frontality combined with a profile-head—again most likely elicited by a specific theme (see ills. 46 a, b).

The problem of frontality highlights the difficulties that the two-dimensional medium poses to the inexperienced child and some of his solutions—for example, a house drawn in frontal view with the inhabitants showing through—tend to perplex adults who view them as "transparencies" or X-ray pictures. Figural differentiation is not limited to the drawing of visible parts. As the child's competence in drawing increases, he may wish to draw a baby inside the mother's womb, food in the stomach, or the "bones" of the body (see ills. 47). Drawings that depict the "inside story" tell us that the apparent frontality of the figure stands for more than what is visible at a particular moment in time from a specific vantage point. What appears as frontality

a.

b.

45. *Apple Picking*
a. Girl, 4;11. "My face is turned around, see."
b. Boy, seven. The children standing on ladders are depicted from a rear view.

a. *b.*

46. *Figures that Combine Frontal and Side Views*
Figures are drawn with a head in profile and a frontal body.
a. Boy, 5;9. Mommy and baby.
b. Boy, seven. Playing ball.

is meant to express that which is typically human and, depending on the child's intention, represents the inside as well as the outside of the object. As Arnheim and Willats remind us, the contour of the figure stands for the volume of the object and represents its outer boundaries in the third as well as the second dimension. Its inside area can stand either for the inner parts of the object or for its outer surface. Once again, we are faced with an early graphic conception that does not distinguish between two- and three-dimensional views in pictures, and the simpler two-dimensional view must, of necessity, serve in a dual capacity. Such graphic strategies do not indicate the child's confusion about the inside and outside of an object, but reflect his limited skills to cope with the vexing task of translating the three-dimensional object to the flat, two-dimensional surface of the paper. Seen from this perspective, the term *transparency* is a misnomer for an early form of graphic representation.

A variant of the transparency phenomenon has been described as form-overlap, a failure to occlude the parts that remain hidden from the viewer. Frequently this occurs when the child aims for a complex representation of a person who wears clothes. In this case the lines that depict clothing tend to intersect and overlap with those that indicate the basic body parts. The sequence in which the body is drawn, and the lack of advance planning for the garments, yield overlapping lines; thus, the earlier drawn parts are still visible and may be said to "interfere" with the later ones. As graphic statements become more ambitious, such figural overlap occurs more frequently (see ills. 48). Lines cross internal boundaries, as when a mother is shown holding a baby. The figure of the mother is first completed, followed by the arms that are drawn toward the inside of the figure to hold and hug the baby, and the baby is superimposed on her arms and body. Some children resolve the ambiguity inherent in the space created by the contour by coloring it in or shading it, and thus lending it greater solidity. Most commonly, such coloring-in applies only to the body and limbs. Recently, however, I have noted an increase in the coloring-in of faces to indicate the racial identity of the drawn figure.

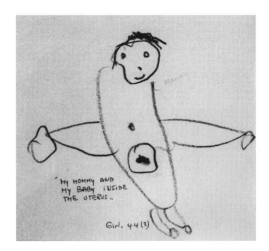

47. *Transparency*
Girl, 4;4. My mommy and my baby inside the uterus."

48. *Line Overlap*
Girl, 6;4. First, the figure of the mother was drawn; next the baby was superimposed on her body.

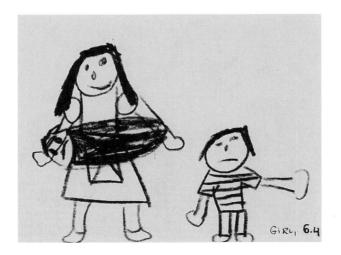

In summary, the orientation of the human figure is at first dominated by frontality, a non-specific all-encompassing view that represents the totality of the person. Only gradually will frontality become restricted in its meaning as the possibility to represent specific views is conceived of and leads to experimentation with side, rear, top, and three-quarter views. The developmental progression, once again, proceeds from a global graphic conception to a more specific and differentiated view of the human figure.

Size Differentiation

Once the major forms have been differentiated, children are also ready to turn their attention to the relative sizes within a series of figures and to their proportions. The child who draws her family is apt to distinguish adults and children by their relative size, and she may introduce size distinctions between younger and older siblings. She is also beginning to pay some attention to the proportions of a figure; for example, the torso tends to grow to twice or three times the size of the head. However, the child still seems unconcerned with the "realistic" or true proportions of a figure, and head size is either over- or underestimated until late into the childhood years (see ills. 49 *a, b*). It is worth noting that a new concern with the relative size of objects in drawing does not by itself indicate that an earlier conceptual handicap has been overcome. In a study especially designed to assess children's awareness of size differences and their ability to portray their perceptions, three- and four-year-olds were asked to draw pairs of objects that clearly varied in their absolute sizes: a mommy and a baby, a kitten and a giraffe, a tree and a flower, a snake and a worm, a house and a car (Golomb, 1981). The vast majority of these youngsters made distinct size discriminations in their drawings of the pairs of objects, although in their own spontaneous drawings they paid little attention to size differences (see ills. 50 *a, b, c*; see also ills. 26). Apparently, instruction and task manipulation can elicit seemingly precocious skills that the child does not yet exhibit under ordinary

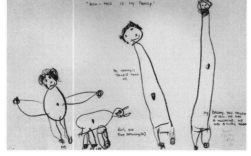

a.

b.

49. *Size Differentiation*
a. Girl, 4;4. "Now this is my family."
b. Girl, 6;9. "My family."

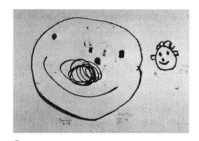

a.

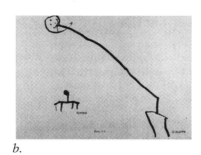

b.

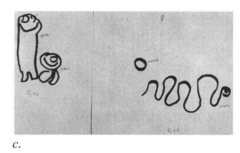

c.

50. *Size Differentiation*
Although preschoolers tend to ignore size differences in their spontaneous drawings, when asked to draw animals or people of contrasting sizes, they reveal sensitivity to this aspect.
a. Girl, 3;9. Mommy and baby.
b. Boy, 4;2. Giraffe and kitten.
c. Girl, 5;6. Mother and baby, snake and worm.

conditions of drawing. Once again this finding cautions us not to draw hasty conclusions about cognitive deficits as the basis of drawing characteristics.

Figure Construction

I have described the transformation that the human figure undergoes as shape, line, direction, size, and proportion become differentiated. I shall now turn my attention to the method used to construct the figure. With few exceptions, children compose their human by the addition of separately drawn parts. Each individual part is drawn as a self-contained unit and either attached to its neighbor or aligned with it despite a spatial gap that separates the parts. Such gaps can be found in early trials and disappear fairly soon with the discovery that adjoining forms lend the figure greater solidity and coherence (see ills. 7 *c* and 8). Some children tend to adopt an "assembly line" approach when drawing a series of figures. Such a technique may call for drawing all the heads first, the bodies next, and so on with the remaining parts. The majority of the children, however, construct their figure in the vertical order described in chapter 2, with parts following each other. Figure completion can thus be achieved by an additive procedure that joins the successively created parts into a coherently organized larger unit. This process permits the construction of fairly complex figures.

Once this differentiation via the addition process has been accomplished, approximately at ages six or seven years, a reorganization is attempted. With the exception of the head, the parts of the figure tend to be drawn in a single sweeping outline that follows the contour all around the body until the comprehensive line completes its journey and creates a unified figure (see ills. 44 and 51). This procedure indicates that the child has attained a better grasp of the totality of the figure, and the drawn contour is inspired by this graphic conception. The nature of the object, in this case the human, now dictates that lines should be varied, drawn straight, curved, and multiangled, and eventually, thick and thin. Using an embracing line requires an awareness of how each part relates to the total figure, and it necessitates planning that guides the continuous outline until the several parts are fused into a closely structured and unified whole. It is an ambitious effort that requires more complex visual-motor coordination than was the case with the separately drawn shapes, and it does not immediately accomplish its goal. Many early single-contour figures lose their previously

GIRL, 5.9.

51. *Figures Drawn with a Continuous Outline*
Girl, 5;9. The single contour figure is a new graphic model for this artist. It lacks the balance and appeal of her earlier drawings.

a.

b.

52. *Profiles*
a. Girl, 4;11. Playing ball. The figure on the left faces the child holding the ball.
b. Girl, 6;0. The children who swing the rope face each other.

attained balance, proportion, and aesthetic appeal (see ills. 51). Occasionally, a child seems to discover the all-embracing contour quite early and seemingly spontaneously. Those four-to-six-year-olds who either quickly outgrow the segmented approach or seemingly bypass it create a more naturalistic-looking and expressive figure that perhaps marks these children as talented in the visual arts (see chapter 7).

Approximately at the ages children begin to experiment with the single body contour, they also draw their first profile faces. The data on the incidence of profiles are inconsistent and suggest, among other things, the impact of the culture. P.A. Ostherrieth and A. Cambier (quoted in Freeman, 1980) report rather low percentages: 10 percent for six-year-olds, 20 percent for seven years, and 30 percent for eight-year-olds. Betty Lark-Horowitz, Hilda Lewis, and Mark Luca (1967) report somewhat higher percentages; 25 percent, 39 percent, and 51 percent, respectively. My own data indicate that the profile is likely to appear when the theme calls for an interaction among individuals, for example, playing ball or chasing each other (see ills. 52 *a, b*). However, many children continue to depict the frontal view even when a side view would be more appropriate and help to enhance the viewer's understanding of the theme. In the past, authors have commented on the mixed profile, a head drawn from the side but equipped with two eyes, which is inconsistent with a single viewpoint. Georg Kerschensteiner's 1905 publication includes several examples across a wide range of ages, which indicates that these drawings were not altogether rare at the beginning of the 20th century. The incidence reported by Lark-Horowitz et al. from extensive studies at the Cleveland Museum of Art (Munro, Lark-Horowitz, & Barnhart, 1942) is low: 1 percent for ages six through eight, with a high of 6 percent at age ten. Brent and Marjory Wilson (1982a) have examined more contemporary sources and found that the two-eyed profile has altogether vanished. They see its disappearance as evidence for cultural influences on children's drawings, specifically chaneled through interactions with siblings and peers. (For a more detailed discussion see chapter l0.)

I have followed the course of graphic development from the undifferentiated animate-looking tadpole to the quite sophisticated single-outline drawing of a human. At this point I also note the appearance of changes in line that can convey finer observed aspects of an object. In some cases, thick lines are now used to express the character of a figure, while lighter and more sketchy lines serve to portray gesture and movement. From the age of eight years on, one can find some variability in the manner in which lines are used on some of the tasks.

Overall, the evolution of the drawn figure has told us something about the child's agenda: form differentiation takes precedence over differentiation of size, proportion, direction, and orientation. When the figure has attained a satisfactory level of graphic differentiation, children are ready to pay attention to the representation of age, gender, status, and eventually, to actions and interactions. Actions are particularly difficult to portray, as I shall indicate when next I consider the depiction of movement.

Movement and Action in the Drawing of the Human Figure

In order to study children's techniques for portraying actions two themes were selected: the depiction of a chase and planting. On the first theme, I asked for the drawing of two people running, with one chasing the other and trying to catch him. Our participants were 104 elementary school children enrolled in grades one through five, and a group of 50 college students. All subjects, independent of age, organized the figures in the horizontal plane, and most used proximity of figures as a major device to convey the notion of a chase. For the first graders, the orientation of the two actors is, predominantly, frontal and arms are drawn at right angles to the figure's vertical axis. In approximately 25 percent of the drawings, the runner is depicted in profile with arms placed sideways and pointing, quite appropriately, in the direction of the object of the chase. Interestingly, among these drawings I find several "mixed" profiles in which various elements derived from frontal and side views are combined; for example, a single eye characteristic of the side view is drawn with nose and mouth derived from the frontal view. In the case of the profile drawings, one can also determine the direction of the chase, which is well marked by arms drawn parallel to each other, pointing in the same direction, ready to capture the escapee. The movement of the chase proceeds mostly from the left side of the paper to the right side. Overall, the figures of these first graders appear in a vertically upright stance, of straight body and limbs (see ills. 53 *a, b*).

Among the second graders, I note a significant increase in profile drawings and arms drawn sideways, even in the case of frontal figures, thus indicating the direction of the chase. While the standard frontal orientation with arms extending symmetrically from both sides of the body continues to dominate the drawings, I also observe a great number of slanted legs, some knee bends and speed marks to indicate that the figures are in motion. The direction of the chase is still, predominantly, from left to right (see ills. 54 *a, b*).

a.

b.

53. *The Chase*

a–b. First graders. The theme is suggested by the relative proximity of the two figures, the use of profiles, and the sideways orientation of the arms.

54. *The Chase*

a–b. Second graders. The subject matter is somewhat better conveyed by endowing the figures with slanted legs and some knee bends.

a.

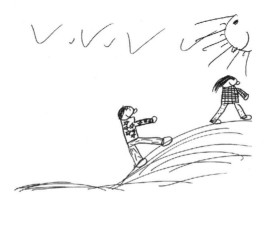

b.

a.

b.

c.

55. *The Chase*
a–c. Third and fourth graders. The drawings display greater variability of limbs and their movement and an increase in side views of the actors.

A further increase in profile drawings characterizes the work of third and fourth graders, although they do not completely displace the much favored frontal orientation. One third of the drawings display the symmetrically attached arms, an indication of children's reluctance to relinquish the frontal orientation. By fourth grade, the direction of the limbs shows greater variability, with the majority of the drawings depicting slanted legs, bent knees, and feet drawn diagonally, all of which indicate that the body is in motion. The depiction of arms stresses the sideways orientation of the figure, and we note the appearance of a single arm or the partial occlusion of an arm, which indicates that a particular viewing point is considered (see ills. 55 *a*, *b*, *c*). For the first time we note arms that are drawn at different angles to the body axis—for example, the left arm raised in an upward motion while the right arm points downward—and some attempt to bend the torso. These efforts, however, are limited to a few drawings only. The runners continue to move from left to right.

By the fifth grade, the reliance on proximity as a major device for depicting the theme of a chase is overshadowed by the use of more effective representational means. Profile drawings dominate; almost all figures display slanted legs, bent knees, diagonally lifted feet. There is also greater attention to arms location and direction, with the left arm usually lifted and the right arm dropping (see ills. 56 *a*, *b*, *c*). However, the incidence of slanted figures and bent torsos remains low. While in a majority of the drawings the action still proceeds from left to right, there is an increase of figures moving in the opposite direction.

Similar findings hold for the adult sample of mostly liberal arts college students, where the trends noted for fifth graders are amplified. Slanted figures now comprise one third of the drawings; we note an increase in bent knees, diagonal feet, and arms overlap, and variation in the direction of the arms. In a majority of the drawings the movement of the actors continues to proceed from the left to the right.

The findings for the total sample document the gradual and orderly differentiation of the human figure in motion, beginning with head orientation and the direction of the arms, proceeding with diagonally drawn legs, legs bent at the knee, and arms drawn at different angles to the body. Limbs seem to be the most "bendable," and are relatively simple though reliable indicators of motion. Bending the torso appears to be a most difficult task even for my college-educated adult sample.

A request to draw a picture of children planting flowers probes children's ability to portray a different sort of action that requires a postural change. The majority of the first graders depict one or more children standing next to a plant, and a few draw the child standing either above or behind a plant. In all of these cases there is no clear indication of the nature of the task, of the relationship between the child and the plant (see ills. 57 *a*, *b*, *c*). When contact is established between these two items, it can occur in a variety of ways: the child may be seen holding a plant, extending his arm to touch the ground, bending the figure toward the plant, or kneeling down. Children in the second grade continue to use the side-by-side arrangement that still

a.

b.

c.

56. The Chase

a–c. Fifth graders. Further variability in the direction of the two arms and some success in the occlusion of body parts.

a.

57. Planting

a–c. First graders. All the major elements are drawn in a side-by-side arrangement. Neither action nor intention of the central figure is depicted. The presence of seeds and of garden tools are suggestive of the theme.

b.

c.

58. *Planting*

a–e. Second graders. New graphic devices are used to suggest contact between the planter and the plant. They include raising the plant to the level of the child, lengthening the arms, long shovels or rakes, and a kneeling position.

comprises one third of all the drawings. Devices for creating contact between child and plant include extending the length of the arms to reach the ground, enlarging the size of the plant and bringing it within easy reach of the child, raising the plant to the level of the child by standing it on a hill, and introducing shovels. Different solutions include lowering the child to the ground either by seating him next to the plant, or showing him bending down or kneeling (see ills. 58 *a–e*). Kneeling requires the greatest postural differentiation of arms and legs. By the second grade, the majority of the drawings display figures that are lying down, sitting, bending, or kneeling. Kneeling, the most effective way to portray the activity of planting, increases steadily thereafter. The side-by-side arrangement declines in grades three and four as figures stoop and kneel in the act of planting (see ills. 59 *a, b, c*). In fifth grade, close to 80 percent of the figures are kneeling down, a trend that is quite similar for the adult sample (see ills. 60 *a, b, c*). These findings, once again, demonstrate how the demands of the task modify the preferred upright standing posture of

a.

b.

59. *Planting*

a–c. Third and fourth graders. Activity is more explicitly suggested by depicting the planter in a seated or kneeling position. Right-angular relations predominate in the upright torso.

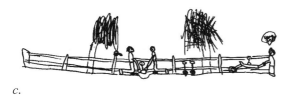

c.

60. *Planting*

a–c. Fifth graders. Side views of the human figure increase and bodies tend to bend and curve. The activity of planting is more skillfully portrayed.

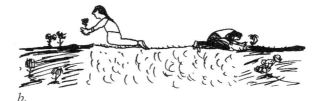

b.

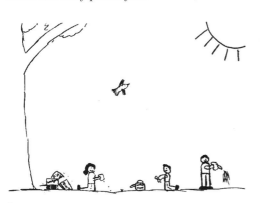

a.

c.

the human figure. For the sample as a whole, the overall tendency is to change only the direction of the limbs and to maintain, where possible, an upright torso that preserves the stability of the right angular relationship.

My review of the changing graphic models for the representation of the human figure reveals both continuities and discontinuities. There is a clear discontinuity between the early global human and later models—for example, between the global man and the open-trunk figure. The former embodies the assumption that a single, undifferentiated unit can represent a complex object, whereas in the open-trunk figure two or more basic units fulfill this function, establishing a closer correspondence between the drawn forms and specific aspects of the object. As this development indicates, the degree to which justice is done to structural features of the model has changed markedly.

Continuity between the various developmentally significant models can be seen in the increasing detail with which the drawn human figure is endowed. This is best illustrated in a model whose overall structure has been maintained, and where the additional detail serves to further define the character—for example, clothing, eyelashes, and hair. Continuities are most noticeable when an existing structure or model is elaborated on; discontinuities when it is overhauled. There are no strict dividing lines and the incorporation of significant detail is not limited to a specific graphic model. Indeed, both restructuring and elaboration of detail can happen at the same time as a figure is revised and significant details are added.

From a formal point of view, discontinuity in the structure of various graphic models refers to the changes in the meaning of the units that occur as a function of the differentiation of forms. The circle of the tadpole figure presents a good example of changes in meaning. In the tadpole, the circle represents both head and body; in the open-trunk figure its meaning is restricted to head only. The so-called discontinuity in graphic models, however, should not be construed as an arbitrary change. The developmental processes that I have documented so far provide a record of visual thinking in the graphic domain. They demonstrate an orderly transformation of models guided by an internal logic that leads to the differentiation of form, line, direction, size, and orientation of the figure. One can note additions that enrich the figure and additions that transform it structurally. As the function of lines and shapes is better specified, the drawn figure attains greater clarity in the meaning it conveys. Graphic differentiation means eliminating ambiguities and exerting control over the medium. This can be achieved in a variety of ways, and though I have at times referred to the differentiation of shape in terms of a "vocabulary," we ought to remember that there is no fixed relationship between a graphic sign or symbol and its referent. An eye can be represented by a dot, a slash, a diagonal, a circle, or an oval, and various combinations thereof. Conversely, a relatively complex figure can be constructed with the use of a single shape—the circle.

The major impetus for change lies in the child's desire and need to create more differentiated models that can better represent his intention. While children's drawings are made within the social and cultural milieu in which they live, it is remarkable how little their early efforts are determined by picture books and illustrations that are quite abundant in Western-style environments. As the evidence indicates, the development of human figure drawing follows an orderly progression characterized by some degree of invariance in the manner in which the first models emerge, are perfected, and then revised.

Animal Drawings

What are the transformations in the early figures that yield recognizable representations of various animals? Do they follow the same principles I documented for the human figure? I turn to a study explicitly designed to address this question (Golomb, 1981). Linda Whittaker and I asked 250 two-to-seven-year-old children to draw humans, animals, plants, houses, and cars. The class of animals included drawing a cat, giraffe, fish, bird, snake, and worm—animals that differ markedly in shape and size. Overall, the findings replicate the course of differentiation of form, line, direction, orientation, and size that I previously documented for the human figure. The drawings begin with minimally differentiated all-purpose forms of circle and straight line. The early forms do not clearly differentiate between the various animate creatures that look much alike. Furthermore, as was the case for the human figure, right-angular relations characterize the arrangement of the parts of the animal's body, which is also portrayed in standard orientation. As was the case with the human figure, the global animal figures begin their course of differentiation by internal subdivision and the addition of separately created shapes. Only later will the continuous outline incorporate all the elements of the figure in a single and comprehensive line. Once again, attention to relative size and proportion appears late in the course of graphic differentiation.

More specifically, while most of our two-year-olds were clearly prerepresentational children who scribbled in response to our request to draw objects, the data reveal the beginnings of a process of differentiation. When the tendency to produce unruly whirls diminishes, circular contours emerge for most objects, with the exception of the snake and the worm (see ills. 12 *b, c*). The latter are drawn as single vertical, horizontal, or diagonal lines, and 26 percent of our youngsters produced such representations. For this young age group, the incidence of global tadpole-type looking figures is a relatively high 22 percent for a human and a low 5 percent for cat and fish. Humans and cats are quite indistinguishable and are drawn in the form of global circles with facial features, with or without limbs, and the occasional fish is drawn as an ovalish figure with some internal markings and a tail. The request to draw a giraffe and bird did not yield representational forms in this group of two-year-olds.

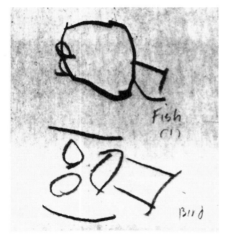

a.

b.

61. *Fish and Birds*
a–b. The drawings of three-year-olds.

62. *Differentiation of Human and Animal Models*
Boy, 4;8

In the group of three-year-old youngsters, one observes a dramatic increase in the number of children who no longer respond with scribbles to our request, but create recognizable shapes that are clearly representational. As the scribble-action ceases, controlled contours appear that are endowed with a few distinctive marks. The percentages of recognizable figures suggest the relative difficulty of drawing the assigned subjects. Snakes in the form of straight lines are clearly the easiest to portray and appear in 65 percent of the requested snake drawings. Humans follow with 42 percent and cats with 33 percent of the requested drawings. The remaining animals proved difficult for these three-year-olds as seen in the low percentages: 23 percent birds, 19 percent fish, and 15 percent giraffes. Humans, cats, and giraffes are primarily represented by an indiscriminate global tadpole-type figure (see ills. 37). Occasionally, ear markings and whiskers appear on the cats and diagonal necks on the giraffes. The snake model, however, becomes unmistakably "snakish," with its separate head, elongated slim body, and now exclusively horizontal orientation. Fish are drawn with a horizontal ovalish body and sideways orientation. By comparison with the other models, the graphic differentiation of birds lags behind, but several attempts are marked by the inclusion of wings (see ill. 61 *a, b*). The primary shapes used for the construction of the various animal figures consist of the circle and the straight line.

Representational competence and self-confidence increase with our four-year-olds, and more children complete all the assigned tasks. Humans are still drawn most frequently, with 88 percent of our youngsters drawing people, 81 percent snakes, 77 percent birds, 65 percent fish and giraffes, and 58 percent cats. Figures begin to look more like the objects they are intended to represent, with approximately, 50 percent of the children adopting graphically distinct models. As the drawings indicate, children are no longer satisfied with a global animate model that represents humans as well as a variety of animals, and we now observe efforts to differentiate humans along the vertical axis; horizontality assumes an equally important role in the depiction of animals (see ills. 49 *a* and 62). There is a strong inclination to draw the animal body in the horizontal orientation—at first by using a one-dimensional line, later on by two-dimensional closed shapes. Increasingly, the appearance of the real-life object exerts its influence on the experimentation with various graphic animal models and gives rise to a number of tentative solutions ranging from relatively minor adjustments in the familiar tadpole figure to more radical transformations.

To represent a giraffe, a number of children continue to employ the ubiquitous tadpole but the majority struggles, more or less successfully, with the task to develop a more differentiated model. Various strategies are adopted; for example, elongating the body of the giraffe and depicting it mostly in the frontal view, which creates a humanoid looking figure distinguished by an upward-extended body

that requires additional markings to reveal its animal nature (see ills. 63 *a*).

A very different effect can be obtained when the giraffe's trunk is drawn in the horizontal dimension with its neck extended in the contrasting vertical or diagonal direction. The transition from a vertically extended body to a horizontal one represents a major transformation in the graphic model (see ills. 63 *b*).

In general, the tendency is to depict neck and trunk with single one-dimensional lines, drawn at right angles. Legs are also drawn as straight lines, perpendicular to the horizontal body. In this model, we frequently find a mixture of views with the body drawn sideways and a frontally drawn head that stares directly at the observer. When both head and body are drawn in side view, the head tends to assume an ovalish or triangular shape. In addition to the long and slender neck, the giraffe also begins to exhibit ears, horns, and spots that help define the appearance of this animal (see ills. 63 *c* and 67 *f*). Interestingly, quite a number of children who were at first perplexed by the assignment depicted the giraffe with a long diagonal line, a tiny head

63. *Giraffe Models*
a–c. Right-angular relations predominate in the drawings of these four-year-olds.

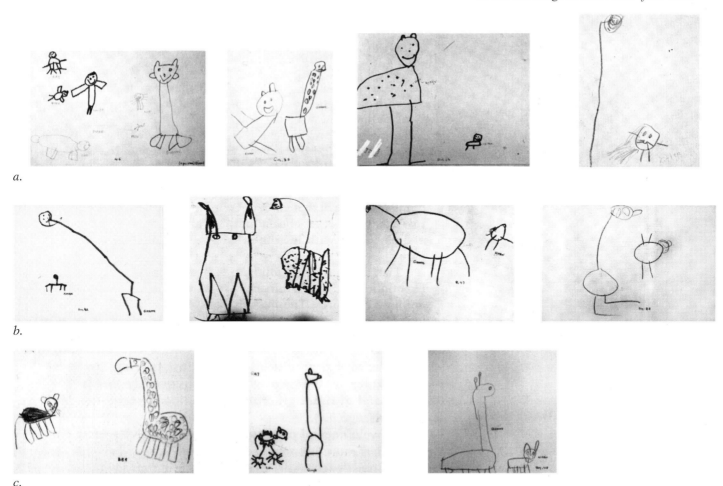

a.

b.

c.

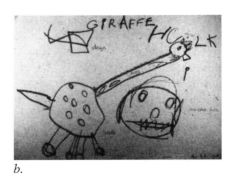

a.

b.

64. *Diagonal Giraffes*
a–b. Some four-year-olds use the diagonal to capture the essence of this animal—its extended neck.

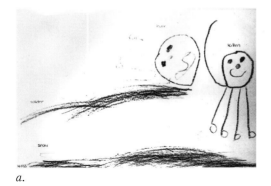

a.

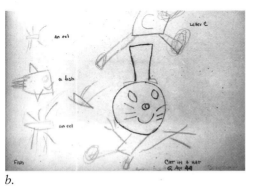

b.

65. *Cats*
a–b. Drawings by a four-year-old boy and girl. (See also cat drawings in 63.)

and multiple legs. This model differs from the more commonly seen right-angular relations, and the diagonal direction contrasts with the well-known difficulty preschoolers encounter when copying oblique lines (see ills. 64 *a, b*).

The majority of four-year-olds tend to draw cats with a one-dimensional horizontal body displayed in side view, a head in frontal view, four straight legs, and an occasional tail. Variations on the tadpole figure show attention to whiskers and triangular ears as the defining attribute of this animal. Of these, some are only equipped with two legs, but others boast four legs and, at times, a tail (see ills. 63 *a* and 65 *a, b*). As with the other figures, right-angular relations dominate.

Fish and birds also follow this general trend toward greater differentiation, and only a minority of four-year-olds depict them as global animate creatures. The majority draws both in side view, although facial features continue to be drawn, quite frequently, from a frontal view. Typically, the body of the fish is drawn as an oval with the characteristically sideways fish-mouth, one or two eyes, and a tail, whereas the bird is graphically defined by its wings and beak. The snake becomes two-dimensional and frequently displays a long, wave-like, and at times gracefully curved body suggestive of its motion (see ills. 66 *a, b, c*).

The developmental progression observed in the work of four-year-olds becomes more pronounced for five- to seven-year-olds. Animals are now almost exclusively drawn in their standard sideways orientation, which highlights the distinctive features of the subject. The majority of giraffe drawings present the animal's two-dimensional body and head, quite consistently, from a side view; the cat's body and head often display mixed views that deftly combine some of the visual characteristics of this animal (see ills. 67 *a–f*). Fish are almost exclusively drawn in a sideways orientation, whereas birds are also depicted in aerial views (see ills. 68 *a, b, c*).

With few exceptions, graphic differentiation in terms of the sheer number of parts does not increase markedly between the ages of five to seven years. Instead, we see an increase in single-outline drawings in which a sweeping line bends and curves its way along all the major parts of the body. We also notice the use of shading and coloring

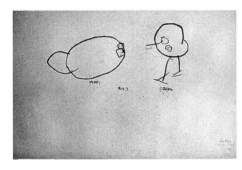

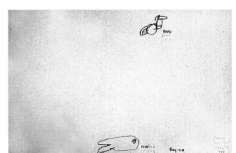

a.

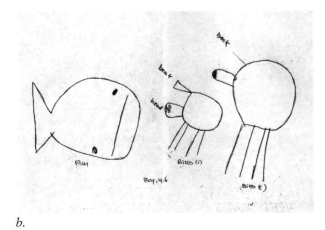

b.

66. *Early Models of Birds, Fish, and Snakes*
a–b. Drawings of four-year-olds.
c. Drawings of five-year-olds.

c.

81

a.

b.

c.

d.

e.

f.

67. *Giraffes and Cats*
a–f. Ages 5;5 to 6;5.

techniques in an effort to lend more solidity to the outlined figure. The single-contour line appears somewhat earlier in drawings of animals than of humans, and in some cases attains striking results (see ills. 69 *a, b, c*).

As was the case for the human figure, animal drawings of four-legged mammals that have attained some degree of figural differentiation also display the right-angular directions described earlier for humans. The animal's legs are drawn perpendicular to its horizontal trunk, which creates a clear distinction between the major parts of the body. In the case of birds, head, body, and tail tend to be aligned horizontally, whereas the wings extend vertically. Similarly, the head and tail of fish constitute the horizontal direction, and gills and fins extend vertically. As previously mentioned, although size differences can be elicited fairly early on when the theme involves extreme contrasts, an interest in the portrayal of "realistic" size and proportion emerges only late in the developmental sequence.

My findings on animal drawings by two- to-seven-year-old children once again highlight the developmental principles articulated earlier in this chapter and documented in greater detail in my account of human figure drawings. One can now see that the principle

a.

b.

c.

68. *Fish and Birds*
a–c. Ages 5;4 to 6;4.

of differentiation applies broadly across a wide range of tasks and subject matter, and that these animal drawings illustrate the same stages in the differentiation of shape, line, orientation, direction, and dimensions. (An individual child's performance on different subjects can be seen in ills. 70 *a–g.*)

The assignment of the various animal tasks also brings into focus a second principle that guides development; the desire to create a likeness to the object. It is this desire to capture the object, to represent it

b.

a.

c.

69. *Animals Drawn With a Single Contour*
a. Boy, 4;10. Cat and camel.
b. Boy, 5;10. Horse.
c. Girl, 6;0. Giraffe.

a.

70. *Individual Children's Drawings on Diverse Subjects*
a–g. Artist ages 3;11 to 6;4.

b.

c.

d.

e.

f.

g.

truthfully and thus to establish a kinship with it, that guides the direction the differentiation of form takes. At its earliest, we see the impact of the object's characteristic features in the one-dimensional straight-line drawing that represents the snake. In this case, the visual concept of the long, thin snake militates against the use of the all-purpose circle (see ills. 12 *b, c*). The latter, for example, is useful as an early representation of the giraffe, but the giraffe also demands the depiction of height. Thus, the circle first becomes extended in the vertical direction to indicate the height of this animal and is then superseded by other shapes for the representation of the body, horns, and ears. The body tends to be drawn as a rectangular shape, whereas the latter are best depicted by triangular shapes. The course of the differentiation of form may be likened, by analogy, to an organismic unfolding of functions and capacities. However, we also need to consider a second principle; the orientation toward the reality of the object that co-determines the path of graphic development.

The account of my cross-sectional study of animal drawings that were collected at one moment in time, as one task among many, provides only limited information about the individual child's earnest efforts—and even struggles—to create adequate models. To get a glimpse of the latter, let me turn to an account of Heidi's drawings of a horse, her favorite subject over a period of many years. For this account we are indebted to Sylvia Fein who documented the drawing development of this talented and highly motivated child in a beautiful book called *Heidi's Horse* (1984).

Heidi's Horse Drawings

The record of Heidi's graphic output begins with scribbles made during her third year of life; circular whirls, spirals, and coils during her fourth year; and the creation of the circle at the beginning of her fifth year. Once Heidi has drawn her first circle, she never returns to the earlier practiced scribble-patterns. We see how she embellishes the circle with additional circles drawn inside the contour and on its outside. Within a very short time, at the age of 4;2, Heidi draws her first human figure. It is a global-tadpole-type man with six radiating lines that represent arms and legs. Soon thereafter, at 4;3, Heidi draws her first horse, a right-angular configuration composed of a circle-head with circular facial features drawn in frontal view; a one-dimensional, horizontally drawn straight line for the body; and seven legs perpendicular to the body line (see ills. 71 *a*). Heidi lives on a ranch and learns to ride horses at an early age. For the next 12 years, the horse motif becomes the dominant theme of her drawings, and we can follow her daily efforts to work out problems of shape and spatial relations until she creates a horse that meets her representational ambition. We observe her early experimentation with the length of the body-line and see it shrink until the four legs fill up the available space. A next phase of exploration sets in when Heidi discovers the two-dimensional use of lines; she applies this knowledge first to the legs and then extends it to the body, which now assumes a rectangular

a.

b.

c.

d.

e.

f.

g.

71. *Heidi's Horse*
(Courtesy Sylvia Fein, *Heidi's Horse,* Exelrod Press, 1984.)
a–d. Age four to six. During this period, Heidi's horse changes from an undifferentiated figure composed of a circle and one-dimensional straight lines to a sophisticated representation in which a single outline encompasses head, neck, body, and legs.
e. 8;7. The horse in motion.
f. 9;4. First three-quarter view.
g. 10;4. Deliberate variations in the quality of line create an expressive portrayal of the horse.

shape. Struggling with this new graphic formula, she loses, temporarily, control over the length of the body, which again leads to a multiplicity of legs to fill in the space between head and tail. Once this problem is recognized, she makes the necessary adjustments in the length of the line and limits the number of legs to four. In rapid succession, she organizes the legs in pairs, fore- and hindlegs. At the same time, she is also experimenting with a sideways-turned head, drawing several heads in a mixed-profile that combines frontal and side views and eliminates the superfluous features; from now on she concentrates on profile drawings of the head. Her next efforts are devoted to curving the back-line and, accordingly, she modifies the horse's rectangular body into a line that dips between head and tail. The freedom of the curving line suggests additional modifications; she also begins to experiment with the slanting of the legs. These deviations from the perpendicular relationship of the parts to one another are carried through in many new ways: the angular shape of the head, the angle at which the horse's head is attached to the body, and details such as the bridle (see ills. 71 *b*). Once the new structural relations have become firmly established, many new details are added that reflect her extensive knowledge of the horse and enrich its pictorial meaning. She adds manes and forelocks, saddles and blankets, bridles and stirrups. Her next persistent effort is focused on the creation of a unified line that will encompass head, neck, body, and legs. Within a few weeks of multiple trials, Heidi achieves her goal, and we can quite literally follow the effect of this persistent practice on the evolving contour-lines (see ills. 71 *c*). We notice the effects she creates by coloring and shading of body parts, and how her interpretation of an accidentally drawn bend in a hindleg ushers in a new phase as she begins to bend the lines of the legs to indicate motion. Before her sixth birthday, Heidi successfully uses overlap as she eliminates the line of the bridle that is hidden from view. Discovery comes to Heidi by "doing," and repetition helps her to consolidate her new accomplishments.

The shape of the horse has undergone a marked transformation as diagonals are incorporated and the parts of the horse become unified within a single outline. Heidi also begins to erase lines she finds unsatisfactory, which indicates how consciously she works at her horse and how aware she is of the difficulty to draw it to her liking. The amazing record of Heidi's daily drawings, of her successes and failures, provides us with a rich record of Heidi's visual thinking and her growing drawing competence. That Heidi is extremely proud of her achievements can be read in the written comments that accompany her drawings (see ills. 71 *d*). In two years, Heidi has moved from the primitive global figure composed of the circle and the straight line to a rather sophisticated representation of a horse, drawn with a single outline that encompasses head, neck, body, and legs.

At the age of seven years, her interest in dramatic action finds expression in graphic narratives that depict multiple actors, all focused on the beloved horse. Horses are shown in training, rearing, jumping, kneeling, and bowing on command. During the period when narrative

of dramatic actions dominate, Heidi is satisfied with simple horse renderings, graphic models that are much simpler than the ones she had previously evolved and perfected. This phase lasts for, approximately, one-and-a-half years, and at 8;6 years she returns, once again, to the drawing of single horses with or without a rider. She struggles with the problem of overlap and how to refine the body-contour when the horse is in motion (see ills. 71 *e*). We witness progressions and regressions in the service of establishing control over the medium and consolidating achievements.

Her drawings over the next two years indicate an extraordinary knowledge of the horse at rest and in motion, and we notice a first three-quarter view of the horse's head (see ills. 71 *f*). Heidi now produces fewer works but pays close attention to detail. By age ten, the quality of the lines is further differentiated as she uses thick and thin lines, dark and light ones to express the horses's essence (see ills. 71 *g*). In the author, Sylvia Fein's, words: "Her work has had a continuous, harmonious, disciplined evolution because she was permitted to develop and manifest whatever rich forms and artistic relationships she needed to communicate her curiosity, playfulness, experience, and enthusiasm. No exterior imposition, no teaching method could have elicited from her this genuine, unaffected product of her own creativity" (Fein, 1984, p. 157).

This account of Heidi's drawing development documents a personal "working through" of the graphic problems she encounters without having any obvious recourse to the readily available pictorial models of her culture. This talented child, who grows up in an environment that supports and fosters her interest in drawing, clearly did not lack picture books. As far as we can tell, there is no immediate impact of picture book materials on her drawings. Instead, we see Heidi engaged in a personal problem-solving quest that takes her through very recognizable phases in representational development. Her solutions emerge gradually, the outcome of her own efforts and her understanding of what she wishes to change, revise, and reconstruct. Her work provides an enlightening example of the stage-like progression of the differentiation of shape and line. It might also provide an argument for encouraging such autonomously guided development, as the insights won are truly mastered; they grow out of genuine and productive visual thinking that yields the artist a great deal of pleasure and pride in her achievements.

Plants

My data on the drawing of flowers and trees are less detailed than those on humans and animals. Because these were assigned tasks, it is possible that our children were less challenged by these objects and responded in a somewhat minimal fashion. These data ought to be supplemented by drawings made spontaneously, at the child's own initiative. Recognizing the limitations of my present set of drawings, I shall briefly review the findings.

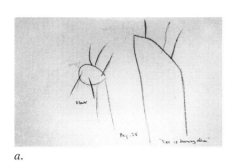
a.

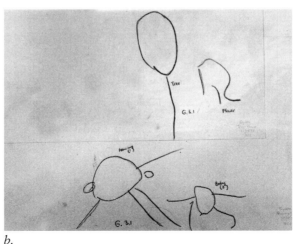
b.

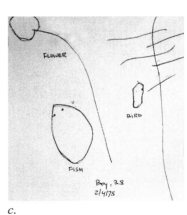
c.

72. *Early Graphic Models of Flowers and Trees*
a–c. Artist ages 3;1 to 3;8.

Similar to the graphic origins of humans and animals, the first representations of flowers and trees are also circular shapes. Approximately 40 percent of our three-year-olds could be induced to draw a flower and a tree. Among them we find children who draw the flower as a simple circle, a circle floating above a vertically drawn stem, or a stem that ends in the radial pattern of a circle with lines or loops (see ills. 72 *a, b, c*). By ages four to five years, almost all the children draw the flower as a circle and attach it to its stem. The circle either remains bare or is elaborated into a radial pattern; leaves are drawn infrequently. At this elementary level of depiction, the drawings represent a flower in the simplest possible manner. Considerable refinement can be seen in the drawings of five-to-seven-year-olds who develop more detailed depictions, most commonly variations on the radial pattern. These youngsters tend to mark the center of the flower and to enrich the stem with leaves. The stem also begins to curve (see ills. 73 *a–d*).

Trees undergo a similar process of differentiation. Three-year-olds tend to employ circular shapes either with or without a trunk. The circular crown of the tree can vary in size from tiny to large; it may appear as a radial pattern reminiscent of the flower or as a mere scribble-pattern. At this early stage, almost all the tree-trunks are drawn as one-dimensional vertical lines. In the drawings of the four-to-five-year-olds, two-dimensional trunks become more numerous; the crown or foliage of the tree continues to be represented by a circle. Other competing models, however, are not lacking, and some children adopt right-angular patterns with horizontal lines drawn either above the trunk or emanating from it. Altogether, the tree models of three-to-five-year-olds are sparse and lack detail. Rarely does a drawing indicate the existence of branches, twigs, or leaves. By ages five to seven years, the two-dimensional trunk has become the standard model. No longer is the crown drawn as a simple circle; its contour assumes an undulating pattern whose dimensions tend to be wider than the tree trunk. In some of the drawings we now discover branches, apples, and roots; increasingly, the trunk tends to be shaded and a darkened circle in its center suggests a hole, perhaps the

73. *Flowers and Trees*
a–d. Artist ages: 4;4 to 5;10.

a.

b.

c.

d.

home of an animal or the place where a branch has been cut off. By virtue of the solidity of the trunk, the shape of the crown, and its very size, the tree drawing has become clearly differentiated from the flower (see ills. 73 *a–d*).

Houses and Cars

Houses and cars only slowly outgrow their circular beginnings as the child struggles to capture the angular contours of man-made objects. Even at ages four to five years, approximately one half of the houses display a circular shape; the remaining ones attain squarish, rectangular, or triangular outlines. Very little detail is included in these early house drawings, which are mostly composed of closed contours, two-dimensional windows, and a door. By ages five to seven years, all houses attain angular shapes consisting of a squarish or rectangular base and a triangular roof. Houses are drawn in a predominantly frontal view, within a strictly right-angular directional framework, and now include numerous windows, the standard door, a chimney, and occasionally, an attic louver, TV antenna, and door steps.

Cars undergo similar transformations from circular to more squarish forms; as wheels make their appearance, the bottom part of the car is often left "open," a graphic model reminiscent of the open-trunk-human (see ills. 74 *a–d* and 75 *a, b, c*). By ages five to seven years, cars more closely resemble their referents and we notice greater attention to such details as windows, doors, drivers, hub-caps, fenders, lights and light-beams, exhaust fumes, radio antennas, and wipers.

a.

c.

b.

d.

Cars are drawn from a side view, and most commonly depict only two wheels (see ills. 75 *d, e, f*). For a detailed and longitudinally based account of the drawings of cars, see Eytan's drawings in chapter 7.

Although I have used approximate age ranges as a convenient device for describing developmental patterns, the data indicate considerable variation in graphic skills, and accomplishments on specific themes vary tremendously. Ages are not to be taken as milestones of graphic achievements because the variability within an age group frequently exceeds that between older and younger children. More significant than age per se are the developmental patterns and the order in which they tend to arise. They offer an account of children's repeated trials to invent graphically satisfying models.

So far I have discussed the growth of form in drawings that clearly refer to a real-life context. Whether or not we value the early graphic efforts, the child's drawings of humans, animals, plants, and man-made objects are representational in their intent to capture an aspect of the real world. I shall now, briefly, consider the designs children make and their role for graphic development.

74. *Early Models of Cars and Houses*
The early and undifferentiated drawings elicit many interpretive comments:
a. "The house has wings; it's a car with feet."
b. "It's a bulldozer with a flat tire."
c. "House with antenna."
d. "Fire—it's a fire car.
Artist ages: 3;3 to 4;9.

75. *Experimentation with Models of Cars and Houses*
In the early models, cars and houses are often left "open."
a–f. Artist ages: 5;4 to 5;10.

a.

b.

c.

d.

e.

f.

Abstract Designs

Some authors have attributed great significance to the child's geometric and abstract designs, and have deplored their decline during the childhood years as the pressure to draw recognizable figures increases. Rhoda Kellogg (1969) adopts an extreme position in her thesis that all representational drawings derive from earlier, nonpictorial patterns. According to Kellogg, child art develops from nonpictorial designs, unaffected by the visual attributes of the object. Shapes are developed for their own sake, for the intrinsic interest they hold and the pleasure their balance creates. It is only later, between the ages of four to five years, that shapes in their various combinations can also

be used to depict objects. Even then, according to Kellogg, shapes have no intrinsic connection with the object they stand for, and when the child makes his first "pictorial"—a human—this figure is not based on observation of the object but is strictly a derivative from earlier patterns. The value of nonpictorial exploration of the medium has also been espoused by Malka Haas (1984, 1998, 2003), an early childhood educator who specializes in child art. She attributes great importance to the line patterns practiced by preschoolers, and encourages their continued exploration even after the child has discovered the representational possibilities of the medium and has become fascinated with his newly won powers to draw meaningful shapes.

Since children's graphic explorations occur within the social setting of the family, the child-care center, or the school, the frequency of pure design often depends on the taste of the adult who provides the material and encourages drawing or painting activity. In settings where easels, large sheets of paper, brushes, and tempera paints are available, this medium lends itself particularly well to sweeping arm movements that yield colorful patterns. Such pattern-making requires less planning and fine visual-motor control than a representational theme. Exploring the somewhat unexpected effects of strokes and dabs with thick brushes while using different paints can be a fun activity, and to the extent that it is actively valued and encouraged, one may find children who "specialize" in designs. A study by Judith Helmund (1987) reveals the fascination of kindergarteners with the unexpected outcomes of using paints, brushes, and "folding" techniques. She reports on the sensuous delight children display when using these materials. Interestingly, while many seem to prefer easel painting to drawing with crayons, it is the latter they use for representational purposes.

In my own studies, I have found little evidence of an early prevalence of deliberate design-making. Usually, before assigning a task, I ask children for one or two "free" drawings: "Please, draw anything you like" (Golomb, 1981). In response to such a request, children up to the age of four years either scribble, or more commonly, make an attempt to draw a representational figure. It is only among those four-year-olds who already draw distinctly representational figures that I also find designs—approximately in 30 percent of the drawings. The designs are quite simple in their construction and the child, far from being content with her abstractions, tends to interpret them and to assign meaning to the configuration (see ills. 76 *a–d*). For the five-to-seven-year-olds of my studies, designs seem to hold less attraction, and their incidence declines to a mere 10 percent of all the free drawings. These findings suggest that the desire to make designs, and to create purely decorative effects independent of meaning, emerges concurrently with the ability to represent objects. My data, however, are inconclusive and may not reflect the spontaneous activity, of the child who, left to his own devices, selects the medium, determines the activity, and chooses a theme. Longitudinal studies reveal significant individual differences in motivation and talent; the creation of decorative designs and the desire to embed figures in a richly decorated

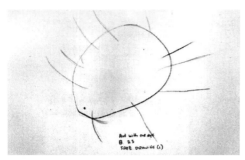

a.

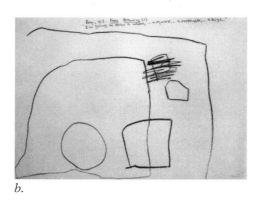

b.

c.

d.

76. *Designs*
Children tend to interpret their designs and to assign "meaning" to seemingly abstract configurations.
a. Boy, 3;3. "Ant with one eye."
b. Boy, 4;2. I'm going to draw a wheel, . . . a square, . . . a rectangle, . . . a big L."
c. Boy, 3;8. "Sea—where the fish, crabs, and lobsters live."
d. Girl, 4;4. "I think it's a machine."

frame or background can play a central role in the drawings and paintings of highly motivated, talented children. The love of designs most often finds expression in colorful ornamentation that balances figural and decorative trends (see chapter 7).

I have described the evolution of graphic models and the child's growing ability to differentiate form, the direction of line, and the size, proportion, and orientation of the figure. His effort to create a better resemblance between his figures and their referents indicates an increasingly self-reflective mental activity, an awareness that modifications are possible, desirable, and to be accomplished within the graphic domain. The child begins to understand that the picture has to make its own statement quite independent of verbal and gestural supplements, and that there are graphic means that can accomplish this aim. The child who understands the necessity of making the drawing speak for itself has come a long way from the early actions-on-the-medium that could not, on their own, sustain a meaningful message. The role of verbalization changes radically as graphic competence makes romancing, reading-off, and verbal designation superfluous devices, to be replaced by self-instruction that guides the execution of a drawing plan (Golomb, 1974, 1977, 2002). Verbalization can now play a role in monitoring the activity, reviewing the action in progress, and making desired corrections. It may also find its way into a drawing in the form of a written exclamation or a dialogue between partners.

I have come to the end of my account of the graphic differentiation of early models of humans and animals, and my more limited review of the graphic differentiation of plants, houses, and cars. I have dealt in much detail with the differentiation of form and considered such aspects as the direction and dimensionality of line, the orientation of the figure at rest and in motion, and the manner in which figural units are created and combined. Questions that concern the specific problem of the third dimension of objects in space and the use of color will be taken up in subsequent chapters.

My exposition of the course drawing development takes has been guided by Arnheim's conception of differentiation. Arnheim describes this process as a lawful mental activity that reflects in all its phases the level of visual thinking reached by the individual who grapples with the task to represent on a flat, two-dimensional surface, with mere pencils, markers, and brushes, a complex three-dimensional object extended in space. It is a journey of discovery, of learning a language that is unique to the two-dimensional medium, and it involves a progression from simple to complex solutions, all of which are based on visual thinking. The law of differentiation presents us with a very general formulation of the course development takes; it provides a conceptual framework within which to view children's changing graphic formulas. As a general law that aspires to universal status, it does not specify a timetable or approximate ages for certain achievements. It does not address the role of intelligence, talent, motivation, practice, instruction, and the provision of graphic models. It does not predict whether and to what extent *décalage* across subject matter—that is, uneven levels or degrees of differentiation across subject matter—is to be expected, and when and how the desire to restructure an existing graphic model might occur. Perhaps the law of differentiation might lead us to underestimate the impact of the object on graphic experimentation. Its formulation tends to stress intrinsic aspects of growth rather than extrinsic ones such as imitation; its conception of development as an autonomous process is more partial to the unfolding of natural capacities than to their training. Such a view of development in the artistic domain was first forcefully stated by Gustaf Britsch (1926); it became a major focus for Schaefer-Simmern's theory of artistic development and has been further articulated by Arnheim. His statement, "Any shape will remain as undifferentiated as the draftsman's conception of his global object permits," (1974, p. 181) places the process of unfolding within a more dynamic relationship, in which the nature of the object as conceived by the draftsman co-determines the graphic effort. Arnheim's theory really postulates two forces: an internal one that strives toward simplicity, and an external one where the object makes its own demands on the nature of the representation. At an early level of development, abstraction or simple, generalized forms are the only option available to the inexperienced artist, the true starting point for representational development. This kind of abstraction ought not to be mistaken for the adult artist's deliberate choice to return to the simple forms of childhood.

A theory that stresses intrinsic factors in development must demonstrate that the process is not an arbitrary one and that it follows a universally valid, relatively invariant pattern across different cultures and historical periods. The underlying logic of the development of drawing must outweigh cultural and social conventions, at least in its early phases. The early global models must always precede more differentiated ones, and the visual logic that determines the drawing of a particular subject is likely to determine the graphic model of other subjects. In such a conception of development, cultural factors in the form of available models and directed training, will play a relatively minor role in the early years.

To what extent can I say that my data and their analysis support this view of differentiation over the course of early development in drawing? My findings document the orderly, almost invariant sequences in the evolution of graphic models and their transformation over time. The kind of restructuring in the graphic models that occurs time and again indicates an intrinsic lawfulness that is above and beyond the impact of conventional graphic illustrations. If the illustrations were a major factor in development, they would lead to a less orderly progression and more arbitrary deviations from its course. This is not to belittle the impact of peers, of practice, of exposure to interesting and understandable graphic models, or the role of individual differences; most likely such influences have been minimized by theorists who adhere to a somewhat doctrinaire stage conception of drawing development. Also, we find considerable *décalage* or discrepancy in the drawing of different objects by the same child, which suggests that practice and motivation to master a subject are important determinants. In chapters 7 and 10, I shall examine more closely the role of talent and the impact of cultural variables on drawing development.

To what extent are the earlier drawings more symbolic than the detailed and more realistic drawings of a later period? Many authors have described the early graphic models as "symbolic" in their seeming indifference to realism (Barrett & Light, 1976; Burt, 1921; Selfe, 1983; Sully, 1901, 1910). However, such a distinction ignores the very essence of representation; namely, that all drawings, regardless of style and sophistication, are equivalents for the real object they signify, and in this sense are symbolic. Even a perspectively organized drawing is an equivalent for an aspect of the world, a portrayal and not a replica of the three-dimensional object in all its complexity. The progression from a global to a differentiated figure reflects the child's changing conceptions, skills, and knowledge of the constraints and possibilities of the medium. It is neither more nor less symbolic in the sense that lines and forms point beyond themselves in their intent to represent our experience. In psychoanalytic theory, the term symbolism carries additional meaning that is linked, quite systematically, to unconscious and repressed psychic contents. Although the investigation of such symbolic meanings in the arts is a legitimate enterprise, it does not address the distinctions previously discussed. I shall return to the issue of symbolism as metaphor and unconscious meanings in

chapters 5 and 8, which deal with the expression of feelings and the drawings of emotionally disturbed children.

My studies of the development of animate and inanimate models has highlighted the importance children attribute from an early age to "likeness" in their drawings. It is the urge to capture the characteristics of the object and to eliminate the ambiguities of his global figures that propels the child to search for better means and leads to graphic differentiation. The child's major concern is to create a visual likeness to the object, and he measures his success and failure accordingly. It is this symbolizing tendency that establishes a graphic order, that fosters articulation, and governs the process of differentiation.

What, perhaps, has not sufficiently been spelled out is the dialectic of the drawn model and the real object, the child's desire to come closer to the object's individuality and to find a personal voice. When the child moves beyond the general forms of the early trials to more differentiated and specific ones, she creates forms that are more personal statements about herself as well as the object. If we see the process of graphic differentiation only in terms of an "unfolding" of preordained graphic shapes, as if forms existed independent of the objects they refer to, we overlook the child's overriding concern "to make it look like." The latter can be achieved in diverse ways, but the desire or motive indicates the intimate relation between graphic forms and their referents.

As my studies indicate, the evolution of representational forms cannot be fully explained by reference to earlier practiced nonpictorial forms and subroutines, as Kellogg would have us believe; it is more than the sum of graphic exercises. As I have shown, it is the object and its visual attributes that co-determines the graphic organization and the choice of forms. This process does not automatically lead to realism. One can see clearly that forms are used economically, that the tendency toward simplicity predominates for a long time. But the urge to represent has a referent out there in the real world, and it guides the process of differentiation to an important degree. The solutions to the problem the child faces are worked out quite autonomously, determined by the nature of the medium, the simple visual logic that guides the child's explorations, and the dialogue that ensues between the child's drawing and his satisfaction with the outcome. I would like to suggest that the child's drawing is determined by his search for meaning and likeness, but that it is also constrained by his experience with the medium, by his interest, motivation, attention span, ability to monitor his actions, and the willingness to revise his work.

We have witnessed in the drawings of young children a highly sophisticated process marked by a spontaneous awareness of equivalences between graphic forms and real objects, and it is in this sense that I define drawing as a symbolic activity. It is this symbol-making propensity that is uniquely human that enables the child to leave a record of his mental activity and to go beyond reality as immediate experience.

4 Space: In Search of the Missing Dimension

Drawing or painting creates pictorial space. At a very elementary level every drawn shape can be seen as a figure that is distinct from its background and tends to protrude from the picture plane, while the ground appears to extend behind it. Thus, by virtue of drawing a contour the child also creates pictorial space. True, the figure-ground constellation can be said to yield pictorial space in only an elementary and undifferentiated sense. Drawing a figure that stands out from its background does not yet address the essentially intractable problem of representing on a flat, two-dimensional surface a solid object extended in three-dimensional space.

Our real-life experience is dominated by the force of gravity, which provides us with a stable, largely horizontal surface from which we explore our spatial world. As actors and observers our primary orientation is determined by our vertical uprightness in relation to the horizontally extended ground. Our immediate experience includes space that surrounds us, that extends above and below the bodily self, that can be navigated in up, down, front, rear, and lateral directions. During his second and third year of life, the toddler attains a basic understanding of spatial relations, including those that refer to objects hidden from view—for example, items placed inside a container or underneath another object (Bower, 1974; Piaget, 1954).

Unlike physical space, the domain of pictorial representation consists of only two dimensions, which precludes a veridical solution to the problem of the missing dimension. The only recourse is to create the illusion of volume and depth. Graphic illusions are not arbitrary inventions; they can be described in terms of the geometry of the projection of light rays onto a flat, two-dimensional surface (Dubery & Willats, 1983). As inventions, they vary considerably in sophistication, aesthetic quality, and in the power to convey meaning. The history of art reveals a variety of projective systems that reflect the conceptions and the needs of artists living in a specific era. A review of the different graphic solutions that have served artists in their varied pursuits suggests that there are no absolute advantages to be found in any one

specific spatial-pictorial system (Arnheim, 1974, 1986, 1988; Bunim, 1940; Dubery & Willats, 1983; Gombrich, 1960; Hagen, 1986; White, 1967). With this caveat in mind, we now turn to a brief description of developmental findings.

With the discovery of the figure-ground relationship in drawing, the child quickly expands her newly won insight and creates multiple figures that are dispersed across the page. So long as figures merely declare their individual existence, orientation per se is an irrelevant attribute, and almost any place on the page will do. At first, the location of figures indicates a disregard for the vertical and horizontal directions of the paper, however, it reveals a principle that, at least implicitly, seems to guide the child's effort to safeguard the integrity of each figure so that it can emerge clearly from its own background, unimpeded by other figures that might compete for the same space. The dispersal indicates an intention to separate figures from each other, and several authors have drawn attention to this early spatial principle that avoids invasion of one figure by another. Considering the young child's primitive graphic means, it is this principle of separation that indicates respect for boundaries and facilitates the recognition of the figure and the meaning it is intended to convey (Goodnow, 1977; Schaefer-Simmern, 1948).

The arbitrary dispersal of figures and other items across the page quickly gives way to an effort to draw them in close proximity to each other. Nearness or proximity provides the most primitive connection in the pictorial plane. With the addition of a directional rule that yields a side-by-side arrangement of figures, we observe an ordering principle that privileges the horizontal direction. At first, horizontal alignments of items can occur anywhere—for example, figures may be aligned with the top edge of the page, floating in an undefined space. Regardless of the particular location on the page, figures tend to be placed in a side-by-side arrangement with little attention to the size of individual figures (see ills. 77 a–d). The child's own orientation vis à vis the paper can play a role in the alignment of the figures, and if his orientation is not perpendicular to the edges of the paper, the figures may appear to be diagonally aligned across one corner of the page (see ills. 78). Eventually, horizontal alignments across the middle of the page or along its bottom edge begin to predominate, with thematic variables affecting the choice of location on the horizontal axis. At first, mere ordering of figures next to each other disregards the space that surrounds them, but the experience of drawing different themes encourages some degree of spatial differentiation. When a theme calls for the drawing of a family, figures tend to be aligned across the center of the page within approximately one third of the central section; in outdoors scenes figures are likely to be aligned in the bottom sector of the page. The tendency to identify the lower part of the page as the ground on which objects stand or from whence they emerge reflects a growing respect for the principle of gravity that binds objects to their ground and leads to the invention of a standline. To the extent that figures descend to the bottom part of the page, the upper part is identified as air or sky, and the vertical dimension of up

a.

b.

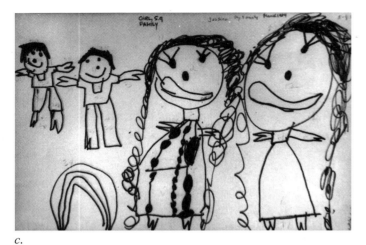

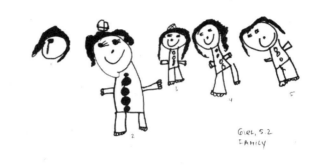

c.

d.

77. *Side-by-Side Arrangements of Figures Along a Horizontal Axis*
a. Boy, 4;5.
b. Girl, 4;1.
c. Girl, 5;9.
d. Girl, 5;2.

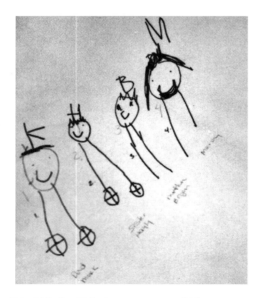

78. *Side-by-Side Arrangement of Figures Along a Diagonal Axis*
Girl, 5;1.

and down, of ground and sky, becomes specified. Concurrently with this spatial differentiation, side-by-side arrangements come to stand for left–right directions (see ills. 79 *a, b* and 49*b*). Thus, the vertical and horizontal axes of the page can now be used to specify two directions of space. When the child wishes to portray a more complex theme that cannot be compressed into a single horizontal groundline, a second groundline may be introduced, or even a third one. This procedure of multiplying baselines to accommodate a variety of figures (which can also be seen in Egyptian or early Chinese art) does not yet indicate distance or an intention to depict near and far objects, but it highlights the spatial problem graphic artists face when they wish to portray depth as well as height. For a time, the vertical axis of the page serves in a somewhat indiscriminate manner the dual function of representing the up–down as well as the near–far dimension. The child, as all artists, faces the difficult task to differentiate between near and far objects, between the ground common to all objects and the sky that extends above them. More specifically, the child must solve spatial problems that involve the relations within a single figure, those among several figures and, finally, the complex relations between multiple figures and the total available space.

We have seen that the earliest discoveries concern the segregation of the figure from its background and its emergence as a distinct entity that unilaterally appropriates the contour. The unique figure-contour relationship that differentiates between an object and empty

a.

b.

79. *Side-by-Side Arrangements Come to Stand for Left-Right Directions*
a. First grader.
b. Third grader.

space can be seen most clearly in the case of certain ambiguous, reversible patterns that can yield two different, mutually exclusive figural organizations (see ills. 80). At first, the child's drawings exhibit very clearly the two-dimensional character of the graphic medium; that is, the near-flatness of the figures. Since the many-sidedness of objects in reality presents a formidable problem of translation into the two-dimensional medium, graphic representation necessitates a selection among possible views and aspects of the object. In the previous chapter I discussed an early preference for canonical orientations that provide information that is most characteristic of and congruent with the nature of the object. I shall now explore a number of drawing systems that children seem to construct as they struggle with the limitations of the graphic medium. A detailed account of graphic inventions using line drawings of right angular man-made objects has been formulated by John Willats (1977, 1981, 1985, 1997).

Drawing Systems

In his first study, Willats explored how children and adolescents draw a rectangular table on which three items, a radio, a box, and a saucepan, are displayed. The spatial arrangement of the four objects includes side-by-side as well as in front–behind relations. In this display, the box is partially hidden—that is, occluded by the radio—while all three objects occlude sections of the far edge of the table (see ills. 81 *a*). Analyses of the drawings reveal a number of distinctive solutions to the problem of representing a three-dimensional table on a two-dimensional surface. Among the youngest children, ages five to seven years, the predominant tendency is to arrange the items separately, without indicating a specific relationship to the table, which creates an appearance of objects floating in space. According to Willats, drawings of this type depict the items as a random collection that does not relate objects to each other (ills. 81 *b*).

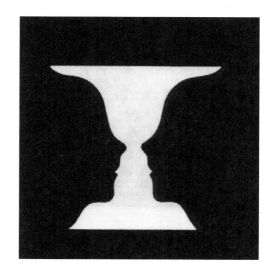

80. *Edgar Rubin's Reversible Figure*
It can be seen as a pair of faces or a vase.

81. *Willats' Classification of Drawing Systems* (Courtesy John Willats, *Quarterly Journal of Experimental Psychology,* 1977).

a. Correct perspective of table with three items: a box, a radio, and a saucepan. The items overlap with the table top and with each other.

b. Table top is drawn as a rectangle; the three items are drawn separately, floating above the table top.

c. Table is drawn in orthographic projection. A single face, the edge of the table, is represented. It serves as the base for the three items that are drawn without any overlap.

d. Table is drawn in vertical oblique projection with parallel horizontal and vertical lines. Two faces are depicted: the frontal edge and the table top.

e. Parallel oblique lines depict three sides of the table, which is drawn as a parallelogram; the front, side and top faces are shown.

f–g. Table is drawn in perspective. Willats defines as "naive" perspective a drawing in which the lines that represent the side edges of the table converge only slightly. When the angle of convergence corresponds more closely to the optical projection of the scene, the drawing approaches true perspective.

The use of a simple but coherent drawing system emerges next. The plane surface of the tabletop is depicted as a single line, viewed as it were from an eye-level position without any reference to the side edges of the table. Thus, only a single face or aspect of the object is depicted. Despite this obvious limitation, the relationship between the various items and the table top is clearly represented. Because these drawings represent the object in the frontal parallel plane, this drawing system is defined as *orthographic projection.* It represents the true horizontal and vertical directions of the display. This kind of drawing portrays a single face of the object that serves quite successfully as a base for several items; the individual items are portrayed without any overlap of lines. This drawing system, which ignores the horizontal extension into depth of a real tabletop, emerges as the most common graphic solution for elementary-school children, ages 7 to 12 years (see ills. 81 *c*).

A more advanced solution which depicts the edges that extend into the third dimension, can be seen in drawings that utilize the vertical direction for this purpose. The tabletop is drawn with a series of parallel lines, and the verticals in the picture come to represent the horizontal surface of the table. This system depicts two faces of the object; the frontal edge of the table and its top. The two faces are, as it were, conjoined into one rectangular unit that permits some degree of

differentiation between the near and the far side of the surface of the table. Willats defines this drawing system as *vertical oblique projection*, and the largest number of drawings in his collection comprise this category, which is most frequently employed by 12-to-13-year-olds (see ills. 81 *d*). Despite the advantage of depicting the tabletop as an area, it retains a high degree of ambiguity because it uses vertical lines to indicate a horizontal surface and fails to differentiate between elevation and depth. Only a minority of youngsters resolve this ambiguity when they discover that slanting lines can be used to indicate the third dimension (see ills. 81*e*). The advantage of using parallel oblique lines lies in their power to depict three sides or faces of a rectangular object—in this case, the front, side, and top faces of the table. When children adopt this type of solution, and it is by no means a universal strategy, it appears among the 13-to-14-year-olds in Willats' sample. In this drawing system, parallel edges of the objects are shown as parallel lines in the drawing that, despite the deviation from the true rectangular shape imposed by the tilting lines, creates a convincing solution. Finally, a minority of youngsters employ converging lines that characterize the *perspective projection* system (see ills. 81 *f* and *g*). Even if one includes what Willats terms "naive" perspective, which refers to minimally converging lines in his classification of perspective drawing, fewer than half of his 14-year-olds produce such drawings, and only a very small number of subjects draw the tabletop in approximately correct perspective, using angles of convergence that correspond to the optical projection of the scene. Altogether, the data from this study reveal that, in this sample, oblique and perspective drawings appear at similar ages, which suggests that these graphic solutions might be viewed as alternative rather than successive systems.

Willats' data on overlap—that is, the superposition of one part on another one—suggest a more continuous progression in the use of this graphic device to depict the "in front of" or "behind" relationship of the objects in this display, although the gradual increase in the use of overlap may also have been a function of the manner of scoring (Willats, 1985). In this study, overlap is rarely used before the age of nine years. From nine years on, there is a steady increase in the use of this technique, which levels off at the age of 14. It is noteworthy that even among the oldest participants in this study, ages 15 through 17, only a few depict all of the six possible points of overlap presented in the display of objects (see ills. 81 *a*). Willats did not detect a consistent relationship between a particular drawing system and the degree of overlap in a drawing, a finding that suggests that these are two independent representational problems.

Willats' account of the development of drawing systems highlights the somewhat discontinuous nature of the graphic solutions and supports the view that the early inventions are largely self-taught. Drawing systems seem to be discarded as the child's dissatisfaction with a particular model demands a more complex depiction. As Willats points out, the early systems do not imitate the depictions children see in photographs or book illustrations, and thus the culture seems

a.

b.

c.

82. *Representation of a Table Top and Cube* (Courtesy Rudolf Arnheim, *Art and Visual Perception*, 1974)
a. The table top is drawn in its true shape.
b. The table top is drawn with converging lines that represent the depth dimension but distorts its true shape.
c. A preferred drawing of a cube which cannot be derived from the retinal projection.

to exert little influence on the adoption of the first projection systems. Moreover, the oblique systems tend to deviate from the optical array given under ordinary viewing conditions, a finding that underlines the constructive character of these inventions. Like Arnheim, Willats refers to the reluctance with which children relinquish the representation of true shape—in this case, the rectangular shape of the table. The oblique lines eliminate the ambiguity of verticals that stand for both vertical relations and the depth dimension in the real world, but at the price of distorting the true shape of the tabletop, representing it as a parallelogram—and in the case of converging lines, as a crooked trapezoid (ills. 82 *a, b*; Arnheim, 1974, p. 114). To employ distortion of shape for the purpose of creating a more realistic-looking three-dimensional form is counterintuitive and requires a major revision of the child's representational concepts. However, what appears as true shape, as a preferred representation of a solid object, is not a simple function of the retinal projection. Arnheim's drawing of a square and two parallelograms (ills. 82 *c*; Arnheim, 1974, p. 267) creates a most convincing representation of a cube, even though the figure cannot be derived from the optical image of a cube nor can a camera produce it. The demonstration that preferred representations are not simply derived from the retinal image reminds us of the transitory nature of the image, which is not consistent with the visual concepts we construct from our constantly changing viewing positions of the object. According to Arnheim, "views" are counterintuitive in that they create contours where none exist in the object, and occlude some parts of the surface while displaying others. His figure of a cube is such a satisfying representation because it captures the cube's right-angular property. This attribute reflects its internal stability as well as its firm relationship with the horizontal–vertical axes of the page; the symmetry of the parallel oblique lines suggest depth with a minimum of distortion that does not disturb the figure's balanced structure.

In a further effort to validate his account of the development of drawing systems, Willats constructed a group of rectangular objects that includes, among others, an intact cube and a cube that had a section in the form of a smaller cube removed from one corner. The youngest children, between the ages of four and seven years, tend to draw the object as a closed, usually circular shape that represents the total volume of the object. Such a drawing does not single out a specific aspect or view. Willats concurs with Piaget's notion that such drawings are best characterized as topological and fall outside the projective geometry system. In topological geometry, the shape and size of an object are irrelevant attributes, subordinate to such properties as openness or closedness, and the object is considered independent of viewpoint (Piaget & Inhelder, 1956). At the next stage, children draw a square that stands for a single, though typical, face of the cubic object. This is followed by a drawing that represents the multiple aspects of the cube in a fold-out fashion, its faces aligned both vertically and horizontally. Progress in representing a cube yields a vertically aligned figure comprised of two faces. At approximately the age of 12 years, children tend to acquire the use of slanting lines to depict

depth, which yields a drawing that displays three distinct faces of the cube. Willats' description suggests that the acquisition of oblique lines, which follows the discovery that one may use different representational techniques in orthogonal planes, constitutes a major advance and that perspective is perhaps subordinate to the class of oblique-line drawings.

These findings provide only partial validation for Willats' attempt to describe the drawings in terms of geometric constructs. They affirm, once again, that the use of oblique lines to render the three-dimensional quality of objects is a relatively late achievement, most likely subject to cultural influences. In terms of the relative paucity of perspective drawings, these findings are quite congruent with earlier studies by Georg Kerschensteiner in Munich (1905) and Thomas Munro, Betty Lark-Horowitz, and E. N. Barnhart at the Cleveland Museum of Art (1942), which reported a low incidence of perspective drawings for 14-to-15-year-olds. Thus, perspective drawings do not appear to present a "natural" endpoint of development even in our Western culture, which is inundated with photographic images, and few adolescents attain this skill without explicit training or copying of models (Cox, 1992, 1993; Golomb, 1992b, 2002; Pariser, 1995b; Thomas & Silk, 1990; van Sommers, 1995).

On closer analysis of the data, Willats acknowledges the limitations inherent in a taxonomy based exclusively on projective geometry. The earliest stage described in terms of topological representation of the object does not fit into a system of projective geometry, and such intermediate steps as the fold-out procedure of multiple faces also fall outside this system. Furthermore, animate figures, best exemplified by humans, call for a different analysis because they do not display the sharp edges and directional discontinuities of man-made objects. When we inspect children's drawings of the human figure, the limitations of an approach based exclusively in projective geometry become quite apparent. Such considerations have convinced Willats of the need to specify the denotational aspects of the child's graphic vocabulary, and his analysis of the lines children draw represents an effort to formulate a comprehensive set of descriptive rules (Willats, 1981, 1985, 1997).

The denotational system can be applied to the child's first explorations of the medium when she discovers that contours, or in Willats' terminology, "regions," can stand for volumes; that is, for the whole object. Somewhat later regions become more restricted in their denotational value and represent the "faces" of an object. A more advanced level of representational effectiveness is reached when one-dimensional lines come to represent edges and contours of an object, with some children acquiring the ability to use T-junctions to denote points of occlusion and end-junctions to denote points at which contours end on the surface of smooth forms. These advanced achievements represent the youngster's learning of new pictorial techniques. In this account, the child gradually constructs a denotational system of dots, lines, and faces, and develops a system where graphic elements specify the dimensional properties of an object. From this position, development is

seen in terms of an increase in the number of units that are differentiated, that is, specifiable and thus informative. Willats considers the developmental progression as a problem-solving activity, with the more advanced denotational rules yielding more effective representations that overcome the ambiguity of the earlier systems. The desire for effectiveness becomes the prime motivator for drawing development. (For a more detailed account of Willats' theory, see Golomb, 2002, and Willats, 1997.)

In summary, these findings suggest that it is the quest for a meaningful representation that determines the early drawing efforts and not the desire to capture retinally accurate but transitory images—a position that is based on a by-now outdated theory of visual perception. The child invents increasingly more powerful and informative equivalents; she develops a rule system that specifies the spatial framework in terms of horizontal and vertical coordinates on which, somewhat later, the oblique or diagonals are superimposed. With the discovery of slanting lines, the child has broadened the spatial framework so that it can also represent the missing depth dimension. However impressive the spatial-representational systems are that some children and adolescents invent, we ought to keep in mind that only few individuals reach the stage of oblique or perspective representations on their own—that is, without instruction—and this finding is quite remarkable given the rich pictorial environment of our contemporary culture.

Willats' account of the development of drawing systems embraces a cognitive view of drawing. He considers the various spatial solutions as serious efforts to solve a difficult problem. According to Willats, the nature of the task dictates the type of system children invent—their attempts are not arbitrary or unreasonable ones. When the tension between production and evaluation rises, old systems are discarded and more sophisticated drawing solutions are tried out. The earliest drawing systems reflect this problem-solving process best because they are autonomous constructions arrived at independently. The later ones, best subsumed under the category of oblique systems, are most likely derived from models exhibited in the pictorial environment of a given culture (see chapters 7 and 10).

Piaget's Account of Drawing Development

How well does Willats' suggested sequence of stages in the development of drawing systems fit a psychological account of cognitive development? The most ambitious and comprehensive analysis of cognitive development has been formulated by Piaget and his colleagues (Inhelder & Piaget, 1964; Piaget, 1950; Piaget & Inhelder, 1956, 1971; Piaget, Inhelder & Szeminska, 1960). Piaget considers the development of drawing as a specific manifestation of the child's conception of space, and his analysis is designed to document a close linkage between spatial concepts and the ability to represent them in drawing. He deals with the representation of space as a single domain where,

for example, drawing, copying, ordering a series of discrete items, and mathematical reasoning are closely related to a common cognitive structure. Piaget locates the developmental progression of drawing within a clearly delineated time span. Its beginning can be traced to the prelogical period of early symbolic thought, while its end-point is "realism" or drawing in perspective.

The first stage in the representation of space, according to Piaget, reflects only a concern with the general property of "boundaries" and ignores the size and shape of objects. Accordingly, the first general quality to be represented in drawing is the closed shape. At the most elementary level, the rules of *proximity* and *separation* of elements yield figure-ground relations, best exemplified in the form of a closed circle. At this stage the child cannot yet draw or copy a square or a triangle. The rounded shapes drawn by three- and four-year-olds are based on the topological relations of proximity and separation from which the quality of openness and closure is derived. With the addition of a principle of *order*, some degree of spatial succession and symmetry is attained and parts are arranged sequentially, as illustrated in the orderly depiction of facial features (see ills. 14 *b*). The rule of *enclosure* further differentiates between the inside and the outside of the figure; for example, eyes are drawn on the inside of the contour and ears on the outside of the boundary (ills. 16 *c*). The last principle to complete this stage of development is that of *continuity*. This principle insures that body parts are attached (ills. 42 *a*).

Of these relationships, proximity is the most primitive one because it does not imply any ordering of parts. When proximities become ordered, they are at first quite imprecise—as demonstrated in the "wrong" attachment of arms to the head (ills. 83 *a*). Ordering requires an act of mental representation, and during the first stage, approximately ages three and four years, the child's limited analysis of the elements that constitute a figure and his equally poor attempts to synthesize them yield "defective" representations that Piaget, following Luquet (1913, 1927), labels *synthetic incapacity*. It is a representation of space that is ignorant of Euclidean relations of proportion, length, distance, and shape, and unconcerned with the projective relations of perspective.

The next stage, which extends between ages four to seven or eight years, is characterized by Piaget as *intellectual realism*. The child includes more details in his drawings and the internal ordering of parts is much improved. However, topological principles still predominate in the child's representation of complex objects; a human or an animal may be drawn without much concern for the object's true shape, size, and proportion (see ills. 83 *b, c*). In the case of simple shapes Piaget observes the emergence of Euclidean and projective relations—for example, in the copying of a square at four years, a triangle at five years, a diamond at the age of six or seven years. The drawings begin to employ straight lines and angles, as in the drawing of a house with a roof. Although circles, squares, rectangles, and triangles are now clearly differentiated, they are only crude approximations of the model because they ignore its exact measurement and proportion.

a.

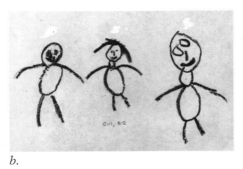

b.

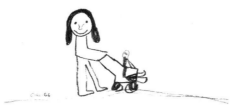

c.

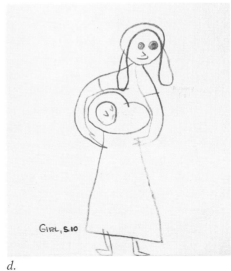

d.

83. *Piaget's Stages of Drawing Development*
Stage 1 is characterized by topological relations of proximity and separation, of order, enclosure, and continuity (see 14 *b*, 16 *c*, 42 *a*).
Stage 2 is defined by *synthetic incapacity* (see 83 *a*).
Stage 3 represents *intellectual realism* (see 83 *b, c*).
Stage 4 achieves *visual realism* by considering the viewpoint of the observer (see 83 *d*).

According to Piaget, the object is still "distorted" in the drawing, and the child's representation of space reflects only a primitive level of understanding, a concern with relations that are merely *internal* to a figure—for example, the correct attachment of arms to the body of the drawn person. At this stage, only a limited form of correspondence exists between the drawing and its model. Piaget defines these drawings in terms of a set of conspicuous "errors"; *transparencies* that depict in the same space inside and outside aspects of an object such as a house drawn in frontal view with its inhabitants and furniture showing through, or a mother with a fetus in her womb. Other errors include *mixed views*, in which a body might be drawn in frontal view while its head is depicted in side-view; and *fold-out* drawings, in which a wagon might be drawn as a square with its wheels rotated into the horizontal plane. Piaget also points to the persistent tendency to arrange figures side-by-side, which ignores the vertical dimension for the depiction of near–far relations, and to the failure to use *occlusion* to indicate that one object stands behind another one that partially obscures its view. Additional defects can be seen in the right-angular bias displayed in the slanting chimneys of houses that, instead of pointing upwards, are drawn at a right angle to the roofline; in the vertical water levels of drawings of a tilted jar containing a liquid; and in the "empty space syndrome," which refers to clusters of figure at the bottom of an otherwise empty page. All these faults, and many more, Piaget attributes to an inability to draw what the child actually sees. Instead of drawing what she sees, the youngster draws what she knows—that is, what she understands of the objects and their relationship—and this limited and somewhat distorted understanding as indicated before, Piaget calls *intellectual realism*. This term, with its emphasis on knowledge, refers to the child's inability to depict the object from the particular viewing position she happens to occupy. The child's drawing combines aspects that are visible from different viewpoints, and in

this sense the child represents her knowledge rather than her actual perception of the object. Intellectual realism is contrasted with *visual realism,* the ability to depict the object realistically as it appears to the viewer from a particular station point. (A very simple approximation can be seen in ills. 83 *d*; see also chapter 6.)

Visual realism is the final stage discussed by Piaget and it emerges during the period of concrete operational reasoning. During this period, which extends over a broad age range from approximately 8 to 12 years, projective and Euclidean relations develop from the earlier topological ones and begin to be organized according to a coordinate point of view. Relations of left and right, of in-front and behind can now be represented. Drawings begin to conserve straight lines, angles, curves, and distances through various transformations. Intellectual realism is on the decline; it is replaced by visual realism that depicts objects more accurately and portrays them with some degree of photographic fidelity. From now on, the viewpoint of the observer is respected, and from age nine years on the child begins to draw objects in correct perspective.

In his analysis of the construction of intelligent thought, Piaget links the development of logical operations to the growth of spatial-mathematical reasoning and to the ability to coordinate perspective, proportion, and distance in drawing. Although he notes that the analysis of geometric figures in copying is far more advanced than in free drawings (Piaget & Inhelder, 1956, p. 77), he treats both as indices of the same spatial-representational intelligence. It is during the concrete-operational period that a complete reconstruction of the child's understanding of physical space yields reversible mental representations. The concrete-operational child overcomes the earlier limitations of topological relations where space is considered purely *internal* to a figure, in total isolation from other figures and without reference to a common spatial structure. By contrast, the coordination of objects-as-such and their location in terms of a system of axes, leads to Euclidean space, whereas the coordination of viewpoints and a concern with locating objects relative to one another and in terms of a particular perspective (before-behind, left-right, above-below), yields projective space. Unlike topological relations that remain internal to each object and do not involve relations with other objects, projective and Euclidean space consist of comprehensive systems that establish a workable frame of reference for pictorial representation.

How well have Piaget's formulations that emphasize a close relationship between stages in the evolution of geometric constructs and of drawing systems stood the test of time? Let us begin this assessment with a quotation from Piaget on the drawing achievements of the concrete operational child: "in contrast to perceptions, representation of perspective implies operational, or at least conscious coordination between object and subject; or in other words, a recognition of the fact that they both occupy the same projective space extending beyond the object and including the observer himself" (Piaget & Inhelder, 1956, p. l78). Thus the achievement of perspective drawing, of visual realism, is deemed characteristic of this period. The empirical

data, however, tell a different story. The late and sporadic appearance of perspective drawings, so well documented by Willats and others (Cox, 1992, 1993; Kerschensteiner, 1905; Lark-Horowitz et al. 1967; Lee & Bremner, 1987; Munro et al., 1942; Phillips, Inall, & Lauder, 1985; Thomas & Silk, 1990; van Sommers, 1995) does not support Piaget's assumption of a close link between concrete operational reasoning and drawing. The data suggest that the relationship between these two domains is not as direct and simple as Piaget has postulated. The drawings in orthographic projection, which are typical for ages 7 to 12 years, cannot be derived from "knowledge" or from "viewpoint"; they can neither be explained in terms of intellectual nor of visual realism. Surely, children do not ordinarily view a table from eye-level, nor does the single horizontal line correspond to known illustrations of tabletops (see ills. 81 c). A similar problem arises in regard to the vertical oblique and oblique drawing systems that depict the surface of the table as a rectangle and a parallelogram, respectively (ills. 81 d, e). These drawings do not correspond to what the child sees—indeed, a bird's-eye view of a table or a position that would yield its oblique projection would be most unusual—and the drawings are certainly not derived from adult models. Thus, despite its long history in the literature on children's drawings, the theory that maintains that first knowledge and then perceptual viewpoint determine the adoption of drawing systems cannot present a convincing account of graphic development.

Why do children draw the tabletop as a single line when it corresponds neither to their concept of the object nor to their viewing position? If a table's major function is to provide a stable surface for objects to rest on, the horizontal line can serve as a *graphic equivalent*, albeit in an abstract and simplified manner. This line that stands for edge as well as for plane surface provides a secure base to which figures can be attached. Evidently, such a drawing is a "readable" visual statement and avoids the ambiguity of the rectangular and parallel oblique systems that follow it. As a very general statement, however, it is limited in the information it can convey, which encourages transformations that, eventually, yield better specified representations.

Perspective is not the only achievement that, according to Piaget, crowns concrete operational reasoning. A review of additional drawing devices usually subsumed under the broad terms of intellectual or visual realism indicates that we are not dealing with a unitary representational ability that emerges in close synchrony with concrete operational thought.

Transparencies

One of the presumed hallmarks of intellectual realism, as defined by Piaget, is a type of drawing that exhibits transparencies—that is, that uses form overlap without eliminating lines that denote invisible parts. Typical examples are in the drawing of a human in which clothing is superimposed on the figure's basic structure. In such cases, however, the temporal sequence of completing the figure before

dressing it yields the presumed transparency; the body shows through the clothing. It is not an intentionally produced effect, nor does the figure carry deep symbolic meaning. The transparency merely indicates that the plan, which guided the series of actions, did not foresee the visual problem the procedure of drawing one part after another might create for the viewer. Above all, incompleteness, whether of a figure or an object, is unnatural and inimical to the logic of early representations. Thus, while young children avoid overlapping forms—the crossing of boundaries when they represent separate objects or identities—they seem less perturbed by overlap that is internal to a figure (see ills. 84 *a*, *b* and 45 *a*). Because the criterion of "realism" has not yet been adopted, overlapping lines is a reasonable solution for creating a more complex figure that tells the viewer that the person wears clothes. Usually, this type of representation is of relatively short duration, and to the extent that figural differentiation comes to include clothing as a mark of gender identity (see chapter 3), planning to draw a mommy, for example, specifies a body in the shape of a dress. The problem of the elimination of lines hidden from view will reoccur whenever new and ambitious projects are undertaken that create unforeseen problems.

There are also types of transparencies that are designed to depict the inside of objects such as the interior of a house, a baby in its mother's womb, food in the stomach or a chick in its shell (see ills. 47). In these cases the child intends to portray the interior, which carries the central meaning of the picture. Instead of a desire to occlude the interior view that, objectively, is invisible to the spectator standing on the outside, the child wishes to "reveal," to draw attention to the scene, which is not unlike some of Chagall's paintings (*Pregnant Woman*, 1913; *The Cattle Dealer*, 1912; *Listening to the Cock*, 1944) and those of primitive artists who use similar pictorial devices. Indeed, unlike the type of figural overlap described earlier, which is a short-lived, transitory phenomenon soon to be abandoned, the second and deliberately planned type of transparency continues to serve as a favorite drawing device. It is likely to be used when the theme calls for an economical way in which to portray the general as well as the specific aspects of an object—for example, a home. In this case the shell of the house with its roof states the general theme and identifies the setting while the interior displays such additional familiar characteristics as furniture, a lamp, humans, and pets that point to the lifestyle of the family and add an element of intimacy to the picture (see ills. 85 *a*, *b*, *c*).

Whereas transparencies tend to decline with age as children begin to apply a rule that demands the elimination of "invisible" lines, the deliberate use of overlap to occlude body parts that belong to different planes and create the impression of depth is used infrequently before the adolescent years. Its low incidence is similar to Willats' findings on linear perspective, and only a minority of students employ it successfully. Children face the problem of overlapping body parts and the need to eliminate hidden lines most acutely when, in their desire to portray actors in different orientations, they discard the canonical frontal view of humans to indicate actions, interactions, gestures, and feelings.

a.

b.

84. *Figural Overlap*

a. Girl, 4;11. The imposing figure of the teacher is completed first; the book is superimposed on her arm: "I'll make you reading stories."

b. Boy, 6;5. The artist draws his family in a left-to-right order. When he runs out of space, he draws himself and his mother above the earlier drawn members of his family: "I'm behind my sister . . . my feet don't go far enough down; my mom is behind my dad." The figure on the left with tears streaming down his face is drawn with one short leg to avoid overlap, while the mother is drawn with long legs that cross the arms of the previously drawn figure.

a.

b.

c.

85. *Transparencies*
a–c. Artist ages 6 to 12.

Foreshortening

Foreshortening, another device for depicting volume, is a powerful technique for indicating the solidity or depth of a figure by proportionately contracting some of its parts so that an illusion of extension in space is obtained. Rarely is it achieved before adolescence, and even then most likely with the help of instruction (Reith & Dominin, 1997). When it appears spontaneously at earlier ages it is usually associated with a precocious giftedness for the visual arts (see chapter 7). Under special conditions, and to a limited degree, it can be elicited in younger children. David Pariser (1979) reports that the instruction to draw the contour of an object as if the hand were touching its boundary, without looking at the lines as they are drawn on the paper, seems to elicit in some elementary school–age children attempts at foreshortening. Equally rare at these ages are techniques that use shading, modeling, or cross-hatching of lines to suggest the rounded character of animate bodies.

One Object in Front or Behind Another:
The Depiction of Relative Position

I shall now focus more explicitly on the child's invention of strategies to depict relations among objects, specifically those that indicate the near-far positions of an object, and such relations as "in front of" or "behind" another one.

In their extensive study of the child's conception of space, Piaget and Inhelder examined the child's ability to depict in front–behind relations (1956, chapter 14). For this purpose, children were asked to make a drawing from a model village. The findings indicate that up to the age of nine years, children tend to ignore the depth relationship and draw all the figures in frontal view and along a single horizontal axis. Piaget's inquiry reveals the child's reasons:

[PIAGET:] Is it drawn the way it is arranged here?
[KRA, AGE 6;1:] *No, because I can't draw it like that.*
[PIAGET:] Try again.
[KRA:] *No, I can't manage it.*

On a second trial, the child is presented with a different model composed of a tree, a church, a home, and a bridge. The model is displayed on a low-standing table, and the child who views it from above is asked to make a drawing of this model. Again, Kra draws all the objects in frontal view and orders them in a straight horizontal line.

[PIAGET:] Is it possible to see a village from above looking like this?
[KRA:] *No, you can only see the roofs.*
[PIAGET:] But what have you drawn here?
[KRA:] *I wanted to draw the whole house and the church as you can see it complete.*
[PIAGET:] Look carefully and draw what you can actually see.

Kra's next drawing is identical with the drawing made on the first trial. Piaget further probes the child's understanding of spatial relations by drawing his attention to the front–back relationship in the model, to which Kra responds: *"I can't draw it behind. I would have to pierce through the paper."* The dialogue indicates that the child's knowledge is more extensive than the drawing, and that Kra is well aware that the drawing is not visually realistic. The drawing is simply the best he can do. Clearly, the experimenter and the child define the task differently—the examiner emphasizes a "view" that does not yield a meaningful representational account of the scene, and the child aims for a recognizable and meaningful depiction of houses in their canonical form. Nevertheless, Piaget considers these drawings as symptoms of the child's primitive spatial concepts. It is at the next stage, according to Piaget, that the seven-to-eight-year-old child abandons her reliance on the horizontal axis and uses the vertical dimension to portray the near–far and front–behind relations. According to Piaget, the consistent reference to the vertical and horizontal dimensions in spatial representation speaks of the construction of a network of relations. Finally, this process culminates in the ability to represent a model to scale, to make maps and diagrams, and to represent a scene in perspective.

The issue of the verticalization of spatial representation, of using the vertical dimension to indicate the near–far relation, has recently attracted the interest of several investigators. In a series of studies designed to detect when and how children differentiate the near–far, in front–behind relationship between objects, psychologists have begun to shed some light on this subject (Cox, 1981; Freeman, 1980; Ghent-Braine, Schauble, Kugelmass & Winter, 1993; Klaue, 1992; Light, 1985; Light & Humphreyes, 1981; Light & MacIntosh, 1980; Light & Simmons, 1983; Park & Bin, I., 1995). There is now considerable agreement that when young children, ages five to six years, are instructed to draw one object behind another, they draw separate figures and align them in a side-by-side horizontal arrangement. Thereafter, particularly when their attention is drawn to the in-front and behind relations displayed in the model, children tend to use the vertical dimension of the paper to indicate the near–far spatial relationship. This usually occurs among seven-to-eight-year-olds. Still, the objects continue to be drawn as separate entities, each within its own boundary, and few children utilize superposition or overlapping forms to capture their specific viewpoint in which the near object partially occludes the far object. Note, however, that their actions indicate an awareness of spatial relations, and far from drawing the items in a random fashion, they draw the near object first and on the left side and place the far object to the right; when children use the vertical axis, the far object is drawn last and placed above the near object. Clearly, we are witnessing a rule governing the ordering of items.

Approximately at the age of nine years, a majority of youngsters adopt the technique of occlusion; either partial occlusion, in which case a part of the far object is seen while the rest is occluded by the

a.

b.

c.

86. *Horizontal Interposition*
a–c. A large object serves to "hide" the
child from his pursuer.
Artists are first and third graders.

near object, or complete occlusion by the near object, which hides or masks the far object. According to Maureen Cox (1981), until eight or nine years, children are determined to portray objects as complete wholes, and this insistence has little to do with knowledge as proposed by Luquet and Piaget. Such children, reminiscent of Piaget's account of Kra, tend to ignore specific viewing points. Even when their attention is drawn to what they can actually see from this vantage point, it does not seem to curtail their desire to portray the whole object. Paul Light (Light & MacIntosh, 1980; Light & Simmons, 1983) interprets this phenomenon in terms of the dominance of the "visual world" view over the "visual field" view, a position derived from Gibson (1966, 1979). A visual worldview would lead to a depiction of the object the way it normally looks, rather than to its portrayal from the somewhat arbitrarily chosen view of the experimental situation. This formulation is quite congruent with Freeman's account of a preference for the canonical orientation of the object. However, Freeman considers drawing styles as indices of specific cognitive abilities that enable the child to handle pictorial depth relations. As the ability to use hidden line elimination increases, the tendency to segregate objects declines, and children display a better overall grasp of pictorial depth cues. Freeman does not consider transparencies a symptom of conceptual immaturity and instead emphasizes the difficulties the child faces in the production process, where built-in mental "biases" such as the insistence on canonical forms lead to inadequacies in planning and execution strategies. These biases underlie the intellectual realism of children's drawings and are, ultimately, indicative of the limitations of spatial reasoning in the child.

Task Effects

In an effort to determine the extent to which the preference for complete forms indicates a genuine cognitive constraint on the child's performance, Cox (Cox 1981; Freeman & Cox, 1985) designed a study in which "hiding," and therefore also occlusion, is intrinsic to the task of depicting a game of "cop and robber," with the robber hiding behind a wall. In this lifelike situation, in which hiding is an essential aspect of the theme, even the six-year-olds use partial occlusion to portray the robber—a clear indication that the avoidance of overlap reflects a drawing style, perhaps even an aesthetic decision, that by itself does not necessarily implicate the child's reasoning abilities. Furthermore, this experiment is also more specific in what is to be communicated by the representation. In the child's other drawings, he may presume that the identity of the object is the major issue and outweighs other concerns.

In a similar study that I designed to assess the child's spatial strategies when the task calls for the hiding of an object, Susan Peluso discussed the game of "hide and seek" with elementary school children ranging in age from 6 to 11 years. The participants were 165 children from grades one through five. After she ascertained that the

children were familiar with the game and understood the implications of hiding from a pursuer, she asked for a drawing that depicts the searcher's, but not the viewer's, difficulty in locating the hidden child. Thus the child who is hiding is visible to the viewer of the picture but not easily detected by the pursuer. The results provide a number of important findings. First to be noticed is the dominance of the horizontal-alignment strategy for all ages. Although the majority of the participants create a second level in the form of a skyline, birds, and/or a sun, the differentiation of space into a foreground, a middleground, and a background to the action is rarely attained before the fifth grade, and even then only by a minority of children.

The most common solutions to the problem of "hiding" are horizontal interposition and partial occlusion. In the case of horizontal interposition, a large object separates the hider from the seeker, which suggests that the large object, usually a tree, represents a massive item capable of hiding the person standing next to it. The drawing depicts all figures side-by-side with the tree obstructing the view of the seeker. The two-dimensional outline of the tree represents a three-dimensional object that can hide a person from its pursuer. Obstruction of view is a global and unmarked concept that precedes the more differentiated understanding of in-front or behind, which are difficult to portray in the two-dimensional medium and derive their meaning from a fixed point of view (see ills. 86 *a, b, c*).

Partial occlusion, the second-most-frequent solution, appears most commonly in the form of a head drawn next to the tree, peeping out, as it were, from behind the tree that occludes the rest of the body. This arrangement, like horizontal interposition, conforms to the overall horizontal alignment strategy (see ills. 87 *a, b, c*). Other less-frequent solutions include drawing the figure hiding in the branches of the tree, inside a house, or underneath leaves or snow (see ills. 88 *a–e*). The strategy of horizontal interposition continues to be employed with approximately similar frequencies through grades one to four, and declines markedly by grade five. With age and grade level, there is a corresponding increase in the successful use of partial occlusion, from 30 percent for first graders to 60 percent for fifth graders.

Concerning the orientation of the players, I find that the frontal view of the human is the dominant stance for all ages, for figures hiding as well as for those seeking. Both are drawn in frontal view, looking directly at the viewer instead of gazing in the direction of the partner. This orientation, with a high of 86 percent, is most pronounced for the first graders, although 56 percent of the fifth graders still adopt this frontal view. The incidence of frontal orientation remains essentially unchanged for the remaining grades, age 7 to 11. Truly coordinated views are absent in the drawing of the youngest children, the first graders, and remain at a low of l4 percent for the higher grades. In coordinated views, the orientation of the concealed figure and the pursuer suggests the nature of their relationship. In this case frontality is subordinated to the dictates of the theme and the spectator remains external to the action. In between these two extremes, I find

a.

b.

c.

87. *Partial Occlusion*
a–c. The successful occlusion of parts of the figure suggests a game of "hide and seek." Artists are first graders.

88. *Diverse Solutions to the Theme of "Hide and Seek"*

a–e. Hiding inside a house, up in a tree, underneath a pile of leaves, a mound of snow, or a table.

Artists are first and third graders.

a.

b.

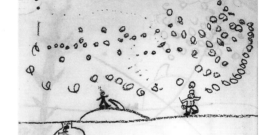

c.

d.

e.

partial coordinations in which, for example, one child is drawn in frontal view while the other is depicted in profile, or both actors are drawn in profile, pointing in the same direction without any suggestion of their specific relationship (see ills. 89 *a–d*). Such partial coordinations occur infrequently in the drawings of first graders but increase to approximately 30 percent in the other grades. In addition to extensive experience with drawing, coordination of views and of ori-

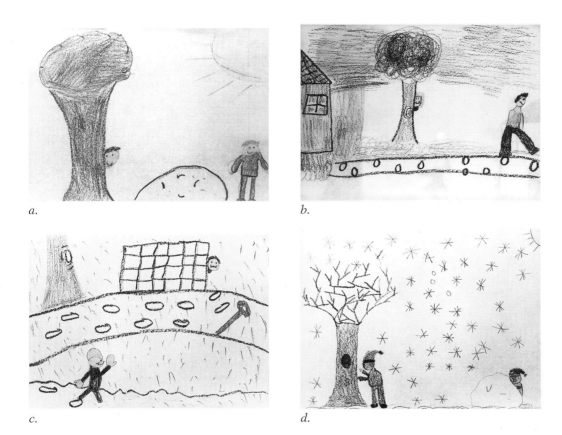

a.

b.

c.

d.

entation of the figures requires *decentration* in Piaget's sense. Decentration refers to the ability to take the point of view of all participants into account—that is, the view of the major actors whose aims are at odds in the hide and seek game, as well as that of the spectator of the picture who is not involved in the action but needs specific information in order to interpret the picture.

Overall, and across all age groups, there is a considerable similarity in the graphic solutions. In terms of the spatial differentiation of the paper, however, one can detect a new sophistication in the drawings of the ten-to-eleven-year-olds. Among this age group, 27 percent of the children make effective use of the vertical axis to depict distance and to suggest the continuity of space. These youngsters overcome the earlier attraction of the single horizontal axis (see ills. 90 *a, b, c*).

To what extent does the theme of a drawing determine the spatial arrangement of the figures, such, as the use of the single horizontal standline on which figures are drawn standing side-by-side? Answers to this question come from a study I conducted that employed such varied themes as "Draw a Family," "A Teacher Reading a Story to the Children in Her Class," "Three Children Playing Catch with a Ball," and "Apple Picking." The participants ranged in age from 4 to 12 years. The simple side-by-side arrangement of figures along a horizontal axis and in a frontal orientation is most pronounced for the Family theme. With few exceptions, this proves to be the dominant

89. *Partial Coordination of the Orientation of the Players*
a–d. Artists are third and fourth graders.

b.

c.

a.

90. *Hide and Seek: New Conceptions of Pictorial Space*
A more sophisticated depiction of space which extends beyond the single horizontal axis.
a–c. Artists are fifth graders.

spatial arrangement for family members across the whole age range (see ills. 91 *a, b, c*; see also 79 *a* and *c*). On the Teacher Reading a Story theme, we find two types of spatial organization. In the first, teacher and children are drawn standing on a single horizontal line, separated by spaces and perhaps by a chair to differentiate the teacher from the students (ills. 92 *a–g*); in the second type, two separate levels are indicated, with the teacher drawn above a row of children (ills. 93 *a–d*). These two strategies, which appear already among four-year-olds, continue to be used by all the children from kindergarten through the sixth grade. However, unlike the findings of the Peluso study on the theme of hide and seek, first graders already display a fairly high incidence of coordinated orientations, although frontality retains its dominance. Coordinated orientations, in which the teacher faces the children who look directly at her, increase with age, but even the 12-year-olds are still seduced by the simplicity and expressiveness of the facial frontal orientation of both teacher and students (see ills. 92 *e, f, g*). On the Playing-Catch theme I also observe two types of spatial organization; the horizontal side-by-side alignment of figures and a triangular arrangement that uses elevation to depict both depth and distance among the players. Among the latter, there is a high proportion of coordinated views, for example, two players in profile gazing at each other, with the third one drawn, quite appropriately, in frontal or rear view; or all three players drawn in

91. *Family Alignment*
a–c. Most commonly the family members are placed side by side.
Artist ages seven to nine.

a.

b.

c.

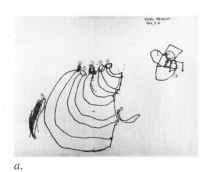

a.

92. *Horizontal Alignment of Teacher and Pupils*
Children often comment spontaneously on their work.
Adam (*a*), 5;5: "I made them curvy 'cause that's how they sit down. I think I made them too curvy."
a–g. Ages 5 to 12.

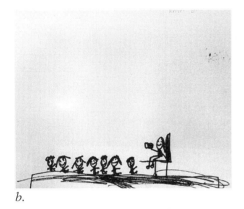

b.

c.

d.

e.

f.

g.

93. *Teacher and Pupils are Organized on Two Levels*
a–d. Artist ages four to nine.

a.

b.

c.

d.

a.

b.

c.

94. *Playing Ball: Horizontal Alignments*
a–b. Frontal view.
c. Profile and rear views capture intent of action.
Artists are in grades one to three. (Also see 46 *b*.)

profile oriented toward each other and toward the ball (see ills. 94 *a*, *b*, *c*; 95 *a–e*, and 34 *a*). While triangular arrangements and coordinated views increase with age, horizontal alignments in full frontal view can still be seen among the 12-year-olds. On the Apple-Picking theme one notes, quite predictably, a pull toward the utilization of the vertical axis for trees, ladders, and apple pickers, with baskets arranged either to the side or below the trees. While on this theme coordinated views that deviate from the frontal orientation are more numerous than on the Family drawings, they occur less frequently than on the Teacher and Ball-Playing tasks (see ills. 96 *a–g*; see also 45 *b*).

In a further exploration of the child's representation of pictorial space, Debbie Farmer and I asked children ranging in age from 4 to 13 years to draw a Garden, Children Playing, a Birthday Party and an Interior scene (Golomb & Dunnington, 1985; Golomb & Farmer, 1983). In the Garden theme, most children use the bottom of the page to depict flowers, trees, and a pond, which are requested items, and spontaneously draw the sky in the upper part of the paper. For most

95. *Playing Ball: Triangular Arrangements*
a–e. Artists are in grades one to five.
(See 34 *a*.)

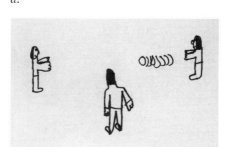

a.

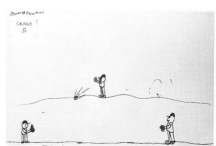

b.

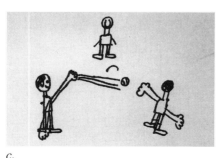

c.

d.

e.

a.

b.

c.

d.

e.

f.

g.

96. *Apple Picking: Emphasis Is on the Vertical Axis*
a–b. Ages 4;8 to 5:1.
c–g. Children in grades one to five.

children, this theme calls for two levels of space: the ground and the sky (see ills. 97 *a–g*). Some youngsters embellish this theme with hills and add a second baseline to accommodate trees and flowers. In a number of drawings we find the spontaneous use of overlap—for example, a cloud partially occluding the sun and trees overlapping each other. However, not a single drawing displays size diminution to suggest distant figures, nor do we find texture gradients to indicate depth. A similar preference for a single horizontal alignment can be seen in the drawings of Children Playing. Such arrangements yield only limited differentiation of space—for example, two children playing ball may be portrayed in profile, facing each other with the ball located between the two figures, which suggests real space for playing. The rest of the page is left undifferentiated. Does it stand for three-dimensional space or does it merely indicate its status as a blank page? Also quite common is the arrangement of figures on two implied baselines, particularly in the drawings of older children who depict the typical array of playground items: a slide, swings, ladders, and a sandbox. Among these drawings, the problem of confounding the near–far and the up–down dimensions can emerge quite acutely when, for example, a hopscotch pattern intrudes into the skyline as it touches a cloud (see ills. 98; see also 97 *f*).

On the Birthday Party theme, some gifted eight-year-olds overcome the pull to represent humans in their preferred frontal view. They draw a table with a birthday cake and seat the children appropriately; they coordinate their orientation vis à vis the table and each other with the point of view of the observer in mind. Accordingly, children are depicted in frontal, side, and rear views—a quite

97. *Garden*
a–g. Artist ages 6 to 12.

98. *Playground*
The vertical axis serves the double function of representing depth and height, which can yield confusing messages. Does the hopscotch pattern, which overlaps the clouds and sky, reach into the heavens?

sophisticated achievement that stands in contrast to the limited figural differentiation and the absence of linear perspective (see ills. 99 *a, b, c*).

Of the four themes, drawings of Interior scenes present the most difficult task and demonstrate quite early on the limitations inherent in the single baseline. In the depiction of a room, depth and height compete for the same space, and furniture, lamps, windows and paintings crowd in on each other. These themes confront the child with a dilemma and, in some cases—as in the hopscotch pattern touching the clouds or a large tree pressing against the top of the page—"seeing" the problem gives rise to a new strategy. However, discoveries are not limited to complex problems as demonstrated by a five-year-old who planned to draw four children in a row. Due to space limitations, she could only fit three children into a single line and the fourth child had to be drawn above the first one, which

a.

b.

99. *Birthday*
a–c. Artist ages 8 to 12.

c.

elicited her comment: "No space for me. I am on a hill further away." (For a more detailed account of these themes see chapter 6.)

My review of the findings on the relative position of objects, the preference for canonical views, the avoidance of overlap and occlusion, and the dominance of the horizontal axis reveals early representational tendencies that are grounded in the graphic logic of the child, but also highlight the extent to which the nature of the task can affect the outcome and elicit new drawing strategies. The usual experimental situation, in which objects are arranged in an array that to the experimenter involves in front–behind relations as essential aspects, carries little significance for the child. What counts are the number and types of objects rather than their arrangement in space. When task demands are made quite explicit, when they appeal to the child's own experience and thus gain in ecological relevance, many young children seem to be able to overcome their firm preferences for preserving the integrity and completeness of the figure and are willing to occlude as well as to adopt less-preferred orientations. In some special cases, we even find a seemingly precocious coordination of the positions and orientations of the actors. Clearly, this variability, which is a function of the nature of the task, does not support the notion that drawing strategies simply derive from the child's spatial-geometrical concepts. Cognitive abilities do not translate directly and independently of experience, talent, task demands, and culture into drawing strategies. The graphic devices I have discussed represent different solutions to the problem of the missing dimension. Some of

these devices seem to emerge approximately at the same time. For example, as the incidence of transparencies declines, we find, under some conditions, a corresponding increase in the use of partial occlusion. These spatial acquisitions, however, do not predict linear perspective, foreshortening, size diminution, or texture gradients, which are rarely used before adolescence, and even then only infrequently.

The overall development toward a greater differentiation of figures and their organization into a coherent spatial framework need not be confused with a tendency toward realism in art. The term realism can carry a number of different meanings, and the necessary distinctions are not always clearly made when children's drawings are evaluated. At times the term refers to the increasing complexity of a drawing, its richness of detail that yields a better likeness to the referent. However, realism is also used to describe a naturalistic drawing style in which shading, for example, can create borderless transitions between various figures that evoke an impression of depth, and at times refers to planes separated by the use of color gradients. These drawing styles create a "lifelike" representation without the use of perspective drawing devices. Finally, the term realism is applied to drawings of seemingly photographic fidelity that employ principles of linear perspective and a vanishing point. When students of child art write about the child's tendency toward realism, they often mistake the desire for greater detail in a composition for a striving toward a style characterized by central perspective. Drawing from the object in the sense of capturing a static or frozen point of view has not commonly been the practice of artists (Gombrich, 1960) and it does not usually appeal to children interested in drawing and painting.

Let us now summarize the diverse findings on the development of spatial differentiation in children's drawings. I have sketched the child's discovery of the simple figure–ground relationship, the insistence on a separation of boundaries, the preference for canonical orientations, and the pull of gravity that leads to the horizontal alignment of the figures and to the introduction of baselines. The differentiation of space is a gradual process as the unilinear direction of the side-by-side alignment gives way to a distinction between ground and sky. The vertical axis comes to be used for a depiction of the spatial concept of up–down, while left–right positions are indicated on the horizontal axis. The increasing specification of the horizontal and vertical axes of the page, and the constraints it imposes on the young artist, create new possibilities and facilitate the depiction of more intricate relationships. As more complex figure–ground relations are tried out, the rule that specified the inviolability of figural boundaries gives way to a limited use of overlap, some coordination among the orientation of figures, attempts to show more than a single face of an object, and the use of oblique lines to indicate depth. Spatial differentiation requires new transformational rules of location, orientation, interposition, occlusion, and size. By the end of childhood, practice with drawing has taught the child what some of the problems of this two-dimensional medium are and may yield more satisfying solutions, particularly in the case of talented children. But

established patterns are not easily discarded as the continued preferences for canonical orientations and orthographic views indicate, and only the most gifted youngsters aspire to depict space that unites foreground, middle-ground, and background. Despite these limitations, the paper-space now invites the use of the whole surface and we observe efforts to relate the various sectors to each other. At this level, space calls for the differentiation of distance and height, both of which use the same vertical axis in the drawing surface to represent the spatial characteristics of near–far and up–down.

The graphic devices useful for the depiction of space emerge only slowly and do not suggest a unitary cognitive ability. The tendency to represent the whole object in an undistorted fashion clashes with the need to depict the missing third dimension and pits various rules and values against each other. The studies we have reviewed lead to seemingly paradoxical findings. On the one hand, the extended period during which preferred pictorial strategies are maintained may suggest a gap between the intellectual achievements of concrete operational reasoning and drawing that characterizes all but the most artistically gifted youngsters. On the other hand, when task demands are made quite explicit, graphic skills not ordinarily seen among five- and six-year-olds can be elicited, skills that are not usually tapped even in the drawings of older children. If the execution of a drawing does not offer a simple reading of the child's intellectual concepts, we might view the enduring preference shown by 7-to-13-year-olds for the relatively primitive orthographic and vertically oblique systems as a need for the consolidation of newly acquired graphic skills. This brings us back to an assessment of Piaget's claims, particularly to his distinction between the stage of intellectual and visual realism. The data as well as my theoretical analysis of the nature of representation suggest that Piaget adopts a false dichotomy between drawing styles or systems when he distinguishes between knowledge and visual perception. Knowledge of objects and their interrelations in the world is ordinarily not independent of visual experience. When drawings become more detailed, organized, and informative, it is enriched visual knowledge and graphic techniques that lead to more sophisticated images. To elevate the momentary viewpoint to a highly valued standard is antithetical to Piaget's own analysis of the nature of perceptual activity and also ignores the impact of the culture. The retinal image and the static viewpoint do not correspond psychologically to the visual information we derive from our experience with the object as we move our eyes, head, and body. The three-dimensional conception of the object never coincides with a single, momentary view. To the extent that pictorial representation is concerned with meaningful forms, the value that we attribute to the retinal image derives mainly from cultural standards of artistic achievement. The impact of the culture on a child's drawing is evident from the very beginning in terms of available implements, peer influence, early training, and ready-made models (Wilson & Wilson, 1982a). While the preschooler seems less affected by the pictorial models than older children, it is during the school years that exposure to books, posters, and instruction

sets the standards that are likely to be valued. However, despite the pull toward so-called pictorial realism noted in Western cultures for school-age children, the effects of training in perspectival drawings of geometrical objects of, for example, a cube or a trapezoid, does not easily generalize to the drawing of other objects or to new orientations (Phillips, Inall, & Lauder, 1985). Studies using a da Vinci window that restricts the viewing conditions through a small aperture—a round peephole through which an object is viewed monocularly—demonstrate that drawing the projective view of a scene is not easily accomplished, even in the case of adults (Reith & Hong Liu, 1995). Learning the techniques of perspective tends to be quite task-specific and, as Michelmore has suggested, it is best to conceive of drawing development in terms of finding and remembering of appropriate graphic descriptions rather than some general and slowly evolving conception of space (Michelmore, 1985).

Our findings call for a reassessment of the relationship Piaget proposed between drawing competence and spatial-geometrical constructs. The popular notions of intellectual and visual realism have little explanatory power and prove unsatisfactory for gaining an understanding of drawing development. Piaget did not develop a theory of pictorial representation; rather he dealt with the representation of space as a single domain where drawing, copying, and mathematical reasoning are closely linked to a hypothesized cognitive structure. Assuming a far-reaching correspondence across intellectual domains, he borrowed Luquet's concepts and wedded them to his analysis of spatial constructs.

Robbie Case's Neo-Piagetian Approach to Children's Drawing

The broad outlines of Piaget's account of the logic or rules that underlie cognitive development in its diverse manifestations, and the assumption of significant correspondences across different domains, have inspired neo-Piagetians to reassess some of Piaget's fundamental assumptions and to emphasize domain specificity and such information processing variables as working memory and attentional constraints (Case, 1992a, 1992b; Fischer, 1980; Morra, 1995; Morra, Moizo & Scopesi, 1988; Pascual-Leone, 1988). The neo-Piagetians tend to accept the proposition that cognitive development proceeds in distinct and qualitatively different stages, but they emphasize domain specificity that is independent of symbolic logic. They assume that each structure is constructed independently of other structures but subject to a *common general constraint* that is imposed by the attentional system. At each stage of their development, children assemble separate conceptual structures that are relevant to each domain. These cognitive structures are conceived as *modular* but their development is subject to general cognitive constraints of the *central conceptual structure* (Case et al., 1996). While the content of a domain is modular, the structures are system-wide and change with age in a predictable stage-like progression. Robbie Case and his colleagues hy-

pothesize that a common central conceptual structure underlies mathematical, social, and spatial reasoning.

According to Case, a central principle that applies across all stages of mental development and that accounts for the constraints that characterize thinking at its various levels is the concept of *working memory*. Working memory can be thought of as a form of short-term memory and is defined as the number of mental operations a child can hold in memory while carrying out a task. It is the information-processing capacity that is available to the child to operate on items stored in memory and involves the capacity to hold in mind different schemes or units of meaning that can be coordinated and that facilitate the development of effective executive strategies. Young children may have a number of such schemes stored in their memory, but they cannot gain simultaneous access to this information; this precludes the development of an efficient problem solving strategy. The attentional capacity of the child is closely related to the developmental constraints imposed on working memory, which has a strong maturational component.

Working within this conceptual framework, Case and his colleagues have studied children's compositions and defined composition somewhat narrowly in terms of the depiction of spatial relations (Case, 1992a; Case et al., 1996; Dennis, 1992; Porath, 1997), with photographic realism as the endpoint of the hypothesized developmental progression. The center piece of this research is a study by Sonja Dennis (1992), whose structural model of drawing development is based on Case's theoretical framework, which specifies four structural levels and four working memory levels at ages 4, 6, 8, and 10 years. This model was first developed on the basis of 75 children, ages 4 to 10 years who were asked to "draw a picture of a little girl (boy) your age doing something that makes him (her) happy." The findings from this study were interpreted as yielding four distinct stages extending from the depiction of single objects, to the establishment of a relationship with other units involving the drawing of a groundline, a foreground and a background, eventually encompassing also a middle-ground. The results of the spatial-drawing scores and the scores for the working-memory tasks, with age partialed out, yielded only a modest correlation with 6 percent of the variance accounted for by working memory. Dennis interpreted her findings as supporting Case's four structural levels, and that progression through these levels or stages is mediated by an increase in the working memory capacity of the child.

In order to more fully test this set of hypotheses, Dennis designed a second study comprised of five tasks, each increasing in level of complexity that was meant to represent the structural levels identified by Case. The instruction to the tasks was as follows: Task 1. "Draw a picture of a man." Task 2. "Draw a picture of a girl standing in a park next to a tree." Task 3. "Draw a picture of two boys shaking hands in a park with a fence just behind them." Task 4. "Draw a picture of a man and a woman holding hands in a park. The baby is in front of them and a tree is very far away behind them." Task 5. "Draw a picture of a mother looking out of a window of her house to see where her son is

playing in the park across from where they live. She only sees her son's face because he is peeking out from behind a tree." In principle, the scale comprises four steps, beginning with graphic solutions to task 2, but since task 5 was included to avoid a ceiling of this test and was expected to be beyond the competence of the 10-year-olds, the scale de facto comprises only three steps—that is, a very global measure of the depiction of spatial representational competence. The results indicate that despite the liberal criterion of 50 percent "pass" for each age group, the scores on tasks 3 and 4 fall short of the predicted level, which is also the case for the working-memory scores. Furthermore, the scores for the 8- and 10-year-olds are quite similar, which runs counter to the prediction derived from the theory. In this study, the age-partialed correlation coefficient between working memory and structural scores accounts for 11.6 percent of the variance—still only a modest support for the working memory hypothesis as defined in this study.

In his general reassessment of Piagetian theory, Case has stressed the importance of experience within a domain and practice with specific tasks, as well as cultural and individual factors that affect performance. However, in his research on children's drawing, Case and his collaborators appeal to central cognitive factors and their constraints that yield immature spatial-conceptual reasoning, and they disregard the nature of the two-dimensional medium and its constraints on the representation of a three-dimensional world. Altogether, the appeal to central conceptual structures comes at the expense of such variables as the medium, talent, motivation, and practice, and drawing development is presented as a unilinear path toward realism. This goal of pictorial realism is supposed to be attained with the growth of working memory and, in the formulation of other neo-Piagetians, when mental operations become reversible.

How important is the role of the medium and to what extent are children's drawings constrained by the two-dimensional nature of the paper rather than by the constraints of the central conceptual structure? Frank Gallo and I decided to test the implications one can derive from an Arnheimian and neo-Piagetian perspective (Gallo, Golomb & Barroso, 2003). From Arnheim's theory the characteristics of the medium—that is, its dimensional features—and different task demands ought to have a major impact on a child's representation. In contrast, the neo-Piagetian view would predict relative uniformity in compositional trends across tasks and media that make similar cognitive and working memory demands. In other words, two- and three-dimensional tasks with similar processing demands ought to produce similar outcomes because any significant variation would negate the central role of cognitive structures. With these positions in mind, we designed a study that included two- and three-dimensional media and a number of different themes. In addition to drawing we included a two-dimensional felt board with a set of prepared cutout pieces constructed in different orientations and a Plexiglas board with three-dimensional pieces. The instructions were held constant for each

theme across the different media, but the tasks varied in terms of the information-processing *load*. Creating each item in drawing, the child literally starts from scratch, whereas both the felt board and Plexiglas tasks present the child with ready-made pieces. Both drawing and felt board utilize a two-dimensional medium; the difference is in the load of the two tasks, with drawing more demanding than the felt board with its prepared figures. The felt board and Plexiglas tasks both provide ready-made parts but differ in the dimension of the medium. Moreover, unlike drawing with markers, which is an essentially non-revisable medium, felt board and Plexiglas media permit rearrangements of figures.

By keeping the two-dimensional medium constant in drawing and felt board, but controlling for the additional load of creating forms on drawing, we are able to distinguish between compositional strategies that are medium specific (due to the two-dimensional character of the medium) and age/stage related, and those that are a function of the "load" on memory in drawing. By keeping the load constant on the felt and Plexiglas tasks we can differentiate between effects that are due to the constraints of the medium and those that are a function of spatial-conceptual immaturity. The Plexiglas board with its three-dimensional pieces was designed to elucidate the issue of conceptual immaturity in that it directly tests the child's three-dimensional spatial conceptions that might be masked in the two-dimensional media of drawing and felt board.

In terms of predictions, the neo-Piagetian approach predicts considerable *uniformity* over theme and mode of presentation when working memory demands are similar. Thus, two- and three-dimensional tasks with ready-made items should yield similar results, and they should exceed the scores for drawing. According to Case's model (1992a,b), the child's *drawing* performance, which requires him to hold the necessary schemes concurrently in working memory, should eventually match those of the less taxing *revisable* tasks when the child's working memory capacity allows for such an undertaking, between ages 8 and 10. Neo-Piagetians who do not focus on working memory constraints and rely more on general Piagetian constructs (Milbrath, 1998; Piaget & Inhelder, 1956; Reith, 1990) would predict relative uniformity in outcome across all media and instruction, the level of production dependent on the child's spatial-conceptual reasoning and ability to organize spatial relationships.

From my previous research (Golomb, 1983a,b, 1987a), and given my conceptual framework, I predicted considerable *variation* across age, media, and theme, and anticipated increases in scores from drawing to felt board, and most significantly to the Plexiglas board. On the latter, which is not constrained by the two-dimensional medium, the child's three-dimensional spatial conception can find its most direct expression; on the felt board, we predicted that the scores would fall short of those obtained on the Plexiglas, but better than those obtained on drawing, given the revisable nature of this task with its ready-made parts. The variations across media were expected

to be most pronounced in the younger children, the five- and seven-year-olds who have not yet developed their spatial-representational repertoire to compensate for the missing third dimension.

We selected three themes that varied in the number of items to be represented, beginning with a relatively simple theme and a limited number of items and increasing in thematic and numerical complexity: Jump Rope, Birthday, and Camping. We read the instructions aloud: 1. *Jump Rope:* "The bell rang at school and it was time for recess. Katie ran out to the schoolyard and saw three girls jumping rope. Katie asked the girls to play but they said, 'No, you cannot play with us! go away!' Katie had no one else to play with. She stood by herself all through recess, watching the other girls play without her." 2. *Birthday:* "Today is Tommy's birthday and he is having a party. Tommy invites three of his best friends to come over to his house to celebrate. They each bring him a present and put it on the table. Tommy looks at the three presents on the table and can hardly wait to open them." 3. *Camping:* "Suzie is camping in the forest with her three friends. She goes for a walk by herself to collect some sticks for the campfire and when she thinks she has enough, she begins to walk back. She looks everywhere, but cannot find the tent and her friends. She is lost in the woods and is getting scared."

Our participants were 45 children ages five, seven, and nine drawn from after-school programs in metropolitan Boston, representing a fairly broad middle-class sample. The productions were scored on Golomb's Revised Compositional Scale (2001) and then analyzed for the effects of media, age, and theme. Age and media, but not theme, were significant main factors. Thus, on the drawing tasks we found significant age differences between the scores of the five- and nine-year-olds and the seven- and nine-year olds; on the felt tasks we found significant differences between the scores of five- and seven-year-olds, and the five- and nine-year-olds. Most interestingly, on the three-dimensional Plexiglas medium, only the scores for the five and nine-year-olds reached significance, with a mean score of 5.07 for the five-year-olds, and a mean score of 5.64 for the nine-year-olds—a relatively small mean difference of 0.57 on our six-point scale. This small difference suggests that even our five- and seven-year-olds have a sufficient understanding of three-dimensional relations that is not apparent in the drawing tasks. To better understand the structural differences in compositional strategies on the different media, we also made pairwise comparisons between Drawing and Felt, Felt and 3-D Plexiglas, and Drawing and 3-D Plexiglas tasks for each one of the age groups. All of the pairwise comparisons were statistically significant; the results clearly indicate that in the Drawing and two-dimensional Felt task, all age groups fall below their respective levels of spatial understanding as assessed by their scores on the three-dimensional Plexiglas task. The differences between the Drawing and Felt tasks further illuminate some of the inherent constraints of the nonrevisable drawing medium. It is of interest that revisions on the Felt tasks were highest for the five-year-olds, although the time spent on these productions was short (between one to two minutes). By and large, this age

group brought a pretense play mode to bear on the felt and Plexiglas media with their ready-made parts.

In summary, these findings, especially the fact that the drawings of the nine-year-olds fall significantly below their scores on the three-dimensional Plexiglas medium, do not support the neo-Piagetian position that maintains that children should be able to transform their three-dimensional spatial understanding into an adequate representation on the two-dimensional picture plane by that age. The finding that five- and seven-year-olds and seven- and nine-year-olds do not differ significantly on the three-dimensional tasks highlights the children's abilities to represent three-dimensional spatial relationships in a skillful and intelligent manner. Although we clearly found an age progression on all tasks, the superior scores for the two- and three-dimensional revisable tasks compared with the drawings indicates that children's graphic compositions do not predominantly reflect a conceptual-spatial limitation, nor are they solely attributable to working memory constraints. This findings suggests that drawing ought to be studied within its own domain and with an approach that regards the child's "graphic logic" as an intelligent problem-solving activity. Of course, many examples of the compositions of young four- and five-year-olds (see ills. 45 *a*; 49 *a*; 52 *a*; 68 *a*; 73 *a*, *b*; 84 *a*; 96 *a*, *b*; 130 *a*, *b*; 136 *a*, *b*; 138 *a*; 150 *b*; 152 *a*, *b*; 153 *a–c*; 157 *a*) indicate that the hypothesized working model constraints of a single unit (for example, one figure) is not generally applicable, and is especially inadequate when we consider the drawings of talented youngsters who pursue drawings with intense interest and daily practice (see the drawings of two-to-four-year old Eytan in chapter 7).

We have seen that Piaget's emphasis on realism as an important milestone in drawing development continues to inspire students of child art, but that the empirical evidence for his theory and its reformulation by Robbie Case and his colleagues (Case, 1992a, b; Case & Okomoto, 1996; Dennis, 1992; Porath, 1997; Morra, 1995) fails to support the theory.

In the light of the foregoing analysis, it is reasonable to consider the graphic medium as a separate domain with its own unique properties and rule systems. Thus, we should not expect progress in projective-geometry and in perspective-taking tasks to automatically translate into perspective drawings, nor should we consider perspective drawing as a stage-dependent natural endpoint of development. However, there are parallels between the problem-solving skills that Piaget defines as concrete-operational reasoning and the ability to plan a drawing. To relate multiple figures engaged in various activities within the totality of pictorial space requires cognitive skills that emerge and become systematized during the middle childhood years. Planning a drawing requires the ability to coordinate viewpoints, to utilize flexible and reversible thought processes, and to monitor the action and to revise it—all cognitive skills that develop during this period, but are not fully utilized in children's drawings; nor do they, by themselves, guarantee artistic achievements. Clearly, some forms of problem solving defined by Piaget as concrete-operational skills facilitate the analysis of a task and the coordination of

planning strategies. These cognitive abilities seem necessary though not sufficient for thematic organization, and a developmental analysis of drawing will have to derive its laws from the graphic medium. The issue of the coordination of figures and the depiction of multiple relations will be taken up in chapter 6, when we explore compositional development in a more comprehensive fashion and consider cognitive, motivational, and aesthetic factors.

Color, Affect, and Expression: The Depiction of Mood and Feelings

5

So far, I have placed special emphasis on the differentiation of form and space and described the child as an inventor and problem solver. Of course, our inventive child is also an affectively motivated human being who approaches drawing with feelings, fantasies, and wishes. Thus, this chapter will focus on drawings as a representation of the inner world of feelings. A natural starting point is an examination of the role of color, which traditionally has been seen as having a direct link to human emotions.

Psychologists have long been fascinated by the expressive quality of colors and their quick association with feelings and mood states. While a comprehensive account of the relationship between color and affect has not yet been worked out, evidence drawn from diverse domains and from different levels of analysis strongly suggests such a connection. Thus, for example, clinical psychologists who employ projective techniques for personality assessment have paid close attention to the manner in which color affects the subject in the testing situation. The person's response to the Rorschach test, which consists of a set of unfamiliar and ambiguously structured inkblots of varying shades of black, gray, and white, interspersed with some chromatic colors, provides the clinician with insight into the individual's emotional disposition. The extent to which form and color contribute to the person's perceptual judgments reveals whether the emotions function adaptively, as is the case with a well-integrated personality, or function disruptively (Exner, 1974, 1978; Klopfer & Kelley, 1942; Rorschach, 1928/1954).

The assumption of a significant link between color and affect is not limited to clinical psychologists. In their experiments with animals, ethologists, for example, point to the role color can play in eliciting courtship patterns and in signaling approach or avoidance behavior vis à vis a stranger. A different property of color has engaged physiological psychologists, who distinguish between colors that arouse and those that have a calming effect on the observer.

But beyond the interest color perception holds for the specialist, we all know from our daily experience that we are highly responsive

to the various colors in our environment. Depending on color and brightness, our environment looks friendly or cold; for example, a sunny day with its bright blue sky looks inviting, while a clouded sky looks gloomy and at times even threatening. Indeed, many languages suggest a relationship between colors and affective states best captured by such phrases as "seeing red," "feeling blue," "being green with envy," or a "black mood." Just as we are sensitive to the presence of colors, we also note their absence and would dread living in a colorless universe such as described by Oliver Sacks and Robert Wasserman (1987) who report on the experience of an artist who, due to an accident, lost the ability to perceive colors and for whom the living world, including his own body, became repugnant.

Given the centrality of color in our perception of the world, and the unique link psychologists have postulated between color and the expression of affect, I shall now examine the role color plays in the child's drawings and offer an account of the changing relationship between form and color in child art. First I shall focus on the manner in which children of different ages use colors in their drawings and how experience with the medium fosters a more differentiated approach to their selection. A second issue to be examined concerns the linkage of color and affect; it addresses the question of how the child comes to depict feelings, intentions, wishes, attitudes, and various mood states. This concern with internal states brings us to the problem of expression—that is, the deliberate use of color and shape to convey a psychological reality, an inner state of the heart and the mind. Finally, the problem of expression, of the artist's own mood and feelings and those of the characters he portrays, leads us to the child's motivation for art-making. This chapter, then, addresses three separate though related issues: (1) the trends in color use that are developmentally meaningful; (2) the depiction of feelings, thoughts, and intentions—that is, of internal psychological states—and (3) the motivational factors that predispose children to art-making.

Developmental Trends in Color Use

Few studies have explicitly addressed the developmental aspects of children's color choices in their drawings and paintings. In a study designed to explore the relationship between painting and personality, Rose Alschuler and La Berta Weiss Hattwick (1947, 1969) postulate that normal development progresses from an early use of predominantly warm colors like red, to such cold colors of the spectrum as blue and green. These authors associate a painting comprised of mostly warm colors with impulsive behavior and the child's need for immediate instinctual gratification. The ability to control impulses and to adapt to the social environment is reflected in paintings in which the colder colors dominate. Alschuler and Hattwick consider color in easel paintings as the ideal medium through which the preschooler can directly express his feelings, conflicts, and difficulties.

They deem this nonverbal expression of the emotions of particular value for ages two to five years. Thus, color gives the clearest indication of the nature and the degree of intensity of the child's emotional life; it is the language of feelings.

The authors' emphasis on color seems to be based, at least in part, on their judgment that abstract or prerepresentational paintings and drawings are more expressive of the child's inner feelings and also aesthetically more valuable than his early representational efforts. The following is an example of the authors' analysis of a child's painting. Danny, at age 4;8, paints a blue rotational whirl on a stem. This painting is interpreted as reflecting the child's anxiety over parental pressure to toilet-train him and his failure to gain control over his bowel movements. The color is described as "anxiety-blue." A painting done five days later, which employs a mixture of green and brown colors, is described as a typically dirty and smeary picture that, once again, expresses the child's concern over elimination. The next day, Danny paints a clear rectangle with patches of color and lines placed inside the outline. The better controlled use of shape and of color is interpreted as a sign of the child's greater self-assurance and of Danny's readiness to establish voluntary bowel control. According to the authors, the tensions that the child had experienced concerning toilet-training diminished when the parents left town for a month. The observed change in the paintings occurred within a single, or at most a few, days, suggesting a situational response rather than a more enduring intrapsychic conflict.

Alschuler and Hattwick offer many interpretations in this vein, which is not surprising given the psychoanalytic orientation of the authors and the age of the preschoolers, many of whom struggle with the issue of toilet-training and worry about who is going to establish control over their bodies.

Although this study represents a pioneering effort, it suffers from serious methodological shortcomings and from an unduly narrow conceptual focus. The methodological weaknesses lie in the manner in which Alschuler and Hattwick collected their data. Foremost is the lack of standardization in the number and kinds of colors available to each group of children, the order in which they were displayed, and inattention to the child's handedness. There is considerable evidence that young children's choice of color can follow a sequential order from either left to right or vice versa (Biehler, 1953; Corcoran, 1954). Such a tendency might be enhanced by handedness, with a left-handed child selecting colors in a left-to-right order, while a right-handed youngster may proceed in the opposite direction. Furthermore, thick brushes and drippy paints do not easily lend themselves to the creation of distinct shapes and thus constrain what can be done with them. Indeed, a great many, perhaps even the majority of the paintings, are nonrepresentational works, the product of gestures that leave their marks on paper. One might contend that the actions of these young preschoolers might just as well have utilized a different medium. Finally, the raters who interpreted the meaning of each

painting based their account not only on the appearance of the painting, but also, and perhaps primarily, on extensive knowledge of the child's behavior and personality traits. It is thus difficult to avoid the impression that many an interpretation is offered on an ad hoc basis, without providing convincing evidence for the assumed relationship between colors and the child's emotional status.

In regard to the conceptual orientation of the authors, it is quite clear that the image that guides their study and its interpretation is that of a conflict-ridden preschooler caught between his primitive impulses and the parental demands for his socialization. This leads to an exclusive concern with the child's impulses, needs, conflicts, and their direct expression in the medium of painting, to the exclusion of other, more cognitively oriented accounts of the same behavior. In this sense, then, their work reflects the tenor of the times (the 1940s) and provides a somewhat one-sided view of graphic development. Nevertheless, in its intent to explore the link between affect and color, this study makes a contribution to the literature that examines child art as an emotionally significant enterprise.

In general, there seems to be an agreement among students of child art that young children use colors idiosyncratically, without much regard for their realistic value, and that development proceeds toward greater realism. Some authors consider the preschool child's use of bold primary colors as particularly appealing and assign genuine aesthetic merit to the early works (Gardner, 1980; Winner, 1982). Others see in this use of color a mark of immaturity that is overcome when progress in intellectual development predisposes children to pay closer attention to the objects themselves and to the cultural conventions for their depiction.

When assessing developmental trends, one should provide similar testing conditions for all children across a wide age range, a rule not always adhered to in previous studies. Mindful of the need to control for the major effects of the theme, the materials, and the age of our subjects, Debbie Farmer and I provided 75 youngsters, ages three to eight years, with standard-size manila paper and a set of eight crayons. These were displayed in the following left-to-right order: green, purple, black, orange, red, brown, blue, and yellow. To facilitate the analysis of children's use of color, both within an age group and across the total age-span, and to control for potential task effects on the use of color, we specified the content of the drawings by assigning four themes: a Family; Children Playing; a Birthday Party; and a Garden with Trees, Flowers, and a Pond (Golomb & Farmer, 1983).

The great majority of our three-year-olds used only a *single* color on any given task, and only 17 percent of these youngsters employed more than two colors. Concerning the frequency with which colors were used over the four tasks, I note that with the exception of the color black, which was rarely used, all colors were employed with comparable frequencies ranging between 11 percent to 16 percent. At this age level, then, one cannot detect a consistent principle for the

child's choice of colors. This is also illustrated in Pat Tarr's observation of a two-year-old's systematic exploration of colors. He drew, in turn, a red, blue, yellow, and green picture (P. Tarr, October, 1987).

Examination of the drawings of four-year-olds offers a first indication that colors can also serve a representational function. When drawing humans, houses, pets, toys, and cakes, children maintain a considerable degree of freedom in their color choice. Depending on the subject matter, however, some restrictions begin to appear: water tends to be drawn blue, the sun yellow, the earth black, grass green, and trees in browns and greens. When a child violates such norms by, for example, making grass orange, her laughter clearly indicates that such a choice is meant as a joke. The most realistic colors are found on the Garden theme, whereas the least conventional colors characterize the Family and Children Playing drawings, on which color seems to be used for its own sake. There is also a significant decline in the use of single colors; pictures become color-rich and 50 percent of our four-year-olds use more than two colors per theme. In terms of specific color choices, green was chosen 19 percent; blue and red 14 percent each; black, brown, yellow, orange 11 percent to 12 percent; and purple 8 percent.

In the five-year-olds, I note a selective, task-dependent increase in the use of single colors. On the Family and Children Playing themes, the single colors once again increase to a relatively high 63 percent as contours of the human figure become monochromatic. Quite the opposite holds for the Garden task, in which multiple-color use increases to 80 percent, a phenomenon closely related to the landscape theme. Now, invariably, grass is green, water and sky blue, and tree trunks brown. The color red is mostly reserved for flowers. When for the purpose of analyzing color incidence all tasks are combined, green and orange rank first as the most frequently used colors, with 19 percent each; followed by red and brown with 16 percent each; blue 13 percent; and yellow, black, and purple trailing behind. The high incidence of flesh-color orange for humans and the realistic selections for the Garden scene appear designed to enhance the visual definition of the theme and its major constituents.

The trend toward a more naturalistic use of color reaches near perfection in the group of six-to-eight-year-olds. Colors for the Garden theme are object related or "true local colors" and the outlines for humans are drawn with a single color, preferably orange or black. Although most drawings are colorful, a principle of realism guides, as well as constrains, color use. Thus, well-known attributes of the object dictate certain color choices; for example, brown or blue eyes, red lips, yellow, brown or black hair. With the exception of the color purple, which in our tasks is used sparingly, all available colors appear frequently, and appropriately.

Let me summarize the trends observed in our three-to-eight-year-old children and note the changes in color use that are closely related to the child's representational competence. I find that once representation has become the purpose of the picture, our youngest children

employ single colors, picked at random, that serve the purpose of creating recognizable forms and figures. Whereas representational form is already important, color is not yet significant. This function of creating meaningful forms takes precedence over all other factors and subordinates whatever pleasure the child might otherwise have gained from the free exploration of color. This early singular emphasis on form to the exclusion of color diminishes in the four-year-olds who, having attained some basic representational competence, tend to employ many colors and do so without too much concern for their representational value. Such youngsters either ignore or are unaware of the constraints of realism, as they join forms and colors in a playful and somewhat arbitrary fashion. The relative ease with which forms can now be drawn permits this evidently pleasurable exploration of colors. Among the five-year-olds, the use of color becomes more theme-dependent, a tendency that the six- to eight-year-olds of our sample elevate to the status of a representational rule. Color now helps define the meaning of forms, and it can provide additional spatial anchors for the ordering of multiple items in a picture. This is well demonstrated in the baselines, drawn in brown or black, which serve the important function of providing a common ground on which objects stand, and in the blue sky that clearly demarcates the top part of the paper. Together, baseline and sky create a spatial framework within which objects and events can be portrayed.

Data that I collected from older children, whose age range exceeds that of the present sample, indicate some attempt to vary the brightness value of a specific color. Thus, for example, a light coloring of the background can serve to create the airy impression of being outdoors, and it also suggests distance, both of which serve to unify the composition (see chapters 4 and 6). As this example illustrates, color is no longer subservient to form or merely cojoined to a previously drawn contour; it now becomes a major determining force of the picture. Interestingly, among the older children we also find an increase in monochromatic drawings, usually drawn in pencil. This finding need not be seen as a deliberate avoidance of colors. Most likely, it reflects a conscious effort to exert greater control over the medium. Indeed, erasure marks are quite characteristic of these drawings.

Clearly, the developmental changes in color use chronicled so far do not suggest a linear progression. The waxing and waning of single-color use depends on the particular task at hand and the child's representational competence. Most likely, individual preferences that Pat Tarr already noticed in two-year-olds also play a role in the case of older children. There is little support in these findings for Alschuler and Hattwick's account of systematic changes in the use of warm and cold colors as indices of a developmental progression from impulsivity to impulse control. Although the nature of our study is unlike the free easel paintings analyzed by these authors, and the results of our respective studies are not directly comparable, the methodological flaws of the design that I referred to earlier may account in part for the different findings.

The Portrayal of Feelings

I now turn to a question posed earlier regarding the relationship between affect and color-choice in children's drawings. More specifically, we ask when and how children come to depict feelings in their drawings, and whether color plays a major role in this development. Thus, the next study focuses on the child's ability to depict some well-known and commonly experienced feelings. Patty White and I designed two sets of tasks. In the first one, each participant was asked to make drawings of a happy, a sad, and an angry child. The second assignment specified the drawing of a happy and a frightening dream, respectively. We were interested in discovering the means children would employ to portray these contrasting emotions, and our analysis focused on color use, expressive features, line quality, and posture. Our participants were 175 elementary school children with an approximately even number of girls and boys at each of the six grade levels.

One of the more striking findings of this study concerns the widespread practice of using the *same* color crayon or magic marker to depict the three highly different mood states. Most often, color is used in a rather undifferentiated manner that does not distinguish among the different emotions. In grades one through five, 50 percent or more children used the same or similar color combination for the happy, the sad, and the angry child, a trend that diminished somewhat for sixth graders. Interestingly, when first graders made selective use of color to indicate different mood states, the color purple most often represented the happy child, blue the sad child, and red the angry one. While this pattern appears to suggest a color code for these different emotions, this was not the case for the children in the other grades. Among the older children, the sixth graders chose the color blue with the same frequency to depict both a happy, a sad, and an angry mood. From these data, no clear color-feeling relationship emerges.

But emotion is expressed not only by color, but also, and perhaps more prominently, by shape. Examination of the features that are most commonly singled out to portray feelings reveals that lips, eyebrows, and to a more limited extent eyelashes, gradually come to serve this function. Among first graders, happiness is almost uniformly indicated by an upwardly curved, one-dimensional mouth, whereas sadness is portrayed by a downward-curving line. Somewhat more diversity can be seen in the portrayal of anger. Close to 50 percent of the first graders use straight horizontal lines with or without right-angular endpoints, and we also note some diagonal slashes, a few two-dimensional lips with teeth showing through or with a heavy dot placed above the lips. The portrayal of happiness is, with minor modifications, quite prototypical for all ages, with the older children elaborating the upward-turned mouth into two-dimensional heart-shaped lips. A parallel depiction holds for the sad mouth, and most children continue to employ the downward-facing curve, which becomes two dimensional in the drawings of the older ones. The diversity noticed in

a. *b.* *c.*

d. *e.* *f.*

100. *Happiness, Sadness, and Anger: Variations in the Shape of the Mouth a–f.* Ages 6;0 to 10;4.

the first graders' depiction of anger also characterizes the drawings of older children who adopt such additional techniques as zigzag, wave-like lines for lips and show an increase in the representation of teeth (see ills. 100 *a–f*).

In contrast to the early tendency to modify lips for expressive purposes, eyebrows only gradually come to depict mood states. The first and second graders include eyebrows only occasionally and without any differentiation. In the drawings of third graders eyebrows appear more frequently, with some distinction in the shape of semicircles for the happy child and diagonal slashes for the angry one. The drawing of eyelashes increases with age, and there is a slight tendency to include them somewhat more frequently on the drawings of the happy child. Tears, a very literal indication of sadness, appear in 10 percent of the drawings of first graders, increase to 90 percent for third graders, and still characterize 50 percent of the drawings of sixth graders (see ills. 101 *a–e*).

In general, it is the head or the face that is singled out as the carrier of affective meaning; body posture remains essentially undifferentiated. This emphasis on the face as the most expressive part of the human is demonstrated in the drawings that include only a head or a head and bust. In the first grade, approximately one quarter of the figures consist of a head only. In grades two through five, such emphasis on the head with or without a bust makes up more than 50 percent of all drawings.

Across the whole age range of our sample, humans are drawn in an upright stance and in the standard frontal orientation. A first indi-

a.

b.

c.

d.

e.

101. *Happiness, Sadness, and Anger: Variations in the Direction of Eyebrows a–e. Ages 9;2 to 11;1.*

cation of postural differentiation can be seen in the upward-pointing arms, a position meant to indicate a happy state, which appears as early as first grade and increases in frequency among the older children. By the sixth grade, the raised arms denote more varied mood states—for example, a complaining gesture indicative of sadness, or raised arms suggesting anger and threat. I also note drawings of crossed arms to signal anger, arms drawn parallel to the body as a mark of sadness, and the frequent holding of a prized item to indicate happiness (see ills. 102 *a–e*). A few children begin to experiment with leg position, such as a short leg lifted to kick or stemmed in a provocative-threatening gesture. T-shirts with "Beat It" complete this repertoire of devices that indicate anger and threat.

Although the general shape and direction of lines indicate the dominant feeling, there is yet little variation in the more subtle aspects of line quality along such dimensions as light versus dark, thin versus thick, or continuous versus discontinuous lines. Thus, variability in the direction of lines, whether upward or downward, horizontal or diagonal, takes precedence over other aspects of line quality.

Analysis of the drawings of a happy and frightening dream provides additional information about children's growing competence to depict affectively charged events. From the third grade on, a majority of our participants graphically differentiate between the dreamer and his dream state. The dreamer is depicted lying in his bed and the dream content enclosed within a boundary that clearly distinguishes the dream event from the reality of the sleeping child. The latter is frequently connected to his dream by a series of bubbles emanating

a.

b.

c.

d.

e.

102. *Happiness, Sadness, and Anger: Changes in Posture*
Variation in the direction of the arms suggests different mood states.
a–e. Ages 9;7 to 12;0.

from the head. This graphic device, most likely borrowed from cartoons and comic books, depicts both separation of the fantasy world from reality as well as its intimate connection with it. Such graphic depiction, which is strongly influenced by cultural conventions, can vary markedly from sample to sample. In this specific study, the depiction of the dream inside a bubble appears in approximately 10 percent of the drawings of first graders, increases to 36 percent for the second graders, and becomes the major mode of representation from the third grade on. The same graphic means characterize the happy as well as the frightening dream (see ills. 103 *a–d*). In a replication study conducted in a different school system, the incidence of bubbles to depict the dream state was much lower for grades one through five and disappeared altogether for grades six through eight!

Themes for the happy dream show considerable variation in content. Rainbows dominate the drawings of first graders who use it as a concrete symbol of the state of happiness. Minor themes refer to the outdoors, to smiling and thus happy people, birthdays, holidays, playing with friends, and having money (see ills. 104 *a–e*). The incidence of the rainbow theme declines for second graders, and it is no longer a central item in the drawings of the older children. Themes of happy people, wealth, pets, and sweets increase in frequency (see ills. 105 *a–e*). New themes appear to gain ascendancy for fourth graders who emphasize power, strength, fame, popularity, stardom as depicted in sports, and a concern with wealth and friendship (see ills. 106 *a–e*). By the sixth grade, the major themes are holidays, wealth, power, popularity, school, pets, and sweets.

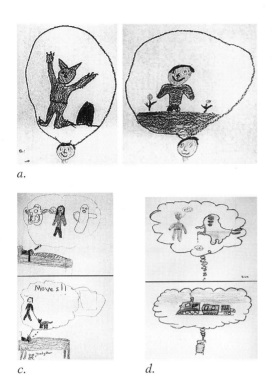

a.

b.

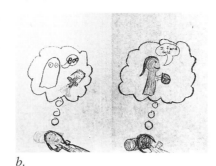

c.

d.

103. *Happy and Scary Dreams*
The dream content, enclosed within a contour, is connected to the dreamer's head either directly or via a series of "bubbles."
a–d. Artist ages 7;7 to 10;8.

104. *Happy Dreams: First Graders*
a–e. Ages 5;10 to 6;11.

a.

b.

c.

d.

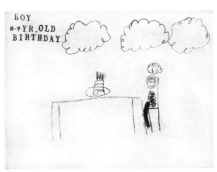

e.

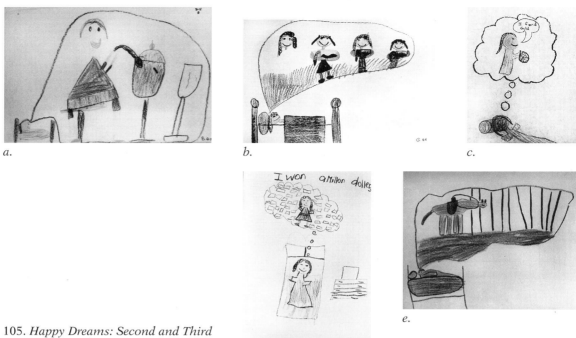

a. *b.* *c.*

e.

105. *Happy Dreams: Second and Third Graders*
a–e. Ages 7;7 to 8;6.

d.

a. *b.* *c.*

e.

106. *Happy Dreams: Fourth to Sixth Graders*
a–e. Ages 9;8 to 11;9.

d.

a. b.

c. d.

107. *Scary Dreams: First Graders*
Halloween images of ghosts and witches.
a–d. Ages: 6;1 to 6;10.

There is less variation in themes that depict a frightening dream. The great majority of first graders represent Halloween scenes with an assortment of ghosts, witches, goblins, vampires, graveyards, spiders, and pumpkins. No doubt the prevalence of this theme relates to the period during which we collected the drawings (see ills. 107 *a–d*). Halloween remains an important topic for second graders, and by the third grade it is replaced by a concern with monsters and an occasional extermination machine intent on harming the dreamer (ills. 108 *a, b, c*). References to harm and threat become more personalized for sixth graders who depict frightful attacks by people rather than by monsters and offer more detailed and effective portrayals with blood flowing and screams for help. Tears as a literal indication of unhappiness and fear appear less frequently than in the previous task that asked for the drawing of a sad child (see ills. 109 *a–e*).

108. *Scary Dreams: Second and Third Graders*
Threat emanates from witches and monsters.
a–c. Ages 7;10 to 8;6.

a. b. c.

a.

b.

c.

109. *Scary Dreams: Fourth to Sixth Graders*
Monstrous looking creatures continue to play a role in the depiction of scary dreams. For the sixth graders harm and threat become more personalized in the form of human attackers or falling off a cliff.
a–e. Ages 10;2 to 12;0.

d.

e.

As the foregoing description indicates, the majority of our children displayed some ability to depict the dream state as a mental event and conveyed a feeling of happiness or fear through an appropriately chosen thematic content. Even the younger children, who did not graphically differentiate between the dream and the dreamer, were usually able to depict at least two relevant items. I note that even at a fairly primitive level of representation, form cannot be separated from content, and that together they constitute the affectively charged message. Even the youngest children, who merely draw a smiling figure or a ghostlike apparition, use their relatively simple forms to represent the basic character of the object—to express its very nature. The undifferentiated figure of a ghost endowed with but few relevant details, such as hollow eyes and a gaping mouth, conveys an eerie, spooky creature. It is the very shapelessness of a ghost that conveys anxiety, an emotional state that also tends to be ill defined and of indefinite boundaries (see ills. 110 *a, b*).

In general, bright and more numerous colors were used for the happy dream; darker colors, no doubt related to the Halloween theme, tended to dominate the frightening dream, at least in the case of the younger children. However, as I already noted on the drawings of a happy, sad, and angry child, no unique color code applied to a specific type of dream. Consider, for example, the Halloween theme with its black witches, orange pumpkin, and yellow moon; the contrasting colors most likely indicate a concern for realism and are not yet a statement about the struggle between good and evil or hope and despair.

While the findings on our first task—the drawing of a happy, sad, and angry child—indicate that children use a very restricted vocabulary of graphic forms, and that they select their colors somewhat arbitrarily, the data for the thematically more meaningful subject of dreams suggest a greater expressive competence. Even our youngest children, the six-year-olds, convey feelings of pleasure and comfort in their drawings of a rainbow that protectively embraces the child, whereas the drawings of a centrally located and ominous looking ghost with two black and looming eyes looks quite threatening (see ills. 107 *a*, *b*). True, not all the drawings are equally successful— indeed, some depict both ghost and frightened child with the same big smiling mouth (see ills. 111).

Seven-year-olds make greater use of thematic possibilities as they portray the happy dreamer riding on his horse toward a castle. Another example is the image of a frightened child caught in the center of a web of radials, threatened by the presence of a black creature, perhaps a black spider; the wavelike radials that trap the figure convey a state of nightmarish tension (see ills. 112 *a*). Thus, on a more meaningful task, some six- and seven-year-olds can create images that are quite powerful. The themes of eight- and nine-year-olds become more diverse, and at times even individualistic, as the dreamer discovers that the members of his family are ghosts (see ills. 112 *b*). More conventional themes range from imprisonment—being tied to a stake as a witch stokes the fire under a pot of boiling water—to monstrous-looking fish with gaping jaws (see ills. 112 *c*, *d*, *e* and 109 *a*). Inscriptions multiply as an additional device to communicate terror and menace. Older children also begin to use color contrast to heighten tension and to convey threat.

Expression is also manifest in spatial matters, such as the size and location of a figure in space. A tiny figure squeezed in a corner carries much expression as compared with a brash figure in the center. The deliberate use of size and location, however, is infrequent in the drawings of elementary-school children.

In summary, our study of the depiction of three well-defined emotions portrayed in the drawings of single figures reveals a rather limited repertoire of simple forms. On this "context free" task, the earliest depiction of emotions consists of a transformation in the shape of the mouth. In the case of the contrasting emotions of happiness and sadness, the reversal of the semicircle aptly captures the opposing direction of these feelings, whereas anger tends to be expressed by the compressed straight line or by an abrupt change in direction. With few exceptions, notably the direction of the arms, body posture remains essentially static and does not aid in the differentiation of diverse emotional states. Similarly, color selection remains rather nonspecific, although the darker colors appear more often in the frightening dream. Emotions are most successfully depicted when they are embedded in a meaningful context—for example, happiness is playing with a friend, finding a pot of gold, and winning a game; fright means being attacked and harmed, hanging from a cliff, or facing an extermination machine. Thus, external events represent the

a.

b.

110. *Ghosts*
a–b. Ages 5;10 to 6;9.

111. *Undifferentiated Mood State*
Girl, 6;11. Both ghost and frightened child display a smiling mouth.

b.

a.

112. *Nightmare*
a. Girl, 7;10. The dream depicts a
frightened child caught in a web of radials.
b. Girl, 8;3. The dreamer discovers that the
members of her family are "ghosts."
c. Girl, 8;2. The hour of terror has struck:
the time is 12:05!
d. Boy, 8;5. The dreamer is imprisoned.
e. Boy, 9;8. Tied to a stake, the dreamer
watches helplessly as the witch stokes the
fire.

c.

d.

e.

emotions quite literally. The images are culture-specific, with rainbows and monsters derived from cartoons and commercial items. Suns, rainbows, goblins, ghosts, and gold are all stock-in-trade characters that represent happiness or fear. However, a rainbow is not of the same concrete order as candy, and a pot of gold stands for what one can buy with it, suggesting that these images, while conventional, function more like metaphors in that they are also symbolic and representative of a general mood state. Thus, on the one hand these findings reveal the child's restricted vocabulary of expressive forms, but on the other hand some ability to render the meaning of an emotionally charged theme can be detected (see also Winston, Kenyon, Stewardson & Lepine, 1995). Such competence in the depiction of a theme is most likely the case when the child, intent on portraying a personally relevant theme, uses simple figures and arranges them symmetrically. Even without the skill to make subtle distinctions of line, form, color, and shading, some of this early work can express its theme quite forcefully because the highly economical drawing can be easily grasped by the viewer (see ills. 113 *a*).

One might argue that our tactics of studying the child's ability to express feelings are constrained by the assignment of a theme that is to be completed in a relatively short time, under the probing eyes of the experimenter. Surely, distinctions ought to be made between drawing a nightmare and feeling nightmarish; the emotions that are expressed by a happy child drawing a bad dream and those depicted by a truly frightened child cannot be equated. Clearly, assigned themes do not tap deeply felt emotions in the same way as drawings

made spontaneously and in response to an inner need, such as nine-year-old Talmi's drawing of a terrorist attack on his kibbutz. His composition of men firing machine guns, or perhaps hand-held rockets, at a building that goes up in flames, with people trapped inside unable to escape, forcefully and directly expresses his anxiety about such an attack (see ills. 113 *b*). The depiction of emotionally charged content can reach an expressive power not usually seen in drawings made on request, as illustrated in the drawings of Ayana, a six-year-old girl who, faced with an incurable illness and under emotional duress, invented highly expressive and even metaphorical representational means that captured her anxiety and expressed deep-seated feelings of impending destruction and chaos.

The Drawings of Ayana

The spontaneous drawings of five-year-old Ayana are quite typical of a child who loves to draw and uses this medium freely and quite frequently. Most of her drawings depict flowers and people, which are of great interest to her. During the period when the family home is being built, Ayana incorporates houses in her repertory. The drawings are colorful and reflect a graphic vocabulary that is quite typical for this age (see ills. 114 *a–d*). It is during her sixth year of life that Ayana falls ill; as her abdomen swells, the illness is diagnosed as an inoperable tumor. Her drawings now undergo a marked transformation. The human figure drawings of this period depict a princess with a disproportionately small head and chest, and a very large body-dress. The problem area is marked by a thick black arrow that points downward to the troublesome region, which is further highlighted by an

a.

b.

113. *a. A Spooky Night*
Girl, 6;4.
b. Nightmare of terrorist attack
(From the collection of Malka Haas)
Artist is a boy, age nine.

a.

b.

c.

d.

114. *The Drawings of Ayana Before Her Illness*
a–d. The drawings of four- to five-year-old
Ayana are quite typical of preschool art.

115. *The Drawings of Ayana Made During Her Illness*

a–c. The human figure drawings of five-year-old Ayana highlight the troublesome region of her abdomen where an inoperable tumor makes her belly swell.

a.

c.

b.

undefined geometric design (see ills. 115 *a, b, c*). The few flower pictures drawn during this period display a black stem and a black sky overhead. As the disease progresses and the family acknowledges the inevitable outcome, Ayana draws several pictures with bodiless humans. This child who before her illness only drew representational figures and themes, now draws a series of weblike structures whose center is accentuated as if to symbolize the experience of feeling trapped, a situation without an exit (see ills. 116 *a–f*). Her drawings attain a metaphorical expressiveness in a rather distorted figure drawn in profile, with diagonals radiating from the center of the body, suggesting an implosion (ills. 116 *g*). A painting from the same period, an abstract in black and red brush strokes that move from the lower left diagonally across to the upper right, conveys the tension of forces that push relentlessly and are out of control (ills. CP-1). These pictures acknowledge her despair and the threat of chaos that she would not express verbally. In a tape recording that her mother made shortly before Ayana's death at the age of six years, the mother questions Ayana about her extended belly and asks her what she thinks will happen, an answer Ayana does not provide verbally, but that her pictures depict forcefully and symbolically. Thus, when intense experiences gain center stage, the drawings of even young children can reveal unsuspected expressive qualities that convey in a highly condensed fashion the depth of their feelings, in this case of fear and loneliness (see also ills. 117 *a–d*).

I now turn to the drawings of a group of children who lived under life-threatening conditions—children who became the victims of the Nazi Holocaust.

a.

c.

e.

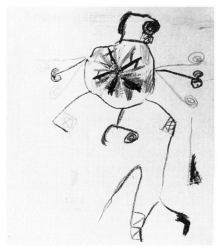

g.

b.

d.

f.

116. *Impending Doom*
a–f. The disembodied figures and web-like structures symbolize Ayana's growing despair.
g. This distorted human figure suggests an implosion emanating from the center of the body.

117. *Drawings of Hospitalized Children*
Boy, age nine.
a. Fears: "To be alone in the hospital room for infectious diseases."
b. Happiness: "My family comes to visit me." Girl, age nine.
c. Fears: "I'm most afraid to vomit." Self portrait in pajamas, vomiting into a bowl.
d. Happiness: "I like TV." This seriously ill girl depicts herself in her hospital bed, hooked up to an IV dispenser, watching television.

a.

b.

c.

d.

Children's Drawings from Terezin

A unique collection of 4,000 children's drawings made by the youthful inmates of the concentration camp at Terezin, the Czech Republic, is currently housed in the State Jewish Museum in Prague. This collection, although not representative of all the drawings made by the 15,000 children who passed through the camp (of whom only 100 survived), is a moving document of the human urge, in the child as well as the adult, to create and thus to leave a record of his being. Perhaps it is also an act of spiritual defiance in the face of overwhelming powers amassed by the Nazis to destroy any trace of their victims' existence.

The nature of this collection of drawings and paintings is in part determined by the circumstances that favored their preservation and retrieval, that is, on casual inspection these drawings do not seem particularly revealing of Nazi brutality. Most of the drawings were made in makeshift classrooms, with the support and guidance of adults who secretly assumed the role of teacher and counselor. Nevertheless, the themes are as diverse as is usually the case with children's drawings: they are drawn from daily life or from memory; they represent wishes, stories, and teacher assignments. They include landscapes, animals, fairytales, and matter-of-fact accounts. The extraordinary aspects of their lives, the daily events of standing in line for food, burials, hangings, and beatings are also portrayed. The nature of the drawings, the representation of objects and their arrangement, is quite typical of the developmental stages I have outlined so far. As with all child art, these drawings display the constraints within which

children depict a theme. The figures are always simple in their construction, there is little concern with the realistic size and proportion of the items portrayed, and right-angular relations and orthogonal views tend to dominate a scene. The drawings indicate with highly economical means the essentials of daily life. People are characterized by their utter simplicity and lack of adornment. The minimal figural differentiation, which is almost carried through to an extreme, is perhaps not quite typical of what their age-mates living in a more normal environment might portray. The reduction to essentials conveys the meaning of the picture quite poignantly. There is no mistaking of the events that are depicted with an austere rhythm. The themes that are not "childlike" but record nightmarish events in the simple graphic style of children, reveal their expressive power in the very form and content of their work which, among others, describes a burial procession using figures of utter simplicity, drawn with only minimal differentiation. The symmetry in the size, form, and placement of the two bearers of the coffin, with the four evenly spaced candles, conveys the grimness of the event. The two additional figures that comprise this procession, and the baby carriage out of which crying sounds ascend, suggest that the person in the coffin is perhaps the mother (see ills. 118). In their childish graphic language, the drawings convey the bleakness of the living quarters, the horror of a hanging, or invoke the wistful image of a Passover celebration. The latter evokes the memory of family life on a festive occasion in which the head of the household reads from a book, most likely the Haggada, which commemorates the exodus from the slavery of Egypt. Although these drawings are typical examples of child art, constrained by the limited figural differentiation as well as the compositional simplicity based on a principle of symmetry, they "work," and the intended meaning of the event is effectively portrayed (see ills. 119, 120, 121, 122).

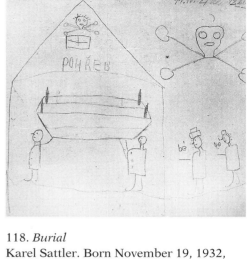

118. *Burial*
Karel Sattler. Born November 19, 1932, deported to Terezin September 8, 1942. Deported to Auschwitz October 4, 1944 where he perished. (From the Collection of the State Jewish Museum in Prague.)

119. *Three-Tiered Bunk*
Josef Novak. Born October 25, 1931, deported to Terezin April 24, 1942. Deported to Auschwitz May 18, 1944 where he perished. (From the Collection of the State Jewish Museum in Prague.)

120. *Three-Tiered Bunk*
Alfred Weisskopf. Born January 24, 1932, deported to
Terezin December 22, 1942. Deported to Auschwitz
December 18, 1943 where he perished. (From the Collection
of the State Jewish Museum in Prague.)

121. *Execution*
Josef Novak. (From the Collection of the State Jewish
Museum in Prague.)

As the foregoing, rather brief, description indicates, when a theme
is personally meaningful to a child, the drawings can convey her
mood, feeling, and a view of the event, despite the very obvious repre-
sentational limitations that characterize child art. I have not ad-
dressed the use of color in these drawings, because I have had only
access to reproductions and not to the originals in this collection. It
appears, however, that color use is quite similar to the wide variation
one commonly finds in children's drawings and paintings, which de-
pends on the availability of paints, pencils, and crayons, the theme,
the mood and individual preferences.

122. *Seder*
Eva Meitnerova. Born May 1, 1931,
deported to Terezin July 4, 1942. Deported
to Auschwitz May 18, 1944 where she
perished. (From the Collection of the State
Jewish Museum in Prague.)

Drawings of the Holocaust

How do present-day children convey in drawings their understanding of the Holocaust? An exhibition at the museum of Yad Vashem in Jerusalem commemorates the uprising in the ghetto of Warsaw with a collection of children's drawings on the theme of the Holocaust. The theme is well-known to Israeli children who participate in the yearly memorial events of the Holocaust day, study this period in history classes, and most likely hear about it from close relatives. In 1982, Israeli schoolchildren between the ages of 6 and 14 years were asked to submit their drawings or paintings on this distressing theme. Out of 500 submissions, a total of 70 paintings and drawings were chosen for the exhibition. Although the conditions under which the drawings were made are by no means standardized, and we do not know whether and to what extent teachers influenced the individual works that were submitted to the museum, they illustrate how children grapple with an emotionally evocative theme. By and large, the drawings portray the sadness that marked the victims of the Holocaust and the loneliness of the children imprisoned in a ghetto or concentration camp. The predominantly dark colors portray the hopelessness, depression, and sadness of the victims (see ills. 123 a–e; CP-2 a, b, c). The most common themes emphasize barbed-wire fences that imprison the inmates, who are cut off from the outside world, and include

123. *The Holocaust*
Drawings by Israeli School Children. (From the Collection of Yad Vashem, Art Museum, Jerusalem.)
a, b. Concentration camp inmates behind barbed wire. The work of fourth to sixth graders.
c. Ominous looking buildings enclosed by barbed wire. The work of a sixth grader.
d-e. Trains with their doomed passengers enter the concentration camp. The dark colors and the highly symmetrical composition convey threat and hopelessness. Artists are sixth graders.

a.

b.

c.

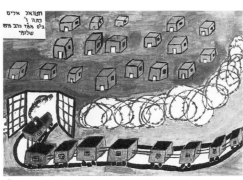

d.

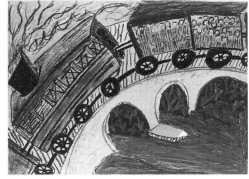

e.

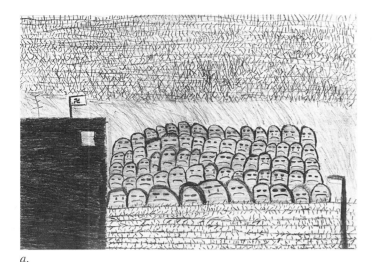

a.

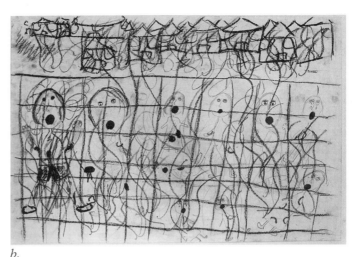

b.

124. *The Holocaust*
a–c. The densely spaced figures and the
relentless repetition of similar looking
faces and bodies convey the anonymity of
the victims herded together and their
horror when facing the gas chamber.
(From the Collection of Yad Vashem, Art
Museum, Jerusalem).

c.

bleak depictions of a humanless universe of crumbling houses and
fenced-off areas. There are trains that arrive with prisoners, crowds of
same-looking figures, or faces with the sadly drawn mouth. When in-
dividual figures are portrayed—for example, a single child centrally
placed in front of a fence—tears indicate her sadness. Composition-
ally, the repetition of similar faces, the crowding in of the figures who
no longer occupy their truly separate spaces in this world, creates a
powerful impact of doomed prisoners, of truly lost souls (see ills. 124
a, b, c). The crowding of faces and figures which runs counter to the
child's usual tendency to give each item its separate space, effectively
conveys oppression and lack of freedom. Very few of the drawings
portray group action such as an uprising, which is the actual theme of
the exhibition. Perhaps the Holocaust theme with its imagery of con-
centration camps and gas chambers is the more prevalent image in
the mind of the children as well as the adults.

Conveying Meaning

Once again, I note that despite the simplicity of the representation seen in the limited graphic vocabulary, in the mostly orthogonal viewpoint, in the flatness of most objects, and in the predominantly rightangular relations that prevail among individual figures and their surroundings, a basic unity of form, color, and content is achieved that conveys the message. This finding is the more impressive if one considers both the essentially static nature of the medium and the need to portray in a single frame a series of events that lead up to the moment of imprisonment and its aftermath, all known to the children.

The pictorial expression of affect has been a major concern of this chapter. In a set of empirically based studies, I have shown that the depiction of feelings is most successful when a theme is personally meaningful to the child. The study that asked for the somewhat out-of-context portrayal of three simple emotions showed a slowly developing repertoire of forms that serve in a very limited way to discriminate among the emotions of happiness, sadness, and anger. In this study, no link was found between color and emotions. The study that probed the depiction of happiness and fearfulness in dreams was somewhat more successful in eliciting portrayals that differentiate among these emotions, and color distinctions in terms of bright versus dark came into play. The depiction of emotions in a dream is content-bound, and subject matter plays an essential role in the expression and communication of affective meaning (see also Gregorian, Azarian, De Maria & McDonald, 1996).

The drawings of six-year-old Ayana call attention to a motivational factor, namely, that a drawing that depicts a personally significant state or event can express the concern of the young artist quite vividly. Continuing to search for drawings that deal with emotionally meaningful events, I presented some evidence that drawings about the Holocaust, both by inmates of a concentration camp and by children exposed to accounts of such camps, can lead to representations that capture the emotions of horror, loneliness, sadness, and doom.

I have stressed the many constraints on the child's ability to depict his intention, constraints that are intrinsic to an early phase of representational development. It is during this period that simple and somewhat static-looking figures, as yet undifferentiated in shape, direction, orientation, use of space, and the depiction of gesture, predominate. At an early phase, the child seems to be seduced by colors and does not select them with a specific representational purpose in mind.

As the previous exposition suggests, the question of how the child comes to depict affective states is really subordinate to the general problem—of the communication of meaning. The deliberate use of form, color, and space to convey affect is but an aspect of the more general problem to create meaning that conveys mood and feelings. What, then, are the devices children use to indicate such feelings as love, joy, closeness, anger, sadness, fear, and aloneness? The specific themes I have examined point to the portrayal of relevant items that embody their message: a barbed-wire fence, a child alone in front of a large

wall, ominous-looking trains that carry prisoners rather than passengers, a child with his dead mother as opposed to a child embraced by his mother (see ills. CP-3). Subject matter emerges as the dominant factor that organizes meaning and portrays feelings. It is intrinsic to the affectively charged theme, and forms as well as colors have to be congruent with the theme. Expressive properties of a drawing or painting need not be linked with the ability to use metaphors appropriately. Fences, trains, weeping children, crumbling houses, and fallen trees are quite concrete embodiments of harrowing events. Closer attention to the graphic devices that effectively portray their message also reveals that primary or even primitive forms can be quite expressive, especially when used in conjunction with some form of symmetry that repeats the same motif, and thus draws attention to a central meaning. Simple, unadorned forms that are symmetrically arranged can be quite effective because nothing extraneous detracts attention from the message.

Viktor Lowenfeld: The Child's Expression of Affective Meaning

Unless one understands the laws that govern the child's drawings during the early phases of representational development, one is apt to misread the drawing and its emotional content, for example, by placing an excessive emphasis on omission of parts and exaggeration in their depicted size. Such a position is taken by Viktor Lowenfeld, a major figure in the world of art education, who contends that the art of children is an expression of autoplastic (that is, of bodily) rather than visual experiences (Lowenfeld, 1939, 1947). Based on his early studies of the modeling of blind children he formulated a contrasting typology of "haptic" and "visual" types, which he later expanded to all artistic expression. According to Lowenfeld, the child's representations are affective statements and express in symbolic forms his subjectively felt values. The exaggerations in proportion and sizes, so characteristic of child art, express the child's intentions and emotional evaluations of objects and events. In his drawings the child expresses only what is important to him and what he knows intimately from his own bodily sensations; thus, autoplastic experience becomes the vehicle for artistic expression. The internal sensations are deemed to be at the source of all creative behavior and they force a change in the commonly used drawing schema, for example, by exaggerating the size of a body part to indicate its emotional importance. In this manner expressive symbols are created that are viewed as constituting the core of child art. According to Lowenfeld, the relations between objects are determined by personal, subjective feelings—they are relations of value; objective proportions are only portrayed when the child does not stand in a special relation to them. From this account, subjective experience emerges as the central factor in child art. Lowenfeld offers many examples of such affective symbols, for example, a significantly enlarged head to represent a headache. Examination of G.R.'s drawings (1939, figures 11, 17, 22, 23, and 35), however, reveals that he equips *all* of his human figures with a disproportionately large head, and that this rep-

resentation in fact constitutes G.R.'s human schema, independent of the specific content portrayed. Other exaggerations, such as the lengthening of an arm, are interpreted in a similar vein. D.H.'s drawing of "Searching for the Lost Pencil" depicts a person who is equipped with a straight torso, a curved neck, and elongated arms that reach to the ground to locate the lost pencil. The author maintains that the exaggerated length of the arms represents the child's kinesthetic experience of reaching, and the large size of the pencil indicates its emotional significance for the child. A simple functional explanation is overlooked, namely, that lengthening the arms is the most straightforward manner in which to solve the problem of reaching without having to change the posture of the body and legs, and that the pencil's size has to be large enough to be grasped or, better yet, to indicate the intended action of grasping (Lowenfeld, 1947). Another theme, of a mother picking tulips, drawn by a seven-year-old child, is interpreted in a similar vein. In the author's words, "The exaggerated size of the tulips remaining to be picked emphasizes their relative importance" (Lowenfeld & Lambert-Brittain, 1970, p. 176). A simpler interpretation takes note of the graphic logic that underlies the same height of mother and flowers, that brings the tulips into easy reach, and thus aptly circumvents the problem of bending the figure.

Surely, there are examples where changes in size carry a very personal meaning. I merely wish to draw attention to the pitfalls of relying on a fixed set of symbols as the presumed carriers of affective meaning while ignoring the child's problem-solving efforts. The value and beauty of child art is not limited to the representation of tactile and kinesthetic sensations, and it seems one-sided to endow only those experiences with expressive potential. Emphasizing the visual reasoning that underlies such graphic solutions is not meant to deny that at times size can play a symbolic role expressing a complex set of feelings, as the drawing of four-year-old Jessica suggests (see ills. 125). The drawing is of her mother and the figure is graphically well

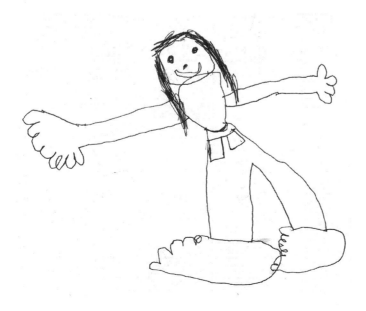

125. *Mother*
Girl, age four. The exaggerated size of the right arm and the two feet indicate Jessica's concern with mother's power and her ability to inflict physical punishment.

differentiated, particularly if we consider the age of our young artist. But our attention is primarily drawn to the size of the right arm and the two feet, which in Jessica's own words reflect her concern with mother's power: "Mom gets mad when I am bad. We talk about being bad. . . . I have to make big fingers, mommy uses her big hand when I'm bad. My momma has big feet. . . . Momma has little shorts on now."

Affect Through Narrative Drawings

Attempts to overcome the restrictions that a single frame imposes on the artist and to portray an action sequence by, for example, moving the protagonist across the picture space to a new location, can be seen in what Brent and Marjory Wilson have termed "visual narratives." Such pictorial narratives utilize successive frames for the telling of a tale that, if successful, comprises a beginning, a middle, and an end. Often the visual narratives portray themes of adventure, villainy, a struggle between the good and the bad guys that ends in victory for the brave and righteous. Such drawings reflect the concerns of the growing child with violence, harm, and loss. The Wilsons have done extensive work locating children who, spontaneously and mostly outside the classroom, produce numerous pictorial narratives. The analysis of these drawings highlights the impact of comic books and television on the creation of characters, their action, and mode of representation. These sources provide children with popular themes, ready made images, and a graphic vocabulary to express their hopes, fears, and wishes. The dramatic action is often played out on a seemingly impersonal plane of fantasy, on which superheroes and archvillains enact their struggles (B. Wilson, 1974; Wilson & Wilson, 1977, 1979). According to Marjory and Brent Wilson, and Paul Duncum (1981), the models presented by these popular media facilitate the expression of deeply held concerns of children and preadolescents in providing a format for the productive articulation of conflicts and their resolution. The fact that in their pictorial narratives children follow a readily available model does not imply that their work lacks individual character, personal meaning, or creative invention. The truly devoted and also gifted serialists populate their world with protagonists who, though they bear a resemblance to the heroes and villains of the popular youth culture, are nevertheless the offspring of their maker, carrying his very personal, at times even idiosyncratic imprint. While the narrative dimension is clearly evident in the serially ordered frames that depict a story, the Wilsons detect in most of child art a fantasy narrative. According to this view, child art is play art and, in its expression, akin to dramatic play. (For a related view on the early antecedents of play art see Matthews' account of infants and toddlers reviewed in chapter 1.) The child or adolescent engaged in drawing is performing for an "audience of one." Spinning tales of power, woe, destruction, and rescue, the youngster offers his version

of the mythical themes provided by his culture. The act of drawing becomes a vehicle for the expression of personal fantasies that are embedded in emotionally significant themes of a collective nature and thus provide the means for participating in the shared imagery of the youth culture. Boys and girls tend to elaborate on different themes: the spontaneous productions of boys reveal an intense concern with warfare, acts of violence and destruction, machinery, and sports contests, while girls depict more tranquil scenes of romance, family life, landscapes, and children at play.

In her essay "Combat in Child Art," Sylvia Feinburg (1976) traces the theme of war in the artwork of her son that spans a period from early childhood to the onset of adolescence. Between the ages of four to five years, the monster and dinosaur themes dominate. From six years on, war pictures gain center stage, with hordes of men, planes, ships, artillery, bombs, and rockets. According to Feinburg, the major theme for boys between the ages of 6 to 12 years is the contest between the opposing forces of good and evil, of victory and defeat.

The development of a similar theme of power and conquest has been examined by Dinah Blake (1988), who studied the drawings of a precociously talented, highly verbal boy. At the age of six years, Roger invented an imaginary world of space creatures and their battles. He populated his fantasy world with spacemen, their companions and enemies, vehicles and weapons, living and traveling environments. The extensive collection of his drawings made over a period of six to seven years demonstrates his intense fascination with the space theme.

Initially, the predominant creatures in Roger's world are the powerful "Planorbisons," the good guys. They are blue and purple human-shaped creatures with domed heads. Unlike humans, however, the Planorbisons see with their whole body, have the capacity to roll up into little balls, and do not need to eat. They travel, converse, and eventually engage their enemies in battle (see ills. 126 *a–e*).

As Roger continues to elaborate his space world, he creates even more powerful "good guys," the Terrikeips who engage the enemy. The Terrikeips look like the Planorbisons except that their colors are reversed. Together with the friendly wormlike "Dedicated Assistants," they share the space environment with unnamed enemies marked by their triangular bodies. The early Planorbison spaceship is doughnut-shaped with a clear bubble over the central cockpit; often it is surrounded by a convoluted force field outlined in green. The Terrikeip vehicles are pointed and angular. Stars, planets, and "just plain space" form the background of the Planorbison universe.

Roger spends two years refining the Planorbison world (see ills. 127 *a–e*), after which his interest in this theme begins to decline. His fascination with science fiction, however, does not fade away. As his technical competence increases, he creates more elaborate aliens of essentially human shape, creatures with flame heads and vaporous extremities that "dematerialize." Only one of the aliens is female. He also develops complicated three-dimensional spaceships and bodies

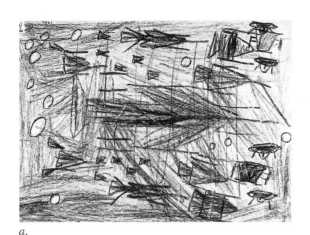

a.

b.

c.

126. *The Planorbisons*
a. Spaceships surrounded by early stars.
b. Planorbisons and spaceships with force fields.
c. Planorbisons in their habitats, which are interconnected by travel tubes.
d. Planorbisons, spaceship, and buildings. "Dedicated Assistants" appear in travel tubes.
e. Planorbison: "Doesn't need to eat, sees with his whole body."
Age of artist seven to eight.

d.

e.

of aliens. As his representational strategies are perfected, the space creatures engage in battles that involve guns, bullets, flame-throwers, and the like. Roger's "good guys" always vanquish their enemies.

Roger invented his space creatures during his first year in elementary school. Having to adjust to a new and perhaps less-obliging environment than his home, he sought comfort in the companionship of his powerful space creatures. He involved himself with the nonthreatening creatures of his own making, and they provided him with a sense of social power and superiority. Wishes for power and control find expression in his fantasy characters. It is telling that the Planorbisons, who were "creatures superior to people," needed to be reinforced with the Terrikeips, who were even more powerful. Clearly, the Planorbison world provided Roger with an environment that he could totally manipulate and over which he ruled supreme.

Roger's fantasy space world also provided him with an outlet for the expression of aggressive feelings in a socially acceptable form. The shooting of enemy aliens, the flame-throwing, and explosions are emotionally charged themes that could be explored without risk, en-

127. *Outer Space, Creatures, and Planets*
a. Planorbisons in building, air shuttle, and flying with jet-pack. "Dedicated Assistants" doing a dance in lower right.
b. Robot with electric Bostaff accompanied by "Elemental Assistant." Planets and spaceship in background.
c. Spaceship, alien, and terrain vehicle shooting rocket ship.
d. Steam powered spaceship.
e. "He's coming now." Flamehead alien materializing in front of "Elemental Aliens." Age of artist: 9 to 11.

acted within a safe environment, remote from the daily interactions with the powers that be. As Roger developed friendships with the boys in his neighborhood, drawing sophisticated spaceships and space creatures became a socially respected activity, now often engaged in jointly. During those elementary school years, when he felt socially isolated, Roger chose to express himself through graphic narratives, because, in his words, "They were incredibly easy to draw."

Girls employ imagery that is often derived from fairytales, with kings and queens playing an important role in their drawings. Animals can also assume center stage and become the focus of repeated drawings, a finding particularly well illustrated in the drawings of Heidi, for whom the horse became an object of enduring and passionate concern that led to an in-depth study of its appearance and very nature (Fein, 1984, see chapter 3). The differences in the content of drawings of boys and girls that was already noticed by early investigators (Ballard, 1912; McCarthy, 1924) and the relatively high output of

drawings during the childhood years, indicate their status as a much-favored activity and dictate a closer look at the motivation for art-making.

Motivation

Drawing is a solitary activity with crayons, magic markers, or pencils that creates an imaginative representation of an aspect of the child's world. The child who discovers the magic power he can wield over the blank page engages in a uniquely human activity that transforms his ordinary experience of the world and represents it on a new, and perhaps mythical, plane of action and thought. Unlike children's stories, drawing leaves a visible record, a tangible trace that can be examined, talked to and understood quite independently of the sequence that gave rise to it. The child's actions in play, storytelling, dance, and song are of a temporary nature; they vanish when the action has ended. However, long before the child can effectively use the written word, his drawings already make a statement that endures.

To leave a mark, to make a form, to give shape, are all means of exploring and understanding both oneself and the object that is drawn. For the young child, the motive to represent is simple; namely, to create forms that bear a likeness to the object. It is a limited aim that reflects the directness of his relationship with his world, the desire to perceive and to make that can be captured in the statement: "I am what I do." As the questions raised and the issues addressed increase in complexity, so does the motive for drawing. New problems are set and new solutions are found. Likewise, the involvement changes as simple form–color statements of perceptions and actions give way to more ambitious projects whose symbolic meaning affords more varied forms of satisfaction. The act of drawing asserts control over the objects represented; it is the power to make and to unmake, to come to know the object more intimately and to possess it in unique ways. The approach to the world, in the child as well as the adult, is always affectively colored, and the drawings portray significant relations, concerns, desires, fears, and wishes, classifying major events as either good or evil, beautiful or ugly, attractive or repulsive. To a large extent, the involvement with art-making is inner-directed and propelled toward increasingly greater articulation, as the previous chapters have demonstrated. Drawing and painting are expressive statements about what one knows, feels, and wants to understand. It is a dialogue with oneself and, as all meaning, intrinsically affective. (For a more detailed presentation of the motivation for art making see the longitudinal accounts on the drawings and paintings of several talented children reported in chapter 7.)

Beyond these general observations—which apply to both children and adults, males and females—there are also a host of individual motives that determine art-making that are as varied as we are one from another. Some children are endowed with intensely vivid images and with a hunger for visual stimulation that leads them to search for

pictures and illustrations, wherever they can find them, even in the musty books of their parents' library. Brent Wilson's account of little Julian offers a convincing portrait of a six-year-old literally driven to immerse himself in the pictorial world of "naked people, men and women being hounded and whipped before a cruel torturer" (1976, p. 53). Among the youngsters Wilson has studied, he draws attention to the graphic narrators whose massive and continuous output of characters and their adventures suggest an immense urge to put an internal storehouse of images on paper. In the words of ten-year-old J.C., "I have a whole bunch of superheroes in my head, and I am trying to get them out of my mind, and I cracked out a few I had forgotten" (1974, p. 3). Paul Duncum (1981) also reports on the prolific image-makers he has come to know, and the necessity these children feel to create pictorial images, often in the cartoonist's tradition, developing intricate narrative plots. Theirs is a passion to draw, and some may feel desperation at the thought that the supply of paper might run out!

The narrative tendency is motivated by the desire to tell a story—to convey information about the nature and function of objects, the layout of a scene, and the actions and intentions of protagonists. It drives the desire for narrative competence, for differentiating and coordinating the various elements of the composition to effectively convey the message. The expressive tendency manifests itself in the selection of forms and colors that convey an affective message, often by exaggerating the size and color of body parts and in the aesthetic delight children find in ornamentation. These tendencies lead to the development of different styles of representation and yield their artists different kinds of satisfaction.

Some children are colorists who tend to use dramatic rather than naturalistic forms, and they relish the expressive and decorative attributes of color, texture, and design. For them, the sensuousness of a painting, the quality of the brush-strokes and the choice of color is, next to the theme, of utmost importance; for these young artists color can become the dominant organizing principle of a composition. For other children, the master motive is to render a scene with as great a fidelity as they can muster, and they return to a similar theme time and again, attempting to improve on their vision and depictive skills. We can distinguish colorists and those that value the fine pencil or marker that permits maximum control over the line (see chapter 7, the art of Amnon, Eytan, and Varda). There are children who use this medium to truly understand their world—the world of nature and of man-made objects—for whom to "make" is to "know," and they can be relentless in the pursuit of a problem they have set themselves (see Eytan, chapter 7). For others, fantasies only vaguely understood become the propelling force to grapple with conflicting, at times terrifying, feelings of love and hate, erotic attraction and repulsion, birth, death, and destruction; with themes of punishment, loss, jealousy, generosity, and the desire for recognition. The fantasy dimension of pictorial expression may diminish the intensity of emotional conflicts that are particularly painful because of the child's dependency on

adults and her powerlessness vis à vis them. In the realm of drawing, it is the child who conducts affairs, asserts power, and determines the fate of his or her characters. Similar conditions may pertain in the life of an adult. The drawings of Charlotte Solomon (*Charlotte: Life or Theater? An Autobiographical Play* [Lane, 1981]) offer a moving example of a young artist in her twenties, powerless vis-à-vis the Nazi machinery out to destroy her, telling her life's story in a serially ordered pictorial narrative. In nearly 800 small gouaches she conveys with simple lines and a limited color palette, accompanied by words and musical references, the full drama of her existence. Clearly, drawings can provide multiple sources of satisfaction that are at once of an emotional, cognitive, and aesthetic order. Above all, drawing, unlike the camera, does not capture a ready-made slice of the world; it is a true construction that requires a vision.

I have roamed broadly in response to the question of how children come to depict internal states of mood and feelings. I began with an inquiry into the role of color in children's drawings and an examination of the graphic devices used to portray emotions, and ended with a description of the gradually emerging competence to convey an emotionally significant theme. My concern has been, once again, with the processes of differentiation—that is, how children come to make effective use of the medium. The representation of mood, feelings, intentions, and gesture is not simply the result of elements being added or imposed on a previously affectless drawing. From the very beginning of the representational enterprise, forms are intrinsically meaningful and expressive. True, they are constrained by the limited differentiation that characterizes all beginnings, and in the medium we are considering, this means using simple forms, representing most objects in a standard orientation, and paying little attention to detail, size, proportion, and true color. However, child art touches a responsive chord in the adults who study the drawings of children, and the frequent references to its affinity with folk art and the art of modern artists of the 20th century attest to its power to engage us in a dialogue. Child art has its own "physiognomy" and can best be understood in the broader framework of studies on physiognomic perception that examine the expressive characteristics of objects (Arnheim, 1974, 1988; Asch, 1952; Gibson, 1979; Kennedy, 1984; Merleau-Ponty, 1962; Sartre 1962; Werner, 1948; Werner & Kaplan, 1963). According to Arnheim, expression is the primary content of vision in daily life; it resides in the perceptual qualities of the stimulus pattern. Similarly, John Kennedy (1984) has argued that an excessive emphasis on the conceptual aspects of art, on the notion that art forms are merely arbitrary conventions, ignores the very nature of perception and of representation, both of which are intrinsically expressive and not merely the product of a cultural convention.

My studies, which were designed to probe the child's competence to depict feelings, have demonstrated that deeply felt experiences and meaningful themes can attain a directness of expression that, despite its simplicity, is engaging and valued by the child as well as the adult. Expression resides in the total composition, with the theme determin-

ing the choice of characters, objects, and their arrangement. Even the simple arrangements young children make can convey complex feelings and relationships. Consider a drawing of the family in which all members, with one exception, are drawn in similar ways, ordered according to decreasing sizes, with the baby in the family portrayed as a tiny tadpole, perhaps equipped with a single hair. Such a depiction in which the least differentiated figure represents the youngest, most helpless, and least competent member of the family is quite common.

Simplification is a form of abstraction and condensation of meaning that affects the observer with the directness of its message. Consider the drawing of a haircut by a six-year-old girl. The composition includes all the essential elements: the seated child, the mirror, the hairdresser with his scissors pointing at the head, and the mother. It portrays a moment of tension and of potential terror overcome, a resolution of tension in mother's assumed pride in her brave daughter (see ills. 128). The drawings of the young can convey a vision that is devoid of artifice, and at times the immediacy of its message can be highly effective. In the words of a student who argues that content and composition in drawing are inseparable: "These pictures of birthday parties I have viewed present the last second before cake, child, dish, fork, chair, and table become a fused mass as the children consummate the eternal longing to consume the most birthday cake as frequently as possible." In this view, expression inheres in the total picture, in its form, color, and content. It does not reside in the individual figure, but is an intrinsic part of the composition and its meaning. While the use of gesture, movement, facial expression, line quality, and color combinations are all important ingredients, expression

128. *Haircut*
Girl, six years.

lies in the thematic and structural arrangement of the elements. In the words of Arnheim, "The visual form of a work of art is neither arbitrary nor a mere play of shapes and colors. It is indispensible as an interpretor of the idea the work is meant to express . . . the subject matter is correlated with the formal pattern to supply a concrete embodiment of an abstract theme (Arnheim, 1974, p. 460).

This brings us to the heart of the matter—namely, that expression resides in the arrangement of all the elements of a composition, a theme to be taken up next.

Composition: The Creation of Pictorial Space and the Communication of Meaning

<div style="text-align:right">6</div>

Composition in the visual arts refers to the intentional arrangement of all the elements of a work. The primary function of composition is to arrange the elements of line, form, space, and color in a manner that indicates to the viewer what the work is about. To compose means to employ grouping principles that determine how figures are arranged to form units, and it is their organization into patterns that facilitates the communication of meaning and elicits appreciation of the work.

A major issue, pursued in the previous chapters, concerned the nature of figural differentiation; that is, the growing competence to draw animate and inanimate objects and the ability to attend to a figure's relative size, proportion, and orientation. Figural differentiation is essential for the making of a graphic statement, but figures that are drawn as separate entities, in relative isolation from each other, can state their identity only in a very restricted sense, without clearly establishing the intent and mood of a theme. In order to depict a theme—that is, to state the subject matter of the drawing or to narrate an event—figures as well as other pictorial objects have to be organized in the pictorial plane; they have to be grouped in some meaningful way.

The study of compositional development in drawing examines the manner in which children distribute forms across the page and how these are ordered. The creation of pictorial space depends on the coordination of several different frameworks that specify (1) the relations among the parts of a single figure or object, (2) the relations among several figures, and (3) the relation of groups of figures to the superordinate structure that unites the different components into a coherent pictorial statement. At the most basic level it is necessary to consider the construction of an individual figure, the differentiation of its parts, its likeness to the referent, and the means by which this is accomplished—a subject I discussed at length in chapter 3 and 4. At the next level of complexity, the orientation of the figure and its location in space are considered. A figure's orientation and location can

<div style="text-align:right">169</div>

indicate whether it is "aspatial," that is, unrelated to the surrounding space or related to its background in a systematic fashion that maps directions derived from the real world onto the paper. Finally, there is the need to analyze the relationship between figures and their surrounding, and to identify the principles that govern the whole structure and incorporate the earlier-mentioned levels. Such a coordination of all the elements that comprise a drawing makes great demands on the cognitive planning capacities of the child, and it requires, at the very least, an intuitive understanding of part–whole relations and their mutual regulation.

I shall begin with a general description of developmental findings and then take a closer look at the manner in which the subject matter dictates the adoption of compositional strategies. An examination of task effects reveals how themes can modify a preferred mode of organization and precipitate new understanding.

Compositional Trends in Development

What organizing principles can one detect in the development of compositional skills? What are the earliest attempts to order the figural elements and to create a unified whole? My report derives from a close examination of over 1,000 drawings collected under standardized conditions from 197 youngsters ages 3 to 13 years who were seen in individual sessions (Golomb, 1987a; Golomb & Dunnington, 1985; Golomb & Farmer, 1983). These findings are supported by a second set of drawings on the same themes that were group-administered to approximately 400 children in grades one through eight. In order to determine the extent to which compositional strategies depend on the nature of the task, the children were asked to draw several themes: the Family; a Birthday Party; Children Playing; and a Garden with Trees, Flowers, and a Pond. Approximately one half of the youngsters were also given the assignment to draw a Living Room and their House and Street. Additional drawings on other themes were also obtained from a group of 36 four-to-six-year-olds. On the basis of a careful analysis of these drawings, I can delineate the emergence of simple grouping tendencies that can be subsumed under two compositional principles: alignment of items in a gridlike fashion along both horizontal and vertical axes, and centering strategies, which organize items around a pictorial center.

At first, the page merely serves as background for the depiction of individual forms, and there is no discernible relationship between the drawn items. Figures are dispersed in a seemingly arbitrary fashion with little attention to their location or their orientation. At times it appears as if the child merely fills the available space. This phase of placing figures and other subjects randomly across the page is usually short-lived. Among our youngest children it appears infrequently, and only in the drawings of very simple shapes. It is soon followed by a tendency to draw items in close proximity to each other, which yields clusters of indeterminate orientation (see ills. 129 *a*, *b*, *c*). Proximity,

a. b. c.

however, is not a very satisfying ordering principle even for our three-year-olds. This rather primitive effort to create units conveys little information about the topic. The arrangement of items by mere proximity undergoes a marked transformation when directionality is introduced, which imposes a new order on the array. Figures are now drawn side-by-side on an imaginary horizontal axis, and they are partially aligned with one of the edges of the paper. Alignment of figures occurs in a single direction, and this unidirectionality constrains the earlier nonspecific rule of proximity. The majority (55 percent) of the drawings of our three-year-olds are partially aligned. The line-up often consists of a repetition of similar items without, however, paying much attention to the exact size, placement, or spacing of the figures. Although the line-up introduces direction into the display, the exact location on the page is still of little importance and shapes, sizes, distances, and endpoints are not closely attended to. Figures are placed unevenly and appear to be floating in a space whose coordinates are indeterminate (see ills. 130 *a*, *b*; 27 *a*; 77 *b*, *d*; 96 *b*). Despite this lack of uniformity in the size and placement of the individual figures, partial alignment can impart a primitive sense of belongingness to the various items, and one might consider their directional line-up suggestive of a "common fate" (Wertheimer, 1923). Alignment is a form of enumeration in which the proximity of items implies a relationship. However, enumeration by itself interprets the nature of the relationship only in an elementary way. So long as figures are merely

129. *Early Compositions: Figures Are Dispersed Across the Page*
a. Girl, 3;4. Family.
b. Boy, 5;0. People, animals, plants, and house.
c. Girl, 5;7. Family.

130. *Partial Alignment of Figures*
a. Girl, 3;5. Family.
*b.*Girl, 4;7. Playing ball.
(Also see 27 *a*, 77 *b*, 79 *d*, 96 *b*.)

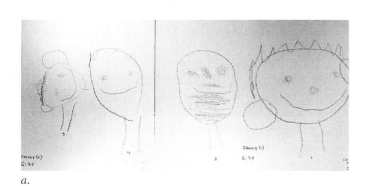 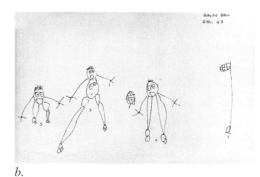

a. b.

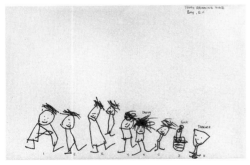

a.

b.

131. *Simple Alignments*
a. Boy, 5;11. Story reading.
b. Girl, grade two. Playing ball.
(Also see 39 *a*, 77 *a*,)

drawn side-by-side without regard for size, figural differentiation, orientation, and distance—that is, without utilizing principles of similarity and of contrast—the thematic structure of the drawing is minimal. Partial alignment is the precursor of ordering an array within the clearly defined horizontal and vertical coordinates of the Cartesian grid. Organization within such a grid emerges when the child attains a better grasp of the nature of pictorial space and, eventually, it comes to dominate the drawings of older children. Line-up of figures is not to be mistaken for symmetry. Only with attention to equal spacing of figures and the deliberate use of similarity in regard to size and shape can one speak of a symmetrical arrangement.

Among the four-year-olds a decline in the use of proximity and partial alignment is evident, and a tendency emerges to align figures more carefully, with some attention to spacing and to the endpoints of a series. Figures begin to show greater similarity in form and size, which yields a more ordered display. They are still aligned along an imaginary horizontal axis without the benefit of a ground- or stand-line although, occasionally, their alignment along the bottom edge of the paper substitutes for a baseline (see ills. 131 *a, b*; 39; 49 *a*; 77 *a*).

With the application of a simple principle of similarity, the undifferentiated alignment of figures gives way to a more ordered arrangement of similar figures that are now evenly aligned across the horizontal axis. Since such a pattern merely repeats the same rather simple figure, the nature of the relationship remains unstated, undefined, and open-ended. There is as yet little, if any, thematic ordering or grouping of figures, and the alignment is a mere enumeration of items that belong together. This is most clearly seen in the Family task, in which similar figures are evenly spaced without differentiating the age and sex of individual members (see ills. 132 *a*). Alignment need not be limited to homogenous figures—it can also be the organizing principle for several different figures; it demonstrates in both cases that the mere enumeration of items does not easily constitute a theme (see ills. 132 *b* and 79 *a*). Also, alignment of items need not be confined to a single plane, and if space on one level is insufficient to accommodate all the objects, the next one may be used. Here I note that three- and four-year-olds extend their figures across the whole page, either by drawing large figures that easily fill the available space or by aligning them along appropriately parallel horizontals.

The trends described so far continue for five- and six-year-olds who appear to use the alignment principle of spatial organization with greater confidence. The alignment strategies that organize space in a gridlike fashion of horizontals and verticals include more varied figures, frequently aligned on a single baseline—a simple grouping principle that anchors all figures in the common plane. The figures tend to be located in the bottom part of the page, which implies that the open space in the upper section now represents air or sky. I also find a more explicit representation of the sky marked by birds, clouds, or sun. In such drawings, two distinct areas of "up" and "down" are defined, and gravity is generally respected (see ills. 94 *a*).

a.

b.

As the number of graphically differentiated figures increases, as horizontal baselines, groundlines, and skylines are introduced that anchor the figures and "frame" the picture, the drawing gains in thematic complexity. The sheer increase in the variety of forms, sizes, and colors, and the more explicitly drawn spatial referents of ground and sky, suggest that the figures belong together, that the items constitute a unit either in nature or merely in the drawing. However, without the employment of additional grouping principles, the theme conveys meaning only in a general sense (for example, the "outdoors," "people," "playground," and "parties" see ills. 133 *a, b, c* and 79 *b*). Although in these instances the subject matter of the drawing may be guessed correctly, it is not explicitly or compellingly stated. Contrastingly, the intentional use of rules of proximity and separation, of similarity and difference in size, color, activity, location, and orientation, yields a more explicit grouping of figures that can suggest meaningful relations. For example, children may be grouped together in the drawing to indicate play, a collection of houses can refer to a street or a village, and trees and flowers can convey the flavor of a park. Thus, alignment strategies based in a gridlike structure of horizontal and vertical coordinates can be used to depict a theme. Depending on the degree of order or grouping of the elements, the alignment strategy might yield a primitive enumeration of items vaguely suggestive of

132. *Alignment*
A mere enumeration of items cannot clearly convey the nature of the theme.
a. First grader. Family and pets. The artist employs the same graphic formula for all the members of the family. Neither size nor clothing distinguish adults from children, males from females. Labeling of the figures aids in the identification of the family theme.
b. First grader. Family. "My family is inside the house."

133. *Advanced Alignment Strategies*
When graphically differentiated items are carefully aligned, they can suggest their theme in a general way.
a–c. Artist ages 7 to 12.

a.

b.

c.

a.

b.

c.

d.

134. *Alignment Strategies and the Grouping of Elements*
Figures are grouped into meaningful units that enrich the theme.
a–d. Artist ages 11 to 12.

the subject matter, or it can generate a thematically unified and fairly coherent picture (see ills. 134 *a–d*). In general, alignment strategies do not employ repetition of subpatterns, which means they do not make intentional use of symmetry, nor do they aim for a balanced composition.

Along with the effort to create order and meaning by aligning figures in the horizontal plane, first on single and later on multiple standlines, a second organizing principle can be detected that begins with the act of simple figural centering. Almost from the beginning of compositional development, a tendency can be noted to place a single figure in the center, somewhere along the vertical midline of the page. At its simplest, this strategy acknowledges the reality of the paper-space and bestows a degree of prominence and stability on the figure. Along with centering of single items, primitive precursors of early forms of symmetry can be seen, in which fairly simple figures are enclosed by a contour that imposes cohesion on the configuration. The contour links the figures and enhances a directional vector (see ills. 135). Enclosing contours reflect the intuitive assessment that "floating" figures lack meaning, that they need to be anchored or grouped together. This is one of the earliest grouping principles, following proximity

and partial alignment. The early appearance of symmetry is perhaps surprising given the primitive graphic means of our youngest children and the cognitive demands of planning even a simple symmetrical arrangement (see ills. 136 *a*, *b*). Overall, centric strategies appear in approximately 15 percent of the drawings of the three-year-olds.

A more advanced version of enclosing figures within an embracing contour can be seen in the deliberate "framing" of figures drawn off-center, in a section of the page. In such cases the frame establishes a new center that ignores the rest of the page and firmly ties the figures into a coherent unit (see ills. 137 *a*, *b*). Other forms of early symmetry can be seen in groups of figures or other objects that are balanced around a center (see ills. 138 *a*, *b*; and 96 *c*). Among our four-year-olds there is a notable increase in centrist tendencies, which now define 36 percent of the drawings.

Five- and six-year-old children display a better grasp of the centric principle of spatial organization and make more deliberate use of symmetry. Symmetry can be defined as the correspondence in size, shape, and relative positions of parts that are on opposite sides of a dividing line or that are distributed about a center or axis (*Webster's Third New International Dictionary*, 1976). Among our youngsters, symmetrical arrangements now include equal spacing among figures, similar distances from the edges of the page, systematic variation in

135. *The Enclosing Contour*
Separate figures are tied into a configuration.

b.

136. *Primitive Forms of Symmetry*
a. Girl, 3;9.
b. Girl, 3;11.

a.

137. *Framing*
The frame ties the figures into a coherent unit.
a–b. Artists are first graders.

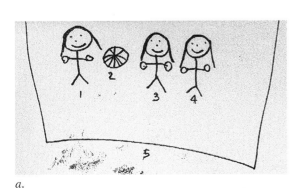

a.

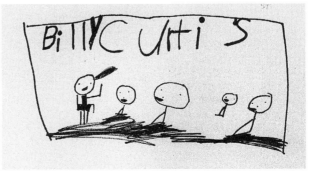

b.

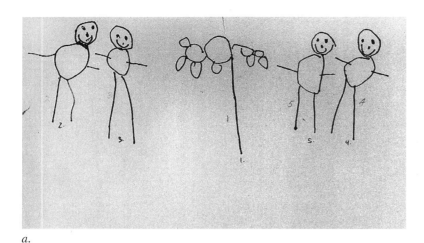

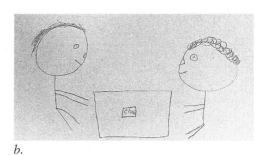

a.

b.

138. *Early Forms of Symmetry*
a. Girl, age five. Apple picking.
b. Girl, age nine. Children playing.
(See also 96 *c*.)

139. *Simple Forms of Symmetry*
Symmetrical arrangements create visually
pleasing and balanced compositions.
a–c. Artist ages five to seven.

size of figures, pair-formation and repetition of subpatterns, and bilateral symmetrical arrangements around a central figure and on parallel planes. The incidence of these centric tendencies varies from a low 11 percent on the Garden theme to a high of 56 percent on the Birthday Party. With the application of a simple principle of symmetry, visually more pleasing and better balanced displays are created (see ills. 139 *a*, *b*, *c*; and 26 *d*).

The same dual-compositional trends continue to dominate the drawings of older children ages 7 to 13. In terms of the horizontal and vertical coordinates that organize the composition, I note increasing differentiation in the number and type of figures and in the spatial arrangement on two or three levels, and an effort to order figures into subunits. Figures begin to be grouped together to indicate a special relationship or a common interest, and such grouping occurs on the basis of similarity of size, color, form, and activity (see ills. 140; 49 *b*;

a.

b.

c.

85 *c*; 91 *b, c*). When three parallel levels are organized, the relation of figures to their background becomes more complex (see ills. 141 *a, b, c*; and 95 *d, e, f*; 97 *g*). Only in a minority of cases, however, are grouping principles effectively used to portray the specific meaning inherent in a theme. In terms of balance, it is rare to find a composition in which all the elements are well-integrated. At best, a number of subunits draw attention to themselves and achieve a state of partial balance.

The complexity of a composition tends to increase with practice, and more detailed configurations can be seen that portray actors engaged in similar activities and employ principles of symmetry across several planes or levels. Progress can also be seen in the use of more subtle and complex forms of symmetry that make more interesting statements. A differentiated spatial framework, for example, can enhance the near symmetrical division of the picture into an upper and a lower plane, and the deliberate use of several grouping principles tends to enhance the meaningfulness and aesthetic appeal of the scene. I shall use the term "complex symmetry" to describe arrangements that maintain spatial order and meaning with more varied items and whose organization no longer demands a strict one-to-one

140. *Symmetry and the Effective Use of Grouping Principles*
Figures are grouped together to indicate a special relationship or a common interest. Artist is a second grader.
(Also see 49 *b*, 85 *c*, 91 *b, c*.)

a.

b.

141. *More Intricate Forms of Symmetry*
a–c. Ages 8 to 12.
(Also see 95 *d*, 96 *a, e, f*, 97 *g*.)

c.

numerical or figural correspondence. Such forms of symmetry, which do not exactly duplicate the two sides of an array, are usually found among the older and more talented youngsters (see ills. 142 *a–e*). In these cases, a symmetry of weights is maintained in the balanced placement of figures rather than through their actual identity. In more complex symmetrical arrangements, individual figures no longer maintain strictly bilateral similarity of size and shape, and a central figure may be flanked by a large object on one side and two smaller ones on the other side, which results in a fairly balanced configuration. For ages 7 to 13, the incidence of symmetrical arrangements ranges between 35 percent to 86 percent.

Balance can be attained in a number of ways. In its simplest form, balance can result from the homogeneity of figural elements or from the repetition of a pattern. A strict application of the principle of symmetry yields a somewhat static balance devoid of the tension of opposing visual forces. The balance that can be attained by varying some dimensions, for example, size and shape, while maintaining distance or location constant, rests on a more complex interplay of visual forces. Balance is an aspect of "order," and just as lack of order impedes understanding and yields a low level of visual interest, so the various attempts to enhance balance by employing grouping principles serve to increase the significance of the figures, to suggest a relationship, and to enhance the appeal of a drawing. Among our older children, we find compositions that do attain some degree of balance. This is the case when centric and gridlike spatial principles are to some degree coordinated, or when compositions are based on complex symmetrical arrangements.

In our studies of compositional development (Golomb, 1983a,b, 1987a; Golomb & Dunnington, 1985; Golomb & Farmer, 1983), we found only a few attempts to use dynamic principles of balance. The description of this compositional category is based on Arnheim's formulations (1974, 1988). Accordingly, a composition that employs principles of dynamic balance aspires to a visually more compelling ordering of forms, which yields a dynamic equilibrium. The perception of space under the pull of gravity creates asymmetries. Although, geometrically, space is a homogeneous expanse that is undifferentiated in respect to up and down, left and right, under ordinary conditions we tend to perceive space as pervaded by unequal forces. Due to the unequal distribution of weight in visual patterns, we perceive, for example, that a form in the center exerts less weight than one placed in the upper portion, to the right side, of large size and volume, or of bright and contrasting colors—all of which appear heavier. Isolated forms, regular shapes, and compact and vertically directed forms appear heavier than their respective counterparts. Thus, according to Arnheim, dynamic balance is determined by weight, direction, and location of forms, and the distribution of visual weight must be made so as to balance around the center of a work. "In a balanced composition all such factors as shape, direction, and location are mutually determined in such a way that no change seems possible, and the whole assumes the character of 'necessity' in all its parts. An unbalanced

a.

b.

c.

d.

142. *Complex Forms of Symmetry*
Instead of a bilateral similarity among the individual items, a symmetry of weights maintains the balanced placement of figures.
a–e. Artist ages 12 to 13.

e.

composition looks accidental, transitory, and therefore invalid" (Arnheim, 1974, p. 20). The need for balance is the need for clear unambiguous statements that require the integration of opposing forces.

The two dominant compositional tendencies that I have described so far—the alignment principle and the centric symmetry tendency—are descriptive principles of organization, empirically derived from my data. They are reminiscent of the two competing perceptual-spatial systems described by Arnheim in his book *The Power of the Center* (1982, rev. ed. 1988), in which he focuses on the tension between two spatial systems: the centric and the eccentric systems. Each operates according to its own organizing principle: the centric system organizes space around its internal center; the eccentric system reflects an outward-directed tendency in that it responds to external centers. The Cartesian grid, a system in which straight lines meet at right angles, is a special case of the eccentric spatial system. The Cartesian coordinates serve as a frame of reference for the location of objects; they provide a framework that is essential for the depiction of human experience under the dominance of the force of gravity. It is intriguing, though somewhat speculative, to note that with the exception of dynamic balance, the structuring tendencies of young children are quite similar to those of adults, even though their compositions are remote from the visual intelligence and aesthetic sensibility of the adult artist. However large the distance between the child's alignment and centering strategies and the work of the accomplished adult artist, both may have a grounding in the same origins of visual thinking and aesthetic sensibility.

Task Demands and Choice of Compositional Strategy

To comprehend fully compositional development, the description of general age-related trends must be supplemented with an analysis of task effects; that is, an examination of how the nature of the theme affects the child's choice of strategies.

Family

Of the three drawing tasks that explicitly involved humans, the simplest theme is that of the Family. The overriding tendency for all age groups is to align the family members side-by-side in full-frontal orientation. Among the youngest children, the three- and four-year-olds, partial alignments dominate the productions and the location of items remains fairly unspecified. Figures may be placed in the middle of the page, to one side, dangling from the top edge of the paper, or drawn diagonally across the page (see ills. 77 *a, b*; 78).With increasing experience, alignments become more streamlined and the child's sensitivity to the coordinates of the paper yields a more orderly array of figures. When figures are placed off-center—for example, in the upper quadrant of the page—they are often "framed"; that is, they are set

apart from the rest of the page, which is thereby rendered irrelevant to the composition. Framing is a more complex strategy than mere alignments because it uses an additional principle to tie the figures into a unit. The very simple strategy of aligning same-size figures across an imaginary horizontal axis continues to be used extensively: of our 12-year-olds, 55 percent adopt this compositional principle in the Family task (see ills. 143). Although alignment of figures yields an ordered array, it is important to note that without figural differentiation the meaning of the theme remains obscure, and the viewer has no way of knowing that the figures are meant to portray the members of the family.

The three-year-olds tend to forget the theme and romance about their picture; four-year-olds remember the assigned topic and most youngsters depict it in some way. Four- and five-year-olds are careful planners who often decide in advance whom to include in their picture and where to locate the figures. Frequently, they review the work-in-progress, making additions or corrections; for example, crossing out what they don't like. The accompanying comments inform the listener and seem to guide the child in planning his composition. Thus, the listener learns about the members that constitute the family, whether they are to be included or omitted, the ages and gender of siblings and self, and various drawing options that the child considers—for example, whether to draw stick-figures, to clothe them, and to identify them by writing their names (see ills. 144). Despite ample verbal indications of the child's awareness of differences in the looks of the various family members, attempts to differentiate the size and shape of the figures are limited. Such differentiation is more likely to be found among the older children. Invariably, all of our youngsters portray the family in the "photographic stance"; that is, in frontal orientation, standing side-by-side, which increases the homogeneity of the figures. Once alignments have become ordered, approximately 50 percent of the figures are drawn in a central section of the page; alignments in the bottom or top part of the page are also quite common.

Within the alignment strategy, size can serve as a grouping principle by aligning same-size figures or by contrasting, for example, the large size of the adult with the smallness of the baby. In these instances, size also reflects the significance and power of the adult. At other times, size as an ordering principle is ignored and gender may be used as a grouping device, drawing all females alike and structurally dissimilar from the males in the family (see ills. 129 c, where females are drawn with triangular bodies and males only with heads). Common actions may also serve as a grouping principle, for example, two figures holding hands, siblings playing, or three people engaged in a charitable action while the fourth person is portrayed as self-centered or frivolous. Symmetrical ordering of family members begin to appear in 16 percent of the drawings of four- and five-year-olds. Among the six- and seven-year-olds one sees a rapid increase to 38 percent in symmetrical arrangements of family members. This can be accomplished by grouping the older and younger members separately,

143. *Alignment: A Preferred Strategy for Portraying the Family*
Boy, 9;4.

144. *Planning A Drawing: The Family*
Girl, 6;8. "Should I put clothes on them? They are not going to have clothes. Some are going to be like this (the two-dimensional figure of "dad"), and some are going to have stick- bodies. I'll put initials on them."

a. b.

145. *Grouping of Family Members: The Use of Overlap and Partial Occlusion*
a–b. Ages 10 to 11.

for example, two parents followed by an array of children, two parents in the middle with a child on each side, one child in between the parents, an alternating pattern of adult-child-adult-child, or an ascending order from the youngest to the oldest members in the family. When such ordering occurs, it imparts relevant information about the relationships that characterize family life, suggestive of parental preferences and a hint at hierarchical relations of power and dependency in the family (see ills. 139 *b*). Such arrangements are also quite effective in differentiating the family unit from other social groups in suggesting relations that are both age and gender related (see ills. 49 *b*; 91 *b, c*).

Between 7 and 13 years, the incidence of symmetrical solutions varies considerably with a low of 23 percent at age 10 and a high of 45 percent at age 12. Symmetrical solutions are not strictly age-dependent and may vary from sample to sample. Perhaps the variability also reflects a greater interest in elaborating the individual characteristics of figures, a tendency that may compete with the earlier ordering according to size. Moreover, for the older children, size is no longer a potent indicator of family relations and the relatively static Family theme tends to favor a simple alignment strategy. A few of the more gifted children achieve a more closely knit grouping of the family members. They diminish the distance between the figures, and by a successful employment of overlap and occlusion they create a more cohesive and unitary display, which combines alignment and centering strategies (see ills. 145 *a, b*). However, the desire for closeness is not the only dynamic that characterizes family life. What about other aspects, for example, the portrayal of tension, conflict and alienation? The data at my disposal suggest that under our conditions of soliciting the drawings, the most commonly used alignment strategy does not picture such feelings, even in the case of children who have suffered at the hands of their family (see chapter 8). At times, however, when the family constellation is very problematical, a drawing may depict the artist's feelings about her place in the family as ills. 146 indicates. More positive feelings about one's place in the family can also be expressed, as the drawings of this teenager reveals who depicts herself in the center of attention (see ills. 147).

146. *Family Breakup*
Girl, age 12. "Where do I belong?"

147. *A Family Portrayal*
Girl, 9;8

a. *b.* *c.*

148. *Children Playing*
a. When children are portrayed in a joint activity, a symmetrical strategy is often favored.
Artists are six-year old children.
b–c. When playground activities are depicted, alignment strategies are likely to be adopted.
Artists are nine- and ten-year old children.

Children Playing

Unlike the Family theme, the task of Children Playing implies an activity, although its exact nature remains unspecified. On this theme, the child has to define type of activity, number of players, play objects, and whether the activity occurs indoors or outdoors. When two children are portrayed in a joint activity, for example, playing ball, jump rope, or two on a seesaw, a symmetrical solution is often favored or even dictated by the theme (see ills. 148 *a*). Although symmetrical arrangements appear quite early on this theme, they do not comprise the dominant strategy and are used only in about 30 percent of the drawings of 7-to-13-year olds. When playground activities are portrayed, alignment strategies usually predominate as jungle gyms, monkey bars, slides, and swing sets are drawn side-by-side (see ills. 148 *b*, *c*). Older children occasionally draw a football or baseball field and distribute the players evenly, which creates a highly symmetrical display.

When the theme is further specified, more extensive planning is called for, which even young children appear to be able to accomplish. A variant of the above-mentioned play-theme that identifies the activity and the number of players demonstrates this quite clearly. When the topic is Three Children Playing Ball, symmetrical arrangements increase to 42 percent of the drawings of five-year-olds. The drawings reflect the child's planning concerning the number of players, their location, and orientation. The overall tendency is to center the figures, and even when an alignment strategy locates them in a single plane, the placement of the ball usually indicates the nature of the game. The ball may be drawn above the three children, below them, or between two of the figures; its path may be described as a line that extends between the players, as multiple balls on the expected trajectory, or each player equipped with a ball depicting the moment it is about to be thrown to the next in line. Many youngsters use the profile orientation; the location of arms as well as their direction depict the interaction among the players and the ball, and in a few cases one of the players is depicted from a rear view (see ills. 149 and 34; 46 *b*; 94 *c*; 95 *c*). Altogether, this theme tends to elicit many creative variations that demonstrate successful planning on the part of the child.

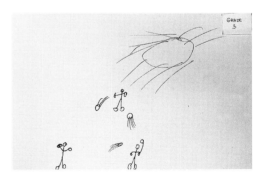

149. *Playing Ball*
Boy, third grader. Multiple balls depict its trajectory as the ball is thrown from one child to the next in line.
(Also see 34 *b*, 46 *b*, 94 *c*, 95 *c*.)

Four-year-old Minelva provides an example of the careful planning of people and their actions. She first draws a hill, saying, "This is a big mound. I'll make three girls." Next, she draws the first figure beginning with the legs to assure their proper attachment to the mound. It is the only figure that is drawn in a bottom-to-top sequence. She exclaims, "She is looking at you, she is throwing the ball to the other girl," a reference to the second figure that has *not yet* been drawn. Minelva extends the baseline, draws the second figure to the right of the first one, and comments, "She throws the ball to her [reference to the third figure that has not yet been drawn]; I'll make her face *that* way [profile]." The third figure, drawn to the left of the mound, faces in the direction from which the ball will be thrown (see ills. 52 *a*).

Teacher Reading a Story

The graphic solutions adopted on the Ball Playing task demonstrate that specification of a theme can lead to early grouping efforts. Similar effects can be seen on two additional themes: a Teacher Reading a Story to the Children and Apple Picking.

On the Teacher Reading task, symmetrical solutions comprise 48 percent of the drawings of five-year-olds. A favorite compositional strategy places the teacher above a row of children. The teacher is drawn large in size, equipped with arms and a book, while the children are much smaller and less differentiated, at times hairless, armless, and even faceless. The large size of the teacher and the different space she occupies clearly differentiates between the status of teacher and pupils. The contrast in size and location and the proximity of like-figures structure the theme; when the major figure is centered, the visual impact of this hierarchic conception is quite effective and the meaning of the theme is clearly stated (see ills. 150 *a*, *b*, *c* and 26 *d*, *e*; 93 *b*). Narrative action is portrayed in compositions that utilize the alignment strategy such that a large figure with a book is placed at the beginning of the line-up, separated from the other figures by a greater distance (see ills. 151 and 26 *a*, *b*; 92 *a*; 93*c*). Interestingly, the most important figure, the teacher, is usually drawn first, before the row of children, as the following example shows.

Five-year-old Adam first draws the teacher, beginning with the head, the body, and the chair. Next he adds facial features and a book: "I'll think I'll add a bunch of books on the floor . . . may be I won't." The children are drawn at some distance from the teacher, a grouping defined by the posture and closely spaced alignment of the figures. "I'll make them curvy 'cause that's how they sit down. I think I made them too curvy." In addition to grouping by size, location, distance, and figural detail, posture may be used to indicate that the figures belong together; in this case, they represent the seated children (see ills. 92 *a*).

Whereas on the Family task most four-year-olds draw same-size figures, on the Story Reading theme, the teacher, as the most powerful adult in the classroom, is usually distinguished by her size and the

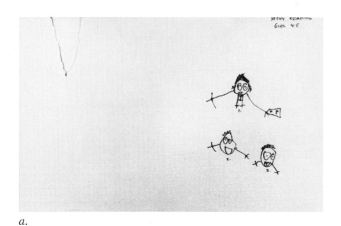

a.

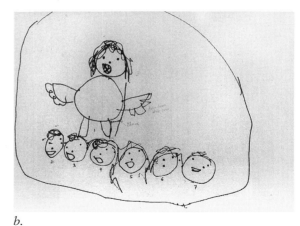

b.

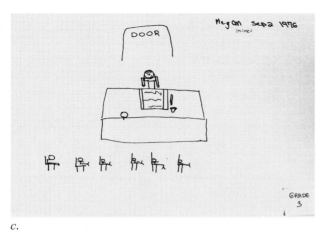

c.

150. *Story Telling: A Hierarchic Conception a–c.* A hierarchic view of teacher-student relations is exemplified by the size and position of the teacher who towers over the children. Her power and status is clearly conveyed by contrasting her size with that of the pupils, depicting her in greater detail, separating her by location and distance from the children who are placed in close proximity to each other. Artists ages four to eight. (See also 26 *d, e* and 93 *b.*)

151. *Storytelling: Narrative Action*
The alignment strategy is useful when narrative action is portrayed. The teacher, with book in hand, is placed at the beginning of the line-up. Her status is indicated by her size and distance from the children.
Artist is a third grader. (See also 26 *a, b,* 92 *a,* and 93 *c.*)

composition is generally more tightly structured. Apparently, the novelty of the task impels the child to search for on-the-spot solutions to such problems as representing an item for the first time and organizing the subject matter. Thinking out loud, new strategies are tried out, some of which the child finds quite satisfactory, whereas others are rejected.

Four-year-old Julie comments on her efforts to draw a book: "First I'm gonna make a book. I have to think how I'm gonna make a book . . . I have to make a straight line first; in a book, do we put a line up? I know we put a line this way [horizontal]; I don't know if we put a line up this way . . . the book has lines and it's open."

Five-year-old Taylor struggles with the orientation of the teacher vis-à-vis the children. He draws three children standing side-by-side and makes a square underneath each one of them that is identified as a "carpet." The children, although drawn in frontal view and of straight posture, are described as sitting on the carpet. The teacher, equipped with a large head, is rotated 90 degrees and drawn horizontally at the bottom of the page.

Marci, also a five-year-old, draws the first figure, the teacher, at a slant, a function of her own posture vis-à-vis the paper. All the other figures are horizontally aligned with the first one. "Oops, ha, ha, it looks like this one is falling on this one and is knocking the rest

down! Whoopsie! . . . Looks like the teacher is falling off the chair! (Laughs.) . . . I'll do as many children as can fit on the page . . . now he's getting smaller [refers to last one]" (see ills. 26 *b*).

Four-year-old Dana seems frustrated with her attempt to depict the seated children and the teacher reading from a book. She draws three figures off-center, in mid-air: "This kid is mad 'cause the book takes too long to read . . . this kid is mad too. . . . I can't make a book . . . " She draws a rectangle and declares, "Here is the book and now this one [first drawn figure] is the teacher."

Apple Picking

Apple Picking calls for more complex planning, as trees, apples, ladders, children, and baskets are drawn to depict the topic. Most commonly, the tree is drawn first, usually in the center of the page. The problem of getting to the apples in the tree can be solved in a number of ways—for example, by increasing the size of the picker and defining her as a "grandma," by extending the length of the arm, or by the inclusion of a ladder. Overall, verticality of the arrangement predominates, and symmetrical solutions decline to, approximately, 18 percent of the drawings of five-year-olds (see ills. 152 *a*, *b*; 45 *a*, *b*; 96 *a*, *b*). The graphic rendition of the simple narrative makes new demands on the child, who must organize the diverse objects in ways that can convey the message. The particular problem of getting to the apples in the tree induces many new solutions. Some children draw the tree and the apples, with or without branches, and simply place a row of vertically aligned children in or near the crown of the tree, their arms reaching toward the apples. The intermediate steps of getting up the tree are omitted. Upon inspection of the drawing, the depiction seems unsatisfactory to five-year-old Marci, perhaps because the children are suspended in thin air or hanging precariously from the branches. As she adds a large figure that matches the height of the tree, she comments, "I'll draw a grown up to watch them" (see ills. 96 *b*).

Other children, like four-year-old Mike, solve the problem by making grandma as tall as the tree so that the apples are in easy reach. Typically, the tree is drawn first, without the benefit of a stand-line. In order to align grandma with the tree—more specifically, to have both items aligned on an imaginary horizontal axis—he draws her legs first, matching the endpoints of the legs to the bottom of the

152. *Picking Apples*
a–b. Ages 4;1 and 5;2. (See also 45 *a*, *b* and 96 *a*, *b*.)

a.

b.

tree, and then proceeds with the construction of the figure from the bottom-up, a procedure that he does not adopt on any of the other tasks involving humans (see ills. 96 *a*).

Five-year-old Taylor extends the length of the arm to reach for the apples, a solution discussed by Lowenfeld as evidence of kinaesthetic sensations (see chapter 5). Taylor comments on the long fingers he has drawn as follows: "Those are growing. They came up [to the tree]. I did that too long, by accident." Another solution is to represent the action scene after the fact, as it were. Lorrain (age 5;2) first draws the tree and the branches and then equips each branch with an apple, making an exception for the two lower branches, whose apples already have been picked: "I left two open because the kids have two apples in their hand" (see ills. 152 *b*).

Some children realize that they ought to find a means for bridging the gap between the child on the ground and the apples high up in the tree. Four-year-old Sarah notes: "They need a ladder to get all the way up there. So I have to make a ladder . . . Only one child is going up. He'll pick the apples for the other kids." When ladders are included in the drawing and children placed on the rungs, overlapping of lines is quite common, a result of the order in which the items are drawn. Altogether, when ladders are introduced, new solutions are tried out— for example, drawing the climbing child from a rear or side view, which takes the observer's position into account (see ills. 45 *a*).

Birthday

The effect of the Birthday Party theme on the choice of compositional strategy can be clearly seen over the total age span. Although alignments continue to be used, solutions that employ various forms of symmetry increase steadily for all ages and range between 46 percent to 86 percent for ages 7 to 13. The compositions vary from a simple arrangement of a table with cake and chairs to a more complex symmetrical arrangement that includes multiple people sitting around a carefully set table complete with birthday cake and candles, with streamers and balloons filling the upper part of the page. Rarely is the room in which the birthday party takes place—that is, the interior with its walls and ceilings—depicted. Most commonly, the various items (for example, table, chairs, and presents) are aligned with the floor or groundline while streamers descend from an implied ceiling (see ills. 153 *a, b, c*; 85 *b*; 99 *a, c*; 135 *c*). Interiors are particularly difficult to portray, and the simplest solution is to align the items with the bottom of the page and to use the vertical axis to indicate height. At times, the tendency to center a symmetrical array and to use the vertical axis to depict the floor space clashes with the vertical-as-height dimension.

The items themselves are usually drawn in an orientation that best conveys their nature and function. For example, tabletops are depicted as rectangles, as if the surface of the table has been flipped up; in Willats' terminology, such a drawing is based on a vertical oblique projection system. The sideways portrayal of chairs and the

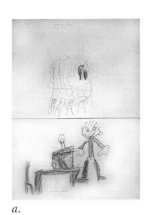

a. b. c.

153. *Birthday*
a–c. Ages four and five. (See also 85 *b*, 99 *a, c* and 133 *c*.)

squarish-looking wrapped presents are based on orthographic projections, whereas the seated children often combine a frontal body with a profile head. Individual items tend to be drawn in their canonical orientation unless their grouping demands otherwise, as is the case with children drawn in profile facing each other across the table. Thus, graphic solutions can be said to be object-specific, that is, to depict each object according to its most defining attributes, relatively independent of its neighbors and their location in three-dimensional space. The child artist does not yet concern herself with a single viewing point or consider the observer at a stationary position vis-à-vis the drawing. The pictorial space that she creates functions mainly to relate objects to each other and in accordance with their significance for the theme. Overall, the pictorial organization stays within the right-angular framework of horizontals and verticals; even when diagonals are introduced to depict the third dimension of an object, such a solution remains tied to an individual object and is a local event that is not yet coordinated with other items and their orientation vis-à-vis the viewer. Thus, although no single view is imposed upon the array—and, at most, objects are merely coordinated with each other and are not yet organized within the totality of the picture space—some degree of compositional unity can be achieved on the basis of symmetry that is carried through on several levels. Even a simple grouping of the items that constitute the birthday theme conveys the intended meaning quite clearly, no doubt a function of the use of symmetry in conjunction with a few core items.

Garden

On the Garden theme, most figures are pulled down to the bottom of the page and spatial directions of "up" and "down" are established. Partial alignments dominate the drawings of younger children, whereas more complex alignment strategies characterize those of older ones. On this theme, the major items are specified in advance, which encourages drawing as an enumeration of items with or without additional embellishments. Consequently, symmetrical arrange-

ments are quite infrequent for younger children, a low of 11 percent for six-year-olds, and increase to an average of 40 percent for 8-to-13-year-olds. Apparently, for a majority of children, the Garden assignment elicits little effort to plan the composition; most children draw a single tree, a cluster of flowers, and a pond, often in this order. The flowers tend to be grouped, but most items are drawn as separate entities, united by a common ground-line or aligned with the edge of the paper see ills. 154 *a, b, c*). Simple attempts to connect the separate figures can be seen in drawings whose background is colored, which establishes a link among the various items, a technique that precedes grouping by figural overlap (see ills. 155 *a, b, c* and 142 *b, c*). Most drawings depict a single tree. It is quite rare to find a cluster of trees whose overlapping contours suggest a meaningful unit (see ills. 142 *c*). When symmetrical arrangements are used on this task, they are the result of carefully planning the items and their location. For example, a pond may be drawn in the center, flanked by hills and trees, with the sky, clouds, and birds overhead. The Garden task provides an example of a subject that lends itself to an alignment of items either on single or multiple levels and that conveys its meaning almost independently of the arrangement of the depicted items. Where symmetrical solutions are adopted, the drawing gains in aesthetic appeal.

Grouping on the basis of the successful use of partial overlap can be a very effective compositional device. In children's drawings, such a grouping is a relatively late development that runs counter to an earlier tendency to give each object its optimal, unobstructed space. Partial occlusion appears at first when a topic specifically calls for it; for example, on the hide and seek task described in chapter 4, and again on the Garden theme when a child wishes to depict a group of closely spaced trees. A grouping on the basis of partial occlusion calls for a more complex depiction of the figure–ground relationship in which, for example, the partially occluded object at first serves as ground for the unobstructed fully outlined figure, and then, in turn, becomes figure for another partially occluded object. Such transitions from figural to ground characteristics call for more complex organizational skills; if successfully executed, they enhance the unity of the compositional elements. When textural gradients are introduced in a drawing, figure–ground relations no longer need to rely on the explicitly drawn contour-line and borderless transitions become possible (see Schaefer-Simmern, 1948). Although some efforts at grouping by relative overlap of forms has been observed in this study, the more sophisticated uses of texture and shading that facilitate the borderless transition from figure to ground are beyond the expertise of most children and adolescents.

Let me now briefly summarize our findings on compositional development. The invention of rules for pictorial organization provides further evidence for the processes of differentiation that govern all aspects of the development of drawing. Compositional development proceeds from an early aspatial depiction of figures, arbitrarily dispersed across the page, to rule governed alignments and centering of figures. It is a process that reflects the child's growing understanding

a.

b.

c.

154. *Garden*
Most items are drawn as separate entities aligned with the bottom edge of the paper or standing on a common baseline.
a–c. Ages 6;4 to 6;10.

a.

b.

155. *Garden*
The colored background unites the separately drawn items. Where clusters of trees or shrubs are depicted, contours begin to overlap. (See also ills. 142 *b* and *c*.)
a–c. Artists ages: 9 to 12.

c.

of the constraints of the medium and his or her capacity to plan and to monitor the ongoing activity. Principles of proximity and of alignment require relatively little planning on the part of the child who does not yet consider the totality of the available pictorial space. When alignments become more ordered, the multiplication of like-forms placed side-by-side might be seen as an early and primitive precursor of symmetry. Thematic demands alter this alignment strategy in only limited ways, with glimpses of partial groupings and an intuitive centering of major figures. Symmetrical ordering of figures requires a greater degree of planning. Symmetry creates patterns, and the repetition of like-figures attracts attention that guides visual exploration and suggests that the pattern carries a specific meaning.

Centering, at its simplest, involves placing a figure in the center of the page, which acknowledges the significance of the paper-space and endows the figure with importance and stability. When several figures are placed side-by-side in a central portion of the page, a primitive sense of order and balance can be maintained. Such alignments, however, are soon modified as the figures are pulled downward, away from the center of the page. In this case, new developments disturb an

earlier and intuitively achieved form of primitive balance. Further differentiation and the use of various forms of symmetry help to reestablish a limited degree of pictorial balance and, eventually, a more complex form of centricity is created, most likely a compromise between gridlike and centric organizing tendencies. Such interactions yield more structured compositions suggestive of a hierarchical order of relations. This development that begins with the primitive relations of proximity and simple alignments—an effort to create pictorial space that precedes the intention to represent physical space—demonstrates how symmetry imposes a new order on the elements and how it restructures the units into a meaningful and aesthetically satisfying whole.

Compositional development is an ongoing process of revision, of monitoring the performance, planning actions, inspecting the outcome, deciding on its merits and flaws; a dialogue between what the eye sees, the mind constructs, and the hand creates. This monitoring of the drawing process, and an awareness of the demands it places on the child artist, is nicely demonstrated by Nicky. Nicky, a six-year-old, completed a series of drawings consisting of the Family, Playing Ball, Teacher Reading, and Apple Picking, and commented: "Is Kathy [his four-year-old sister] next? The teacher and apple picking may be hard for Kathy to draw. The family and ball pictures are easier than the last two. The pictures begin easy and get harder, don't they?" This kind of reflection, and the ability to consider the task demands from his sister's perspective, are evidence of flexible and reversible thought processes that can lead to productive problem solving in drawing tasks.

A major finding concerns the effect the nature of the task has on the adoption of compositional strategies. (See also the Gallo, Golomb, & Barroso study (2003) on compositional effects in two- and three-dimensional media reported in chapter 4.) The results clearly document the impact of task demands on the drawings of all age groups. There is also a steady increase with age in compositional competence that, however, tends to level off between ages 9 and 13 years. A number of factors might be responsible for this leveling effect—for example, the growing efforts to differentiate figures and a greater concern for detail, attention to problems of proportion, orientation, movement, color, and experimentation with the quality of lines—all of which compete with the need to organize the elements into an overall structure. Although the ordering of objects is essential for the composition of a picture, figural differentiation remains the major vehicle for the communication of meaning; that is, for the portrayal of a theme. Without such differentiation, the subject matter is only dimly stated. Composition, as previously noted, involves the organization of all the elements—shape, line, size, color, location, and direction—into a coherent structure. The developmental progression toward this goal is a slow, though orderly, process that begins with isolated object-centered descriptions, in which each object is depicted as an independent unit. Next, objects or figures show some degree of interdependence that is illustrated in the manner in which they affect each other. It is

only at the height of artistic development that the structure of the whole determines all of the elements of a composition. Thus, development proceeds from multiple local graphic solutions, through partially coordinated mixed views, to a more unitary conception that dominates the composition. This brings me back to the introduction of this chapter, in which I referred to the coordination of three frames of reference: a system that is internal to a single figure, discussed at length in chapters 3 and 4; a spatial framework that can relate figures to each other, which has been a major concern of this chapter; and finally, the pictorial framework that dictates the use of a comprehensive drawing system that supersedes local rules and is congruent with the observer's viewing position. Only the first two phases of this complex development toward increasing differentiation of compositional strategies and their relative integration into pictorial units have been documented in our sample of young children and adolescents. The higher-order unity demanded by the third framework is a very late achievement, most likely to be attained only by the trained artist. This issue of the organization of a drawing or painting and the interdependence of its elements brings me to the problem of balance in a composition.

To what extent do the children of our study succeed in creating truly balanced compositions? Earlier I quoted Arnheim's statement that, in a balanced composition, "all such factors as shape, direction, and location are mutually determined in such a way that no change seems possible." If one adopts this rather stringent criterion, then none of our youngsters achieves a balanced composition. However, one might also conceive of the homogeneity of figural elements and the repetition of patterns as attaining a simple, somewhat static form of balance. If one accepts this elementary definition of order and balance, then the symmetrical arrangements of our subjects might well be seen as precursors of balanced compositions. At its simplest, a symmetrical drawing that aligns similar figures with only minor variations along a horizontal axis achieves a restricted form of balance that is devoid of the tension of opposing visual forces. When second-order symmetries are introduced, the complexity of a drawing increases, and with it, a more sustained relation between the elements. Although our sample does not comprise drawings that achieve a dynamic balancing of forces, the more complex symmetrical arrangements show an awareness of pictorial space and a need to create balanced groupings. One might consider these more complexly organized symmetrical compositions as a transitional phase that can precede the more sophisticated use of dynamic balance attained by the experienced artist.

Completion Tasks and the Problem of Balance

Because thematic demands play such an important role in the manner in which a picture is composed, and our results indicate how easily a child's competence can be masked (witness the Family theme, which usually elicits a simple alignment strategy), a set of completion

tasks was designed. I wished to explore the child's sensitivity to six pictorial designs that are deliberately left incomplete and exhibit varying degrees of imbalance. The six outline drawings vary in terms of the number and type of items and their distribution across the page (see ills. 156 *a–f*). From a compositional point of view, the drawings are unfinished. They differ in the manner in which forms are distributed, for example, the extent to which they are restricted to a sector of the paper, which creates the impression of an unfinished composition that invites completion. Design *a* displays its forms in, approximately, one third of the right side of the paper; design *b* limits its forms to the upper left quarter of the page; design *c* uses only the left half of the page; design *d* depicts two relatively small figures in the center of the page; design *e* consists of two items, one on the left side and one on the right side of the page; and design *f* depicts three items on a diagonal

156. *Completion Tasks a–f.*

a.

b.

c.

d.

e.

f.

axis from the upper left to lower right side of the page. With the exception of design *c*, all the figures are clearly representational and refer to suns, clouds, flowers, a tree, a human, a boat, and a fish.

A group of 86 children ranging in age from 6 to 13 years were presented with these six drawings that were defined as "incomplete," having been started by someone but not finished. The drawings were presented on an individual basis, one at a time and in a random order, and the child was asked to complete the drawing in a manner that pleased her. For this task, the children were provided with sets of crayons. Following inspection of the drawing, each child had to decide in which way the drawing was incomplete or unfinished and what kinds of additions or modifications were called for. Designs *a* through *e* are so designed that the child can add figures that merely elaborate the theme or make additions that also redress a perceived imbalance in the composition.

The most primitive responses, which consist of coloring the drawn outlines or adding some detail to an existing form, ignore the open spaces and thus reveal an insensitivity to the imbalance in the distribution of forms. Among the youngest children, the six-year-olds, I find that designs *c, e,* and *f* elicit a particularly high proportion of such relatively primitive responses (64 percent, 71 percent and 50 percent, respectively). Design *c*, which leaves one half of the page empty, continues to elicit such primitive responses from all age groups, with the exception of the oldest children, the 12-to-13-year-olds, who have abandoned the strategy of coloring in or of merely transforming the abstract geometric shape into meaningful figures. Solutions to design *c* begin slowly and at first consist of the placement of one or two forms, quite arbitrarily in the open sector. From the age of eight years on, I note the appearance of symmetrical solutions that utilize the total space. Increasingly, solutions indicate attention to space and form, and the number of symmetrical completions multiplies. In the case of design *e*, there is a steeper decline in coloring in, and from the age of eight years on, alignment strategies serve to structure the available space. On this task, symmetrical solutions are rarely used. For design *f*, coloring in remains at a high of 50 percent for the seven-year-olds and declines thereafter as alignment and symmetrical strategies either displace the earlier ones or are conjoined. Quite predictably, design *d*, with its centered forms, elicits the highest percentage of symmetrical solutions—approximately 24 percent for ages 6 to 9 years, and 50 percent for ages 9 to 13. Designs *a* and *b*, from age seven onwards, elicit a preponderance of alignment strategies.

In this completion study, four steps can be observed that reveal varying degrees of competence to redress figural imbalance. At the earliest level, there is little effort to correct the imbalance by way of the distribution of additional figures. Instead, children either color-in the given contours or a larger area that represents, for example, water. Other approaches to the task include single embellishments of a figure, the addition of detail, or a thematic transformation of a form. By and large, children seem to accept the givens and to restrict themselves to minor additions that do not affect the composition as a

whole. At the next level, new figures are added without, however, showing much concern for the available space or the implied theme. Alignments are fairly primitive, with little attention to the constraints imposed by the already existing figures, and thus the total configuration remains unbalanced. When children introduce spatial differentiation into the drawing and show some reliance on grouping principles, they indicate that they have understood the extent to which the drawing was left incomplete. Their completion now indicates a greater sensitivity to spatial and thematic aspects of the incomplete drawing. Finally, the most advanced completions indicate the deliberate structuring of space and demonstrate the effectiveness of simple as well as complex symmetrical solutions. Indeed, with increasing age we observe a greater number of symmetrical solutions, particularly of a more complex type that no longer relies on a strict bilateral symmetry of elements. Coloring begins to fulfill a new function: lightly and often deftly executed strokes fill in the background to suggest the surrounding air or sky and thus unify the various elements of the composition.

The Effects of Repeated Trials

Next I wished to explore what the effect of drawing the same theme on repeated trials might be. Schaefer-Simmern's (1948) demonstration, that a consistent focus on a single theme over a period of weeks or months can lead to remarkable improvements in the drawing of individual figures and in the overall composition, provided the impetus for a study conducted by Stiliani Halkiadakis (1983). Because we could not address this issue within an educational or studio framework, and since we also faced restrictions on the time period within which we could engage the children, we did not follow Schaefer-Simmern's format. Our procedures, though inspired by Schaefer-Simmern, differ significantly from his. In our study children were asked to draw the same theme on three different occasions, usually within six to eight days. Halkiadakis' subjects were 30 five-to-eleven-year-old Greek children who live in a small town on the island of Crete. Each child was provided with manila paper, crayons, and magic markers and asked, individually, to draw a picture that would include a house, a garden with flowers and trees, a person, and an animal. After each drawing session the child was encouraged to indicate what she liked and disliked about her drawing, and asked if there was anything she would like to change if she had the opportunity to do it again. On the following session, she was once again instructed to draw the same theme, without, however, being able to view the first drawing. Altogether, each child drew the requested theme on three different occasions; on the fourth and last meeting with Halkiadakis, the youngster was presented with her set of three drawings and asked to select the one she liked best, to indicate which one she liked least, and to explain her choice.

In general, this study replicates the findings on the development of compositional strategies reported earlier in this chapter. Of major

importance is the discovery that the great majority of drawings show a consistent improvement in depicting the scene as the child moves from the first to the second and third trial. In some cases, most commonly among the five-, six- and seven-year-olds, the improvement in the organization of items is rather striking, whereas among the older children the changes, though significant, are more limited, perhaps, to an inclusion of greater detail or the successful application of the rules of overlap. Because the children could not inspect their earlier drawings, the progression on the later trials is the more remarkable. These findings support the notion of a self-guiding process in which the child learns from practice with the theme. This study suggests that the open-ended and somewhat problematical task induces a desire to master it, and it also demonstrates the manner in which the child modifies the successive drawings.

With the exception of the five- and six-year-olds, most children prefer their third and last drawing over the first two. The choices of the younger children were more randomly distributed. It is interesting to note that the changes that children make from trial to trial correspond to their previously expressed criticism. Apparently, Halkiadakis' questions concerning the child's likes and dislikes facilitated a process of reflection and evaluation and led to corrective actions. In general, the performance on the second trial is superior to the first one, and the achievement on the last trial is better than that of the second one.

Although the compositional scores improve with age and over trials, it is also important to note conservative drawing tendencies. In many cases the degree to which the basic structure is maintained is rather striking. Out of the 30 sets of drawings, 8 are near-identical in the location of items and in the overall conception, and this identity is achieved despite the fact that the child did not view his previous drawing. Evidently, the instruction to draw a specified number of items yields a vividly remembered first drawing, and on subsequent trials this drawing is reproduced in most of its essentials (see ills. 157 a, b, c). In the remaining sets of drawings one notes how the development of the theme leads to the elaboration, embellishment, deletion, or rearrangement of elements (see ills. 157 d, e, f, g). In all cases, the individual style of the artist is easily recognized.

In the great majority of drawings (73 percent), the house is the first item to be drawn, and it is centrally located. The high incidence of houses with triangular roofs is noteworthy, because this style does not reflect the typical architecture of the locally prevalent flat roof; it also suggests that the images of triangular roofs are derived from picture books and perhaps television programs as well.

Finally, I would like to report Halkiadakis' findings concerning the aesthetic qualities of the children's drawings. She employed a scale that rates qualities of unity, detail, color, form differentiation, balance, flavorfulness, expressiveness, originality, spontaneity, and overall appeal. The ratings were performed by two independent judges whose inter-rater reliability on each attribute was good (rang-

ing from 74 percent to 96 percent). The results indicate that, with ascending ages, the ratings on all these dimensions increase, which suggests that children's drawings become aesthetically more pleasing as they grow older and, presumably, gain in drawing experience. This consistent improvement with age on a scale designed to assess the aesthetic properties of a drawing raises questions about the aesthetic value many authors attribute, quite specifically, to *early* child art. Such important writers as Rudolf Arnheim (1974), Howard Gardner (1980), and Ellen Winner (1982; Winner & Gardner, 1981) have pointed to the freshness, the spontaneity, and the originality of early child art. Some authors, for example, Gardner and Winner, subscribe to the notion that child art peaks early, around ages five to six or seven years, and thereafter declines in its appeal as children grapple with the aspiration to draw realistically. They postulate that artistic development in drawing and painting follows a U-shaped curve that peaks early, declines during the elementary-school years, and recaptures its promise during the adolescent years. Art educators have not always taken kindly to such a view, which seems to invalidate their educational efforts, and many have challenged this position or described different periods of peaks and declines (Burt, 1921; D'Amico, 1953; Lark-Horowitz,et al., 1967; Rush, 1984; Wilson & Wilson, 1977, 1979). Indeed, it is at times difficult to distinguish in child art between spontaneity and lack of control, between the primitivity of early and unconventional forms that characterize tadpoles and open-trunk humans freely distributed across the page, and the originality of older artists. Adult artists can exercise a freedom of choice not yet available to children, and their violation of established norms is quite deliberate. A generation of adults exposed to modern art and appreciative of primitive art may well respond enthusiastically to young children's drawings and perceive a kinship between child art and some of the modern and primitive masters. I shall return to this issue in the chapters on child aesthetics and culture (chapters 9 and 10).

So far I have described composition as a single event, a statement that selectively represents a moment in time and space. There is, however, a genre of visual narratives explored by Brent and Marjory Wilson (1976, 1979) mentioned in the previous chapter, which utilizes a series of drawings to tell a story. It is a genre that highlights the child's tendency to return, repeatedly, to an emotionally important theme, and it provides a readily accepted format for the exploration of affectively significant contents. No doubt, exposure to comic strips and to the essentially serial nature of television provide a model for experimentation. A similar impulse finds an outlet in story-illustrations, a favorite pastime of children in the early elementary-school grades. In these examples, verbalizations reappear, this time in written form to capture the dialogue between the actors and to label a theme. Such written commentary can also appear in single-frame drawings to indicate the character of a protagonist, for example, in the drawing of eight-year-old Erica's father. The male figure is broad-shouldered, with clenched fists, and looks quite formidable. The verbal insert,

a.

b.

c.

d.

198

e.

f.

g.

157. *Repeated Drawing Trials on the Same Theme*

a–c. A remarkable similarity in the depiction of the loosely defined theme over three trials.

Artists are five-, seven-, and nine-year-old Greek children.

d–g. Some children explore the theme over the three trials, elaborating, revising, and rearranging the elements.

Artists are nine- and ten-year-old Greek children.

158. *Caption: "Where is my Newspaper?"* Erika, age 8;4, puts her message succinctly into the "bubble." The broad-shouldered male figure looks formidable and exudes a potential threat.

"Where is my newspaper," makes the message crystal-clear (see ills. 158). In such instances, the verbalizations are fully integrated into the graphic medium and their function differs radically from the romancing of an earlier period (see chapters 1, 2 and also Korzenik, 1977).

At the heart of this account of compositional development in children's drawings lies the question of the nature of child art and how best to understand its dominant attributes. My major focus in this chapter has been on the cognitive processes that undergird compositional development, with only few references to aesthetic factors that, of course, also play a significant role in the child's adoption of diverse strategies. These include choice of form, color, texture, and ornamentation, issues that will be taken up in the chapter devoted to gifted child artists.

Finally, I have to acknowledge the limitations of the present chapter, which examines the drawings of children on a variety of set tasks. Even when the child is asked to draw "anything you like," I do not know to what extent such a drawing is similar to what the child creates in the privacy of his room or when motivated to draw over long periods of time in a studio that teaches art. Ultimately, information from all these sources needs to be assessed, from spontaneous child art, from elicited drawings obtained under standardized conditions, and from drawings made in a studio that encourages the making of art and exposes children to the work of masters as well as their own peers.

I have followed the long route child art takes from the invention of forms to the creation of a meaningful composition. The developmental agenda begins early with the differentiation of form, and only gradually is the differentiation of size, color, proportion, orientation, and space sufficiently mastered to give rise to composition as the carrier of meaning and beauty. In the next chapter I shall explore the development of drawing in several highly motivated children who throughout their childhood years, pursued drawing with a great deal of seriousness and intense dedication.

Gifted Child Artists 7

My description of the general course of drawing development has highlighted the creative and inventive nature of the child's early representational efforts. Experimenting with the medium, children construct, quite independently, their first graphic models. In this sense, each child can be seen as an original artist even though others have produced drawings and paintings that bear a striking resemblance to the youngster's work. As the previous chapters have documented, certain formal-structural features characterize all early representations, and they define what is commonly known as "child art." Some authors perceive a discontinuity between child and adult art (Cizek, 1936; Wilson & Wilson, 1977, 1982b), but others have tended to see child art as a precursor of adult art-making, an important phase in the evolution of the mature artist (Arnheim, 1974; Gardner, 1980; Pariser, 1987; Schaefer-Simmern, 1948; Winner, 1982).

The determination of who is an adult artist can be made on the admittedly pragmatic basis of an individual's commitment to the arts and his standing in the artistic community. Most commonly, it is the judgment of artists and of art critics that singles the person out as gifted in the visual arts. Usually, such an assessment is based on a large body of work that attests to the artists's ability and personal vision. None of these conditions can be met when we look at the work of young children, when we attempt to determine giftedness in the visual arts or forecast children's future promise as mature artists. While most adult artists report a passion for their chosen medium that dates from an early age, this is not always the case, and some artists turn to drawing and painting in late adolescence or the early adult years. Van Gogh and Utrillo are famous examples of such a relatively late choice.

Children tend to be identified as gifted in the visual arts when their drawings are considerably more advanced than those made by their age-mates. Thus, giftedness is viewed within a developmental framework and children are most likely singled out on the basis of their more mature use of representational techniques. Many students of child art identify giftedness in terms of a precocious facility to

draw naturalistically; that is, to create a striking likeness to the object. A child who at an early age employs sophisticated techniques, for example, partial overlap of forms and the elimination of lines hidden from view, oblique drawing systems, foreshortening, and modeling—all of which suggest the solidity of an object extended in three-dimensional space—clearly calls attention to special abilities. Since the majority of untrained adults do not become proficient in the use of such graphic devices, the question arises whether the development of artistically gifted children, especially those that show a precocious talent or proclivity for dealing with three-dimensional space, follows the normal developmental course. Do the rules or laws that guide drawing development along its stage-like path apply equally well to the precociously gifted child? Many distinguished students of child art and art educators have answered this question affirmatively (Arnheim, 1980; Gardner, 1980, Lark-Horowitz et al., 1967; Lowenfeld & Lambert-Brittain, 1970; Munro et al., 1942; Pariser, 1987; Schaefer-Simmern, 1948; Winner, 1982, 1996). In general, these authors assume that the progression through the early stages is compressed into a very short time span, that the gifted child very quickly outgrows the schematic childhood drawings, and that a gifted youngster's drawings are distinguished by his or her representationally more sophisticated renderings—that is, by more realistic or faithful depictions. An emphasis on the universality of the developmental progression, however, does not fully account for the graphic development of the gifted child. Thus, for example, Arnheim (R. Arnheim, December 7, 1987) thinks that originality at any level of differentiation is also an essential quality of the gifted child artist. Munro, Lark-Horowitz, and Barnhart (1942) contend that the gifted child artists are able to retain visual memories longer, which enables them to think and to express themselves in the visual medium. From the early teens on, they are more attuned to artistic style and form, able to defend their preferences more explicitly, and inclined to take a more objective stance toward their own accomplishments. These children are also good at experimenting with a new medium.

Thus, although the developmental progression is assumed to follow the general course outlined so far, the gifted child, nevertheless, differs in essential ways from his less talented peers. Lark-Horowitz, Lewis, and Luca (1967) suggest that talent may appear in three ways: a markedly accelerated development and technical skill, an unusually early awareness of artistic form and quality, and a unique and skillful adaptation of existing art styles in preadolescence. Most talented children go beyond the confines of the schematic child art stage in two ways: (1) They may retain the schematic vocabulary and mentality but develop their own vision that imposes an order on the composition that is often reminiscent of primitive and ancient art. In this case, the aesthetic quality does not depend on similarity to nature in the sense of adopting a realistic style, but resides totally within the style of child art. Or (2) they may develop a rich graphic vocabulary and an ability to depict spatial relations clearly, which makes their work, in conception and execution, akin to that of the adult. Accord-

ingly, the work of these gifted children displays an early maturity of adult art expression. How this transition from schematic to realistic adult-like drawing is accomplished is not clearly spelled out. Lark-Horowitz and associates point to the paucity of data on the childhood drawings of famous artists, and that what little remains of their early work is often of adult level—for example, Dürer's self-portrait made at the age of 13.

The Wilsons (1982b) address this issue of transition in terms of a supposed break between the early childhood drawings that characterize the first eight years and later ones. The early drawings are mostly determined by what they define as "innate" factors, which yield a universal graphic language. Thereafter, and in the case of gifted youngsters before they have reached the age of eight years, the inspiration for a drawing is to be found in the readily available graphic models that illustrate exciting themes; for example, in comic strips and caricatures. The Wilsons report on youngsters who are immersed in creating visual narratives, adventures depicted over many separate "frames" that portray the victory and defeat of their heroes and villains. This kind of art making is conceptually as well as graphically very different from "school art." To the extent that it is also created for an audience of one—that is, for the expression of one's very privately held fantasies—such drawings of the gifted may escape the attention of art teachers.

A more radical challenge to the conception of a universal stage-like progression in the development of graphic representation can be found in the drawings of Nadia, an autistic child artist. The body of her drawings made during a period from three to six years is remarkable for the representational virtuosity of her drawings and her sophisticated use of graphic devices. The psychologist who tested her at the age of six years and diagnosed the disorder as childhood autism reported that her talent arose suddenly, seemingly out of nowhere. Her ability to draw seemed to have no primitive or schematic antecedents; its appearance was somewhat miraculous and her talent reached its peak instantaneously (Selfe, 1977). If one can document, even in a single case, that a highly evolved representational ability appears, so to speak, out of phase, and independent of a sequentially ordered development of representational concepts and skills, then the account of stage theorists is seriously challenged. Perceiving such a challenge, Lorna Selfe posed a puzzling question—namely, whether Nadia's graphic achievements were due to her conceptual deficits—and her answer defined Nadia's genius in terms of her autistic pathology. I shall examine Nadia's drawings later in this chapter, after I have presented a detailed exposition of the drawing development of several gifted children.

What do we know about the incidence of precociously gifted children and about the course their development takes? Goodenough (1926), who launched an extensive search for gifted child artists, found such talent to be exceedingly rare. Kerschensteiner (1905), who initiated a massive study of the drawings of public-school children in the city of Munich at the beginning of the 20th century, seems to have

shared this opinion. In his classical text on children's drawings, he reproduces, among many others, the horse drawings of a gifted eight-year-old (see ills. 159). The drawings are indeed remarkable for the vitality of line, the dramatic use of foreshortening, the depiction of motion, and the facility with which different orientations are represented. According to Kerschensteiner, these drawings display by far the greatest talent among all the horse drawings that he obtained from 58,000 schoolchildren ranging in age from 6 to 13 years. A similar position in regard to the incidence of precociously gifted child artists is espoused by Haas, an early childhood educator and a member of a kibbutz in Israel. She has devoted much time and effort to art education. Some 50 years ago, she established a studio in her kibbutz, Sdeh Elijahu. From the elementary school years on, age-mates come in groups to draw and paint in the studio. For each group there is a fixed hour during the week when a child can choose to work with pencil, crayon, or gouache. Once a week the studio is also open for an optional additional hour. The kibbutz membership comprises 125 families, each with four to six children per family. Thus, over many years, Haas has been in a position to assess the incidence of precociously talented children in her kibbutz, and her collection includes numerous longitudinal data sets. She reports that in her many years as educator of the young in this community, she has not seen a single genuinely precociously gifted child. However, her association with the

159. *Horse Drawings of a Gifted Eight-Year-Old*
(Georg Kerschensteiner, *Die Entwicklung der zeichnerischen Begabung,* 1905.)

a. *b.*

Teacher Training College of the kibbutz movement at Oranim has given her access to a much larger body of children's drawings. It is from this source that she has been able to identify some gifted young children whose work, in terms of the vibrancy of lines, the expressive quality of the composition, and the precocious facility to depict volume and three-dimensional space, is far in advance of that of their age-mates. Lark Horowitz and associates (1967) do not specifically address precocious development in the preschool years. Among their illustrations of the work of artistically gifted youngsters, the work of only three children dates from ages four to five years, suggesting that precocious talent is more likely to be found among the somewhat older children, ages 6 to 12 years.

Not all the evidence, however, supports the view that the incidence of exceptionally gifted child artists is exceedingly low. Brent and Marjory Wilson (1976, 1977) and Paul Duncum (1981, 1986) have found a considerable number of youngsters, gifted by their standards of skillful imitation, who spend much of their energy and free time drawing. Their chosen genre often derives from the youth culture, the comic strip media, the heroes and villains of television cartoons. Within the confines of this medium, such children can reach the status of virtuosi who can render their figures in any number of orientations, with radical changes in viewing angle, and portraying a variety of actions. This seems to suggest that talent wedded to interest in certain topics may determine whether a youngster's gift comes to the attention of his art teacher or remains relatively hidden from view. Additional support for such a view can be found in the more recently published case studies of young children whose skill in depicting their figures in diverse poses and with expressive gestures goes beyond the typical child art style (Golomb, 1992a, 1995; Golomb & Haas, 1995; Milbrath, 1995, 1998; Winner, 1996; Zimmerman, 1995). Thus, the incidence of children talented in the visual arts may have been underestimated, reflective of the values of contemporary society (see also Kárpati, 1997).

Considering the sociocultural context, one is reminded of the many gifted children who were apprenticed at an early age, some as early as age nine, to a master painter during the Renaissance and later periods (Muller, 1984; Vasari, 1550/1979). To be apprenticed that young to a master artist, talent had to surface quite clearly and in the style valued during this period. According to Rubin (1984), these talented children, usually the offspring of artists and craftsmen, were exposed from an early age to the work of their family members. By the time they were apprenticed they had already developed a combination of innate and culturally formed graphic skills. In the Netherlands, for example, Gerard Ter Borch The Younger, the son of a well-known painter, was an accomplished draftsman at age seven, as seen in his pen and ink drawing of the *Rear View of a Rider*, in the Rijksmuseum of Amsterdam. In 19th century England, John Everett Millais and Edwin Landseer certainly would have met the definition of artistic child prodigy, a label that might have been applied to John Ruskin as well. Millais is an especially striking case, an accomplished

draftsman who drew vivid portraits at age six to seven, and from eight years on created complex compositions of hunting and battle scenes (Walton, 1972; Warner, 1979, 1981). At age nine Millais gained the silver medal awarded to young artists by the Society of Arts, and at 11 his anatomical drawings were judged accomplished enough to gain him entrance as a full student to the Royal Academy Schools. Landseer was an equally precocious child artist and his animal drawings, his favorite subject, gained him recognition and eventually entry into the Royal Academy of Art (Ormond, 1981). Apparently, the prevalence of children who show an early exceptional talent in the visual arts has not yet been established.

What evidence do we have regarding the course graphic development takes in the case of artistically gifted children and adults? The early childhood work of most great masters has not been preserved, although in some cases individual drawings made in childhood bear witness to a precocious talent as, for example, in the drawings of seven-year-old John Everett Millais, who became a well respected 19th-century English painter. In the case of Picasso, for example, the earliest drawings date from the age of nine years, and they show clear evidence of training and practice. Some of Klee's childhood drawings have survived, and they are quite typical of the stage at which they were drawn. Unlike Klee's early drawings, those made by the young Toulouse-Lautrec show a four- and five-year old wrestle with the problem of perspective, which suggests a precocious drawing talent. The extensive collection of Heidi's drawings (see chapter 3) is quite unique in that these drawings chronicle all the major steps in the development of a highly motivated and intelligent child artist. One can follow her graphic efforts from the first whirls and circles to quite accomplished, detailed, and ornate drawings of her favorite subject, the horse (Fein, 1984). But as Heidi approaches the end of childhood, her interests change, and as far as we can tell from the description of the author, Heidi does not pursue a career in the visual arts. As many writers have observed, giftedness in childhood does not necessarily predict a successful career as an adult artist nor does it, by itself, determine the individual's choice of such a vocation.

Fortunately, several longitudinal collections of the drawings of gifted children exist and have been made available to me. Two sets of drawings come from the collection of Malka Haas. The drawings were made by children who grew up in a kibbutz; they chronicle the graphic development of a boy and a girl, Amnon and Varda. During adolescence and early adulthood, these young artists made a commitment to the arts and chose to pursue art training as an adult vocation. Varda graduated with honors from art school and already in her freshman year, received a first prize for her sculpture. Amnon, from the age of 17, pursued some formal art training; he graduated from a major art school with honors, specializing in industrial design. In the case of these two young artists, who pursued formal training in the arts, access to the longitudinal collection of their early work is particularly valuable. Their drawings provide a rich source of information about children who meet one of the criteria spelled out by Lark-

Horowitz et al., to which I referred earlier in this chapter. Their childhood drawings give evidence of an aesthetic sensitivity and originality that is expressed in their drawings and paintings without, however, showing signs of a precociously accelerated drawing talent. The third artist, Eytan, is an unusually gifted and truly precociously talented child who provides us with a fairly complete record of his phenomenal skill to draw the objects that capture his interest. Eytan, now a young adult, attended art school and chose industrial design as his vocation. The fourth child, Yani, is also an unusually gifted child artist, a prodigy whose work reflects the artistic tradition of her native country, China. My report on her development derives from published sources, and is thus less complete than those of Varda, Amnon, and Eytan.

Before I turn to a description of the drawings of these gifted child artists, we need to ask what this material might contribute to a more general understanding of the child who is talented in the visual arts. For a developmental psychologist, the course of this progression is of major interest. We should ask whether it follows the by-now-familiar stages described so far and to what extent accelerated development necessarily is a mark of artistic promise. Equally important is the question of the characteristics that single out the work of the gifted child, whether they are best defined in terms of a special facility to render objects and scenes in a faithfully realistic style, or whether the artist's originality and ability to use the medium expressively are to be considered as major factors. Finally, the role of culture, of graphic models, and of instruction need to be considered as we attempt to gauge their importance for our young artist's development, as well as the role of parents and other individuals who are important in the life of the child.

The Drawings of Amnon

Amnon is a child of the kibbutz, the second in his family of four children. His parents are artisans; his father is a carpenter and also designs furniture, his mother is a creative designer of children's clothing who, in her youth, liked to paint. Haas describes Amnon as an overall gifted, outgoing, socially adjusted, emotionally balanced, and happy boy. Amnon has always been popular, at the center of the social life of his peer group. Both the arts and academic subjects appealed to him; he excelled academically and involved himself actively with painting, music, and drama. His early graphic development is quite typical of children who have free access to paper and experiment with this medium. His first representations appear at the end of his fourth year and are quite similar to that of the average child. From the age of five years on, one notes stylistic features that begin to set his work apart. From then on, all aspects of his compositions bear the stamp of his individualistic and expressive vision.

The collection of Amnon's drawings begins with an extensive number of scribble-patterns made at ages two and three years. Some

of the scribble-formations are densely packed, suggesting pure motor movement, while others give evidence of attention to the way lines can be controlled. There are numerous whirls, open contours, and loops. Toward the end of his fourth year, Amnon draws a first global human comprised of a large circle with eyes and legs placed inside the contour and an ear drawn on its outer circumference. Other graphic models of a human follow shortly. One consists of a three-sided rectangular figure with the facial features drawn in the top part of the open rectangle and a free floating line above the top to indicate hair, whereas a second figure boasts a differentiated head, facial features, body and legs (see ills. 160 *a*). The figures are drawn with a single color that serves to outline the parts. While developing these graphically more differentiated and clearly recognizable figures, Amnon also continues to make scribble pictures and to create designs. He experiments with gridlike shapes drawn inside a circle, with horizontally placed lattices, and with different forms of scribble-patterns. The designs may or may not have a referential meaning, for example, flowers. From the age of four years on, the drawings become predominantly representational in form and content.

160. *Amnon*
(From the collection of Malka Haas, Kibbutz Sdeh Elijahu.)
a. Age 3;11. An early graphic model of a person.
b. Age four. Amnon tends to fill the picture space with shapes and colors.
c. Age 4;11. He firmly roots his objects in the ground plane.

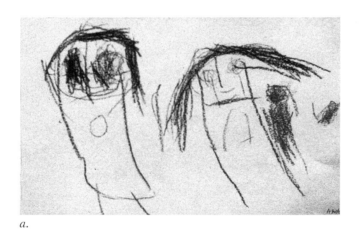

a.

b.

c.

Although the human figure occupies a central place in the large body of drawings made over the next few years, this does not preclude an intense interest in other themes and their elaboration. Animals, houses, vehicles, plants, planes, and tanks populate many drawings that seem to tell a story. Almost from the beginning of his representational drawings, Amnon imposes a certain order on the picture plane that is teeming with a variety of figures and objects. He firmly roots his objects in a ground-plane, differentiates quite early the top and bottom sectors of the page, and often groups his items symmetrically around a large center, or uses other devices based on symmetry. Amnon tends to use the total picture space, by creating, for example, color patches that fill in open areas (see ills. 160 *b, c*). He also makes frequent use of frames, mostly colored ones, that surround his figures and further define the picture space (see ills. 160, 161). As his representational competence increases, the formerly monochromatic figures become colorful. Their outlines are drawn with one or more crayons, but most importantly, different colors are used to fill in the shapes that represent the body parts, a feature that he will develop in a highly original manner. Amnon develops a prototypical human composed of an enormously large head with pronounced facial features, and then proceeds to color the head area, frequently with a dark blue (see ills. 161 *a, b, c*). Until age seven this format continues to play a dominant role in his human figure drawings. Inspection of his large output of drawings makes it clear that these huge-headed creatures are drawn deliberately in this fashion, and that this style is not merely due to poor planning. In scenes, for example, that include many different objects, his smaller-drawn humans show the typical childhood proportions of head equal in size or somewhat smaller than the body. Since he uses different colors for various sectors of the head, these tend to become mask-like. His decorative tendencies find full expression in a series of exquisitely designed animal pictures whose glowing colors transform their subject into a mythical or fairyland creature. Amnon is a true colorist, and his use of color contrast heightens the aesthetic impact of his drawings (see ills. 162 *a, b*; CP-4 *a, b, c*).

In the case of this gifted child, the progressive differentiation of figures and objects follows the same course described earlier in the chapters. Amnon draws his humans in full-frontal view, and his figures are composed of simple flat two-dimensional shapes. With but minor variation in shape and detail, this prototypical figure represents the male as well as the female, the young as well as the old. Usually, the body of the male is represented by a square, that of the female by a triangle. The major axes for the construction of the parts are the horizontal and the vertical, which provide the organizing directions for the total picture space. Other objects are also drawn in their canonical orientation that depicts each item in its most characteristic and simplest way. In most of the drawings, there is a clear disregard for the true proportions and objective sizes of the items. A love for decorative detail and for the rhythmic repetition of an element runs consistently through Amnon's work. This can be seen in an early

a.

161. *Amnon's Prototypical Humans*
(From the collection of Malka Haas,
Kibbutz Sdeh Elijahu.)
a–c. Age five and six.

b.

c.

210

a.

b.

162. *Amnon: Representation and Ornamentation*
(From the collection of Malka Haas, Kibbutz Sdeh Elijahu.)
Representational and decorative tendencies combine to yield imaginative drawings of animals and humans.
a, b. Age six and seven.

and deliberate application of "dots" to objects and surfaces, in the depiction of houses that are almost overwhelmed by color-shape motifs, and in his animal drawings, for example, of peacocks (see ills. 163 *a, b, c*).

What distinguishes the drawings of Amnon between the ages of four and seven or eight years is the uniqueness and originality of his vision, his sensitivity to design features, his self-assurance, and his competence. Above all, he brings a tremendous dedication to this medium. This can be seen in the large, probably daily, output of drawings and the seriousness with which he pursues this activity. Although his drawings are typical exemplars of child art, they are particularly appealing in terms of the ease with which lines and shapes are drawn; the wonderful use of color contrast that while pleasing in its own right, is also suggestive of a symbolic meaning; and the order

a.

b.

163. *Amnon: Love for Ornamentation and Decorative Detail*
(From the collection of Malka Haas, Kibbutz Sdeh Elijahu.)
a. Design.
b. Birthday.
c. Peacocks. "The male says to the female: I'm the more handsome one. The female says: I am also beautiful, and here are the young."
Age five.

c.

that he establishes very early among his figures. Once his drawings become distinctly representational in their intent, one is struck by the facility with which he adopts such compositional devices as centering and symmetry, and how effectively Amnon uses the alignment strategies. Last but not least, one has come to know a child artist who conveys a personal vision, whose drawings are uniquely his own and carry the stamp of individuality.

Does this collection of drawings provide some evidence for a transition from the prototypical childhood drawings to those more commonly identified with adult or academic art? Are the early strategies merely discarded as new models are imitated, or can one document the transformation of earlier and simpler strategies to serve more exacting standards of representation? The drawings of Amnon provide only limited insights into this process. The collection is most extensive through the age of nine years. Thereafter, only few sketches and paintings are in Haas' possession. No longer dependent on the materials made available by the studio, Amnon most likely continued to draw in his own free time and space. Access to the missing data might

a.

b.

164. *Fully Developed Child Art Style*
(From the collection of Malka Haas,
Kibbutz Sdeh Elijahu.)
a. A tank with soldiers. The application of
light shading and color variation suggests
three-dimensional space.
b. Animal. Colorful inserts suggest the
volumetric property of bodies.
Age eight.

have provided better clues to the nature of the transition from child art to more exacting standards of representation. I am aware of the limitations of the available data and shall point only to those changes that are fairly apparent.

Let me begin by calling attention to some of the highlights of the child art style that are well represented in the drawings of eight-year-old Amnon and that also herald a transition to other modes of representation yet to come. There is a drawing of a tank, with its prominent, diagonally protruding barrel, and a line of soldiers with guns that evokes the image of a battle scene (see ills. 164 *a*). The dominant color is black; it is used for the depiction of the tank, the humans, the stooped birds, the soldiers, the fallen man, and what appears as a mass of tangled wire-fence that extends into the distance. The blue sky is barely visible, compressed into a tiny sector at the top of the picture. Overall, the drawing stays within the typically horizontal--vertical framework of the orthographic projection of early child art. Not much attention is paid to size differences or true proportions. Objects are portrayed in their canonical orientation, and there is as yet no attempt to adopt a unified or single viewing position. Despite these childhood characteristics, the objects are tightly organized, and without using perspective, overlapping, or diminishing sizes, the composition suggests a pictorial space that extends from the foreground into the distance. The curving lines of the tank, as well as some shading and variation in the black color, enhance the sense of three-dimensional space. A faint yellow color under the skyline suggests a sunset or perhaps a dim reflection of cannon fire.

In another drawing from this period, a horse led by a child, Amnon succeeds in juxtaposing both a side and a front view of the horse. He accomplishes this new feat by inserting a strikingly different color section, blue, into the horse's body. With this insert that accentuates the horse's chest, Amnon seems to align the front view of

165. *New Techniques for Color Variation*
(From the collection of Malka Haas,
Kibbutz Sdeh Elijahu.)
Man praying in the synagogue. The
contours of the figure are loosened and
color is used to suggest rather than outline
body shape.
Amnon, age eight.

the horse with a view of its side. It is a technique that Amnon has practiced earlier in his somewhat grotesque-looking face-masks in which colorful inserts suggest different facial planes. The technique is reminiscent of the cubist method of decomposing and reconstructing the object (see ills. 164 *b*; CP-5).

In a gouache and crayon picture from the same period, a fallen man is depicted. The figure with its large head, outstretched arms, and red fingers is quite striking, and the two swords or crosses lying on his chest call attention to this detail as well as to a dark eye-patch and lines on his forehead. The dark-colored background is offset by what appears as a brightly colored yellow frame of a picture, reminiscent of flames. The theme of flames is taken up to the left of the man, where candles are burning. Altogether, the composition suggests a somber message. Noteworthy is the choice and arrangement of the various elements that constitute this painting. They seem to carry symbolic meaning, or at least to lend themselves to such an interpretation. There are other aspects in this painting that suggest a modification of older practices. Unlike the flat use of color in his earlier work, in which colors were applied more evenly to fill in open areas, the purplish-gray background is deliberately varied, with lighter and darker patches calling attention to the interior of the room. The brushwork suggests that the uneven application may well present a search for color nuances (see ills. CP-6).

A drawing made with oil pastels at the age of eight depicts a man wrapped in a prayer shawl, blowing a ram's horn. He is standing inside the light-filled synagogue, in front of a partition (see ills. 165). No longer are the body parts firmly outlined; the contours of the figure are loosened and a new way of using color suggests rather than outlines body shape. This treatment announces a modified conception of the drawn human figure. Interestingly, the huge head that so far has been the hallmark of Amnon's humans, has been abandoned. The figure of the man is oriented in a slightly sideways posture, perhaps a seven-eighth view. The figure successfully occludes part of the partition that differentiates the space into a clear fore- and background. Color contrast is used in a more subtle manner, with the color black marking selectively, with a certain rhythm, shoelaces, pants, and scarf. Altogether, only three colors are used: black, white, and yellow. If we contrast this painting with one done a year earlier, some striking changes can be observed. In the earlier drawing, two people with large heads stand in front of a black background, perhaps a room, that sharply contrasts with the brightly colored wall or door next to it (see ills. CP-7). The earlier work is quite gripping with its stark contrast between black and white, and the disproportionately large face that is also darkened. Perhaps it has a greater element of drama, but it is ultimately impenetrable. The work of the eight-year-old portrays a better sense of spatial relations and also begins to capture some of the individuality of the model. Instead of his earlier somewhat archetypal portrait of a human, the more distinctive character of the praying man comes across. Thus, we see that the portrait of the eight-year-old conveys its meaning more fully. So far, Amnon's artistic

development seems to have been guided by his own sense of shape and color, largely unaffected by the pictorial models that were available to him. It might be of interest to note that Amnon grew up without access to television or to comic books, both of which might have affected his graphic development had he been exposed to these sources.

Between the age of eight and nine years, the first pencil sketches appear. Amnon makes deliberate use of shading and black–white contrasts to give the human figure volume and to create a sense of three-dimensional space. The drawings from this period display overlapping—the successful occlusion of parts that are hidden from view as well as transparencies. A portrait done in pen or pencil experiments with sketchy, discontinuous lines and shading in an effort to capture the character of the model, at the same time suggesting the curvature and different planes of the human face. A second and similarly drawn face is overlaid with light water-color patches of shades of red, orange, and purple that mask the facial features, and thus counter the impact of the expressive and perhaps revealing lines drawn earlier. There is a hint here that color and line serve different purposes and that they can be at odds with each other (see ills. CP-8). It also represents a continuation of an earlier practice of overlaying the facial features with a dark color. Since these sketches were made in the children's studio it is not likely that they were drawn from a life model.

A gouache of rock-climbers done at the age of 10 years displays new techniques worked out in color. A more sophisticated use of blue and white color gradients depict the sky, while shape is created with light and dark brush strokes. Most of the landscape consists of solid-looking rocks whose shape is a function of vivid achromatic color contrasts and shading that create new figure–ground relations. The naturalistic-looking colors heighten the viewer's sense of the outdoors, an impression that is enhanced by a diminution in the size of the rocks that suggests the height as well as the distance of the mountain yet to be covered by the mountaineers. No longer does the human figure dominate the landscape; the climbers, one of whom comes to the rescue of the other, are defined by their activity of pulling ropes and fastening stakes rather than by an earlier reliance on the large size of the figure (see ills. CP-9).

The drawings that cover the next period of age 11 to 17 are all sketches done in pencil, charcoal, or ink. Interestingly, the paper size has shrunken, as if Amnon wants to assert control over the line by using smaller areas. The few drawings from age 11 and 12 are studies that explore the effects of shading, for example, in a drawing of a hand with a chess piece. Others indicate some effort to create perspective by using converging lines. Some drawings combine a realistic portrayal of the human figure with elements of caricature as well as decorative motifs (see ills. 166 *a–d*). These drawings suggest that Amnon has become interested in graphic models and that he has begun to study them closely. At this point in his artistic development he appears to make some attempts to draw the figure from a life

a.

b.

1981

c.

166. *Pencil Sketches: The Impact of Life and Graphic Models*
(From the collection of Malka Haas,
Kibbutz Sdeh Elijahu.)
a–d. Amnon, age 11 to 13.

216

d.

model. Drawings done at ages 16 and 17 show Amnon's deepening interest in human anatomy. He wants to portray the figure in motion, to capture action and gesture, and to suggest its volume by using modeling, shading, and borderless transitions between, for example, the folds in clothing. The drawings of emaciated or huddled figures show the impact of a book on the art of the Holocaust (see ills. 167 *a, b, c*). At this point, the use of the clear contour line and of contrasting colors that characterized his early work seem to have been abandoned.

a.

167. *Sketches From Life and Graphic Models*
(From the collection of Malka Haas, Kibbutz Sdeh Elijahu.)
a–c. Amnon, age 16 to 17.

b. *c.*

For the first time, at the age of 17, at his own initiative, Amnon receives some formal training in the arts. One might say that his development so far has been guided mainly from within; he has availed himself of the opportunities that the studio provided, and in this supportive milieu he has determined the rate and type of his own graphic explorations. His parents seem to have played a positive though non-demanding role.

Amnon's drawings changed dramatically between the age of seven or eight and puberty. One can see stylistic changes in the use of line, color, orientation, and dimensionality. In his drawings he moved from the use of the firm and continuous outline to sketchy ones, from the application of uniform and unrealistic colors to true-to-life colors and their more subtle tonal variation. There is a greater freedom to vary the orientation of the human figure, to endow it with motion, and to create an impression of volume. However, no radical break can be seen at any one time between the early and the later work. Older techniques are gradually modified, transformed, and sometimes abandoned. While the choice of subject matter indicates a continuing interest in the human figure, new directions can be discerned in his use of the medium and his preference for pencil and charcoal. At this point of his development, one could not know whether this change was of a temporary order and reflected the desire to exert greater control over the medium, or was indicative of a more fundamental reorientation vis-à-vis color. In the light of his later choice of art media, namely, sculpture in wood and industrial design of wooden furniture, this change may well have been indicative of a future course.

The Drawings of Varda

Varda, the third of four children in her family, was also born and raised in the kibbutz. All of her siblings showed a talent for and love of drawing and painting during their childhood years. Varda's older sister developed a special gift for drawing in a naturalistic style from a life model. On her mother's side there are many artists in the family, and there is a general expectation that the children will be talented in the arts. All the children received much emotional support for their artistic endeavors.

Haas has followed Varda's development from the early toddler years through the present time. She describes Varda's personality as outgoing, warm and open, but Varda is also a nonconformist determined to find her own ways. Drawing and painting were central activities during her childhood and adolescence; she did not show much interest in the academic subjects taught in high school. Haas views Varda's development in all its major aspects, the social, emotional, intellectual, and artistic ones, as all-around good, and her art work as a direct expression of her well-rounded and appealing personality. From a relatively early age, even before Varda reached the age of five, Haas predicted that she would develop into an artistically gifted child. She based her assessment on four factors: (1) family talent; (2) the

quantity of her output; (3) the originality and expressiveness of her art; and (4) the seriousness with which she pursued her interest in drawing.

The collection of Varda's drawings begins like those of most other children, with a large number of scribble-pictures made at the age of two years. Just as she turns three, she draws her first circles as well as other shapes and soon combines them into novel constructions. She continues to make scribble-patterns and experiments with dots that fill the paper space, using both single and multiple colors for her drawings. At 3;5 she draws her first sunburst patterns, circles with radiating lines, and several months later humans appear in her drawings. So far, her development mirrors that of the average child who moves from scribbles to the first representations. Over the next year she seems to play with colors and shapes, and her diverse designs outnumber the representational drawings. Varda develops an impressive repertoire of shapes that, in combination with her coloring techniques, acquire a volumetric quality. Her designs, carefully planned, yield richly elaborated patterns. When she draws representational figures, they play a subordinate role vis-à-vis the more dominant colors, textures, and patterns (see ills. 168 *a*, *b*, *c*). Frequently, the figures are

168. *Varda: Carefully Planned and Elaborate Designs*
(From the collection of Malka Haas, Kibbutz Sdeh Elijahu.)
a–c. Age four.

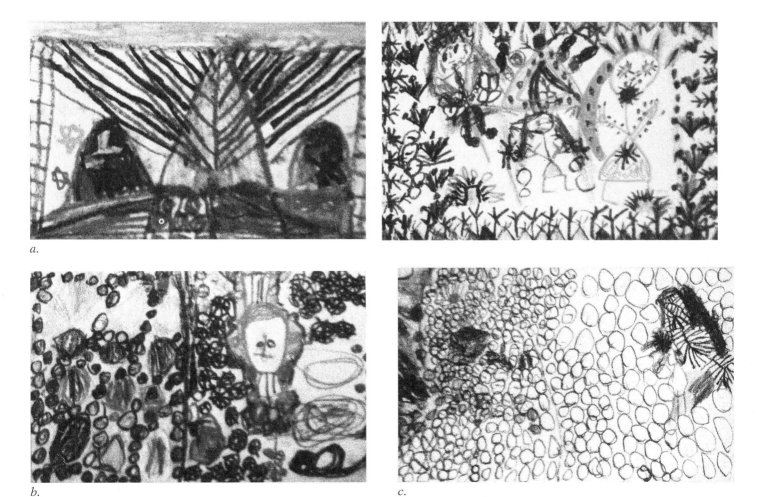

a.

b. *c.*

169. *Ornamentation Tends to Override Figure-Ground Differentiation* (From the collection of Malka Haas, Kibbutz Sdeh Elijahu.) Varda, age five.

embedded in a densely decorated background that overwhelms them and counteracts the more common separation of figure and ground. In some of her drawings, facial features are composed of elaborate designs that tend to compete with the referential meaning of the individual parts. The inclination to fill the total paper space becomes dominant at age five and characterizes most of her work through adolescence (see ills. 169; CP-10). Despite the strong decorative impulse, Varda can establish order among the competing figural and decorative elements, as seen in a drawing with oil pastels made at the age of six years. In this example, the decorative tendencies find expression in the dotted hair, the elaborate facial features, and the facial design on the dress. The many design features are balanced by a strong central figure that dominates the pictorial space. In this painting, her love for texture and design does not overwhelm the figure that is drawn against a strikingly colored background, half pink and half dark blue (see ills. CP-11). Noteworthy are the two faces: the top one with a friendly expression that contrasts with the more fierce-looking face drawn on the skirt.

Many different themes find expression in drawings that combine nonrepresentational and representational elements. In addition to scenes drawn from her daily life, Varda creates a fairytale world of colorful animals and humans populating a well-organized pictorial space. Her affinity for texture and pattern yields beautiful abstracts, but the same techniques can also be put to use when she draws the human figure or an animal (see ills.170 *a, b*; CP-12). Frequently, her compositions reveal an imaginative use of symmetry that is enhanced by rich borders of varied decorative motifs. There is very little routine repetition of elements and their composition, and her output reveals a seemingly unending stream of diverse figures and patterns, and the ability to organize them in novel ways.

I have emphasized some of the unique features of Varda's style of painting and drawing, her play with colors and shapes, and her early developed sense of design. Although Varda creates highly individual means of expression, their broad outlines follow the modes of representation that are typical of all child art. By comparison with other children of her age, Varda achieves a greater expressive power in her

a. *b.*

170. *Representational Drawings Embedded in Decorative Designs*
(From the collection of Malka Haas, Kibbutz Sdeh Elijahu.)
a, b. Varda, age six to seven.

drawings and paintings, employs more subtlety in color use and figural complexity, and imposes a better order on the compositional elements. However, her figures and objects are drawn in their familiar canonical orientations, mostly in full-frontal view, each one occupying its own space, which is organized along predominantly horizontal and vertical directions. Despite the constraints that are inherent in child art, Varda's ability to use the pictorial medium effectively is quite impressive. Within the representational framework that characterizes child art, she develops a rich and expressive graphic vocabulary. She varies the facial features and the shapes of her figures, invents different shapes for the same part, and enhances the subtlety of her background texture. Interestingly, as she perfects her techniques, some of the typical child art features tend to increase in prominence. For example, in her drawings of humans, the size of the head increases steadily, until at ages seven or eight it completely dominates the figure. Varda's work in the child art style reaches its peak of articulation around the age of nine.

Signs of a transition to other forms of representation can be seen in drawings and paintings made between the age of 9 and 10 years. Two paintings of this period, one of a blond girl, the other of a princess or a bride, suggest, by their treatment of facial features and posture, that this is a transitional phase in Varda's artistic development. The depiction of the facial features is somewhat subdued; they are reduced in size, simple in shape, and reminiscent of picture book conventions. The figure presented in its full-frontal view reveals a unified conception of the body and its various parts. It is drawn with self-assurance and its posture suggests a more graceful, loosened stance (see ills. 171 *a*). Animal pictures from the same period portray the very detailed figures of a boy-and a girl-bunny. Both are endowed

a.

b.

c.

d.

171. *Transitional Phase that Heralds the End of the Child Art Style*
(From the collection of Malka Haas, Kibbutz Sdeh Elijahu.)
a. Girl.
b. A boy and a girl bunny.
c. Fairy paying homage to a young girl.
d. Biafra's starving children.
Varda, age nine.

222

with huge and darkened heads that face the viewer, all of which is characteristic of a developed child art style (see ills. 171 *b*). However, unlike her previous drawings, in which action was depicted by varying the angle of the arms, motion in these animals is indicated by bending and curving their legs and arms and by some slight changes in body posture and orientation. This concern with movement is most clearly portrayed in a painting of a fairy paying homage to a young girl (see ills. 171 *c*). The figure of the girl is considerably smaller than in her previous drawings, and body proportions, while not anatomically correct, represent a more conventional relationship between the head and the body. In the forefront, to the left of the girl, a large figure with flowing hair (wings?) is bowing in front of the young girl. The fairy is drawn in a side view and her body shape, no longer composed of distinctly drawn subunits, is suggested by large, flowing brush strokes.

In an expressive painting that depicts Biafra's starving children (reference to the horrors of the civil war in Nigeria), the child art style, although employed to the fullest, is also transcended in the self-conscious use of contrasting colors and size relations. The children are composed of huge heads, their pale faces contrast starkly with the large, dark-rimmed eyes, and the shrunken bodies with skeleton bones showing through tell of hunger and impending death. The subdued brown and black colors, and the relatively sparse designs that fill the background, express a somber mood (see ills. 171 *d*).

Varda develops new techniques for her backgrounds and applies them also to clothing. She overlays colors and uses a technique of scratching to reveal delicate and lacy-looking patterns that enhance the aesthetic appeal of her composition. Alongside expressive paintings that deliberately distort the proportions of the human body, there are also beginning efforts to capture the human face in a more naturalistic mode. She discovers the painterly potentials of her oil pastels that begin to replace her former emphasis on linear contours. She thins colors, uses washes and overlays, and her color mixtures yield nuances, transparencies, droplets, and runs.

Paintings done a year later show further transformations of the child art style and are indicative of new concerns. A portrait of this period depicts the head and bust of a girl composed of colored brush strokes (see ills. 172 *a*). No longer are the facial features carefully delineated; they are sparse, the product of quick brush work and contrasting colors. The ghostly looking skin color, a mixture of green and yellow, calls attention to the mood of the girl and suggests a brooding state of mind. The figure is portrayed against a background noted for the dark-brown color in one half and the tan color in the other half, a technique that Varda has used before (see ills. CP-11), but that in this case may also carry a symbolic meaning.

A large colorful gouache from the same year, made at the age of 10, depicts a woman dressed for a carnival. The exaggerated proportions of the woman, who is almost all hairdo, reveals the artist's lack of concern with the body's anatomical structure. The exaggeration in size and proportion represents a deliberate choice on the part of

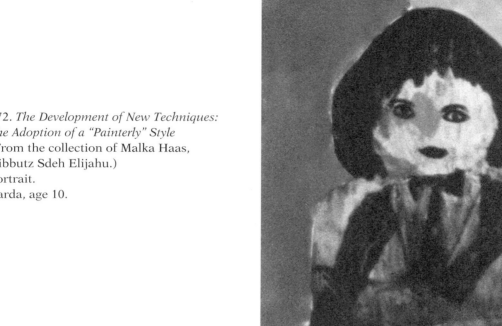

172. *The Development of New Techniques:*
The Adoption of a "Painterly" Style
(From the collection of Malka Haas,
Kibbutz Sdeh Elijahu.)
Portrait.
Varda, age 10.

Varda and no longer reflects the naiveté of the earlier childhood drawings. Most impressive, however, are the novel features of deftly executed light- and dark-colored brush strokes that create the impression of puffed-up sleeves and of a glittering feather-light blouse and skirt. Color contrasts and borderless transitions endow the figure with a degree of roundness, which is further enhanced by the use of overlapping body parts. The dotted background, however, emphasizes the flatness of the two-dimensional space and continues a pictorial tradition that Varda developed earlier on. This treatment of pictorial space shows her lack of interest in creating the illusion of a three-dimensional world (see ills. CP-13). It appears that Varda is intent on forging her own graphic vocabulary and pictorial style, and although she is clearly alert and sensitive to the events in her world, she shows little interest in copying forms from well-known illustrations, nor is she intent on drawing from the observation of a life model, which was her sister's style. As was the case with Amnon, Varda grew up without access to television.

It is during this year that 10-year-old Varda begins to experiment with pencil and charcoal drawings. Her sketches demonstrate that the clear line no longer serves as a major determinant of shape. In her

search for a more naturalistic depiction of the human face, she explores some of the effects of shading and modeling, but continues to place her figures against a flat background. The various pencil sketches suggest that Varda strains to create new images. They reflect a self-conscious effort to pay attention to size, proportion, and shape, a new desire to create more naturalistic-looking portraits and landscapes (see ills. 173 *a, b, c*). Several of the sketches dating from this period depict a girl with downcast eyes, a somewhat stylized image that suggests the difficulty of rendering a lifelike and expressive face

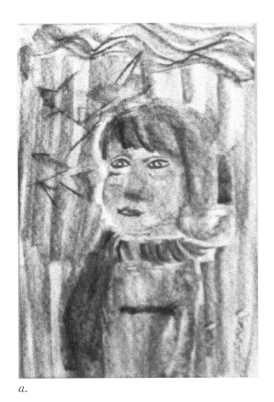

a.

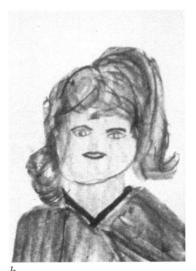

b.

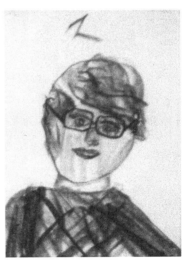

c.

173. *First Pencil Sketches*
(From the collection of Malka Haas,
Kibbutz Sdeh Elijahu.)
a–c. Varda, age 10 to 11.

(see ills. 174 *a*–*d*). According to Varda's recollection, her efforts to depict a scene in a realistic style date from age 13. She remembers drawing her father in a reclining chair and making portraits of various teachers.

When, once again, Varda turns to paints and brushes, the freshness and originality of her vision reappears. Unlike the somewhat stilted experiments with pencil sketches, her portrait of a young girl with glasses reveals a more personal vision. The head and bust of a girl are placed at the center of a colorful and richly decorated background that frames the figure. The head with its hair, facial features, and eyeglasses is carefully drawn in black and white, with lines creating fine textures and facial contours. The neck and clothing are colorful and contrast with the achromatic colors of the face, which carries an earnest expression. The two contrasting tendencies of playful ornamentation and the meditative expression are controlled in a fashion that is quite masterly at her level of development. The polarity between playful sensuality and the expression of deeply held feelings, which has characterized her artwork from an early time, continue to dominate her approach to art.

A portrait of a young girl with glasses who is looking into a mirror, drawn at the age of 12, continues this quest for a psychological understanding of the subject. In this painting, done in oil pastels and watercolor, she applies her newly developed naturalistic conception to the sitter and her background, and captures the individuality and youthfulness of her subject. This painting combines, quite successfully, the older decorative impulse with a desire to depict a visually coherent space. The girl's dress is richly designed and overpowers or masks the underlying body structure. The interior of the room is clearly represented, a function of the effective use of overlapping, some diminution in the size of objects, and color texture (see ills. CP-14).

A review of the drawings and paintings made at the age of 12 indicates that they have outgrown their origins in the child art style. Her drawings and paintings evolved from an early play with shapes and colors into a self-directed search for meaningful forms. Now, at the threshold of adolescence, 13-year-old Varda wrestles with themes of larger social significance that are of special importance to her and her community. In painting after painting she returns to the theme of the Yom Kippur war, to the emotions of bereavement, fear, and consolation. There are images of burials, of waiting for a telephone call from a beloved, of mourners, of a bride receiving bad tidings. Her figures are large, often faceless, and the dominant mood is conveyed by color, shape, and the grouping of the objects. Her compositions are tightly structured, and symbolism is used in an explicit manner. Once again the treatment of the background is most commonly flat and two-dimensional, although not consistently so (see ills. 175 *a*). In these paintings, Varda seems intent on depicting a collective truth, a common fate of grief rather than a psychological portrait of the individual mourner. In these paintings that express complex themes of suffering, broad brush strokes and color patches evoke the theme and its principal characters. Under the pressure of these events, the playful ornamentation disappears; the tendency toward a naturalistic portrayal com-

174. *The Appeal of Naturalism:*
Experimentation With New Techniques
(From the collection of Malka Haas,
Kibbutz Sdeh Elijahu.)
a–d. Varda, age 12 to 13.

a.

b.

c.

d.

a.

b.

c.

175. *Scenes From the Yom Kippur War*
(From the collection of Malka Haas,
Kibbutz Sdeh Elijahu.)
a. Women waiting for a telephone call.
b. Burial.
c. My sister the communications officer.
Varda, age 13 to 14.

petes with a more expressionist use of the pictorial medium and the theme now controls the composition, a mark of her growing artistic maturity (see ills. 175 *a–c*; CP-15 *a, b*).

Somewhat later, paintings made at 17 and 18 are much reduced in size, painted with small brushes and opaque watercolors. The graphic, linear style of this period contrasts markedly with the gouache paintings of the 13- and 14-year-old. They are dense compositions in which form and figures crowd in on each other, and yet are organized in a highly controlled fashion. They reflect the artist's need to control the inner uncertainties and anxieties she experienced at this time of transition in her life. (For a more detailed account, see Golomb & Haas, 1995.)

My description of the childhood drawings and paintings of Varda ends before she takes advantage of formal training in the visual arts; at this point in my presentation, her development is largely the result of her own practice, intuition, and self-directed learning. As was the case with Amnon, there is no radical transformation in this development from child art into something else, a presumably more advanced form of representation. The logic that guides their individual development is evident in the many childhood drawings and paintings, and one feels that for these children art-making was a necessity as well as an adventure.

After completing the military service required of every Israeli citizen, Varda age 20 entered art school, which became a turning point in her artistic development. She turned to sculpture as the major medium of expression and preferred to work with many media, especially plaster, clay, and metals. In this medium and with these materials her work is highly abstract and symbolic but also ornamental and reminiscent of some of her childhood work (see ills. 176 *a, b*). Her focus on sculpture continued after her graduation from art school

CP-1

CP-1. *Abstract*
This painting was made shortly before Ayana's death at age six. It conveys the tension of forces that push relentlessly and are beyond her control.

CP-2a

CP-2b

CP-2c

CP-2. *The Holocaust*
Drawings by Israeli School Children. (From the Collection of
Yad Vashem, Art Museum, Jerusalem.)
a. A menacing guard whips a Jew who is carrying two buckets
with food. Artist is a second grader.
b. Concentration camp inmates behind barbed wire. The work
of a sixth grader.
c. Village controlled by guard with gun. Eighth grader.

CP-3

CP-3. *Mother Is Gone*
Samuel Bak, age 12. Gouache painted in a displaced persons camp in
1945. (From the Collection of Yad Vashem, Art Museum, Jerusalem.)

CP-4a

CP-4b

CP-4c

CP-4. *Amnon: Representation and Ornamentation*
(From the collection of Malka Haas, Kibbutz Sdeh Elijahu.)
Representational and decorative tendencies combine to
yield imaginative drawings of animals and humans.
a–c. Age six and seven.

CP-5. *Fully Developed Child Art Style*
(From the collection of Malka Haas,
Kibbutz Sdeh Elijahu.)
Animal. Colorful inserts suggest the
volumetric property of bodies.
Age eight.

CP-6. *New Techniques for Color Variation*
(From the collection of Malka Haas,
Kibbutz Sdeh Elijahu.)
Fallen man. The purplish background is
varied with lighter and darker patches
calling attention to the interior of the
room.
Amnon, age eight.

CP-7. *Boy and Girl: Highlights of the Child
Art Style*
(From the collection of Malka Haas,
Kibbutz Sdeh Elijahu.)
Amnon, age six.

CP-5

CP-6

CP-7

CP-8a

CP-9

CP-8b

CP-8. *First Pencil Sketches*
(From the collection of Malka Haas, Kibbutz Sdeh Elijau.)
a–b. Amnon, age nine.

CP-9. *Rock Climbers: Deliberate Attempt to Portray a Scene Naturalistically*
(From the collection of Malka Haas, Kibbutz Sdeh Elijau.)
Amnon, age 10.

CP-10. *Ornamentation Tends to Override Figure–Ground Differentiation*
(From the collection of Malka Haas, Kibbutz Sdeh Elijau.)
Varda, age five.

CP-10

CP-11. *A Balance is Achieved Between Figural and Ornamental Tendencies* (From the collection of Malka Haas, Kibbutz Sdeh Elijahu.) Varda, age six.

CP-12. *Representational Drawing Embedded in Decorative Designs* (From the collection of Malka Haas, Kibbutz Sdeh Elijahu.) Varda, age six to seven.

CP-13. *The Development of New Techniques: The Adoption of a "Painterly" Style* (From the collection of Malka Haas, Kibbutz Sdeh Elijahu.) Woman dressed for a carnival. Varda, age 10.

CP-11

CP-13

CP-12

CP-14. *Portrait of a Young Girl*
(From the collection of Malka
Haas, Kibbutz Sdeh Elijahu.)
Varda, age 12.

CP-15. *Scenes From the Yom
Kippur War*
(From the collection of Malka
Haas, Kibbutz Sdeh Elijahu.)
a. Grief.
b. Grief.
Varda, age 13 to 14.

CP-14

CP-15a

CP-15b

a.

b.

c.

d.

e.

176. *Varda's Sculptures*
a. Two elephants within a series of toys.
b. Fish.
c. Stream.
d. Despair.
e. Failed conception.
Works of the young adult artist.

and some of her work was featured in group exhibitions of talented young artists in Israel (ills. 176 *c, d, e*). One can see considerable continuity both in her paintings and sculptures between her childhood compositions and the adult work, which is most noticeable in her tendency to divide a composition, the pleasure in abstract-decorative designs, and the reliance on a personal symbol system for the expression of deeply felt themes.

As a young adult who is reflecting on her artistic development, Varda offers the following comments. She is very appreciative of her parents' and Haas' supportive but nondirective approach to her work. The parents valued their children's diverse efforts and inclinations to make art, and did not exert pressure to develop a specific orientation. Varda feels that she needed to pursue her own inclinations and that she profited from the unconditional support that she received. Although during adolescence she tried her hand at naturalistic-style drawings made from the direct observation of a model, she soon became bored with these exercises, a pattern she repeated in art school. For the first two years of her formal training, she studied realistic drawings in order to prove to herself as well as to others that she was able to do so. Despite her lack of previous training, she very soon excelled in her drawing class. Having demonstrated such competence, she once again left realism behind and turned toward the creation of a more inner-directed pictorial world that she feels is expressive of her personal truth. (Regarding further career development and artistic pursuits, see a later section devoted to the career paths of artistically gifted children.)

One may wonder why the development of pictorial intelligence in these two youngsters, Amnon and Varda, was so little affected by the pictorial models readily available in their environment. Indeed, why do we not see clearcut imitative efforts that might have provided an effective shortcut for these child artists? I venture to guess that Haas' educational philosophy has provided these youngsters with the framework within which their development could unfold. This educator condemns what she sees as mindless copying. She is a firm believer in the notion that child art ought to be supported through the full range of the childhood years, and that so-called shortcuts violate the integrity of the normal growth process and of the child's individual expression. For Haas, art-making and art education ought to be fostered in the service of the development of a healthy and good personality. For this educator, purely aesthetic concerns, although important, are of a secondary order.

The Drawings of Eytan

Eytan is the oldest of four children, and for several years remained an only child. Both parents—his father, an architect, and his mother, a nursery school teacher—are talented in the visual arts. Until he was four years old Eytan lived in the city of Jerusalem. Thereafter, the family moved to an industrial cooperative settlement, a moshav. His parents do not remember whether Eytan ever made scribble-pictures. According to his mother, Eytan, an early speaker, started drawing recognizable shapes at the age of two years. His first drawings depict people, a tractor, a fish, and a cow. His fine motor coordination was advanced for his young age, and he effectively used pencils for drawing and blocks and small Legos for various constructions. His gross

motor coordination, however, lagged somewhat behind and he began to walk only at the age of two years. In terms of social interactions, Eytan was not an aggressive toddler. He did not defend his possessions when other toddlers, encountered in the sandbox, appropriated his toys. For the first years of his life he was a somewhat shy and introverted child.

According to Eytan's mother, his earliest drawings were made in response to objects that caught his attention when going on a walk. She sees these drawings as Eytan's attempt to understand his world; to digest new information and to make sense of it. While Eytan also engaged in pretense play, mostly with toy cars, drawing proved to be the major avenue for working through whatever made an impression on him. For Eytan, to draw is to know.

Between the age of two or three years, Eytan spent an average of 15 to 20 minutes at a time drawing. Each one of these pencil drawings was done quickly, with light, sketchy lines, and in the span of seconds or minutes. Working from memory, Eytan would single out a part, mostly a frontal aspect, and work from there to other parts. He did not draw simple outline figures, but developed quite early a fairly complex conception of the whole object that guided the drawing of the parts. As the extensive collection of Eytan's drawings indicates, he showed an early and abiding interest in cars. Even as a two-year-old he knew all the models on the road. Eytan was an inquisitive child who asked many questions about objects that intrigued him, including machinery, cars, and dinosaurs. He also spent long periods of time looking at picture books. He loved his books and liked to "correct" some of the drawings, for example, adding smoke to the chimney of a house. At the age of four, he enjoyed looking at pictures of cars and of human anatomy in the *Encyclopedia Britannica*. Among childen's books he preferred those that had many illustrations of dinosaurs and other wild animals. According to his mother, Eytan seemed more interested in the visual aspects of a book, in the drawings and the photographs, than in the verbal narrative. Eytan has continued to draw on a daily basis, and at times he has also devoted himself to sculpting and the creation of complicated mechanical models.

By and large, Eytan has taught himself how to draw. He has not received formal training and does not strive for it. When I questioned him at age 12 whether he would like to receive instruction, he indicated that when he wants to develop a new technique he studies drawings and photographs that are relevant to the problem and teaches himself what he needs to know. However, he values the instruction he currently receives in his school and thinks that it has been helpful in developing his sense of color. Eytan takes special pride in his work and accomplishments. He cannot explain his interest or talent—it comes natural to him. Eytan also pursues other activities in sports, music, and chess.

Eytan has a very good visual memory for objects that attract his attention. It is not a photographic memory, but operates selectively and is closely related to his interests. Eytan will look repeatedly at a

favored object or its drawing, and his memory of what he has carefully inspected serves him well when, at a later time, he wants to draw it. He never copied directly from a drawing or a photograph although, when he was somewhat older, his drawings of cars, for example, were influenced by the catalogues he had carefully examined.

The extensive collection of Eytan's drawings dates back to his second birthday. Fortunately, his parents preserved most of his early drawings and noted the date they were drawn. This rich set of drawings makes it possible to trace the development of his representational skills and to detect changes in his pictorial conception and use of drawing system. This body of work is of particular interest in that it demonstrates how a gifted toddler pursued, with incredible determination, his interest in a naturalistic depiction of objects, specifically, of vehicles. Over the next few years Eytan constructs, quite independently, an orderly series of drawing systems that can represent the three-dimensionality of the object and thus provide extensive information about its looks and function.

The first drawings, made at the age of 2;1 and 2;2, are of people, a fish, and a tractor (see ills. 177 a–d). The people are tadpoles composed of a large head, facial features, arms, legs, and hair. One of the drawings depicts Eytan's father, the other the family. The humans are drawn in a typically frontal orientation and face the viewer. The fish, in sideview, is drawn with a sweeping and well-controlled embracing line that ends in a tail, perpendicular to the body. The fish is also endowed with facial features and blows air bubbles. Clearly, this two-year-old has already a graphically differentiated conception of humans and animals. The tractor consists of two large wheels, a shaft, exhaust pipe, seat, driver, and steering wheel. The wheels are represented by two overlapping circles, which suggest the volumetric property of tires.

These drawings of humans, fish, and tractor are representational achievements that effectively convey their message. They are self-assured renderings, most likely not the very first paper and pencil exercises of this young child. Most remarkable is the age of the artist. One month later, at 2;3, the human figure boasts a graphically differentiated and colored-in body, with arms and legs extending from the torso (see ills. 178 a). The tractor (or is it a bicycle?) has also become more elaborate, with spokes crossing the hub of the wheel, and verticals depicting the width of the tire. Two orthographic views of the wheels, a side and a top or rear view, have been juxtaposed, which lend a degree of solidity to the wheels (see ills. 178 b). Other items drawn during this month include a train with its locomotive and many cars, a train on its rail, a ship and its anchor, a group of hunters, a compressor, and an assortment of cars. The wheels of the cars have been further differentiated and include a set of conspicuous nuts and bolts (see ills. 178 c–g). One month later, helicopters and airplanes appear stationary or in flight. There is attention to such detail as rotors, propellors, cockpit, landing gear, and wheels. At 2;6 and 2;7, the inventory expands to include a jeep, a moving van, cement mixers,

a.

b.

c.

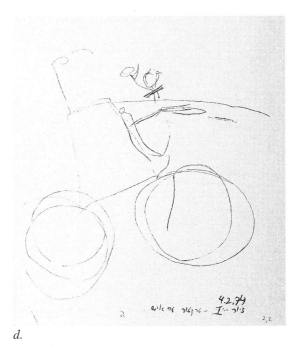

d.

177. *Eytan's First Drawings*
a. Daddy.
b. My family.
c. Fish.
d. Tractor.
Age 2;1 to 2;2.

233

178. *Eytan's Early Drawings*
a. Man.
b. Bicycle.
c. Train.
d. Boat.
e. Hunters.
f. Compressor.
g. Car.
Age: 2;3.

trucks, buses, and a striking series of cows (see ills. 179 *a–g*). The cement-mixing trucks are of special interest because they demonstrate this child's early efforts to capture more than a single face of the object. Instead, the basic side view of the truck is supplemented by a top view of the hood and a rudimentary frontal view of the grille and bumper. This juxtaposition or alignment of different faces of an object along the horizontal or vertical axis represents, in Willats' terminology, a drawing system that is based on vertical or horizontal oblique projection (see chapter 4). Also noteworthy in this drawing is the oval body of the cement mixer. It is marked by a set of curved parallel lines that suggest the roundness or volume of this part. The curling smoke that emanates from the exhaust pipes indicates that the cement mixer is at work.

Between 2;6 and 2;11, Eytan continues to draw his trucks and buses, locomotives and airplanes, and an occasional cow and insect

a.

b.

c.

d.

e.

f.

179. *Eytan's Expanding Graphic Themes*
a. Helicopter and airplane.
b. Toy helicopter.
c. Jeep.
d. Truck.
e. Bus.
f. Cement mixer.
g. Cows.
Age 2;4 to 2;7.

g.

(see ills. 180 *a–d*). The majority of the drawings of vehicles made during the first months following his second birthday employ an orthographic projection system. This means that the object is drawn as if it faces the observer orthogonally, and a single, flat, though dominant, face comes to represent the totality of the object. From the age of 2;5, Eytan's drawings are based, in part, on a vertical or horizontal oblique projection system, and soon it becomes his preferred mode of representation. Eytan draws, for example, the head or tail lights of the car at the upper and lower corners of the body; he rotates the bumper vertically upwards or extends it horizontally in an effort to depict

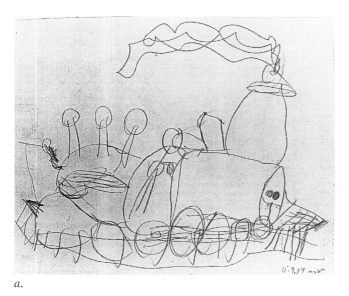

a.

b.

c.

d.

180. *Eytan's Growing Graphic Competence*
a–b. Trains.
c. Airplanes.
d. Insect.
Age 2;6 to 2;11.

a.

b.

c.

181. *Eytan Discovers New Drawing Techniques: Horizontal and Vertical Oblique Projections*
a. Moving van.
b. Coca-Cola truck.
c. Police car.
Age 2;10 to 3;2.

more than a single face of the car (see ills. 181 *a*, *b*, *c*). In these drawings, cars and their different faces are presented to the observer from more than one viewpoint. Alongside the newly discovered vertical and horizontal oblique projection system, Eytan continues to use the simpler orthographic drawing system.

As soon as he turn three, Eytan largely abandons orthographic projection. He now consistently represents the third dimension by attaching top and side faces to the frontal aspects of his vehicles. Eytan draws an astonishing array of vehicles: sports-cars, convertibles, jeeps, trucks, buses, vans, campers, trailers, tractors, bulldozers, airplanes, helicopters, an air balloon, and trains. His detailed representation of exhaust pipes, mufflers, gas tanks, differential boxes, and pneumatic brake boxes reveal how carefully he observes these powerful and fascinating machines. His interest in their makeup extends

a.

b.

182. *Consistent Effort to Depict the Third Dimension*
a. Compressor.
b. Helicopter.
Eytan, age 3;2.

beyond what is easily visible, and some drawings offer a view of what is underneath the hood. Looking inside, for example, yields a view of a compressor with its belts and rotating parts. His helicopters often depict an open door that offers a view of the cockpit (see ills. 182 *a, b*). Although vehicles clearly are a much-favored topic, Eytan includes other items in his drawings, for example, a windmill with sails, skyscrapers, a garage, a guitar, people as drivers or passengers, Eytan and his mother, and a birthday cake (see ills. 183 *a–g*).

Because Eytan returns again and again to his favorite vehicles, one can literally see the evolution of various drawing strategies. The series of buses drawn over the next year demonstrate different types of solutions that he invents, perfects, or discards in his sustained effort to portray the multiple aspects of a bus. For Eytan it clearly is not good enough to draw the characteristic side view of a bus. This three-year-old is not content until he can represent the long side of the bus with the passengers, the windshield with the driver, the hood, top, and front sides of the bus, the headlights and bumpers, all of which indicate the true shape, volume and function of the vehicle (see ills. 184 *a, b*). Similar experiments occur with cars, moving vans, cement mixers, tractors, and combines.

From his third birthday on, and with a growing repertoire of objects and themes, Eytan now employs three major drawing systems based on horizontal and vertical oblique projection, isometric projection, and divergent perspective. In isometric projection the frontal view of the object, in this case the car, is represented by its true shape (a basically rectangular shape), whereas the top of the car and one of its sides are drawn as parallelograms (see ills. 185 *a, b*). The oblique parallel lines of isometric projection represent the edges of the car that extend backwards into three-dimensional space. In divergent perspective, divergent diagonal lines are used to represent depth (see ills. 186 *a, b*). Such drawings present four aspects or faces of the vehicle: the front, the top, and both sides. Eytan does not always base his

a.

b.

c.

d.

e.

f.

g.

183. *Thematic Diversity*
a. Birthday cake.
b. Eytan and his mother.
c. Bulldozer.
d. Going for a ride.
e. Windmill.
f. Skyscrapers.
g. Loading a truck.
Eytan, age 3;0 to 3;9.

184. *Three-Dimensional Depiction of a Bus*
a–b. Eytan, age 3;10.

a.

b.

a.

b.

185. *Drawings that Approximate Isometric Projection*
a–b. Eytan, age 3;9.

a.

b.

186. *Predivergent Drawing System that Approximates Divergent Perspective*
a–b. Eytan, age 3;8 to 3;9.

drawing on a single system. In some drawings he uses a mixture of projection systems, for example, a locomotive drawn in horizontal and vertical oblique projection and one car drawn in isometric projection (see ills. 187). While all three systems appear at age 3;0, a more complex horizontal and vertical oblique system tends to displace the earlier and simpler one. A similar trend can be observed for divergent perspective, in which a more comprehensive treatment takes the place of a previously limited employment of this technique. A combination of isometric and divergent perspective appears to be the system of choice for this three-year-old. Interestingly, the developmentally somewhat less advanced projection systems, for example, orthographic projection and horizontal–vertical oblique projections, continue to be used in Eytan's drawings of multiple objects. In these

187. *Use of Diverse Projection Systems in a Single Composition*
Eytan, age 3;2. Train.

cases, the representation of the nonsalient components of a composition is quite different. Some attempts to use converging lines can be seen in drawings of the hood of a car (see ills. 188). Altogether, Eytan employs various combinations of projection systems to suit his purpose, which is to show as many sides of the object as he can convincingly include in his portrayal of vehicles. He has moved from attaching sides, either vertically or horizontally, to the frontal aspect, to a pragmatic experimentation with oblique lines that approximate in an intuitive, though imprecise manner, various projection systems.

Eytan seems to be able to freely vary the orientation of his vehicles, which can face to the right or the left of the page. An amazing

188. *Early Use of Converging Lines*
Eytan, age 3;10.

drawing of a moving van made at age 3;7 depicts the object in three-quarter view. The vehicle is drawn in predominantly isometric projection, with several changes in the angle of the parallel lines: its overall diagonal axis imparts a sense of motion, of an object coming toward the viewer (see ills. 189 *a*). Another drawing made at 3;7 depicts two people riding a motorcycle, the driver in the driver's seat and his passenger in a separate though attached compartment. The motorcycle, depicted from a frontal and somewhat foreshortened view, evokes an impression of movement (see ills. 189 *b*). Eytan knows how to create tight groupings of figures and their surround, and at times employs size diminution, as is the case in a drawing, also made at 3;7, that depicts a desert scene. The large car, with its driver prominently displayed in the foreground, is set against a background of hills, dwellings, and vegetation, much reduced in size. Clouds and an airplane complete the composition (see ills. 189 *c*).

Eytan's line drawings have become increasingly more self-assured in their rendering of shape and volume. He tends to use sketchy, at

a.

b.

189. *New Strategies that Portray Volume, Movement, and Depth*
a. Moving van.
b. Motorcycle.
c. Desert scene.
Eytan, age 3;7.

c.

times scribbly, lines that extend into the interior of the shape and
endow its object with solidity and also vitality. His zigzag and em-
bracing lines tend to create dynamic representations. By contrast, his
human figure, while certainly advanced for his young age, does not
show the precocious sophistication he so amply demonstrates in his
vehicles. Although the human figure was one of his first drawings, and
the anatomical depictions of the *Encyclopedia Britannica* seemed to
fascinate him, the human body has not captured his lively imagina-
tion to the same extent as the machines. Humans are mostly drawn as
drivers of cars or as passengers; evidently, they are not as intriguing
as the machines that captivate him. People who play a minor role in a
theme composed of many objects are depicted in shorthand style, as
tadpoles, and always face the viewer. Not a single figure in the many
drawings of three-year-old Eytan is drawn in profile.

Over the next few years Eytan perfects his strategies for represent-
ing his favorite objects and includes humans engaged in various activi-
ties, his first profile drawings of a person, animals, and city-scenes in
his repertoire. A tightly structured drawing of Jerusalem, made at 4;2,
depicts the old city with its minarets, towers, and ramparts as seen
from a hill or plaza. The buildings, closely spaced, overlap each other
and diminish in size as the eye moves from the right to the left side of
the page. A car drawn in the right bottom corner shows foreshorten-
ing and some converging lines (see ills. 190 *a*). Returning to one of his
favored themes, in a powerful drawing of a cement mixer in three-
quarters view made at 4;4, he depicts the rear, side, and top aspects
of the vehicle. This drawing, which is primarily based on isometric
projection, is remarkable for its beautifully controlled lines and the
self-assurance with which Eytan varies their orientation to enhance
the effects of volume. His sophisticated use of an elliptical shape for
the partially occluded wheels enhances the three-dimensionality of
the scene (see ills. 190 *b*). Eytan's vehicles are now mostly drawn in

190. *Artistry at Age Four*
a. Jerusalem.
b. Cement truck.

a.

b.

a.

b.

c.

191. *A Young Master at Work*
a–e. Eytan, age 4;1 to 4;8.

d.

e.

244

isometric projection, frequently in three quarter view, foreshortened, and with a marked diminution in the size of the receding parts (see ills. 191 *a–e*). Using this drawing system now in a consistent fashion, he creates powerful images of vehicles and machinery. In place of the earlier and intuitive exploration of various projective approaches, one gets the impression of a deliberate selection of the isometric system that gives him a masterly control over his chosen subject matter. A sense of humor can be glimpsed in the drawing of a gasoline truck with a picture of a smaller truck on the tank, with a still smaller one drawn on the second gasoline truck (see ills. 192). Altogether, the compositions of this four-year-old are well organized and convey a dynamic sense of unity.

I have concentrated on Eytan's drawings of vehicles because they occupy a central place in his collection, and demonstrate so well his use of drawing strategies and their transformation (for a detailed discussion of early strategies, see Golomb, 1992a). It is important, however, to mention that his repertoire is much richer and includes, among others, children playing, on skis, on tricycles, pushing a doll carriage (see ills. 191 *a–d*).

Vehicles and their contents continue to engage Eytan as seen in a drawing of a car with a raised hood, a drawing of a camper, and

192. *Humor: Repetition of a Motif*
Eytan, age 4;3. Gasoline truck.

5.76

a magnificent construction scene, all drawn between 5;0 and 5;2 (see ills. 193 *a–d*). The collection from this age reveals an interest in how to assemble things and also includes drawings of the spaceship *Apollo* (see ills. 193 *e*). Although his interest is mostly vested in vehicles and the mechanics of their construction and action, Eytan reveals an altered graphic conception of the human figure in a portrait of a man, perhaps his father (see ills. 193 *f*). We also see a new theme being developed, the depiction of roadways in city scenes. This topic is further developed by the six-year-old who draws an extensive series of intersecting highways and their traffic patterns viewed from various angles, including aerial views. These are action-packed portrayals of airfields, planes landing or taking off, bombing attacks, near accidents of cars and trucks set against an urban background (see ills. 194 *a–e*). A drawing from this period depicts a tornado passing through a city (ills. 194 *c*). It is a dynamically balanced composition in which the various elements are organized to convey the tension of the theme.

A cityscape of New York, drawn during a visit to the city at age 7;10, employs a mixture of drawing systems. For example, in an attempt to use perspective, Eytan draws the streets with converging lines. The three-dimensionality of the scene is further enhanced by a stacking of the buildings that overlap each other, and by the fairly consistent use of diminishing sizes (see ills. 195).

A new interest appears in a series of drawings Eytan makes between seven and eight years. They depict animals in the wild—leopards, lions, cheetahs, giraffes, monkeys, deer, elks, elephants, and zebras. They are dramatic, action-filled portrayals of life in the jungle (see ills. 196 *a–d*). In these drawings Eytan tries to portray the various animals in their characteristic stance, in motion, and at rest. The pencil drawings of dotted and striped animals display a decorative quality not previously observed. The inspiration for these drawings seems to have come, at least in part, from a calendar and an animal puzzle. In addition to his continuing interest in vehicles, during this period Eytan makes an extensive series of Superman drawings, emphasizing the superhero's muscles and the city he flies over, a theme that now captures Eytan's imagination. In these drawings he uses black magic markers for the figure and scene and various colors for Superman's suit (see ills. 197). In a set of drawings of jet airplanes in flight he returns to his more common use of the pencil.

At age 10 and 11, following another visit to the United States, Eytan makes a series of city skylines drawn in perspective, maps, cameras both open and closed, portraits of the Beatles, and images of muscled-looking sports men (see ills. 198 *a, b, c*). The theme of the muscular human body will continue to engage his interest over the next few years as he depicts sports events and tries to master the human body in its manifold postures. When the drawings are not meant as mere exercises, which is the case in a series of heads drawn in various orientations, they distinguish themselves by their sense of order and balance (see ills. 199 *a–e*).

a.

b.

c.

d.

e.

f.

193. *Artistic Imagination and Competence
at Age Five*
Eytan, age 5;0 to 5;2.
a. Car with open hood.
b. Camper.
c. Construction scene.
d. Car.
Eytan, age 5;11.
e. Spaceship Apollo.
f. Portrait of a man.

a.

b.

c.

d.

194. *Action-Packed Scenes*
a. Accident.
b. Cement or oil truck and parking lot.
c. Tornado.
d. Airfield.
e. City traffic.
Eytan, age 6;6 to 6;8.

e.

195. *New York City*
Eytan, age 7;10.

The drawings of cars made during this period are mainly of cross-sections that depict the mechanical parts of the machine: the crankshaft, pistons, steering column, brakes, calipers, fan, electrical wiring, and the inner springs of seats. Others focus on stylistic differences between various car models. These drawings emphasize mechanical precision and, not surprisingly, their lines are sparse and somewhat lusterless, as is the case with catalogues. They contrast sharply with his drawings of athletes, of basketball and soccer players who present him with a seemingly unending array of postures to be mastered.

a.

b.

c.

196. *Animals in the Wild*
a–d. Eytan, age 7 to 8.

d.

197. *Superman*
Eytan, age seven.

a.

b.

198. *Cityscapes, Beatles, and Athletes*
a–c. Themes of the 10- to 11-year-old
Eytan.

c.

Although Eytan shows a great concern for anatomical fidelity and has taught himself much about the workings of the human body, his interest extends beyond the body in motion to the human face and its complex expressions. As he experiments with different facial orientations, one sees the beginnings of a more psychological portrayal of the athlete.

Other themes that engage Eytan and thus enter his drawings are rock groups and figures from the Dungeons and Dragons game; a series of drawings shows the Beatles in various disguises, for example, in Dungeon and Dragons garb. Political caricatures appear during the last years of high school, and we see the first sketches of teenage girls and young women. Not surprisingly, cars continue to engage him and he creates his own designs, presented from different vantage points.

By the age of 17, drawing no longer serves as a major source of information about the way the world looks and operates. Eytan now draws for relaxation, for self-entertainment, often while listening to music. Art and drawing are relegated to the realm of a hobby that makes no demands on him. His talent allows him to play with whatever elements of reality he might be engaged in at the time.

a.

c.

b.

199. *Group Interaction: Sports Events*
a–d. Eytan, age 12 to 14.
e. Eytan, age 16.

d.

e.

252

Over the years, his relationship to drawing has changed from a compelling desire to master the depiction of fascinating objects and scenes, and thus to control them, to an activity engaged in for his own amusement. But even in the early years, when he drew a great deal and with intense concentration, drawing was a playful and enjoyable activity. Eytan has been consistent in rejecting formal instruction. Earlier, as a 12-year-old, he insisted that he could teach himself whatever he needed. At some point during his high school years he was registered for two courses in art, one of which he quickly dropped—a further indication that he had no desire for formal training and did not wish to subject his drawings to outside criteria.

Eytan was a good student in high school, especially in mathematics, computer science, and English, although in his own words: "I was an average student. . . . I did not really devote myself to school, and I had, like most of the boys, other things in mind."

What motivated such intense dedication to drawing in his childhood years and what might be the reason for the late adolescent's diminished urge to represent his relationship to the world and its meaning in graphic form? Quite striking is Eytan's choice of subjects that exemplify power, energy, and destructive potential: vehicles and machinery, traffic patterns and accidents, tornadoes, wild animals, Superman, the Beatles and other rock stars, and athletes with their extraordinary skill and strength. These subjects carry a tremendous appeal for all children as well as many adults, but in the case of the child the contrast between his vulnerability, weakness, and powerlessness and the world of adults and their powerful machines is so much greater. Eytan was fortunate to have exceptional visual and graphic abilities that enabled him to take a stance vis-à-vis his world, to tame it as he presented it with ever greater clarity and aesthetic delight. Given that he was a somewhat shy child, drawing assumed special significance. As Eytan's world expanded, so did his interests, and the many ways in which he could now cast his understanding. Thus, gradually, drawing lost the urgency that had motivated the younger child.

As a teenager, Eytan engaged in sports, chess, music, and worked in his free time as a draftsman in his father's architectural firm. Of course, he knew that he had talent for drawing and that he was admired for his skill, but he felt no need or desire to pursue a career in the fine arts. The earlier compelling need to draw had petered out. At 18 he was inducted into the army, and following his discharge at the age of 21, he studied industrial design at an art school, from which he graduated with distinction.

In many ways, Eytan and Varda are studies in contrast. Eytan's interest was focused on the outer world, its appearance, and its mechanics; he set out to study it, understand it, and master it via drawing. In contrast, Varda developed a highly decorative ornamental style, an artistic vision within the idiom of child art, forging a language that expressed deeply felt emotions and very private concerns. I shall return to the issue of motivation and individual differences in a later section devoted to the career choices of children talented in the visual arts.

Amnon, Varda, and Eytan, although brought up in a similar Western cultural milieu, explored very different avenues in their drawing ventures—different in the tasks they set themselves, the goals they pursued, the techniques they invented, and the emotions they expressed. Gifted children who seem driven to explore their chosen medium adopt different routes that exemplify the special, sometimes unique manner in which they explore the medium to convey their personal view. I now turn to an account of a Chinese child prodigy and her development in the sociocultural frame of her country's artistic traditions.

The Drawings of Yani

Yani was born in Gongcheng County, in the Guanxi province of Southern China. She is her parents' firstborn child and seems to have been destined for the arts. Her father, a painter whose studio was located in the family's house, reported that the newborn was greeted by the smell of oil paint (Wang, 1987). From the beginning, her relationship with her father was a very close one: she had free access to his studio; observed him at work; was allowed to experiment with charcoal, brush, and ink; and accompanied him on his visits to the studio of artist friends. Father and daughter seemed to have spent a great deal of time together going on walks through the beautiful countryside and on visits to the zoo. According to her father, she started painting at age two; by the time she was six she had completed approximately 4,000 paintings and held her first exhibition.

Only a small sampling of her works have been published. On the basis of this material, painted with brush, ink, and pigments, authors who have studied Yani's artistic development identify two or three major stages, beginning with age three and extending through the middle adolescent years (Andrews, 1989; Goldsmith, 1992; Goldsmith & Feldman, 1989; Ho, 1989; Tan, 1993). The periods can be identified in terms of the dominant themes and the technical and compositional attributes that characterize the paintings of each period. According to Liqin Tan (1993), the first period extends from three to six years and represents Yani's world of monkeys, their play, wishes, fears, and mischief; the second period, from 7 to 11, is devoted to landscape paintings; and the third period, extending from 11 to 15, revolves around flowers and birds.

The media with which Yani works—brushes, ink, pigments, and rice paper—are the traditional tools of Chinese painters. Throughout the history of Chinese painting, the brush stroke has been the central focus, and the use of washes a fundamental element (Arnheim, 1997b; Siren, 1963). By the time Yani is four to five years old, she has mastered a number of basic brush strokes and is able to differentiate between lighter and darker strokes, utilize the different sides of the brush for various effects, and handle light and dark ink washes. Within this relatively short period of intensive practice she has mastered such difficult techniques as mixing ink and color, the flying-

white brush stroke, the wet ink technique, and control of the amount of ink. By manipulating varied tones of ink and color she creates the texture of the monkey's body and its furry coat.

In the eyes of an observer familiar with children's artwork, Yani's paintings of monkeys playing, quarreling, waiting for food, swinging from trees, being drunk, and sniffing wine are a mixture of childish imagination, exuberance, and unusually skillful handling of the elements of the composition. Some of Yani's early paintings from ages three and four portray single figures, for example, a furry kitten, tadpolish in its structure but already expressive in its posture and charm (see ills. 200 *a*). She passes very quickly beyond the early global and undifferentiated forms, varies the monkey's posture, increases their number, and depicts them in a variety of actions and poses that create lively and pleasing compositions, clearly the work of a precociously gifted child. Along with increasingly complex compositions, Yani at age five begins to paint on larger sheets of paper and explore the format of the handscroll, a compositionally and thematically difficult task (Goldsmith, 1992; see ills. 200 *b*, *c*).

Even at this early age, Yani's artwork is clearly defined in terms of the newly revived traditions of her environment and its long artistic history. Thematically, the choice of monkeys continues an old Chinese tradition in the visual arts and in narrative form. In folk stories, the monkey is endowed with magical powers, a trickster who can assume many guises and transformations. In the painting of monkeys

200. *Yani: A Chinese Painting Prodigy*
(Courtesy Wang Chiqiang.)
a. Kitten, age three.
b. Pull harder! age five.
c. Let's have a party, age five.

b.

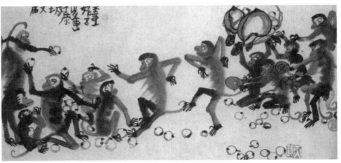

c.

a.

and other animals, artists have developed formulae that involve the order and form in which parts are drawn, beginning with strokes that outline the head, the body, and the limbs. In terms of didactic formulae for monkeys, Tan analyzed three different orders of monkey postures that face to the left or the right (drawn in profile) or the middle (in frontal view). Although her compositions teem with the lively antics of her monkey friends and engage the viewer with their expressiveness and skillful portrayal, the figures are mostly flat and two-dimensional, and this young artist shows no inclination to create the illusion of three-dimensional space.

To the Western observer who considers artistic precocity in terms of the skillful naturalistic rendering of figures and, above all, the ability to accurately represent perspective, Yani's childhood work might seem unremarkable, especially in her paintings of children, which are quite typical of the work of ordinary children. However, contemporary tastes are more pragmatic, and when her work was exhibited in China and in major cities in Europe and North America, her paintings were greatly admired.

What sets Yani's work apart is more than the technical competence which she has achieved under the guidance of her father. The students of Yani's paintings who are familiar with Chinese aesthetics praise the *spirit* of her painting which endows her art with "the breath of life" or "a life-like spirit." According to Dawn Ho Delbanco (1989), Woi-Ching Ho (1989), and Tan (1993), Chinese artists try to portray the essence and vitality of nature and its creatures; they do not strive for a realistic representation of the appearance of a figure or scene.

Around the age of seven, a major shift occurs in Yani's painting that coincides with her entry into school. She now focuses her attention on the natural world of rivers, ponds, and mountains, and on the seasonal changes in their appearance (see ills. 201 *a, b*). She also portrays children—perhaps a reflection of her new social world of peers. According to Tan, this second period in Yani's artistic development is marked by a greater exploration of new ideas and techniques in line with traditional Chinese conceptions of artistic merit. She adopts mainly known techniques and themes and pays greater attention to the spatial and pictorial relationships of her composition. Her style becomes more fluid and painterly, and she creates the illusion of an expanding space with the skillful use of dark–white contrasts and the tonal values of her washes and their overlapping shapes. With her ability to use a variety of textures in monochrome, she imbues the mountains and cliffs of her composition with volume and solidity. She now uses linear elements sparsely and her contours become subsidiary to a fluid impressionistic style that blurs the boundaries between the various depicted objects and creates a somewhat dreamlike landscape. According to Julia Andrews, her work at this period shows the influence of contemporary Chinese painters, especially the artists Li Keran and Qi Baishi. This is not surprising if we consider that she grows up in an artist's milieu, sees painters at work, and most likely visits exhibitions (see ills. 201 *a*).

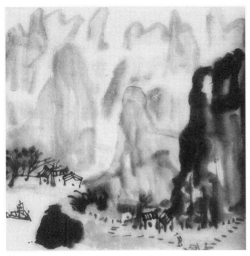

a.

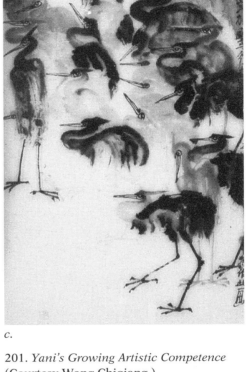

c.

201. *Yani's Growing Artistic Competence*
(Courtesy Wang Chiqiang.)
a. My beautiful home town, age eight.
b. Waiting for the young ones, age 10.
c. Last night I dreamed I saw racing egrets,
age 11.

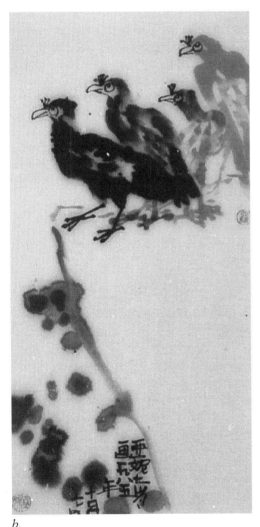

b.

During her adolescent years, 11 to 15, Yani concentrates on the traditional Chinese themes of bird and flower, and these paintings show further development in compositional and brush work techniques (201 *b*). In terms of conventional criteria, the flower and bird paintings represent her most successful brush work. However, according to the evaluation of four Chinese artists interviewed by Tan, Yani's most remarkable work was accomplished during the first period, which depicts, in a highly individualistic manner her childhood world with its wishes, concerns, and fantasies. The intensity of feelings and the expressive powers of her brush work created a magical world of great sincerity and beauty. Her later work became more conventional, and although it showed promise, its future course seemed uncertain, and her achievements more in line with highly trained students.

In Yani, the child prodigy who early on develops a passion for the painterly medium, we can see once again the general characteristics of artistic development as well as its highly individualistic and creative nature. Thus, Yani joins the three child artists described earlier in this demonstration of the diverse paths artistically gifted children pursue in their artwork. Her paintings illustrate, from the very beginning, the impact of established Chinese artistic traditions in the use of the materials, the brush, the ink, and the rice paper. Yani achieves a lifelike representation with artistic means that are not based on linear perspective, and her artwork remains relatively flat, although imbued with vitality and dynamic tension. The passion to paint is most likely related to the very close relationship she maintained throughout her childhood with her artist father. Yani was fortunate to find a highly valued medium that could express her childhood experiences and share the pictorial world she created with her father, a dominant figure in her life.

Gifted Child Artists: Diverse Trajectories

Let me now summarize some of the findings regarding the development of the four gifted child artists: Amnon, Varda, Eytan, and Yani. Careful analysis reveals similarities in the young artists' intense dedication to their drawings and paintings, in the high priority they assigned to this daily activity, the immense output, the fine perceptual-motor skills, and the passionate need (or even hunger) for graphic stimulation. In a broad sense, all four artists work at developing their skills and largely guide their own pictorial development. Their graphic conceptions evolve gradually, although not at a uniform rate. The overall progression is from a simple system to a more complex and differentiated one. One can follow the logic that underlies the drawings and their orderly transformation as practice with the medium leads to greater representational competence. It is a gradual process, grounded in an understanding of the constraints and possibilities of the pictorial medium, and it is characterized by an orderly succession of phases in representational conceptions and skills. The

course of development described in previous chapters is also relevant for an understanding of these gifted children. They do not skip stages and they do not invent or copy perspective drawings before they have mastered orthographic systems of representation. This is particularly well demonstrated in the development of Eytan, who masters complicated projective systems early and apparently on his own, without having skipped over simpler systems.

A closer look at some of the similarities and differences in the development of the artistically gifted children whose work I have presented shows that Amnon's and Varda's development followed, in very broad outlines, the course of child art described for all children. Within this general framework, their drawings and paintings carry the stamp of their originality and individuality, and one can recognize each child's work even over the span of years. Amnon and Varda develop the child art mode of representation to a very high degree, and relish the decorative and expressive characteristics of this approach. Play with color and shape is as important as the drawing of representational figures. Objects and people derive their full significance from intricate designs and from their relationship to the colorful background. The artwork of both children indicates their desire to master the medium, to differentiate the figures, and to articulate a chosen theme. Yet their artistic development occurs, for most of their childhood years, within the framework of the child art style and according to its logic. Both children explore the sensuous attributes of color, texture, and design and reach their artistic peak in this style around the age of eight or nine. Between 9 and 10, these two young artists take steps of transition to more adult forms of representation. Although there are no clear turning points at which this art form is abandoned, the transition to a more adult or academic form of drawing can be seen in Varda and Amnon's choice of pencil for experiments with line and shading. Both have discovered that pencil drawings facilitate the acquisition of new techniques and that they are useful for a more naturalistic portrayal of objects and people. Of course, their development during the adolescent years reveals significant differences, with Varda's continued emphasis on symbolism and color as a major determinant in her paintings contrasting with Amnon's increasing interest in mastering anatomically correct drawings.

Eytan's drawings also follow the typical stages of representational development, but this process is accelerated and he rapidly outgrows the child art style as he masters the elements of three-dimensional projective drawings. In contrast to Amnon and Varda, Eytan aspires to depict objects with as much fidelity as the pen or pencil will render on a two-dimensional surface. What I have termed the child art style of drawing is a relatively short period for this precociously gifted preschooler who teaches himself, through literally hundreds of trials, the elements of isometric, divergent, and convergent perspective. His interest in color is short-lived, as crayon and magic marker do not afford him the same control as the pencil. Above all, he is interested in line, realistic shape, and the portrayal of volume, and he has the

unique ability to accomplish what he sets out to do. It is with a singularity of purpose that he selects certain preferred objects for repeated experimentation, eagerly exploring his world. When he becomes interested in the human body, it is the structure and mechanics of the human figure in a group-action that intrigue him, much as earlier he was interested in the construction of machines and their motion. One should not take this analogy too far, however, because his figural exercises also suggest an interest in the psychological state of the person. Nevertheless, the contrast with Varda's human figures is quite striking. For Varda, a grouping of humans indicates a theme that is of broad significance to the community. The figure is not studied in terms of its anatomy or mechanical construction, but presented as the carrier of a symbolic meaning, the embodiment of a theme. Points of transition in Eytan's work are more related to themes than to style, although each subject and its composition presents him with new problems and thus also with opportunities for new solutions.

As is the case with Eytan, Yani is a child prodigy whose work exudes "the breath of life" identified by Chinese artists: it is lively, engaging in its themes and their often humorous composition, and technically quite sophisticated. She delights in the creation of a magical world of play, mischief, and desires, transparent in their childish motivations and depicted with great charm and competence. Unlike Eytan, whose craftsmanship with the pencil is quite masterful, Yani's accomplished use of the brush and ink is painterly, based on gestures that in Chinese artistic traditions are central in the control of this medium and its subdued tonal variations in color. Her precocious development shows some similarity to Eytan's in her ability to quickly master the stylistic traditions of her culture, and in its development from relatively simple representations to the sophisticated use of her medium. Her work is remarkable for the originality with which she integrates childhood concerns, astute observation of family life, the themes of monkeys, and the artistic style of her culture in the medium with the tools provided by her father. During the second stage of her artistic development, which coincides with the elementary-school years, Yani turns to the depiction of ponds, rivers, and mountains—landscapes viewed in the changing seasons of the year and represented in a painterly-impressionistic style that testifies to her increasing skills of the brush and washes.

Artistic development involves transformation in conception and execution; it implies change and transition. Transition, by its very nature, means leaving the comfort of well-practiced solutions behind and exploring new territory in often fumbling and hesitant ways. Thus, one might speak of peaks and dips in the course of an individual's work that come at varying points in the artist's exploration of his chosen medium. The transition from childhood to puberty is always marked by a greater awareness of the standards that the culture embodies. In the case of Amnon and Varda, who developed their own graphic idiom to the fullest, there is now a new interest in assimilating the graphic models of accomplished artists, at first in the realm of

realism. A similar trend can be observed in Eytan's approach to photographs and illustrations on themes that appeal to him and that he studies attentively in order to deduce the artist's strategy and incorporate it into his own work. A similar trend is seen in Yani's selection of more adult-like themes, her focus on flowers and birds, and the growing sophistication of her methods—all of which speak of a transition out of the earlier childhood concerns.

In broad outlines, the course of development that I have sketched applies to all children. However, giftedness is not merely development compressed in time—it also reflects qualitative attributes that mark the talented. For example, the gifted distinguish themselves by their ability to use line and shape in expressive ways; by the originality of the compositional arrangement; by their sensitivity to line, color, and texture; and by an unusually good memory for objects and their representation. Although the gifted, like ordinary children, pass through an ordered sequence of distinct representational stages or phases, there is no fixed timetable or age bracket that determines this course. As these case studies document, we are not merely dealing with an accelerated rate of development in representational skills. The art-forms of each one of the children identified as gifted are vibrant, evocative, engaging, original in conception and execution—more imaginative, inventive, and expressive than their less-talented peers. We can also identify the factors that are intrinsic to the child and those in his or her environment that are conducive to artistic achievements. From the very beginning these children are motivated to use the pictorial medium to distill their experiences and to preserve them in tangible form. They are great observers, endowed with an excellent visual memory and fine perceptual-motor skills, and with a psychological makeup that propels them to transform their impressions and feelings into meaningful visible statements that express their interests and concerns. Of course, this motivation leads to a great deal of practice in the medium to which they have access, and they are not impervious to the effects their drawings have on parents and other significant people. As they grow older, they also benefit from the inspection of more advanced models from which they deduce the rules that underlie their composition. Their visual analysis and its linkage with successful motor schemes is clearly not a tracing of an image; the progressive changes in the differentiation of the elements that constitute their compositions are hard won, the result of problem seeing and problem finding that they set about to solve in their individually distinct ways.

Different routes of artistic development have been explored in the drawings of Amnon, Varda, Eytan, and Yani. In each case, the child artist developed a highly personal and easily recognizable style of drawing and painting. It is important to note that despite certain commonalities in the development of representational concepts, gifted children may have markedly different inclinations and skills and traverse diverse routes in the development of their artistic talents. This brings me to an examination of the drawings of Nadia, a highly

gifted, though unusual, child artist, whose drawings have presented a particular challenge to the developmental course I have described so far.

The Drawings of Nadia

Nadia Chomyn was born in England, the second child in a family of three. Both parents attended university; the father studied electrical engineering, the mother chemistry. Nadia's early development seems to have been somewhat atypical, and by the age of two years the parents became concerned about her poor communication skills, particularly the delay in language acquisition. At the age of four, Nadia's doctor recommended that she attend a school for mentally retarded children. Because she seemed to make little progress at the school, the mother brought Nadia at the age of six years to the Child Development Research Unit at the University of Nottingham, where she was seen by the psychologists Elizabeth Newson and Lorna Selfe. She was diagnosed as a mentally retarded child with autistic features and her severely delayed language development was noted.

The stack of Nadia's drawings that the mother brought along for the psychological evaluation proved to be quite extraordinary for a child diagnosed as retarded. At an early age, when ordinary children merely scribble or draw global figures, Nadia had drawn horses of extraordinary vitality, in motion, foreshortened and in three quarter view. To the psychologists who tested Nadia extensively and who also observed her drawing behavior, the discrepancy in her mental functions—and, above all, the remarkable drawings that seemed to violate the normal stages of development—posed a challenge to psychological theory and practice.

The collection of drawings that Nadia's mother brought to the attention of Newson and Selfe begins with drawings made at age 3;6. Dating of the drawings relied on the mother's recollection. Nadia's first drawings were made after a joyful reunion with the mother on her return home from a lengthy stay at the hospital. According to her mother, Nadia scribbled for a short while on walls or other surfaces, such as picture books. She was fascinated by illustrations in picture books and would scribble over the contours of the figures. Once she was given access to paper and a ballpoint pen, Nadia drew recognizable representations, at first of horses, birds, and trains. The drawings were made with quick, sketchy lines and completed very rapidly—within the span of a minute. At times she might persist in a drawing session for over an hour, with short bursts of one-minute drawing activity followed by a period of inspection of what she had drawn. These seem to have been happy times, with Nadia engrossed in viewing her drawing, all the while smiling and babbling to herself, often entering a state of reverie that could last for several minutes. Thereafter, she would return to lines previously left unfinished and complete the image with assurance and skill. Nadia was most animated while drawing; it was an activity that gave her great pleasure and in which

she engaged almost daily. The mother encouraged Nadia's drawing—she clearly valued her work and preserved it. The drawings were inspired by picture books and objects encountered on family outings. Nadia never copied directly from a model; her drawings were made days and even weeks after a careful and prolonged inspection of an illustration. In comparison with Nadia's rendering, the picture book original is dull and lifeless. Occasionally, Nadia also drew from direct observation.

The drawings made between the age of 3;5 and 4;0 are of horses, birds, and trains. Her earliest horses are carousel horses, and they show great attention to such detail as saddle, bridle, bit, and the central support pole. Her drawings differ from the model in the quality of the lines and the size and orientation of her horse. Nadia turns her horses with equal ease to the left and the right, and even attempts a frontal view (see ills. 202 *a, b*). The drawings are remarkable for a child not yet four, but they also display some typical childhood features such as the disproportionately large head, the somewhat stiff and schematically drawn legs, and uncertainty about their number and the direction in which they point (see ills. 202 *b, c, d*). The numerous sketches of the horse's head give evidence of extensive practice, of a determination to attain what she considers as the right shape and proportion of her subject. Unlike Nadia's horses, her drawings of trains are quite typical of graphic models developed by other young children (see ills. 203; see also Eytan's drawing of a train, ills. 180 *a*). Her drawings of a rooster and a chicken are again remarkably advanced for a three-year-old. They capture with extraordinary facility the proud image of the rooster with its puffed-up feathers. Apparently, the tongue in the open beak is not derived from the picture model. Once again, the legs are somewhat stiff and the point at which they emerge from the body reflect Nadia's uncertainty about how and where to attach them. This too presents a deviation from the model (see ills. 204).

The horse remains Nadia's most favored subject during the next year, as the now four-year-old expands her repertoire and draws humans, both individually or seated on a horse, dogs, and other animals. The horse drawings are the most interesting ones in this collection; the animal is drawn in motion, its shape is rendered with surprising fidelity, and in some cases depicted in a three quarter view (see ills. 205 *a, b*). These naturalistic-looking drawings represent a distinct advance over the ones produced at age three. The drawings of humans and other animals, however, do not attain the same advanced level of representation. The humans with their huge heads and stiff limbs are more childlike in their graphic conception (see ills. 206). Similar comments apply to the drawings of dogs. The evidence suggests that horses continue to absorb most of Nadia's drawing time and effort, and it is thus not surprising that she displays greater mastery in their execution. Between ages five to six, once again, the most spectacular-looking drawings are of the horse and its rider which are depicted with extraordinary skill, in motion, foreshortened and in three quarter view (see ills. 207 *a, b, c*)!

202. *Nadia's Horses*
(Courtesy Lorna Selfe, *Nadia: A Case of Extraordinary Drawing Ability in an Autistic Child,* 1977.)
a–d. Age 3;5 to 4;0.

a.

b.

c.

d.

a.

b.

203. *Early Drawings of a Train*
(Courtesy Lorna Selfe.)
Nadia, age 3;6.

204. *Rooster and Chicken*
(Courtesy Lorna Selfe.)
Nadia, age 3;6.

a.

b.

205. *Horse in Motion and Three-Quarter View*
(Courtesy Lorna Selfe.)
a. Nadia, age four.
b. Nadia, age five to six.

206. *Nadia's Drawings of People*
(Courtesy Lorna Selfe.)
Approximate age, four.

266

a.

b.

207. *Nadia's Virtuoso Drawing of Horse
and Rider*
(Courtesy Lorna Selfe.)
a–c. Approximate age, five.

c.

Once Nadia enters a treatment facility for autistic children, the educational emphasis on teaching language and other social skills leave her with little time to draw and, perhaps, with less motivation to engage in this solitary activity. The drawings from this period, although still indicating talent, lack the luster and virtuosity of her earlier work.

Almost everyone who has written about the mastery Nadia presents has stressed the lack of "development" in her drawings. Her talent seems to come from nowhere; it bursts on the scene and seems to lack progression. Authors have stressed how little change they can see in Nadia's drawings over a three-year period during which she makes a large number of drawings. With few exceptions, a distinguished roster of psychologists declares Nadia's drawings the work of a defective intelligence (Arnheim, 1980; Pariser, 1981; Selfe, 1977, 1983, 1995; Winner, 1982 [but see a more comprehensive and revised view, 1996]).

Selfe, who tested Nadia at the age of six years, considers Nadia's extraordinary graphic performance closely related to her failure to formulate concepts verbally. She bases her analysis on Karl Buehler's thesis (1930) that drawings are graphic accounts of essentially verbal processes. Selfe sees verbal mediation as a necessary condition for the symbolic and schematic stages in normal drawing development. Anomalous or atypical children do not depict the visual experience of the normal child. Instead, they attend to lines, edges, contours, and angles from a frozen, fixed viewpoint. Their drawing is far less symbolic, their view is fixed, special, asocial, autistic; they are detached and objective, a symptom of the cognitive deficits of autistic children (1977, 1983, 1995). Because Selfe maintains that verbal concepts are essential for representational drawing, she interprets the absence of the typical childhood stages in Nadia's case as a symptom of her cognitive deficits. According to Selfe, Nadia merely copied from memory without truly understanding the nature of the objects she was drawing.

Arnheim and Pariser acknowledge Nadia's unique gift and the aesthetic quality of her drawings, but they too see her achievement as a symptom of autism. Arnheim wonders whether Nadia explored her world in a passive manner, recording images somewhat like a photographic lense. He looks at Nadia's work as "the result of a partial mental faculty running out of gear and attaining its spectacular virtuosity at the price of losing its principle cognitive function," and comments on a "detachment of vision and action from the functionality of the perceived world that endows the drawings of the estranged child with aesthetic charm acquired at so high a price" (1980, pp. 84–85).

A similar position is espoused by Pariser, who speculates that Nadia "inhabited a nameless, unlabelled universe, one which she saw and was able to render with phenomenal clarity without truly 'knowing' (1981, p. 20). According to Pariser, her graphic achievement at ages three to four indicate that she did not pass through the typical preschool stages of drawing development. He attributes her unique achievements, in part, to an inability to go beyond the immediately

given visual world and to her failure to conceptualize what she saw and drew. Because Nadia lacked even rudimentary conceptual categories, she may have been free to see objects as purely perceptual-optical manifestations, thus matching outline to contour without any insight into what she was drawing. These statements imply that Nadia's presumed inability to form visual concepts prevented her from going beyond the information given in the optical array.

Let us consider the main reasons for these interpretations and identify three sources: (1) the knowledge that Nadia is an autistic child, severely retarded and noncommunicative; (2) the presumed absence of precursors to the astonishing realism of her drawings at age three, but mostly ages four to six years; (3) the lack of further development or its rapid leveling off. I shall examine the last two points.

The collection assembled by Nadia's mother begins with an astonishing array of drawings made at the age of 3;6. We know that Nadia scribbled for a brief period, and it would not be surprising if Nadia had also made some earlier attempts to represent, for example, the horse. We have no record of these drawings, which were not deemed worthy of preservation. Once Nadia began to draw in a recognizable and realistic style, however, the drawings were valued and preserved. Indeed, when Nadia came to the university clinic for a psychological assessment of her condition, her mother brought the drawings along. It is quite probable that Nadia did not really skip over the early stages of drawing development, but that she passed very rapidly through them. The drawings of Eytan are quite suggestive in this regard. If his parents had begun their collection only at age three, we would have concluded, quite erroneously, that this gifted child had skipped the early "normal" stages of development.

The argument that Nadia's drawings do not show any development between the age of three to six years is overstated. Careful inspection reveals increasing sophistication in the drawings of her favorite subject, the horse and its rider. There is also considerable variability in the skill with which she draws various objects; for example, animal figures show much greater sophistication than humans, and amongst the animals it is the horse that is drawn with the greatest flair and competence. The notion that Nadia reached the heights of her graphic achievement in one giant leap is unconvincing; one ought to remember that she repeated the same or similar themes over and over again, indicating her interest, fascination, and love for her favorite subjects, and gaining with this practice the remarkable skill for which she is genuinely admired. Of particular importance is Nadia's *selection* of themes, her evident delight and joy in drawing. There is no good reason to assume that she did not understand what she had chosen to draw. A comparison of Nadia's drawings with some of the picture book originals demonstrates that Nadia does not simply copy; her rendering is more dynamic, vital, fluid in outline, and aesthetic in its appeal.

The decline in the quantity as well as the quality of Nadia's drawing has to be considered within the framework of the treatment center's priorities. The therapeutic and educational interventions focused

on helping Nadia acquire essential verbal and other social skills, and drawing was now relegated to a minor role in her activities. From being the only activity at which she excelled and through which she could understand an aspect of her world, drawing became one among several outlets for the human need to create and interact. No wonder that drawings from this period, although far superior to those made by ordinary children, lack the earlier virtuosity and animation that had also been a function of her incessant practice. An additional factor to be considered is her mother's death; it coincided with Nadia's entry into the treatment center. Drawing presented a special bond between Nadia and her mother, and with her absence the motivation to draw diminished.

Although artistically gifted autistic individuals are fairly rare, they do exist, and call attention to themselves by virtue of the gap between their artistic talent and the generally low level of their intellectual functioning, specifically in the verbal domain—which makes their gift even more remarkable. However, to attribute their unique talent for naturalistic representation to the autistic syndrome seems to go beyond the data at hand. A look at Eytan's drawings, and the rapidity with which this normal child taught himself the principles of isometric and divergent perspective, provides us with a timely warning not to pathologize extraordinary talent even in the case of an autist. A search for advanced representational realism and its attainment cannot serve as an index of pathology. The complete account of Eytan's graphic development, from the early tadpoles drawn at age two to the sophisticated trucks, cars, helicopters, airplanes, compressors, and combines at the age of four and five, militates against such an interpretation. It seems, therefore, as Howard Gardner has suggested, that drawing ability might also depend on a hypothetical neural structure, not yet anatomically identified, that in the case of the uniquely gifted permits them such rapid and extraordinary achievements. Gardner states that Nadia "may well have passed through the earliest stages of drawing just as every other child, but with unparalleled rapidity—perhaps in a matter of weeks or days. Her natural talent combined with an uncanny capacity to analyze the pictures and the tenacity to drill for hours on end enabled her to achieve, by age five, the level of a skilled adolescent" (1982, p. 190).

In summary, the study of Eytan's and Nadia's drawing development suggests that in some uniquely gifted children with a special interest in naturalistic depiction, the process can be tremendously accelerated, and that this evidence of a precocious talent should not be confused with pathology. Cases like Nadia and Eytan do not violate the stage progression described for normal development; they merely race through it, at times achieving within days of intensive practice what others cannot master in years. In my view, Nadia's artistic gift, far from indicating pathology, connects her with other talented normal children while her autism separates her. Talent is not a form of defect; it is a rare form of achievement and, in Nadia's case, of mastering an admittedly limited realm of her world and gaining some understanding of it.

Since the time of my early analysis of Nadia's drawings and my rejection of the view that her artistic talent was a marker of autism, additional cases of talented autistic children have been studied that provide us with a more penetrating interpretation of giftedness in the visual arts.

Drawings of Savant Artists

The notion that intelligence is positively correlated with drawing ability has found, in the past, wide acceptance among psychologists. This thesis underlies the early tests of drawings as measures of mental development (Burt, 1921; Sully, 1910; Thorndike, 1913), it motivated Florence Goodenough to develop her widely used Draw-a-Man test (1926), and some assessment of drawing ability continues to be part of most current tests of intelligence.

In line with the presumed linkage between intelligence and drawing ability, it is held that the mentally retarded draw at their delayed or arrested level of development. Several studies have documented that mentally retarded children draw like their normal counterparts of similar mental age (Cox & Bragal, 1985; Golomb & Barr-Grossman, 1977). These studies address cognitive aspects that are defined in terms of linguistic and mathematical competence and examine their relationship to representational development in children. That this is not the whole story can be gleaned from studies published by Henry Schaefer-Simmern (1948). He demonstrated that institutionalized mentally retarded adults with an IQ range of 49 to 79 could generate drawings, paintings, and tapestries of exquisite beauty, an indication that the aesthetic dimensions of art making are not necessarily related to the artist's IQ or mental age. In recent times, Max Kläger (1987, 1992, 1993, 1996, 2002) has documented the artistic development of several Down's syndrome individuals who, within the framework of a supportive workshop, create paintings of expressive power. The work of these artists has been exhibited in several European countries and has attracted considerable attention (see ills. 208 *a*, *b*; 209).

208. *Paintings by Willibald Lassenberger, an Artist with Down's Syndrome* (Courtesy Max Kläger, from *Die Bilderwelt des Willibald Lassenberger,* frontispiece and p.56, 1992.)
a. Krampus, the devil in hell (a popular figure in Alpine mythology).
b. Farm with pigs.

a.

b.

209. *Willibald Lassenberger's Poster for an Exhibition*
(Courtesy Max Kläger)
Crucified Jesus.

The most serious challenge to the linkage between IQ as a measure of linguistic and conceptual reasoning and artistic achievement appeared in the publications of the drawings of a number of mentally retarded autistic children, whose drawings suggest prodigy status and by far exceed the level reached by ordinary children. Since the publications of Lorna Selfe's monograph on Nadia Chomyn (1977), additional case studies of such savant artists as Steven Wiltshire and Richard Wawro have been published, and researchers have wrestled with the question of how to account for the lack of correspondence between intelligence (verbal and performance IQs) and artistic giftedness (Becker, 1980; Buck, 1991; Buck, Kardeman & Goldstein, 1985; Hermelin, 2001; Morishima & Brown, 1977; Sacks, 1993; Selfe, 1995; Treffert, 1989; Wiltshire, 1987, 1989, 1991; Winner, 1996). The term *savant* refers to persons with serious mental handicaps who have a spectacular island of ability that stands in marked contrast to their handicap of mental retardation, autism, or both. Savant skills are far in advance of those displayed by ordinary normally developing individuals.

The most informed set of studies designed to explore this relationship have come from the laboratory of Beate Hermelin and Neil O'Connor at the University of London. In a series of studies that

matched savants with autism or autistic features with normally developing talented youngsters, they found that the graphic talent of the mostly mentally delayed autistics was indistinguishable from that of the normal subjects. They concluded that artistic talent (above a certain IQ range, usually 40 to 70) was independent of intelligence and independent of the autistic syndrome (Hermelin, 2001; Hermelin & O'Connor, 1990; Hermelin, Pring, Buhler, Wolff & Heaton, 1999; O'-Connor & Hermelin, 1987a, b; Pring & Hermelin, 1993; Pring, Hermelin & Heavey, 1995). Such findings highlight the specificity of artistic thinking and creating and provide some support for a modular view of the mind (Gardner, 1983). Of course, this view of selected aspects of the nature of artistic giftedness does not address other symptoms of the autistic syndrome and of the specific cognitive and social deficits associated with it.

Reassessment of Current Findings

We are faced with a set of seemingly contradictory findings. Between the ages of 5 and 10, there is a modest to good correlation between children's drawings of the human figure and their IQ scores. The drawings improve in the number of parts drawn, their relative proportions, and level of skill. Although a single drawing at one point in time cannot be a reliable indicator of an individual child's representational competence, age norms on the Goodenough-Harris Draw-a-Man test (1963) reflect general developmental trends in graphic differentiation until, approximately, ages 8 to 10. The increase in differentiation scores indicates the school child's improved attention span, the acquisition of routinized schemas, a better understanding of the examiner's expectations, practice in planning a drawing, and a more critical stance toward the product. There is no indication that the human figure measures conceptual understanding, and a broader sampling of children's drawing skills reveals considerable intra- and interindividual differences depending on the nature of the task and the child's motivation. After this age, we see a leveling-off effect in the drawings of the majority of children.

The data on precociously gifted normally developing children—for example, the drawings of Eytan and Yani—and of such highly talented youngsters as Romano Dazzi (Beck, 1928), Landseer (Ormond, 1981), Millais (Warner, 1979, 1981), and Toulouse-Lautrec (Pariser, 1995a) who became artists in adulthood, highlight the décalage between their cognitive development and drawing achievements in the childhood years. This finding is further amplified in the artwork of autistic savants such as Nadia Chomyn (Selfe, 1977, 1995), Stephen Wiltshire (1991), Richard Wawro (Becker, 1980; Hermelin, 2001; Treffert, 1989), and Yamamoto (Morishima & Brown, 1977), whose mental and chronological ages are highly discrepant.

Thus talent emerges as a significant variable, and the hypothesized relationship between artistic achievement and IQ becomes more tenuous. In the case of autistic savants, especially those with severe

language deficits, their artwork seems independent of linguistic-conceptual intelligence. The retarded savant's visual-spatial abilities seem to be spared and even heightened, and when linked with pictorial talent they may create aesthetically pleasing works of art. Given the uneven profile of scores on the subcategories of tests of intelligence, the autistic savants are probably limited in the development of their gift. Integration of the diverse and uneven levels of their mental and artistic abilities is not likely to be achieved. Drawing and painting are highly developed skills, and their acquisition requires sustained effort, experimentation, and awareness of artistic styles past and present. Art-making does not occur in a cultural vacuum, and artists actively relate to the art world of their time. Thus, artistic intelligence draws on the diverse sources of human concerns, aspirations, and the capacity for reflection. From this perspective, the art of the mentally retarded autistic savant is "outsider" art unconcerned with the artistic conceptions of the times and the particular challenges that their normal contemporaries face.

The data from our diverse sources clearly support a developmental analysis in terms of an orderly sequence in the acquisition of graphic skills. This holds true for ordinary children, for gifted children, and most likely for the autistic savants, although our longitudinal records are less complete for this population. These children acquire the pictorial skills valued in their culture by consistently exploring the possibilities and constraints of the medium, and by discovering the major rules that underlie their chosen art form. As our review has indicated, the rate of acquisition of mature representational skills was greatly enhanced in the talented children, and the same findings apply to Pariser's analysis of the pictorial skills of three major modern artists—Klee, Lautrec, and Picasso—that showed that their artistic development followed the same orderly sequence documented for all children (1987, 1995a, 1997).

Career Paths of Artistically Gifted Children

To what extent does prodigy status or childhood giftedness in the visual arts predict the pursuit of the arts in the adulthood of the young artists we discussed, and is there a relationship between the childhood passion to draw and paint and success as an artist in the later years? In the case of Varda, who pursued training in an art school and graduated with distinction, the answer was stated quite emphatically in terms of an inner necessity or even compulsion: "For the adult to choose art is fate, it's for whom nothing else will do, a necessity, a destiny" (Golomb & Haas, 1995). Indeed, she continued to sculpt and paint after her graduation. However, having left the kibbutz, and given severe economic constraints, she could not afford to rent a studio and depended on her former kibbutz community to provide her with space and materials. With the birth of her children, and living in a small apartment in Jerusalem that limited her artistic activities, she

redirected her energies and pursued training in art therapy. In a recent interview Varda explains her changed relationship to the arts. As a young child, she drew and painted as a form of self-therapy, born out of pressing internal needs. This motivated her to enter art school, where she enjoyed the subjects she studied and gained great satisfaction from her sculptures and prints and the exhibition of her work. The birth of her children initiated a radical reorientation; caring for her children gave her a new sense of completion and she no longer felt compelled to create artistically. In her words, her work as an art therapist is fulfilling and gratifying; she notes with approval that she is less self-involved and likes being able to give something to others, to nurture their growth and development. Reflecting on these changes, she remarks that she has closed the chapter in which art-making was the center of her life (October 15, 2001).

Eytan never expressed a desire to become an artist—not as a 12- or 14-year-old when I interviewed him, or later, after graduation from high school. He always stressed that he wanted to pursue either architecture or, more likely, industrial design. Indeed, after he completed his military service, he chose to study industrial design, which is his current profession. He has been highly consistent in his interests and aspirations, and his family has supported him in his desires. It is of some interest that his brother is currently studying architecture, one of his sisters is planning to study interior design, and the youngest girl in the family, who is completing her last year in high school, considers the pursuit of painting (she is a colorist) but has not ruled out dance, for which she also has a talent. Evidently, artistic pursuits are valued in this family, and the choices of the siblings reflect individual differences in personality and temperament. In this context, it is worth noting that Eytan was the only one among the children who was a prodigy, a precocious drawer who did not want to become a fine artist.

Yani's father reports that, after graduation from high school, she was accepted by an art school in Beijing but decided to study modern Western art in Germany, where she currently resides. According to her father, she has embraced abstract art and developed a style that also incorporates elements of oriental brush painting. She seems committed to pursue painting as her vocation.

From this set of case studies, one dare not lightly generalize to all gifted children. However, from the published data on gifted child artists it appears that only few persisted in the choice of an artistic career. Eric, whose development and achievements during adolescence was chronicled by Enid Zimmerman (1995) has geared his impressive talents toward the design of computer and board games. Ben, the artistically gifted son of a painter and art educator, is currently pursuing a vocation as a performance artist (Matthews, 1999; 2002).

Amnon, the highly gifted young artist described earlier in this chapter, teaches industrial design with a special focus on the design of furniture. For some time he totally devoted himself to sculpting in wood, a project he found very rewarding. But the economic realities,

his desire to establish a family and a home, and the need to support himself have redirected his efforts. He seems, at least for the time being, satisfied with teaching and designing.

These findings are quite congruent with a longitudinal study conducted by Jacob Getzels and Mihaly Csikszentmihalyi (1976) of male fine arts students enrolled in the Art Institute of Chicago. Seven years after their graduation, 50 percent had dropped out of the fine arts, 23 percent met with some limited success and worked in related fields and the remaining students had found some recognition from the art world (that is, they exhibited in galleries and museums); only one of the original group of art students had become a nationally recognized artist. Success was correlated with the socioeconomic background of the artists who came from well-to-do, educated and higher status families. In a follow-up study conducted 16 years after graduation, 42 percent were employed as art teachers, illustrators, or other related activities, and only a few were full-time artists. Among them, a majority were still involved in painting or sculpture, but only one artist depended for his income on the sale of his art (Csikszentmihalyi & Getzels, 1988).

These findings bear some similarity to reports on the adult careers of child prodigies in other domains, for example, the six child prodigies studied by David Feldman and Lynn Goldsmith (1986). As young adults, none of these children had achieved national status in their original domain of excellence, and some have changed their interests (Goldsmith, 2000). According to Winner, only a few gifted children become creative adult artists who revolutionize a domain (2000).

It is interesting that two of the well publicized autistic savant artists, Richard Wawro and Stephen Wiltshire, continue their engagement in the arts, benefitting from the sustained support of their families and art institutions (Hermelin, 2001). Richard, whose verbal IQ score is 47 and performance IQ is 55, draws mostly landscapes that are based on photographs or on scenes he has seen; however, he creates these paintings from memory. He works with oil crayons, and colors dominate his well-structured compositions. His work has been purchased by prominent individuals and galleries. Stephen Wiltshire's savant ability attracted early attention with his remarkable drawings of buildings and bridges, using a linear style of great precision, in perfect perspective, and executed with flair and expression. With the support of his mentors and family, he has completed training in an art school and seems likely to continue as a graphic artist (Hermelin, 2001). In contrast to these two autistic artists who have continued to develop their talent, Nadia's artistic interests have sadly lapsed and her drawings are now similar to the early works of preschoolers.

To pursue a career as an artist requires cultural support and at least some financial rewards. Talent and an urge to create in the pictorial medium are necessary but not sufficient conditions, and personality factors may play a decisive role. What do we know about the personality of successful artists, or at least of those who pursue an artistic career throughout their life? There seems to be some consensus on the profile of successful artists, and I shall list some of the

qualities that have been identified: rebelliousness, risk-taking and ruthlessness; self-sufficiency, introversion, independence, and a cold-aloof disposition; high self-confidence and ambition; intrinsic motivation, passionate involvement, concentration, and endurance; and a capacity for sustained work (Bloom, 1985; Csikszentmihalyi, Rathunde & Whalen, 1993; Gardner, 1993; Getzels & Csikszentmihalyi, 1976; Sulloway, 1996; Winner, 1996, 2000; Winner & Casey, 1993). Perhaps one should add the skill of advertising oneself to establish and maintain important connections in the art world.

It appears that predictions based on the work of child artists have little power, and that the same applies to talented art students whose work seemed full of promise. To succeed as an artist in the Western world calls on many propitious circumstances, both internal to the artist and external in the form of the gatekeepers of the art world—the curators, gallery owners, and critics who determine to a large extent the style and the subject matter that is valued and marketed.

How does this assessment affect our view of artistically gifted children? Does it detract from our appreciation of their talent and the role it might play in their lives? It seems to me that being talented brings with it many rewards regardless of the role this talent might play in the future. The ability to devote energy and passion to a domain, in this case the visual arts, provides a major avenue for exploration of the self and the art form, for giving form to thoughts and feelings, for confirming one's identity and for confidence in one's ability and competence. It also opens avenues, contemporary and historical, for relating beyond family and school to one's cultural heritage, to the social world that transmits tradition and encourages invention, for feeling connected to an ongoing creative enterprise. Child art, which includes the art of the gifted, prodigies, and savants, ought to be valued and enjoyed for what it is and might become, and of course nurtured to the best of our ability.

A final comment on the relationship between cognitive development and artistic achievement. Whereas in previous chapters frequent references have been made to ages of children or to their grades, this was merely a convenient device for describing large sets of data and depicting a somewhat idealized version of the course drawing development takes. The remarkably accomplished drawings of two preschoolers, Eytan and Nadia, make this point clear. Although their ability to draw in perspective and to use foreshortening indicates a highly developed understanding of how to solve spatial relations, it does not suggest an equally developed capacity to solve problems that, according to Piaget, require the more abstract intelligence of concrete and formal operations. Undoubtedly, the ability to solve graphic problems is an indication of intelligence and of a problem-solving capacity. However, it does not in the same manner affect all the domains of the mind, even though one might expect that graphic problem-solving deepens understanding both in domain-specific and in more general terms. Howard Gardner's discussion of multiple intelligences, each with its own somewhat independent course of development, makes an important contribution to

this vexing problem, which is currently not very well understood (Gardner, 1983).

In the case of Eytan, his highly advanced form of graphic problem-solving was accompanied by a generally inquisitive mind geared toward understanding his world of objects, animals, people, and social interactions. His progress in drawing enriched other aspects of his mental life, which is nicely documented in the changing tasks he sets himself; drawing a wide variety of vehicles, landscapes, animals, cameras, and humans that depicted themes of great concern to him. His drawings reveal his understanding of the shape and function of objects and the habitat of man and animal. Similar changes can be seen in Yani's art during the second stage in her artistic development, which coincides with her entry into school and continues throughout the childhood years. She turns to the more traditional themes of Chinese art, of rivers and ponds, of landscapes seen in different seasons. There is genuine development in these young artists and in their artistic ambitions, which contrasts with Nadia, where we find a capacity that is tragically cut off from such major domains as language—a shining talent that is but an island of intelligence. True intelligence does not function well in isolation, and although its narrow focus does not diminish her talent, it does not contribute much to her other mental functions.

In the next chapter I examine the drawings of mentally retarded children who are not savants, as well as the drawings of emotionally disturbed children, and address the question of the relationship between drawing and personality.

Art, Personality, and Diagnostics

8

Since the end of the 19th century, various attempts have been made to establish a relationship between the personality of the artist and the work he or she creates. Such writers as Abroise-Auguste Tardieu (1872), Paul Max Simon (1876) and Cesare Lombroso (1895) drew attention to the drawings and paintings of the mentally ill and proposed that these products of the imagination provide insight into the psychological state of the patient. The next decades saw an increasing interest in the art of psychotic patients, and psychiatrists began to collect samples of the work of patients incarcerated in the asylums for the mentally ill. Soon major publications appeared, some of which attracted an audience that extended far beyond the medical community (Morgenthaler, 1921; Prinzhorn, 1922; Reitman, 1951). With the notable exception of Hanz Prinzhorn, most writers considered the drawings and paintings of mental patients symptomatic of their mental disorder and, especially in the case of schizophrenia, as confirming such a diagnosis. Thus, a drawing or painting could reveal the pathological condition of the patient's mind or psyche, his alienation from the social and physical world, changes in his perception of self and others, distortions in his experience of time and space and, above all, chronicle the cognitive and affective disorganization wrought by the schizophrenic illness.

A second approach, though originating from a different conceptual framework, reinforced the notion of a close link between personality and art. Sigmund Freud's concern with the unconscious aspects of mental life, his fascination with the subterranean motives of wishes that originate in childhood and undergo repression, led to an examination of works of art along the lines of dream analysis. In his view of the arts, Freud focused on universal human conflicts and neurotic tensions that, in the case of the artist, motivate the creation. His study of Leonardo da Vinci (1910/1957) offered a new perspective on the artist's personality and highlighted psychological determinants that underlie the making of a painting. Although in Freud's view man's most basic desires and strivings do not reach the level of conscious

thought and awareness, they can, however, find a symbolic expression in dreams and in works of art. The symbolic language of instinctual desires and childhood conflicts is not easily accessible to the conscious mind of the artist or of the viewer. It is the task of the analyst to decipher the message, to search for clues to the hidden or latent meaning of a painting. For this endeavor it is essential to gain an understanding of such psychodynamic principles of mental life as the defense mechanisms that transform the primary content and disguise its instinctual and socially unacceptable nature from the artist as well as from his audience.

Although studies on the art of the mentally ill have proliferated, no clear-cut consensus has emerged regarding the meaning of their art, the function it serves, and the plausibility of an interpretive key to elucidate the shapes and pictorial symbols. Authors vary in their stress on regressive, adaptive, or reconstitutive aspects of the art of psychotic patients, and significant differences remain in the positions espoused by representatives of the phenomenological, existential and psychoanalytic schools of thought (Bader & Navratil, 1976; Kris, 1952; MacGregor, 1989; Naumburg, 1950; Pereira, 1972; Pickford, 1970, 1982; Plokker, 1965; Prinzhorn, 1922/1972; Reitman, 1951). Despite these differences, however, one can perceive a common denominator in the view shared by many students of psychotic art; namely, that the art forms are not arbitrary and that they convey a personal truth about the patient's desolate inner world and altered cognitive and emotional experience. It is a view of a world that has become deformed and bent out of shape. Although these positions are quite compatible, and might offer insight into the inner world of mental patients, it is important to note that only a small proportion of psychotic individuals spontaneously turn to drawing or painting. Generally, the numbers are estimated as less than 2 percent of the population of hospitalized mental patients. Thoughtful attention ought to be given to the considerable variation in the styles adopted by patients who have received the same diagnosis of, for example, schizophrenia. By no means can one speak about a uniform art style that is unique to a psychopathological condition. In this context, it is useful to consider Prinzhorn's approach to the large body of art he collected from various European mental institutions. Prinzhorn, a trained art historian, artist, and psychiatrist, focused on the formal characteristics of the work, which he admired for its aesthetic qualities, and remarked on the striking similarity to some of the modern artists (for example, the expressionists). In the case of truly gifted psychotic artists, he often found their work to be indistinguishable from that of artists living outside of mental institutions. When a drawing seemed bizarre and suggestive of disorganized thought processes, he commented on the triviality of focusing on the diagnostic meaning of such a work. A hurried investigation of the drawing for psychiatric symptoms will reveal little more than a hurried evaluation of the patient might yield. He warned against mistaking technical awkwardness or juvenile conceptions for pathology and stressed the similarities among child art, folk art, primitive art, modern art, and psychotic art. Above all, he noted

the robustness of compositional devices. "The suggestive force of the simplest configurative devices such as lining up, regular alternation, and symmetry proves itself surprisingly strong. These devices or principles defy almost all dissolution and therefore testify to a deeply rooted inclination to impose abstract order or rules on the chaos of the outside world" (Prinzhorn, 1972, p. 235). Prinzhorn ends his monumental work on the art of the mentally ill with a tribute to the human urge to create, a human disposition that links the psychotic artist with his more normal counterpart. "These works emerged from autonomous personalities who carried out the mission of an autonomous force, who were independent of external reality, indebted to no one, and sufficient solely unto themselves" (1972, p. 272).

Respect for the art of the mentally ill and a profound sympathy for their work was not uncommon among the modern artists of the beginning of the 20th century, most notably in the case of Paul Klee and in the work and the collection of art brut by the artist Jean Dubuffet (Fineberg, 1997). The hypothesized relationship between some forms of mental illness and the arts has found support in recent publications that document greater prevalence of mental illness among creative artists (Jamison, 1993; Ludwig, 1995).

The Projective Approach to Children's Drawings

The new understanding of the psychological significance of drawing and painting, and the possibility of using the visual arts to assess personality traits as an aid in the diagnosis and treatment of emotional disturbance, was quickly extended to children's drawings. Already from the beginning of the 20th century the drawings of children had been used for an assessment of conceptual development (Burt, 1921; Goodenough, 1926; Harris, 1963; Luquet, 1913, 1927; Piaget & Inhelder, 1956; Sully, 1910; Terman, 1916; Thorndike, 1913). The assumption that a drawing can serve as an index of the child's cognitive status led to several efforts to standardize children's human figure drawings and to the construction of the well-known Goodenough Draw-a-Man test (Goodenough, 1926). Scores obtained on this test show an acceptable correlation with standard IQ tests, provided that the subject lies within the limited age range of 6 to 10 years.

A second approach that has attempted to broaden the analysis of drawings beyond a strictly cognitive assessment of mental ability emerged in the 1930s and 40s and continues with various modifications to the present time. This school of thought emphasizes the usefulness of drawings and paintings for an understanding of the child's personality (Alschuler & Hattwick, 1947; Bender, 1952; Buck, 1948; Burns, 1982; Burns & Kaufman, 1970, 1972; DiLeo, 1972, 1983; Hammer, 1980, 1997; Koppitz, 1968, 1984; Machover, 1949, 1953). Among these authors, only the work of Rose Alschuler and La Berta Weiss Hattwick stands out in its effort to delineate personality variables that are important in the normal course of development. Focusing their attention on the manner in which children use shape and color in their easel

paintings, they attempt to elucidate the relationship between painting and personality, which is indeed the title of their book. The subjects of their investigation are preschoolers who are in the process of discovering the medium of paper, brushes, and paints. The children's early explorations at the painting easel are seen in the light of such developmental tasks as establishing control over impulses and learning to cope with the demands of their social world. At this stage of development, the choice of color and the perceptual-motor action of brush strokes on paper are seen as providing the most direct access to the child's strivings, concerns, and feelings. They also provide insight into the manner in which the child adapts to the social and physical world. For example, crossings of the border of the sheet of paper indicates, according to the authors, a lack of concern for external expectations, whereas a restricted use of space suggests restricted or inhibited behavior. Emphasis on the top part of the page indicates high aspirations, whereas emphasis on the bottom part suggests a firm rooting. Alschuler and Hattwick's investigation into the earliest relationship between painting and personality ought to be seen as an exploratory work, its findings constrained by the young ages of the children and the difficulty the authors face when they try to derive general rules from what often appear to be individualistic stylistic tendencies. (See chapter 5 for a more detailed presentation.) Unfortunately, 60 years later, the work devoted to a developmental analysis of painting and personality is sparse, and most investigators have focused their attention on personality variables that are studied in a clinical context. A further limitation can be noted in the overemphasis on drawings of the human figure.

Because the literature on personality and art in children is practically nonexistent, and investigators concentrate on art and diagnostics, I shall next review some of the major findings in this field. Over the years, the clinical interpretation of children's drawings has become a widely accepted diagnostic device for the assessment of the child's self-concept and her relation to the family. With few exceptions, far-reaching inferences have been drawn about the emotional and cognitive status of a child on the basis of a single, or at most two, drawings of the human figure.

Machover's View of Projective Drawings

Karew Machover, a psychologist who gained considerable experience in the administration and interpretation of the Goodenough Draw-a-Man test, was one of the first to propose a set of systematic relationships between a person's drawing of the human figure and the image she has of herself. Given the widespread psychodynamic hypotheses concerning the projection of unconscious attitudes about the self, the assumption that a drawing carries projective significance, that it is packed with meaning of which the subject has no clear understanding, did not seem far-fetched and led to an enthusiastic search for the correct interpretive key.

Machover adopted Paul Schilder's (1935) concept of the "body image," and formulated a series of psychodynamic hypotheses on

which to base her interpretations of the drawn human figure. Indeed, Machover's 1949 work, *Personality Projection in the Drawing of the Human Figure*, remains the inspiration for almost all of the subsequent research on the clinical significance of human figure drawings. In this pioneering effort, she advances her "body image" hypothesis as follows: "[T]he human figure drawn by an individual who is directed to 'draw a person' relates intimately to the impulses, anxieties, conflicts, and compensation characteristic of that individual. In some sense, the figure drawn is the person, and the paper corresponds to the environment" (1949, p. 35).

Stemming from this premise, Machover proposes a long list of body parts and a key to their symbolic interpretation. For example, Machover states that "the head is essentially the center for intellectual power, social balance, and control of bodily impulses" (1949, p. 46). Therefore, disproportionately large heads will often be drawn by paranoid individuals, especially those with grandiose thoughts as an expression of their inflated egos, and by organically impaired, brain-damaged individuals as a reflection of their diminished intellectual functioning. Similarly, Machover states that "oral emphasis is marked in the drawings of young children, primitive, regressed, alcoholic, and depressed individuals. Since the mouth is often the source of sensual and erotic satisfaction, it features conspicuously in the drawings of individuals with sexual difficulties" (p. 43). So too, as she considers the nose as a sexual symbol of the penis, emphasis on this organ reflects feelings of impotence, whereas a shaded or absent nose is related to castration anxiety. Taking a rather inflexible, psychoanalytically oriented stance toward the symbolic meaning of diverse body parts, Machover interprets such structural characteristics as the size and placement of the figure, completion or omission of features, pressure of line, shading of body and limbs, and erasures as indicative of affects and motives closely related to the person's self-image. Certain form preferences, for example, a circular mouth, are interpreted in terms of the child's unfulfilled oral needs. In Machover's evocative language, the circular mouth represents "the gaping hole of oral deprivation." Likewise, scribbly hair indicates erotic excitement and libidinization of this region, the nose represents the phallus, buttons are a sign of dependency, and drawing a neck at the age of seven is a sign of exerting control over sexual urges, which, quite conveniently, fits the expectation one has of the latency-age child.

Clearly, these hypotheses offer an ambitious agenda for gaining insight into the hidden recesses of the child's mind and heart. They hold out a promise of developing a powerful diagnostic aid in understanding children's emotional disturbances and the possibility of guidance for corrective treatment.

What is the empirical evidence for these far-reaching assumptions? When it comes to the testing of her specific hypotheses, Machover's predictions have not fared well. In their comprehensive and separate reviews, both Clifford Swensen (1968) and Howard Roback (1968) criticize the studies concerning each of Machover's numerous hypotheses, only to conclude that, by and large, the data

do not support her propositions. They are critical of a practice that promulgates criteria that have not been validated, and Swensen correctly points out that such premises, as "[T]he human figure drawn by an individual . . . relates intimately to the impulses, anxieties, conflicts and compensations characteristic of that individual," remain largely undemonstrable since we are faced with a problem of measurement validity. How are we to determine what human figure drawings really reflect? What measure is a "true" index of a person's image of his own body? Swensen concludes that the question, of course, is unanswerable. The inconsistent results of numerous replication studies, particularly in regard to children's drawings, indicate the dubious status of the presumed "clinical" signs.

If one abandons Machover's elementistic and associationistic approach to drawing, which assumes a literal one-to-one correspondence of sign and meaning and uses global ratings, one obtains higher inter-rater reliability scores. Although this finding provides some comfort to the clinician interested in using human figure drawings, it does not offer information about specific pathologies. Furthermore, it raises the serious question of confounding talent with adjustment or mental health. Several studies indicate that there is a positive correlation between psychologists' evaluation of adjustment and art teachers' ratings of talent; drawings that are rated highly by art teachers receive a positive rating of good adjustment from psychologists. Moreover, the highly talented who aspire to a detailed representation will rely more frequently on erasures, shading of areas, and more varied lines, all of which appear as indices of conflict in Machover's manual. As in the earlier reviews of Roback and Swensen, Walter Klopfer and Earl Taulbee offer a similarly pessimistic evaluation of this projective device. They conclude their annual review with the statement, "[D]rawings can only be regarded as a suggestive kind of graphic behavior that will take on meaning as it is discussed with the subject and viewed in the context of other information. Many of the hypotheses formed by authors like Machover are at a level not clearly related to either conscious self-concept or behavior" (Klopfer & Taulbee, 1976).

Despite the lack of empirical confirmation for Machover's signs and the conceptually based arguments that contest the validity of her approach to children's human figure drawings, the field of clinical interpretation has paid scant attention to the concerns expressed in psychology's most reputable publications, namely, the reviews of Roback and Swensen in the *Psychological Bulletin* and Klopfer and Taulbee's chapter in the *Annual Review of Psychology*. We next turn to the work of three major figures in the field of the projective analysis of children's drawings: Elizabeth Koppitz (1968, 1984) and Robert Burns and Harvard Kaufman (1970, 1972; Burns, 1982).

Koppitz' Developmental Analysis of Children's Drawings

That Machover's framework continues to inform the clinical interpretations of children's drawings can be clearly seen in the writings of Koppitz. In her book *Psychological Evaluation of Children's Human*

Figure Drawings, Koppitz posits that *how* a child draws a figure, regardless of *whom* he draws reflects his self-concept. "The nonspecific instruction to draw a 'whole' person seems to lead the child to look into himself and into his own feelings when trying to capture the essence of a 'person'. The person a child knows best is himself; his picture of a person becomes therefore a portrait of his inner self, of his attitudes" (1968, p. 5). The drawing is regarded as a portrait of the inner child of the moment. Although Koppitz distinguishes between the body-image hypothesis and her own approach, the two positions appear quite similar. The discussion has merely shifted from the concept of the "body-image" to the equally broad concept of an "inner self."

Like Machover, Koppitz examines the way individual body parts are drawn by the child. The drawings are scored for the presence or absence of emotional indicators, which Koppitz claims are controlled for the effect of developmental maturity. Attached to these emotional indicators is a catalogue of stock interpretations.

What are the emotional indicators that Koppitz has isolated, and what diagnostic value can we attribute to them? Koppitz begins with a list of 32 "signs" including poor integration, shading of various body parts, asymmetry of limbs, slanting figure, size of figure, transparencies, genitals, absence of either limbs, facial features, body or neck, crossed eyes, sun, clouds and more. Her sample of subjects comprises 76 pairs of children, ages 5 to 12 years. One member of each pair comes from a suburban elementary school, selected by the teacher as an outstanding "all-around" student with good social, emotional, and academic adjustment. Koppitz assumes that the normal children are of high-average to superior intelligence. The other member of each pair was drawn from a child guidance clinic, with IQs ranging from 90 to 148. Although the author treats these two groups as if they were matched on major variables, this appears not to be the case for IQ, and most likely also not for social status and drawing skills. There is also no good reason to assume that the clinical sample was homogeneous in its composition, and it may have included neurotic as well as borderline psychotic patients. If we also consider the small number of children in each age bracket—for example, in four age groups the number was less than 10 children—the results must appear very tentative indeed and do not warrant generalization beyond the specific groups tested. Perusal of the table of results combined for all age groups (Koppitz, 1968, table 13) alerts us to the finding that only eight comparisons reach commonly accepted levels of statistical significance. The signs that occur significantly more frequently in the clinic population are poor integration, shading of body and/or limbs, slanting figure, tiny figure, big figure, short arms, hands cut off, and the absence of a neck—altogether, a rather meager collection of signs. Since there is no separate breakdown per age, it is difficult to offer a meaningful interpretation of the findings—a difficulty that is further compounded by lack of attention to the variability of graphic skill, which may have favored the normal children who were selected by their teacher as "all-around" good students. Appendix E (Koppitz, 1968)

seems to indicate that poor integration refers to the drawings of the youngest children, girls age six and boys age seven. Because 18 of the children are seven years or younger, several of the obtained differences might well be a function of such motivational and emotional factors as avoidance of the task and anxiety over the test situation in a clinic setting. In addition, we must note that 24 percent of the normal subjects used one or two emotional indicators in their drawings, a finding that dictates extreme caution when using this diagnostic manual for the determination of pathology. Despite her extensive practice with human figure drawings, Koppitz fails to understand the role of talent in the visual arts. This is seen in a study in which she defined graphic talent in terms of a difference of 10 points between the performance and the verbal IQ on the Wechsler Intelligence Scale for Children (WISC). Most surprising is the author's stance, which ignores the results of her own statistical analysis. Not only does she continue to use her 30 emotional indicators, as if the outcome of her analysis did not invalidate most of her assumptions, but she also continues to employ the category of "crossed eyes" even though this sign appeared neither in the normal nor in the clinical population. Koppitz simply declares that her clinical intuition justifies its inclusion in her list of pathological indicators.

Koppitz' reading of an actual drawing tends to combine interpretive leaps with subjective references to her list of emotional indicators. For example, in the case of shading Koppitz notes that it is common practice for girls through age seven and for boys through age eight. Nevertheless, she concludes quite arbitrarily that the implications of shading are not altered by the fact that it is so common. Thus, regardless of its normative status in the case of young children, shading is deemed to reveal "body anxiety." How do we arrive at the association of shading with body anxiety? This interpretation derives from the finding that among the older children tested, shading of the body was found more often on the drawings of children with psychosomatic complaints and of youngsters who steal. But how do we know that youngsters who steal are more anxious than their honest peers? Indeed, the opposite hypothesis is quite as likely, as one might argue that those who steal exhibit antisocial or psychopathic tendencies and therefore experience less anxiety than do their peers equipped with more stringent superegos. The empirical evidence on which Koppitz claims to have based her clinical interpretation seems to crumble under scrutiny. When her analysis of the diagnostic significance of the a priori chosen signs yielded only limited support for her thesis, Koppitz basically abandoned the psychometric approach and substituted her clinical intuition for measurement. It is indeed disappointing to be left with only 8 significant emotional indicators out of the initially 32 hypothesized signs, and even worse, not to be able to discriminate in any meaningful way between various states of emotional disturbance. The only distinction Koppitz' findings yield is between an emotionally healthy and adaptive individual and a disturbed one, not much to show for so much effort.

In a sequel to her book published 16 years later, *Psychological Evaluation of Human Figure Drawings by Middle School Pupils* (1984), Koppitz examines the drawings of youngsters ages 11 to 14 years. Because adolescents often dislike drawing and the drawings no longer increase in figural detail after age 11, she simply urges the clinician to "grasp" the "tone" and "wholeness" of the message. The earlier ambition to differentiate between developmentally significant signs and emotional indicators and the stated purpose to validate the clinical signs has been abandoned. She argues that because it is not uncommon for young adolescents to be ambivalent and to show contradictory tendencies and behavior, all combinations of sign in conjunction with all kinds of behavior are possible, and therefore "there is no direct relationship between emotional indicators and a youth' overt behavior" (pp. 29–30).

To arrive at such a vaguely defined position, where the clinician is advised to fall back on his intuition and on his generalized knowledge of the client, is somewhat anticlimactic given the original aim of the author. Koppitz' original intention was to provide the clinician with validated criteria for the psychological evaluation of children's human figure drawings, an enterprise that was to be based on an extensive gathering of empirical data concerning normative developmental items and emotional indicator signs. I shall defer a discussion on what I consider to be the root of this problem to a later point in this chapter, after the presentation of yet another projective approach to human figure drawings, the Kinetic Family Drawings devised by Burns and Kaufman (1970, 1972; Burns, 1982).

Kinetic Family Drawings

In addition to the widespread practice of soliciting the drawing of a single human figure, clinicians have also come to ask for the child's drawing of her family. With their book on *Kinetic Family Drawings (K-F-D)* (1970), Burns and Kaufman introduced a new variant on the family theme by asking children to draw a picture of everybody in the family, including the child herself, doing something. The rationale offered for this request to draw the members of the family engaged in an activity was to help mobilize the child's feelings as they relate to her self-concept and to the dynamics of her family. Over the next decade, Burns and Kaufman published several additional books that provide the clinician with an ever-increasing list of interpretive signs (1972; Burns, 1982). Because inclusion of the Kinetic Family Drawing (KFD) as a major item in the battery of diagnostic tests has become standard practice, a closer look is warranted at the assumptions that guide the interpretations of the child's drawing of her family. To begin with, there is hardly any information about the normative sample, and the clinical sample of 193 subjects includes a wide age range from 5 to 20 years, with great fluctuations in the numbers that comprise each age group. For example, there are only 4 five-year-olds, 6 six-year-olds, but 21 seven-year-olds. Although the authors refer to

numerous signs that they interpret in a literal fashion, their major focus is on what they call actions, styles, and symbols.

What significance do the authors attribute to the actual process by which the family drawing comes about? Oddly, once the instruction for drawing is given, the experimenter leaves the room and returns when the child's drawing is complete. This practice reveals an astonishing lack of insight into the role of planning a drawing comprised of multiple figures; the significance of the order in which figures are drawn and how position and size, to mention just two variables, are affected by what went on earlier. There is no awareness that a child's spontaneous verbalization during the drawing process is important for an understanding of the meaning of the picture, and the constraints that affect representation in the two-dimensional medium are ignored. This can be seen most clearly in the absence of a developmental conception of figural differentiation and a lack of understanding of compositional principles. Above all, the authors seem to be unaware of the difficulty that even adults face when asked to depict motion. A simplistic drawing of all the members of a family holding hands is seen as a sign of normality, of happy family relations, whereas a more ambitious effort to portray each family member in an activity that may be characteristic of that individual is most likely interpreted along defensive-pathological lines.

By asking for a composition, Burns and Kaufman seem to offer the possibility of a new dimension of analysis. The reader is urged to pay attention to what the authors define as "styles": compartmentalization, encapsulation, lining on the bottom, lining on the top, underlining individual figures, edging, and folding compartmentalization. The text, however, makes it clear that Burns and Kaufman consider styles as defense mechanisms rather than compositional devices for ordering the elements of a picture. Thus, in the eyes of Burns and Kaufman, lack of "style"—for example, the absence of a baseline on the bottom, which they consider typical of the drawings of normal children—bespeaks of a diminished need for defense mechanisms, whereas the presence of a baseline on which to place the family members is seen as an indication of instability in the home. Likewise, a line at the top, used, for example, in drawing the sky, is an indication of the child's acute anxiety of "living at the top." When figures are underlined, they indicate the insecure and unstable relation of the child to that person. Encapsulation of a child—whether as a driver in a car, a child with a jump rope, or a figure placed inside a contour—indicate that person's isolation from the family grouping. Compartmentalization is considered typical of social isolates who try to cut off the feeling component between members of the family, whereas edging depicts a defensive child that stays on the periphery of an issue.

In the tradition of Machover, Burns and Kaufman compile a directory of common symbols without explaining whether they are theoretically derived or empirically generated. What the authors refer to as "symbols" turns out to have little in common with the ordinary usage of this term. They provide a list of items that are literally

equated with a single, often arbitrarily selected, characteristic or label. To mention a few: dirt means bad; drum means anger; buttons connote dependency; lawnmower means cutting or castration; a stop sign means impulse control; a large head may indicate high aspirations or headaches; small heads indicate inferiority; unusually large eyes indicate paranoia or voyeurism, whereas small eyes suggest introversion; presence of arms means control, their absence indicates powerlessness; ears suggest paranoia; long feet indicate a need for security; a long neck stands for a dependency conflict; emphasis on the mouth suggests feeding difficulty; a lamp hanging from the ceiling indicates need for love; electricity represents power and sexuality; and crossed legs or arms reflect the control exerted by an older brother over a younger one who is forced into homosexual activity. Unfortunately, there is no documentation for the assumed symbolic relationship between an item and the feeling or activity it is presumed to represent. Neither theoretical nor empirical arguments are marshalled in support of such equations, which are in part adopted from previously mentioned authors.

Just as the authors omit an explanation of how they compiled such a list of "standard" interpretations, they fail to account for the source of their information about the child that accompanies the drawing. The interpretations are a mixture of biographical data seemingly derived from the family and perhaps also the child, and inferences made from the drawing. One must wonder to what extent the interpretation of the drawing merely reflects information already available to the psychologist, who feels no need for the validation of his initial hypotheses. Above all, one misses the developmental norms that enable the clinician to differentiate between those aspects that are individually significant and psychodynamically relevant and those that can best be described in general developmental terms. The problem of how to compose a drawing is amplified by the instruction to portray action, which is extremely difficult for all but the trained and experienced artist. Most adults and children lack the practice necessary to portray action, a problem that needs to be addressed.

This rather harsh review of the major writings on the projective significance of children's drawings is not meant as an outright rejection of a psychodynamic approach to child art. I felt compelled to highlight the methodological and conceptual inadequacies of the major writers in a field that has acknowledged their influence on the psychological assessment of children. I shall now attempt to outline several reasons for the present impasse of the clinical interpretation of children's drawings and suggest some of the conditions that have to be met before we can truly differentiate between so-called normal and atypical graphic productions.

Before addressing the specific problems that face the researcher interested in the drawings of developmentally atypical populations, we need to consider the more general issue of the measurement of children's drawings as an index of conceptual development. Unfortunately, the measurement of children's drawings got under way before

we truly understood what is unique about this symbolic domain and what it may have in common with other domains of intelligence, for example, verbal-logical thought.

In general, the psychological assessment of mental abilities has been based on an assumption of "norms" that are empirically derived and/or conceptually grounded. In their conception of development, psychologists have certain endpoints or achievements in mind that are attained during specific phases of a child's life. In the study of children's drawings, investigators have adopted the "realistic" or "naturalistic" depiction of an object, most commonly of the human figure, as their standard or endpoint of what a representation ought to look like. Given such an aesthetic norm, they have looked for telltale signs of deviation from their standard representation. The criterion of realism led to a preoccupation with what appear to be peculiar or deviant characteristics of a child's drawing—for example, the omission of parts, the disregard for the objective size and proportion of a figure, the unconventional uses of color, the degree of schematization of a drawing, the rigidity of the figure and its location on a page. This list could easily be extended. The major problem with this view of child art and its development is its lack of concern for the nature of the pictorial medium and its specific constraints, and above all, the identification of a certain stylistic preference in pictorial art, such as realism, as the natural endpoint of representational development. Such a position ignores the history of art, which reveals significant diversity of mature graphic styles; it is also a psychologically naive view that mistakes the process of representation for that of copying nature in the manner of a camera. This by-now-outdated position shows no understanding of the graphic logic that underlies a drawing. It assumes that children share an adult aesthetic of visual realism, whereby deviations from the "true" picture reflect deficiencies. A drawing, however, is not a simple printout of the child's concept of the object; it is an act of symbolic representation requiring children to figure out ways in which to depict that which they consider essential to their chosen theme. The rules that determine whether a feature is to be included or omitted are grounded in a visual-graphic logic that, in the case of the human figure, specifies that the head and the vertical length dimension are important defining characteristics, whereas arms, for example, play a subsidiary role. In order to represent three-dimensional objects through drawing, the young artist has to evolve special techniques that will enable her to depict objects of considerable complexity through the creation of structural equivalents.

The search for those elements of a drawing that increase with age and thus can be taken as an index of the child's mental maturity led to Goodenough's psychometric Draw-a-Man test. Indeed, within a limited age range, the sheer number of parts depicted and the style of their representation correlate with other measures of mental development (for example, the Stanford-Binet intelligence test). This finding is not surprising because differentiation is the hallmark of development, as the previous chapters have indicated. So, although Goodenough's conception of drawing development was based on the mis-

taken norm of "realism," and the sheer counting of elements misses the core meaning of graphic representation, the empirical measure, nevertheless, captures an aspect of a developmentally significant process. The limitations of the test are equally apparent in the limited age range to which it applies and the false assumption that the child's drawing of the human figure provides us with a conceptual printout. We know that the figure drawn by a child is not a "constant," that it can vary considerably depending on the nature of the task and the relationship of the figure to other elements of the pictorial theme. In this sense then, the measurement of the elements that comprise the drawing of the human figure got underway before psychologists clearly differentiated between representation as a symbolic process and the more narrow conception of imitating nature.

If these considerations dictate concern about the conceptual basis of the Goodenough test as a measure of the child's cognitive level, the problems multiply when we review the conceptual as well as the empirical basis for the projective analysis of children's human figure drawings. As my criticism of the work of Machover, Koppitz, and Burns and Kaufman indicates, the rationale for the "body image" hypotheses and other variants of the concept of an "inner self" has not been clearly stated, and no comprehensive effort has been made to link the various ad hoc hypotheses to developmental theory. Psychodynamic jargon is not a substitute for formulating a set of propositions derived from a theoretical framework and leading to testable statements. The printout hypothesis, whether of the child's concept of the object or of his inner self, has not been supported by the empirical data. Sadly, the empirical foundation for diagnostic signs of the child's emotional status is much weaker than for the postulated relation between drawing and cognition.

One may wonder why Koppitz' extensive effort has not yielded more tangible results and why the psychodynamically oriented interpretive project has turned into a freewheeling projection on the part of the clinician? Perhaps the answer lies in the associationistic approach of Machover and Koppitz, who brought to their enterprise the conviction that single signs carry a deep symbolic meaning that is self-evident to the clinician. The literal interpretation of "signs" offered by Machover, Koppitz, and Burns and Kaufman, their hunt for a one-to-one correspondence between the depiction of body parts and their meaning, contradicts the hermeneutical tactics that are an integral part of the psychoanalytic method. One might say that these authors fail to consider individual body parts within the context of the drawing text and that they turn a deaf ear to Freud's warning in the *Interpretation of Dreams* against cryptography, or the practice of decoding manifest texts into their unconscious meanings in accordance with a fixed key (Freud, 1900/1953, p. 130).

Have psychologists come to the end of their effort to discern the wider significance a drawing may have for the individual artist? Are drawings devoid of diagnostic significance, and does the search for a deeper understanding of the child artist have to be abandoned? I do not think so. Perhaps, we have to turn to more fundamental questions

yet to be asked about a child's drawing and inquire into the basic syntax of child art and how it is affected by, for example, such extreme conditions as mental retardation and severe emotional disturbance.

One of the most basic questions that need to be addressed in the study of the drawing of normal and atypical children concerns the nature and the course of this development: Is it atypical in the case of emotionally disturbed children, does it deviate from the normal sequence of stages, or is the development of drawing essentially similar, perhaps somewhat delayed in the case of mentally retarded or emotionally disturbed children? In order to answer this kind of question, more information needs to be considered than is commonly provided in the single drawing of the human figure or of the family. For an adequate assessment, a set of thematically different drawings ought to be analyzed in terms of their formal characteristics as well as their content. Attention to the formal characteristics of a drawing calls for an examination of compositional strategies, drawing systems, figural and size differentiation, the use of pictorial space, and the role of color. Content variables call for an analysis of themes and their elaboration and for the child's personal associations to his own drawing. Considering the above-stated criteria, a review of the relevant literature reveals that the study of the representational development of emotionally disturbed children is still in its infancy, and that research into the variables I have listed has barely begun.

By turning our attention to children whose mental and emotional status sets them apart from their more normally developing peers, we hope to gain a better understanding of basic representational processes and to determine the robustness of this developing graphic language. The drawings of exceptional children—for example, of youngsters whose intelligence falls significantly below that of the norm, or of children diagnosed as severely emotionally disturbed—can help us identify those aspects of representation that are most affected by aberrant mental conditions and those that remain relatively intact and within the broad norms that define all graphic development.

I shall first turn to findings on the diagnostic significance of the drawings of mentally retarded and emotionally disturbed children. Next, and more briefly, I shall consider drawings from a therapeutic point of view, as graphic statements that reveal to the subject as well as to the therapist a personally meaningful message that finds its unique expression through this art form.

Drawings of Mentally Retarded Children

The great majority of mentally retarded individuals are usually classified as familial or cultural retardates, indicating a nonspecific form of mental retardation. In these cases, there are no observable neurological defects and the IQs of these individuals, which fall in the range from 50 to 70, are two standard deviations below the mean for the general population. Organic impairment has been established for only

10 to 20 percent of the population of mental retardates and it is heavily concentrated in the lower IQ ranges corresponding to three standard deviations from the population mean. With improved diagnostic assessments, however, the ability to identify biological factors that underlie mental retardation may well increase this number (Bregman & Hodapp, 1991). While the organically damaged group of mental retardates is evenly distributed throughout the population, the familial retardates are mostly concentrated in the lower socioeconomic levels of the population (Balla & Zigler, 1980; Bregman & Hodapp, 1991; Heber, 1970).

These findings have led several investigators to propose a two-group classification for mental retardation: individuals with an IQ of 50 to 70 and without known organic impairment are classified as familial retardates, whereas the second group comprises those whose IQ falls below 50 and for whom some organic impairment or irregularity has usually been established (Balla, Butterfield & Zigler, 1974; Hodapp, Burack & Zigler, 1990; Weisz, Weisz & Bromfield, 1986; Weisz, 1990; Zigler, 1969; Zigler & Butterfield, 1966). The proponents of this two-group approach challenge the widely held opinion that all mental retardates exhibit cognitive defects. They maintain that the familial retardate is essentially a normal individual who differs only in the slow rate of his or her development and in an earlier cognitive arrest. This position finds support in Bärbel Inhelder's work (1968), which documented that the sequence of stages of cognitive development, first described by Piaget, is the same for normal and retarded children. Most investigators, however, contend that the performance of the familial retardate differs from that of his normal counterpart, and they interpret this difference as a symptom of a cognitive defect. Various cognitive deficiencies have been suggested, ranging from excessive rigidity (Goldstein, 1942–1943; Kounin, 1941; Lewin, 1935) to short-term memory impairment (Ellis, 1963, 1970), deficiencies in attention span (Fisher & Zeaman, 1973; Zeaman & House, 1963), inadequate verbal mediation (Luria, 1961; O'Connor & Hermelin, 1959), and information processing deficits (Mundy & Kasari, 1990; Spitz, 1973).

The majority of studies examining the performance of normal and retarded subjects on graphic representational tasks has supported the deficiency hypothesis of mental retardation. Georg Kerschensteiner (1905), one of the early and most distinguished investigators, concluded that the drawings of the mentally retarded child differ significantly from those drawn by the normal child and that they are characterized by a lack of coherence and greater primitivity. Later investigators supported Kerschensteiner's findings. Cyril Burt (1921) maintained that it was possible to differentiate between groups of normal and mentally retarded children on the basis of the degree of coherence of a drawing. Goodenough (1926, 1934) contended that the retardate's drawing (IQ range 50 to 70) was deficient in the depiction of detail and faulty in its proportions, that it lacked proper perceptual-motor control of lines and included such bizarre details as, for example, a double profile that combines in a single drawing the side and

the front view of the face. Other studies (Earl, 1933; Israelite, 1936; McElwee, 1934) found that although the organizational quality of the drawings of retardates was poorer than that of normals, in the depiction of details the retardates surpassed the normals. Taken together, these results seem to support the "defect" hypothesis with its stress on a difference in performance between normals and retardates.

An early exception to this view can be seen in Georges Rouma's (1913) finding that the drawings of the retarded resemble those of younger children. He remarked on the slower evolution of the drawn human figure, a finding quite consonant with Edward Zigler's developmental hypothesis of mental retardation. Finally, Spoerl's (1940) study should be mentioned, which compared the drawings of familial retardates with drawings of mental-age matched normal children. D. Spoerl came to the surprising conclusion that the drawing ability of the retarded child by far surpasses that of the normal child of similar mental age, a finding that is quite similar to a study reported by John Carter (1973). Taken together, these results highlight the variability of the published reports.

A closer look at the design of the above-mentioned studies reveals several methodological shortcomings. Most striking is the failure to control for mental age, organicity, institutionalization, socioeconomic status, family structure, and motivation, at best matching the retardate's mental age with the chronological age of the normal child. Clearly, it is imperative to insure adequate controls over these important variables, and where possible to eliminate the confounding factor of institutionalization.

Given these considerations, Tracy Barr-Grossman and I paid special attention to the selection of our tasks and to subject variables (Golomb & Barr-Grossman, 1977). In terms of task variables, it seemed desirable to include tests that could tap the child's ability to organize the constituent parts of the human figure. If the retarded child lacks the ability to organize the component parts or has acquired idiosyncratic tendencies such as the dispersion of parts all over the paper, the tasks should provide an opportunity for such tendencies to manifest themselves. The tasks should also control for potential "learning" effects; that is, they should counteract the potential effects of training the retarded child to draw the human figure correctly. The test series was designed with these considerations in mind and included representational tasks that tempted the child to fall back on his own organizing tendencies. We also decided to pay close attention to differences in form, proportion, detail, the presence of irrelevant or bizarre detail, the spatial organization of the figure, and the child's verbal interpretation of his drawing. Our selection of tasks included the following set of assignments, all concerned with the representation of the human figure: the drawing of a person, the completion of an incomplete figure consisting of a face only, two form puzzles comprised of numerous geometric shapes from which the child had to construct a person, and a verbal-dictation task in which the child was given the verbal label for a body part but no guidance in regard to its shape, location, or spatial organization. These tasks re-

quire that the child create a correspondence between mere lines on paper and an object in the real world, that she invent forms of equivalence and determine their spatial organization. In summary, these tasks expose the child's mode of representational thinking without excessive reliance on language or special tutoring.

Subject selection was done carefully, and we were able to match the children individually in terms of their mental age, the socioeconomic status of the family, attendance at a public school, and living at home in an intact family—thereby eliminating the confounding effects of institutionalization. Each group consisted of 34 children, with an equal number of boys and girls. The chronological ages of the normal children ranged from 3;0 to 5;10; the retarded children's ages from 4;4 to 13;1. The mean IQ for the normal children was 107, and for the retarded children, 55. The retarded group was composed of familial and familial borderline retardates with an IQ range from 40 to 76. In all cases the cause of retardation was unknown, and children for whom an organic cause had not been ruled out were deliberately excluded from our sample.

The results of our analysis are quite straightforward. On all major measures, the retarded child performs as well as his normal counterpart, and at times even surpasses him. Extensive qualitative and quantitative analyses of the performance of the two groups reveal the essential similarity in representational processes as well as in the final product. The approach to the problem and the general strategy employed are remarkably alike, and the same holds true for scores for figural differentiation, organization, and spatial coherence. Similar results can be seen when we examine the extent and type of verbalization to the tasks of representing a human. Finally, both normal and retarded children respond selectively to the demand characteristics of the tasks—they show a comparable degree of sensitivity to the nature of the task. The differences are all in the same direction; that is, the drawing scores are lower than those obtained on the other representational tasks. Above all, the superior performance on the unfamiliar tasks, the so-called form puzzles and the dictation task, should be noted. These findings militate against the notion of cognitive rigidity of the mentally retarded child and challenge the myth of the retardate's inflexible, stereotyped responses to problem-solving tasks, and thus support Zigler's position.

The qualitative analysis of the results is equally clear-cut. Examination of the drawn human figure from the point of view of its aesthetics, the global appearance of the figure, its balance and organization, line quality, form preference, symmetry, proportion, spatial coherence, idiosyncratic arrangements, and bizarre detail indicates the basic similarity in the performance of both groups on the abovementioned variables. The frequencies of oddly proportioned figures, of scribbly and unbalanced productions, of bizarre detail, and of spatial disorganization are alike for both groups, and no significant differences on any of these representational variables were obtained.

Our tasks are designed to reveal basic aspects of representational thought and they require extensive use of symbolic processes. They

focus on the establishment of correspondences between a graphic mark or a geometric shape and its referent, and on the conception of equivalence by which a two-dimensional form comes to represent a three-dimensional object. On these tasks retardates and normals of matched mental age performed with an equal degree of success. The long-established view of the retardate's inability to organize in a spatially coherent manner the parts of the human figure was shown to be a myth. Our findings highlight the robustness of basic representational processes even in the case of mental retardation and support the notion of a universal graphic language, at least in its early and elementary phases. (For a more detailed account of the retardation study, see Golomb & Barr-Grossman, 1977.) Similar results have been reported by Maureen Cox and C. Bragal (1985) and our results are quite congruent with the remarkable achievements reported by Henry Schaefer-Simmern (1948) on his work with severely retarded adults. More recently, Max Kläger (1992, 1993, 1996, 2002) has called attention to the artwork of severely retarded Down's syndrome adults whose work shows distinct aesthetic qualities (see ills. 208 *a, b*; 209).

In summary, the answer to the question I posed concerning the course of representational development in the familial mentally retarded child affirms the general progression outlined so far. The drawing development of familial retarded children follows the same sequence of stages in the differentiation of the human figure as that described for normal children. For the early phases of the development that we studied, ages three to five years, the child's mental age or mental maturity seems to predict in large measure the level of the representation. Although the drawing development of the retarded is slower and may tend to come to an earlier halt, it is neither defective nor deviant, but follows in all essentials the normal course of differentiation.

The issue of the drawings of Down's syndrome children (a condition with a known organic defect), whether they are best characterized in terms of a "delay" or a "difference" has received some attention in recent years. Several authors suggest that the developmental pathways for Down's syndrome children might differ from that of normally developing children (Clements & Barrett, 1994; Cox & Maynard, 1998; Eames & Cox, 1994; Laws & Lawrence, 2001). Questions have been raised about Down's syndrome children's delayed understanding of spatial concepts, difficulties with fine motor control in the use of a pencil, and some tentative findings that their drawings fail to show a correlation with mental and chronological age. Given the small numbers of participants in these studies and methodological issues regarding task selections, these are tentative suggestions to be pursued in further studies. (See also comments on the art of adult Down's syndrome individuals and their accomplishments and a report on the drawing development of autistic and mentally retarded children in chapter 7.)

The issue of "difference" is most evident in the drawings of Williams syndrome children and adolescents. Cases of this syndrome, though rare, are of interest in that there is a striking disjunction be-

tween verbal and graphic abilities. In general, the mental retardation of individuals with this diagnosis is mild to moderate, with good auditory rote memory and general language ability. In contrast to these abilities, they show a marked weakness in visual-constructive tasks such as block patterns and drawings, especially in the poor integration of drawn parts. In a longitudinal study of several Williams syndrome children who were followed through the adolescent years, a significant improvement was noted in the integration of the drawings by age 12 to 14 (Bertrand & Mervis, 1996).

I now turn to a comprehensive analysis of drawing development in emotionally disturbed children, an analysis that goes beyond the drawing of the human figure.

The Drawings of Emotionally Disturbed Children

As the introduction to this chapter has indicated, the major thrust of the projective hypothesis of children's drawings has been diagnostic in its orientation. Numerous authors have used drawing as if it were a mirror of the child's inner life, a reflection of his self-image, conflicts, fears, hopes, and desires. They consider drawings of special value for understanding the problems of emotionally distressed and socially malfunctioning children. As the review of their writings indicates, the basis for such a determination is often vague and grounded in a somewhat literal application of psychodynamic insights. Truly independent validation, that is, independent of information gathered from sources other than the child's drawing, has not been undertaken. Most authors also seem unaware of the tremendous individual variation in drawing style and competence that characterizes all age groups, and that the within-group variance often exceeds that of the between-group variance. Given the narrow focus of most investigators on a few rather ill-defined variables of doubtful validity, the basic question of representational development needs to be raised once again. Is the graphic development of emotionally disturbed children atypical, does it deviate from that of their normal counterparts, and if so—how? If differences in drawing competence exist, do they indicate the immaturity typical of younger children or are they manifestations of deviant and atypical development? A satisfactory answer requires a comprehensive analysis of basic representational processes such as the use of compositional strategies, the extent of figural differentiation and type of drawing system, use of pictorial space and of color, the role played by the size of a figure, and the incidence of unconventional or bizarre elements. To some extent, we are back to where Prinzhorn left the field of inquiry into the art of psychotic patients, except that my emphasis will be on the developmental question.

With these fundamental questions in mind, Anath Golomb, Jill Dennehy, and I collected children's drawings from two distinct populations: emotionally disturbed and normally developing children (A. Golomb, 1987a). The children who comprise our clinical sample reside for the most part in treatment centers for severely disturbed children:

24 percent attend a day-school for emotionally disturbed children, 57 percent are residents of treatment facilities, and 19 percent are institutionalized in an inpatient psychiatric ward. These children, mostly males, are unable to attend a public school and the great majority cannot function in their home situation. The psychiatric diagnoses of the children include major affective disorders such as depression and suicidal behaviors, prepsychotic and psychotic ideation, borderline personality, conduct disorders, hyperactivity with attentional deficits, and many forms of learning disability. Many children receive medication (for example, Ritalin or Haldol). As a group, these youngsters come from an urban setting of predominantly low-income families characterized by long-term stress, and the majority of the children have suffered from severe neglect and abuse.

IQ scores were available for 74 percent of our clinical sample; the number increases to 80 percent if we include IQ estimates of mental retardation (most likely referring to a range of 50 to 70). The IQ scores for the total clinical sample of 138 children ages 7 to 15 years range from 46 to 132, with 19 percent falling in the range of 46 to 70, 25.5 percent between 70 to 85, 26.5 percent between 85 to 100, and 29 percent above a score of 100. This is clearly a skewed distribution of IQ scores, with a disproportionately large number of children falling in the borderline and mild mentally retarded range. Children whose IQ scores fall below 70 were excluded from the final analysis of the data, which is based on the drawings of 81 youngsters, ages 7 to 12 years, of which 70 were males and 11 females.

Our normal sample comprises 72 children ranging in age from 7 to 12 years. The socioeconomic status of these children is predominantly middle class. In the case of the normal sample, the distribution of males and females is also uneven, with 60 percent females. Although IQ scores are not available for this sample, they are estimated to be somewhat skewed toward the upper end of the normal distribution.

All the participants were asked for six drawings. Only five of the assigned tasks used the same instruction, and these provide the data base for our analysis: Draw Your Family; Children Playing; a Birthday Party; a Garden with Trees, Flowers and a Pond; Your House and Street. The materials consisted of standard size manila paper (12″ × 18″), sets of crayons, magic markers, colored pencils, and lead pencils. All the children were seen individually over two to three sessions. There was no set time limit for the completion of a drawing, and an extensive protocol recorded the child's actions and comments.

Before I report in some detail on our findings, I have to acknowledge that our two samples differ in significant ways on a number of major variables. Ideally, the children in the normal and the clinical sample ought to have been matched for gender, chronological age, mental age, socioeconomic status, family intactness, and motivation. In addition, the children in the clinical sample ought to have been grouped according to their psychiatric diagnosis and type of medication. Unfortunately, this standard could not be attained. There are many constraints on working with children in institutions, some of

which have to do with records that do not include a detailed assessment of a child's cognitive status and psychiatric diagnoses that vary significantly from one institution to the next, or even within the same institution. Furthermore, it is not always possible to gain access to the records, which means that the researcher has to rely on the more limited information that someone else culls from them. Given the uneven distribution of males and females in residential treatment centers, this is a factor that cannot be controlled in this population of severely disturbed children. Finally, one cannot exercise control over the mood of the child who is suspicious of people in general, and even more so of the unfamiliar experimenter. Given the short time for interaction with the child, it is also not always possible to elicit his full cooperation and to motivate him to do his very best.

The comparison of the drawings obtained from the two samples presents us with methodological problems for which there are no easy solutions. The majority of the children who comprise the clinical sample function below their respective grade levels, and even below what can be expected on the basis of their IQ scores. Because matching by grade level is not an option, I decided to group the data according to the chronological age of our subjects, and to focus on the analysis of the 8-to-12-year-olds, as the number of the 7-year-old children in the clinical sample is rather small and data for the normal sample of children tested individually were not available for the group of 13-to-15-year-olds.

Given the nature of the clinical data and our inability to match the two groups on important variables, this study can only be seen as a pilot project—that is, exploratory in intent. Thus, the results of the many comparisons between the two groups will have to be interpreted with great caution. If we find significant differences in the performance of the two groups that favor the normal children, we will have to consider such factors as IQ and socioeconomic background, the child's motivation to draw, and the extent of his or her cooperation—variables on which the children were not matched—before we can attribute the differences to the pathological state of the child. If, however, the obtained scores of the two samples do not differ significantly, such a finding might then suggest that on those aspects that we examined, representational competence is robust indeed, and that it can withstand the effects of severe emotional disturbance.

Composition

The data can be analyzed in terms of ratings or scores that assess the manner in which the major figures and objects are organized into a pictorially meaningful statement. Scores can be ranked from the lowest to the highest, with higher compositional scores reflecting greater competence in ordering the elements of a composition. Beyond a comparison of scores as a quantitative measure of compositional skill, however, we can also analyze the distribution of compositional categories that children employ at various ages. The latter is more informative if we are interested in discovering the strategies that children

adopt on the various tasks, whether they align figures along a horizontal axis, order them symmetrically or establish unity by using more advanced grouping principles. I shall present the analysis of our data along both a quantitative and a qualitative dimension of the material at hand.

The comprehensive analysis of the compositional scores for the total sample of children from the clinical and normative groups indicates that, overall, the obtained scores are quite similar, a finding that replicates an earlier report by Anath Golomb (1987a). The developmental course is the same for normal and emotionally disturbed children.

Although the differences between the two groups are not large enough to be statistically significant, I think that for a qualitative understanding of the findings it is useful to describe some of the trends that characterize the groups. If we examine the mean scores for the different age groups, we find in the normal sample a very modest increase between ages seven to nine, with scores that peak at age nine. For the clinical group, the difference in scores between ages seven and eight is more marked; thereafter, scores increase modestly until age 11. With the exception of the youngest children, the mean scores for the two groups are quite comparable. Closer analysis reveals that while the range of scores is wide for both groups of children, we find in the clinical group a somewhat higher incidence of developmentally primitive compositional strategies than is the case for their normal counterparts. This finding applies to only two of the five tasks, the Children Playing and Garden themes. Additional analyses for the clinical sample of IQ scores 70 and above identify age as the major factor that determines drawing competence.

A closer look at the distribution of the various compositional categories is helpful for a more complete understanding of the similarities as well as the differences that characterize the pictorial organization of the two groups. For our youngest children, the seven-year-olds, comparisons have to be made with utmost caution because the clinical sample was small, with only three children participating on any given drawing task. Keeping these qualifications in mind, it appears that the clinical group employed more immature compositional strategies that are typical of younger children—for example, grouping figures by mere proximity or aligning them only partially across the page, and an infrequent use of symmetry.

The 8-to-10-year-olds from both groups made use of the full range of compositional categories, which extends from such primitive devices as partial alignment of figures to complex symmetrical arrays (see ills. 210 *a, b*; 211 *a, b*; 212 *a–d*; 213 *a–d*). Despite these overall similarities, however, the children in the clinical group also employed such primitive devices as arbitrary placement and the ordering of items by mere proximity; they also used more simple grouping principles, for example, the framing of figures. Although both groups of children used alignment strategies that organize pictorial space with the help of baselines and skylines, the clinical group more often differentiated only the bottom part of the page. In terms of the more ad-

a.

b.

210. *Partial Alignments*
Items appear to be floating in space; they are partially aligned with the top edge of the page.
a. Boy, 11;2. Elementary school child.
b. Boy, 9;10. Emotionally disturbed child with a diagnosis of borderline psychosis.

a.

b.

211. *Primitive Thematic Alignment: Pond Appears to be Floating in Space*
a. Girl, 8;7. Elementary school child.
b. Boy, 8;3. Emotionally disturbed child.

vanced compositional categories, the incidence of complex symmetrical arrangements was higher for the clinical sample, whereas thematic unity based on more sophisticated spatial differentiation and grouping principles was somewhat more represented in the normal sample.

The older emotionally disturbed children, ages 11 to 12 no longer employ the primitive ordering devices of proximity and partial alignments. However, trends noted earlier—for example, simple alignments that do not require differentiated pictorial space and fewer attempts to create simple variants of thematic unity—continue to characterize this group. Paradoxically, the incidence of compositions that employ a more sophisticated treatment of thematic unity, based on a differentiated spatial system and on a more diverse grouping of items, favors the clinical group (see ills. 214 *a, b, c, d*).

a.

b.

c.

d.

212. *Horizontal Alignment of Figures*
a. Family and pets. Family members are aligned with the bottom edge of the page, whereas pets are aligned on several additional levels. The artist, an eight-year-old boy, is a second grader enrolled in a public school.
b. My family. Family members are aligned above a baseline, whereas birds are lined up on a second level. The artist is a ten-year-old boy who resides in a treatment center for emotionally disturbed children. He is diagnosed as suffering from a borderline personality disorder.
c. Garden. The artist is an eleven-year-old elementary school child.
d. Garden. The artist is an emotionally disturbed ten-year-old boy.
Names have been deleted to safeguard the anonymity of the young artists.

302

a.

b.

c.

d.

213. *Symmetry: Birthday Party*
a. Artist is a nine-year-old elementary school girl.
b. Artist is a nine-year-old emotionally disturbed boy. Diagnosis: borderline personality disorder with psychotic episodes.
c. Artist is an eleven-year-old elementary school girl.
d. Artist is an eleven-year-old emotionally disturbed girl. Diagnosis: borderline personality disorder with psychotic episodes.

303

a.

b.

c.

d.

214. *Thematic Unity*
a–d. Artists are twelve- to fourteen-year
olds who reside in a treatment center for
emotionally disturbed children.

Although I have mentioned the higher rate of immature composi-
tions in the clinical group, it is important to note that for the total
clinical sample, comprised of all age groups, the incidence of primi-
tive compositional devices is exceedingly small (for example, only 2
percent for ordering objects by proximity). On other compositional
categories such as partial alignment and primitive thematic align-
ment, the two groups differ by 0.5 percent to 1.5 percent only. The
overall use of symmetry, both simple and complex, is quite compara-
ble for both groups (see ills. 213 *a–d*; 215 *a* ,*b*; 216 *a–h*). The incidence
of thematic unity—that is, of compositions that unify the diverse ele-
ments without relying on a principle of symmetry—although low for
both groups, appears somewhat more frequently in the normal chil-
dren. This more advanced compositional strategy clearly requires
practice as well as talent.

In summary, the same developmental progression in the use of
compositional strategies characterizes both the normal and the clini-
cal sample. In normal children, compositional development for all but
the more gifted children peaks at age nine, whereas the progression is

more gradual in the case of the clinical sample, where it peaks at age 11. In general, the ability to create pictorial space and to organize a graphic composition is similar for the normal and the clinical group of children. The somewhat higher incidence of primitive or immature strategies in the younger children, the seven-to-eight-year-olds, gives evidence of their significantly delayed mental maturity, their lack of concentration and greater restlessness, and their frequently low motivation to participate in the drawing session. Many children in the clinical sample rushed through their assignments in minutes, making only a minimal effort to comply with the examiner's request for a drawing.

Why the small differences between the two groups in compositional competence disappear altogether at age 11 cannot as yet be answered with any degree of certainty. Perhaps the plateau reached by normally developing children at age nine is reached later by the emotionally disturbed children due to their generally delayed cognitive maturity. Possibly attentional deficits also diminish somewhat with age, whereas drawing becomes a more commonly engaged-in activity that affords the child the necessary practice. The findings that IQ plays a subsidiary role for all but the mentally retarded children whose scores fall in the IQ range 50 to 70 seems to be counterintuitive and appears to challenge researchers who tend to use drawings as an instrument for the assessment of intellectual maturity. Chronological age, not IQ, emerged in the clinical group as a significant factor in compositional development, and this can best be understood in terms of the child's growing mental maturity, his repeated exposure to the graphic medium, and an increased ability to attend to the task at hand—all of which enhance his representational competence.

In summary, the findings of remarkable similarities in the use of compositional strategies that characterize the whole sample, but more specifically children from the age of nine years on, suggests that composition, the syntax of the graphic language, is a robust phenomenon that is relatively unaffected by differences in intelligence or mental illness. True, its progression comes to a halt, perhaps temporarily so, at age nine; without additional training and the sustained motivation for its improvement, composition is likely to remain arrested at this point. The fact that such major factors as motivation, mental stability, emotional upheaval, and cognitive delays do not much affect compositional variables, and observing the wide range of compositional strategies adopted by both normally developing and emotionally disturbed children, gives us cause for caution when analyzing children's drawings.

Figural and Object Differentiation

The graphic differentiation of forms and figures is usually considered as the core of representational development. We selected five tasks and four items for closer analysis: the human figure drawn on the Family and Children Playing themes; a table, tree and house depicted on the

a.

b.

215. *Family: Grouping of Figures and Use of Line Overlap*
Drawings of ten- to eleven-year-old children.
a. The artist is a fourth grader enrolled in a public school.
b. The artist is an emotionally disturbed child with a diagnosis of conduct disorder.

a.

c.

b.

d.

216. *Birthday Party: Drawings that Employ Symmetry*
Drawings by twelve-year-old boys.
a. The work of a normally developing child.
b. The work of a boy diagnosed as withdrawn into fantasy, with severe behavioral and learning problems.

Family: Grouping of Figures and Successful Use of Line Overlap
Drawings by eleven- to thirteen-year-old boys.
c. The work of a student attending a public school.
d. The work of a boy diagnosed as depressed with severe conduct disorder.

Birthday Party; Garden; House; and Street themes, respectively. A rating scale consisting of six levels was developed for the assessment of figural differentiation. In the case of the human figure, the lowest level of the scale represents a global or tadpolish figure, the highest level a fully differentiated figure drawn with a continuous outline, and some suggestion of its curves or three-dimensional nature—for example, by depicting more than one side, using overlap, or shading. A similar scale was constructed for the tree, beginning with an undifferentiated trunk or global structure and advancing to a more detailed depiction of two-dimensional branches and leaves, with branches thinning out as they stretch out from the trunk, and shading or overlapping suggesting the volume and roundness of the tree trunk. The drawings of a table and a house were ordered in terms of the projective drawing systems described by Willats (see chapters 3 and 4), beginning with primitive topological shapes, followed by single frontal views of the object, to a graphic description that involves three sides of the object in isometric projection and in convergent perspective.

A comprehensive analysis on all figural differentiation scores for all ages and tasks combined does not yield significant differences.

e.

g.

f.

h.

Garden: Use of Symmetry
Drawings by twelve- to thirteen-year-old girls.

e–h. The upper drawings represent the work of normally developing middle school children. The drawings in the lower sector are the work of severely emotionally disturbed girls who reside in a residential treatment center.

Analysis of the differentiation scores reveals a pattern similar to that described for compositional scores. The scores for both groups increase with age; the differences between the age groups are small and tend to level off—in the case of the normal sample at age 9, and in the clinical sample at age 11. In the case of the normal sample, the mean differentiation scores of the youngest children is 3.07, that of the oldest ones 3.34. In the case of the clinical group, the lowest score is 2.50 for the youngest group, the seven-year-olds—who, due to their small numbers, may not constitute a truly representative sample—and the highest score is 3.40 for the oldest participants. With the exception of the seven- and eight-year-olds, the range of scores and the modal scores (that is, the most frequently occurring scores) are quite comparable for both emotionally disturbed and normal children, at ages 9 to 12 years. Only among the youngest children do we find the low scores for global and tadpole figures. Until age 11 years, the differences in scores, though small, favor the normal children. From the age of 11 years on, the mean scores are very similar for both groups. As was the case for compositional scores, chronological age, not IQ, emerges as a significant factor.

Thus, once again, a somewhat delayed course of graphic differentiation is characteristic for the clinical group. Because, ranges and modal scores, with the exception of the seven- and eight-year-olds, are comparable for both groups of children, figural differentiation by itself cannot serve as a reliable diagnostic means of emotional disturbance.

Color

The role of color in the drawings of our two groups was explored with the help of the following classification system: *monochromatic* drawings, in which a single color or lead pencil is used; *arbitrary color* choice, in which color does not represent the realistic attributes of an object (for example, blue faces, a green sun); *indiscriminate color* choice, in which the particular color or color combination does not violate the nature of the object, but merely disregards it (for example, when many different and contrasting colors are used for clothing or furniture); *local true color*, in which colors are selected to represent the true or realistic color of an object or figure (for example, water is blue, grass is green, the human body is tan-colored); and *color variation* and *color gradients* in which the shades of a color are varied, and color gradients may be used to indicate, for example, distance.

The results for color use are quite clear-cut. The children in the clinical group by far preferred single colors and, with the exception of the Garden theme, used local true color sparingly. This consistent choice of a single color or the avoidance of color in pencil drawings was independent of age and applied equally to the youngest as well as the oldest children of the clinical group. This trend was most pronounced for the boys of the clinical group, although it was also characteristic of the girls. Next in frequency was the arbitrary use of color, and again this was the case for the sample as a whole. Only on the theme of the Garden did an appreciable number of children from the clinical group resort to realistic colors. However, even in this instance the differences in the proportion of realistic drawings produced by the clinical group fell short of the normal group.

Color use was also independent of age in the group of normal children. The categories most commonly employed by all age groups of the normal sample are those defined as local true color and indiscriminate colors, although single colors and arbitrary colors were also chosen for the Family, Children Playing, and Birthday Party themes. In the normal group there is a fair distribution across the first four color categories. Not a single drawing in either the normal or the clinical group employed the most advanced category of color gradients. In our analysis of the drawings of normally developing and emotionally disturbed children, it is color that, quite consistently, differentiates between the two groups.

Location and Size of Figures

The use of pictorial space can also be examined in terms of the location of objects on the paper. With this purpose in mind, and using an

overlay of two vertical and two horizontal lines to divide the paper space, we created a scoring grid consisting of nine rectangles. This division enabled us to examine the manner in which objects were dispersed across the page and to look for unusual patterns that might characterize the clinical group.

The youngest children, the seven- and eight-year-olds, tended to use the whole page in approximately one half of their drawings. This held for both the clinical and the normal group of children. The incidence of limiting the drawing to a small sector of the page was also similar for the two groups.

In the group of 9- and 10-year-olds, a difference emerged in the use of the total paper space. Fewer children in the clinical sample used all of the page, which was particularly pronounced on the Family, Children Playing, and Birthday Party themes. The incidence of using a single or two rectangles only, or unusual patterns (for example, an extreme lateral displacement of figures away from the center), or using other forms of imbalance were infrequent for both groups.

The same trend continues also for the 11- and 12-year-olds on themes that explicitly refer to social relations—namely, Family, Playing, and Birthday. On these tasks, a significantly smaller number of children in the clinical sample made use of the total paper space. This was not the case for the Garden and House themes, on which the clinical group did not differ from the normal children. Interestingly, the number of emotionally disturbed children who restricted their figures to one or two rectangles only rose markedly on the Family task. To a lesser extent this was also the case in the drawings on the Children Playing and Birthday Party themes. In the group of emotionally disturbed children, the Family theme elicited a great deal of uncertainty about whom to include in the drawings. Some children came from single-parent families; many had been abused, abandoned, or placed in foster care; and the issue of family relations was both painful and problematical. The ambivalence and uncertainty the child felt about his family was frequently reflected in drawings that comprised only one or two figures and used a small sector of the page. Not surprisingly, the Family theme elicited the largest number of refusals in the clinical group.

The size of the human figure was determined on two tasks; on drawings of the Family and Children Playing. On each of these drawings, we measured the largest figure and assigned it to one of the following categories: less than two inches, two to three inches, three to five inches, five to seven inches, larger than seven inches. On both tasks, the two groups did not differ significantly in the size of the drawn figure. However, in the clinical sample a trend to use smaller figures was observed on Children Playing. Although children in both groups used the whole range of size categories, the highest proportion—36 percent—of drawings of emotionally disturbed children measured less than two inches, whereas 41 percent of the drawings of the normal sample fell into the size category of three to five inches.

Personal and Idiosyncratic Features

Beyond the formal characteristics of composition, figural differenti-ation, color, location, and size examined so far, we looked for unique characteristics that might set the clinical sample apart from the normal group. Thus, on the drawing of the Family we paid atten-tion to such special features as drawing only heads or busts instead of the whole figure; substitution of animals, robots, or ghosts for the human members of a family; and the drawing of unrelated people. Although examples for each category could be found, the two groups did not differ in the frequencies with which these occurred. The sub-stitution of animals for the human family was quite common for both groups (see ills. 217 *a, b*). On the Birthday theme, we were struck by the number and type of drawings that excluded humans from the picture. A systematic comparison revealed that the propor-tion of such drawings was the same for both normal and clinical groups, 33 percent and 34 percent, respectively (see ills. 218 *a–d*). (Examples of more family-oriented portrayals can be seen in ills. 219 *a, b, c.*)

a.

217. *A Family of Animals*
The incidence of animal substitutes for the human family is comparable for normal and emotionally disturbed youngsters. Artists are two eleven-year-old boys.
a. Artist is an elementary school boy.
b. Artist is an emotionally disturbed boy.

b.

a.

b.

c.

d.

Next we analyzed all the drawings for "unconventional" features, of which we identified the following: (1) *bizarre features,*—for example, on the Family theme, these may refer to faceless figures, to eyes that are only drawn on a single figure of the family, or to mechanical bodies; on the Birthday theme, a black cake, a party for dinosaurs or robots, and human figures baked into the cake qualify as bizarre; deliberate violations of realistic colors on the Garden theme, for example, a green sun or a pink pond were scored likewise; (2) *depiction of violence or of an explosive scene.* (3) *sexual or anal references;* (4) *primitive and irrelevant shapes;* (5) *depressing themes*—for example, a death, a funeral, or all the members of the family depicted as ghosts.

The proportion of any of these unconventional features is small for both samples, and exceedingly rare on the so-called neutral items of Garden and House. On Play and Birthday themes, the percentages are also small and do not differentiate between the two groups. On the Family drawings of the clinical group, however, 15.5 percent were classified as bizarre (see ills. 220), and 3 percent as violent, frequencies that were much higher than those for the normal group—3 percent and 1 percent, respectively. The highest proportion of unconventional

218. *Birthday Parties Noted for the Absence of Humans*
a–b. Drawings of normal public school children, ages 11 to 12.
c–d. Drawings of emotionally disturbed youngsters, ages 11 to 12.

a.

b.

219. *Birthday Parties with Humans Present*
a–c. Artists are emotionally disturbed
youngsters, ages 11 to 12.

c.

220. *Bizarre Characteristics*
The artist depicts his family: father lies on
the couch, mother stands at the stove and
cooks, the artist practices karate, and his
sister kicks: " . . . my sister . . . this stinks,
doesn't it? Her kicking motion, she looks
like an octopus, doesn't she? . . . I can't
draw for shit."
The artist is a twelve-year-old boy
diagnosed with bipolar affective disorder,
attentional deficits, and aggressive
behavior.

221. *A Hanging*
Artist is a ten-year-old emotionally
disturbed boy.

items, 31 percent, is found in the youngest group. Thereafter, the incidence declines with 24 percent for 9- and 10-year-olds, 13.5 percent for 11- and 12-year-olds, 12.5 percent for 13-to 15-year-olds. Interestingly, all the drawings that were characterized as having a violent content were made by boys. When children in the clinical sample were given the opportunity to draw a theme of their own choice, they frequently depicted violent scenes including tank battles, warships, mutilation, and hangings (see ills. 221).

Content Analysis

Our structural analysis of composition, figural differentiation, color use, location, and size of figures provides only few distinctive characteristics that might suggest that the artist is an emotionally disturbed child. His comments, however, on the work in progress and on the final product, whether made spontaneously or elicited by the examiner, can provide insight into the child's mental and emotional state. The following examples illustrate that drawings can access deeply felt concerns and lead to the expression of conflicting feelings, often of a very negative kind.

A. B., a nine-year-old boy whose diagnosis is borderline psychosis with conduct disorder, makes the following bizarre and aggressive comments while drawing the Birthday Party: "Someone stuck their face into the cake. A rotten egg getting thrown. See how I put dots . . . Now this is really funny, a mile-long hotdog. I wonder how long it took to cook this hotdog. Ever seen a strawberry ice cream sundae that big? As you can tell, I have a sense of humor. I'll make sprinkles . . . hot fudge . . . can't see his head . . . hot fudge is dripping on him. Cherry on top. This one is going to get a bowl of rotten eggs" (see ills. 222).

222. *Birthday Party*
Artist is a nine-year-old boy with a diagnosis of borderline psychosis with conduct disorder.

C. D., a depressed, suicidal, and aggressive eight-year-old boy, rejected the assigned themes. Instead he created his own topic that clearly states his preoccupation with and anxiety about anal-sexual matters. He began with a drawing of a man sitting, which he crossed out. Next he drew a man in the top center and commented: ". . . doing dodoo. I forgot to make his sneakers . . . Puma sneakers . . . And he is taking a whizz at the same time, he is taking a poop. He took a big whizz. He has to take another one. Boogers are coming down, he has turned his face because he was throwing up. There is puke everywhere. He might have to go to the hospital, It is all black. He eats his own dookie [Examiner: "What is dookie?"] It is when you are going number two. And now he is picking his butt. His hand is stretching far far away . . . Oh, he digs inside there" (see ills. 223).

E. F. is a 12-year-old boy diagnosed as suffering from a bipolar affective disorder with attentional deficits. He responds with unease to the Family assignment: "Can I just do heads? I can't draw that good. This is stupid, I can't draw for sh . . . You timing this crap? Piss! . . . I can't draw crap, I can't draw crap. This is stupid, they look like chinks, don't they. . . . My sister, how do you make a brat? I want to draw my favorite picture of gore, a man cut up in half with an ax, and you see his organs and everything . . ." (see ills. 224). In terms of the composition and the differentiation of the figures, the drawing, though seemingly floating in space, is not unusual and might have been made by a normally developing child. The anger and aggressive content of the drawing emerges only in the verbal expressions that accompany the drawing.

223. *Personal Theme*
Artist is an eight-year-old boy diagnosed as depressed with suicidal and aggressive tendencies.

224. *Family*
Artist is a twelve-year-old boy with a diagnosis of bipolar affective disorder and attentional deficits.

G. H. is a mildly retarded 12-year-old boy whose diagnosis reads conduct disorder. He describes his free drawing, made at his own request, as follows: "I'll draw pirates and astronauts . . . Another pirate sitting down here. Blow him up. A little pirate hanged [in center]. A little blood comes out. . . . He has a small Uzi gun with a flame [on left]. I'll draw a sub, a little astronaut drowning in the water. He shot him [red dots from submarine to man]. A lot of water on top. Nice, huh! Pretty good trouble. Stay inside the lines. . . . Now Halley's comet, tail on him. A little creature, another astronaut is going to hurt him, little gun. . . ." (see ills. 225).

I. J. is a severely depressed, emaciated-looking 11-year-old boy with a diagnosis of borderline psychosis. Over a year ago, I.J lost his mother, with whom he lived in the apartment depicted. While drawing, he entered a state of reverie in which he evoked the image of the kitchen in his old home. One can follow his remarks by starting at the right of the picture: "This is the sofa and the table. I don't like to make mistakes so I'll cross it out. It could be a fence, oh, I know what it could be, a baby behind that wall so that he does not get into places. This is the refrigerator. See the handle to open it up? Then the counter. This is the stove. This goes to the stove. This goes to the

225. *Pirates and Astronauts*
Artist is a twelve-year-old boy with a diagnosis of conduct disorder.

oven. [Examiner: "What is this?"] A kettle. [Examiner: "and this?—pointing to the wavy lines] Heat. . . . The hiding place. I used to hide when my mother came downstairs when I was in trouble. She mostly used to find me. [Examiner: "What is this?"] The door. I was an inch taller than the door knob. Oh, I keep forgetting the lights . . . Oh, I keep on forgetting the chairs. Oh, I forgot what is most important. Cookies. Chocolate chip cookies." This drawing provides an insight into I. J's deeply held feelings about his lost home, and it may have helped him to retrieve positive memories of the past. The drawing is also of interest because it illustrates that despite the child's intense emotional experience while drawing, the composition did not become disorganized (see ills. 226).

K. L., a 14-year-old adolescent girl whose diagnosis is borderline personality disorder, spontaneously comments on her work as she draws the Birthday Party: "Before or after? Does anyone have to be there? . . . A table. What does a keg look like, it's been a long time. It looks more like an oil-can. I have only seen three before [reference is to kegs], on T.V., at friends, and my brother's party. . . . It looks like an ironing board. I'm so dumb, I don't even know what an ironing board looks like. The hell with it. I don't even drink beer, I don't know

why I am doing it. To be different I guess. It sort of looks like a lonely party, no one there. I can draw a dog, and it could be his birthday party . . . hinges so dog can go out [reference to door]. I'm a little better at drawing animals. I should put a light-switch over here . . . If people can have parties, why not dogs" (see ills. 227).

As these examples suggest, the child's comments while drawing and her personal associations to the theme often touch on issues that trouble her; at times the mood and feelings associated with a drawing can become quite transparent. Thus, a drawing session may be helpful in understanding the child's problems and can provide additional information on which to base a clinical diagnosis as well as a prognosis for treatment. But just as the previously discussed structural analysis of drawings did not yield simple diagnostic profiles, so also the content analysis has to be used with great caution in order to distinguish between common developmental concerns, conflicts, and

226. *Our Kitchen*
Artist is a severely depressed eleven-year-old boy with a diagnosis of borderline psychosis.

227. *Birthday Party for Fido*
Artist is a fourteen-year-old hospitalized adolescent girl with a diagnosis of borderline personality disorder.

anxieties, and the more extreme state indicative of psychopathology. In the hands of the careful clinician and therapist, drawing may provide a useful avenue for the child coming to know herself and to generate the motivation necessary for a more healthy mental development.

In summary, the results of our exploratory study suggest that the development of compositional strategies occurs quite independently of emotional disturbance, that it is a robust phenomenon, a basic syntax for the organization of experience that remains relatively unaffected by psychopathology. This finding is the more surprising because the two samples were not well matched in terms of their cognitive functioning. The answer to one of the initial questions I raised concerning the nature of the observed differences, where they exist, indicates that the strategies employed by the clinical group are not truly deviant ones, although at times they appear to be developmentally more immature. By and large, the clinical group uses the same compositional strategies as the normal group, and disorganization is quite rare, a finding that is congruent with Prinzhorn's insights regarding the art of adult psychotic patients.

The results of our analysis of the graphic differentiation of single objects indicates that although the course of development is alike for both groups, the mean graphic differentiation scores for the younger emotionally disturbed children fall somewhat below that of the normal group. The difference does not lie in the ranges or modes of the differentiation scores, which are alike for both groups, but in the more frequent use of immature—that is, early representational models—by the emotionally disturbed children.

The significant differences across all ages in color use is one of the most consistent findings, strongly suggesting a relationship between mood and color. The two major findings, a preponderance of achromatic or single colors and less concern for realism in the choice of colors, may be indicative of depression, a mood that characterized a large proportion of the emotionally disturbed children. The significantly lower incidence of local true color, which was most clearly seen on the interpersonal themes, reflects, perhaps, the child's lack of concern with the social reality and its demands, indicating both his opposition to the surrounding world and his withdrawal from it. These latter statements, however, are in the realm of hypotheses yet to be investigated.

Our findings regarding the more restricted use of the picture plane by the children in the clinical group, and a trend to draw smaller figures fits well with characteristics often associated with anxiety and depression. Under these conditions, the emotional life of the person is constricted and there is a tendency to shrink within the self and its bodily boundaries. These can be seen as protective measures to guard against openness and expansion, and perhaps an effort to exert control, which is easier to establish over a more limited area. Once again, however, these are tentatively drawn inferences that need to be confirmed.

In an extension of this study on such personally relevant themes as "a happy" and a "scary" dream Patty White and I (1988) collected

drawings from a similar population of emotionally disturbed children and from a normative sample enrolled in elementary and middle schools. Overall, the results on composition, figural differentiation, and color use are quite comparable to our results described above, with similar scores on the happy dream for the emotionally disturbed and the normally developing children. On the scary dream, however, the scores for the normal group exceeded the scores for the clinical participants, a difference that characterized the younger children and no longer held for the 12- and 13-year-olds. We also noted, on the basis of content analysis, that the emotionally disturbed children infrequently selected themes that empower them, and that on themes of aggression and harm the normal boys frequently depicted violence of an impersonal nature directed toward unknown enemies in warfare, whereas the boys from the clinical sample depicted harm of a more personal nature to the child.

A surprising finding for the clinical samples of both studies was the negligible effect of IQ on graphic achievement and the absence of an age effect for the normal sample. That IQ and mental age do not stand in a simple relationship to artistic achievement can be seen in the drawings of Nadia and Eytan, two highly gifted and precocious child artists (see chapter 7). Additional support for the notion that graphic talent may well be based on a unique set of abilities not measured in the commonly used intelligence tests comes from authors who have studied gifted autistic and nonautistic idiot savant artists (Hermelin, 2001; O'Connor & Hermelin, 1987a,b; Pring, Hermelin, & Heavey, 1995; Selfe, 1983, 1995; see also Kläger, 1993, 1996). In these cases, which are extremely rare, mental ability as measured by various intelligence tests falls in the retarded range, while the artistic quality of the drawings is rated highly by experts. These finding are congruent with Howard Gardner's theory of multiple intelligences, in which he identifies spatial intelligence as a separate domain of productive thought and action and hypothesizes that graphic intelligence has its own, as yet unidentified, underlying neurophysiological structure (1983).

Art Therapy with Children

As the previous chapters have demonstrated, drawing is a language that children master in their quest to understand their world and to express their feelings. In my review of studies that focus on the diagnostic value of children's drawings, I have cautioned against using drawings as if they were an X-ray of the child's heart and mind. Although drawings may not yield to a mechanical analysis that ignores the individuality of the child artist, they can reveal to an empathic participant observer what the child's mood is and what feelings he is trying to express. Indeed, a large body of literature attests to the possibility, even the desirability, of using drawings in a therapeutic context. Many experienced child therapists have used drawing in conjunction with other techniques (for example, play therapy and conversations) in an effort to help the emotionally distressed, and at

times severely disturbed, child (Betensky, 1973; Bettelheim, 1967; Case & Dalley, 1990; A. Freud, 1948; Kramer, 1971, 1993, 2000; Naumburg, 1973; Rubin, 1984). For some youngsters, drawing is a substitute for verbal communication; for others it is an additional avenue for discovering and communicating important feelings the child harbors about herself and others. A self-portrait can make a very personal statement that can be shared with the therapist. Although the particular interpretive emphasis depends on the theoretical framework of the therapist, most reports on a patient's progress can be seen as learning to differentiate feelings and attitudes previously not well understood. For children as well as adults, it is much simpler to come to know the external world than to understand the internal landscape of feelings, impulses, wishes, and images. Without the articulation of thoughts and feelings and a desire to work toward change, not much progress can be made in the therapy of older children and adolescents. Although drawing can be a very private and solitary activity engaged in without communicative intent, in the therapeutic session drawing can serve as a means of giving voice to poorly understood inner feelings, coming to know them, and learning to differentiate between those the child wishes to act on and others that he may desire to change. Drawing in the presence of the therapist encourages the child to understand his own message. This may enable him to become more active in his own behalf, to pursue an attainable goal, to gain greater self-respect and, ultimately, to feel better about himself. Above all, drawing in the presence of an accepting adult encourages the child to face the inner world of ghosts and demons, as such a confrontation is now less threatening. The threats that emanate from the child's private nightmares, the thoughts and images of punishment and of destruction that lock her into her gloomy world, can become more manageable and subject to change once they find their concrete expression in a drawing. However, a drawing does not provide solutions magically, and in most therapeutic situations drawings are seen as aids in the working through of the child's emotional problems (see Gregorian et al., 1996).

In summary, drawing development in normal and atypical populations is a sequentially ordered process that is not easily affected by the mental conditions I have examined so far. The basic grammar and syntax of the graphic language provide the underlying structure, but the individual characteristics of the artist are expressed in more subtle ways. His unique drawing style can be seen in the ease with which a person who is unfamiliar with the artist can identify drawings on different themes made by the same child over weeks, months, and sometimes years (see ills. 228 a–d). Such individuality is expressed in the quality of line and shape, in compositional patterns, color use, thematic interests, originality and expressiveness. But if in the case of such extreme psychological states as emotional disturbance it is difficult to establish general rules for differentiating between the normal and the pathological in drawing, how likely is it that we can design a meaningful interpretive key for understanding the personality of the normal child? Here G. W. Allport's (1962) distinction between the

a.

b.

c.

d.

nomothetic and the idiographic is helpful. Although the thrust of academic psychology has been to establish laws that can be generalized broadly, it is the case-study method that seems best suited for an exploration of what is unique in personality. Indeed, in my chapter on gifted child artists, I have adopted this approach. Drawing is a personally meaningful process for the child who expresses some of her thoughts and feelings in her choice of a theme, the manner in which she draws her figures, uses color, and structures the composition. These are qualitative aspects that require attention to the social and cultural context in which the drawing is made, the child's developmental level, her motivation for drawing, her practice with the medium, and a very important factor, graphic talent. Finally, the child is a privileged informer and her thoughts about the drawing or painting ought to be taken seriously.

228. *Continuity in the Style and Subject Matter of a Talented Boy*
Drawings at age six:
a. Indian hunter.
b. Buffalo.
Drawings at age 14:
c–d. Hunting scenes.

9

The Child as Art Critic

In the preceding chapters, we explored the development of graphic representation in normally developing children, in children with special talents, and in mentally retarded and emotionally disturbed youngsters. Throughout, my aim has been to go beyond a mere description of child art in order to clarify the rules that underlie graphic development. With the help of a variety of tasks and procedures, I have drawn a distinction between perception and representation, between the child's knowledge of an object and his ability to translate this understanding into a drawing or painting.

From the point of view of naive experience, perception is a seemingly effortless and instantaneously occurring psychological process that is attuned to the expressive qualities of our world. It requires little awareness of the constantly changing angles from which we see an object and apprehend its qualities, and it differs in fundamental ways from the intention to represent the object with lines and brush strokes. In earlier chapters (see chapters 2 and 3), I documented the fallacy of the notion that drawings are printouts of the child's mental schemas, and I challenged the assumption that a unitary graphic schema imposes itself on the child's drawing, independent of content, theme, and task. Many studies indicate that significant differences exist between conception and performance, between the child's knowledge of an object, her drawing thereof, and the manner in which she completes a partially drawn figure.

I shall now extend this line of inquiry and ask whether the graphic logic that underlies the child's use of forms, colors, and composition also guides his judgment when looking at ready-made pictures. Such an exploration of the child's judgments and preferences, of his likes and dislikes, might be seen as a discourse on an aspect of child aesthetics.

Most research on the child's sensitivity to the visual arts has employed samples of adult art. By choosing reproductions of the work of

acknowledged artists, researchers circumvent the difficulty of having to determine which graphic works are of artistic merit. Many studies have focused on the child's ability to discern stylistic features and, more recently, on the expressive quality of a painting. Children's sensitivity to subject matter, color, form, line quality, texture, and shading have also been studied using reproductions of famous paintings (Blank et al., 1984; Gardner, 1972, 1973, 1974, 1980, 1982; Hardiman & Zernich, 1977, 1985; Machotka, 1966; Moore, 1973; Parsons, 1987; Parsons, Johnson & Durham, 1978; Taunton, 1984; Winner, 1982, Winner et al., 1983; Winner et al., 1986). From these and related studies (Carothers & Gardner, 1979; Lark-Horowitz, Lewis & Luca, 1967; Rosenstiel et al., 1978; Winston et al., 1995) a developmental progression can be seen in which, at first, the child attends mainly to the content of a drawing or painting, color is highly attractive, realistic representations are preferred, and the ability to respond to expressive qualities develops only slowly. There is a prolonged period of insensitivity to qualities of line, shape, and texture that is overcome during the adolescent years. However, the studies also suggest that the format of the tasks, the kinds of illustrations used, the wording of the questions, and the extent to which children have undergone a brief period of training to gain familiarity with the assignment affect the results, and that even young children, perhaps from kindergarten on, can make some stylistic distinctions among different paintings and display sensitivity to aesthetic aspects of a work of art (Gardner, 1990; Lovano-Kerr & Rush, 1982). Of course, there is a long route to be traversed from the child's enjoyment of pictures and the ability to discern certain aspects of a painting (most likely a reproduction), to that of the discerning judgment of the highly trained adult (Parsons, 1987).

Very little research has been directed toward the child's judgment of her own work and that of her peers. By and large, the child's aesthetic responsiveness to child art has been a neglected topic. What might we expect on the basis of the studies discussed in chapter 2? The finding, for example, that a task of completing an incomplete drawing of the human figure elicits a more detailed completion than a free drawing made by the same preschool child dictates close attention to the differences between spontaneous drawings and completion drawings. Likewise, a comparison of the child's free drawing and his selection of the "best" man among ready-made figures reveals significant differences between these two tasks.

I shall now review a set of exploratory studies that examine the child's judgment of drawings that are similar to her own, using test stimuli that are mostly drawn from collections of children's drawings. These studies address the following questions: (1) Do the rules that underlie the child's own drawing also guide his judgment of a picture made by someone else? (2) What is the relative importance of color, form, size, and composition for the child's judgment of a good drawing? (3) Are young children sensitive to compositional variables? (4) What is the child's judgment of his own work?

229. Identical Figures that Vary Only in the Location and Orientation of Arms

Figure Completions and Preferences

I shall begin with a report on a study conducted by Eric Granholm, who compared the free drawings made by preschoolers with their completions of incomplete figures and with their judgments of two sets of predrawn figures. On the free-drawing task, the children drew mostly tadpole figures; other models ranged from an open trunk to a simple but complete figure of a human. The results of the completion task replicate the findings reported in chapter 2, with the youngest and least experienced children drawing more detailed figures on this assignment than on their own free drawing. The older children performed in much the same way on drawing and completion tasks. When asked to select the prettiest or best picture from a set of five human figure drawings, none of the children chose their own graphic schema and several children characterized figures similar to their own as the "ugliest." As the best figure, they selected drawings that were more advanced than their own, and a majority (70 percent) chose the most detailed figure as the best one among the set. When asked to explain their choices, children mostly referred to the greater number of parts of the chosen figure, indicating that "best" was defined in terms of most "complete."

The results of the selection task suggest that the child's choice is determined by the complexity of the figure; the more detailed the figure, the better it is deemed to be. Next we may ask what happens when we keep the degree of completion constant and merely vary the location and direction of the arms. In order to answer this question we designed a set of six figures, identical in the number, size, and shape of the component parts. Only the location and direction of the arms were systematically varied: arms extended from the head, the shoulders, and the middle of the trunk. They were drawn perpendicular to the body or at a slant (see ills. 229). The results on this selection task show that the figure with arms drawn from the head (although similar to their own graphic schema) was considered the ugliest one. Although in their own drawings arms extend at a right angle to the body, the great majority of the preschoolers (70 percent) selected the human with the diagonally drawn arms as the best or prettiest picture.

Line Overlap

In the next study, I examined children's responses to overlapping or intersecting lines. In early phases of drawing development, children avoid drawing lines that cross boundaries. When they draw a family, for example, each member is drawn as a separate unit that does not

impinge on others, and the same principle applies to parts of the figure. Children allocate a separate space to each object and its parts, creating simple, clearly delineated figure–ground relations (Goodnow, 1977; Schaefer-Simmern, 1948). Children who in their own drawings avoid line or shape overlap by drawing the human figure with outstretched arms instead of, for example, with arms folded over the chest, were presented with a set of four drawings of a girl: (a) with outstretched arms avoiding all overlap; (b) one arm bent across the figure; (c) two arms intersecting the figure; (d) additional overlapping lines of collar and apron. The last figure included lines that cross several boundaries and portray invisible parts that ought to be hidden from view (see ills. 230). In most examples of overlap, lines that ought to be hidden from view have not been eliminated in order to approximate the drawing style of the early elementary-school child who tends to superimpose parts, creating the so-called transparencies (see chapter 4). The results are as follows. Without exception, preschool and kindergarten children rejected the figure with the outstretched arms and selected drawings that employed varying degress of line overlap, indicating that the tendency toward simplicity that guides their own drawing or completion of an incomplete figure does not determine their choice of what is prettiest, best, or most appealing. Whether these youngsters fully comprehended the meaning of the overlapping lines or whether they merely ignored the confusing lines and interpreted them as a sign of greater detail was not examined. However, it seems safe to conclude that children's preferences do not necessarily coincide with the principles that guide their own productions (see chapters 2 and 3). Although their own drawings and completions are characterized by simplicity and obey a principle that allocates a separate and clearly identifiable space to each part, when faced with ready-made drawings, they seem to favor some degree of representational complexity (Golomb, 1983).

In a variation on this experiment, Tamar Springer and I designed several sets of human figure drawings and one that depicts a street scene. The drawings in each set varied only in degree of line overlap. In this study, children ages four, five, and six years were asked to select the "best" and the "worst" drawing, and to explain their choices. The results differ from those of the preceding study in that the judgment of the four- and five-year-olds do not reveal a systematic basis for their selections or preferences, perhaps a function of the more detailed questions they were asked. Among the six-year-olds, comments on overlap appear with greater frequency, and they are mostly

230. *Drawings that Vary Only in Degree of Line Overlap*

negative (for example, "crossing lines mess up the picture"). Apparently, first-graders scrutinize drawings more effectively; although they value detail they also consider techniques for their depiction. They tend to criticize overlapping lines that ought to be hidden from view.

Examining the effects of overlapping lines with thematically more meaningful material, Diane Monaghan designed different sets of four drawings each: (1) a girl, a teddy bear, and a flower; (2) a girl with a cat; (3) a boy with a ball; (4) a street scene. Within each set, one drawing avoided all overlap while the others depicted the items with an increasing number of overlapping lines that ought to have been eliminated. Her subjects, four-and-five-year-olds, were asked to select the "most liked" and the "least liked" drawing in each set. As in the previous study, the resulting selections were fairly inconclusive; they distributed themselves over all four categories indicating that, at least in term of overlap, these preschoolers do not reject a method of depiction they avoid in their own drawings. It does not seem a critical factor. This study, however, does more than confirm the previous findings. It highlights the impact of thematic variables on tolerance for overlapping lines. Children expressed a preference for the girl *holding* the teddy bear over the girl *standing* next to the bear, although in the former picture lines crossed boundaries whereas in the latter overlap was avoided. Although this study does not reveal consistent preferences within each set and among sets, when a drawing included multiple line crossings that should have been eliminated and that tended to obscure its meaning, it was chosen less frequently. Within the overall context of the theme—for example, of a child with a toy or pet—children tended to select groupings that held a special appeal such as the girl holding the cat or the bear; this preference either overrode concerns they might have had with line crossings or was unaffected by it.

Taken together, the results of these studies indicate that children's judgments and aesthetic preferences do not stand in a simple one-to-one correspondence to their drawing style, and that they favor some degree of complexity in ready-made pictures.

Preferences for Color, Detail, Proportion, and Dimensions

The question of children's relative preferences for color, detail, size and dimensions was addressed by Peter Manale (Golomb, 1983a; Manale, 1982). Almost all test items consisted of single figures (see ills. 231 *a, b*). Children, ranging in age from 4 to 11 years, were presented with pairs of drawings that pitted these variables against each other. When a detailed drawing was paired with a structurally identical but less detailed one, four-year-olds revealed lack of consistency in their individual responses, which suggests that they did not discriminate among the pairs of drawings. When only children are considered who made consistent choices, their responses indicate a clear preference for a detailed over a less-detailed drawing. This preference for detail increased consistently with age, a finding of considerable generality that applies to compositions of several figures as well as to single objects. When

Color vs. detail

Subset: House

Subset: Boy

Subset: Car

Color vs. Depth

Subset: Cake

Subset: Present

Subset: TV on Table

a.

Color vs. Proportionality

Subset: Boy, Cat, Tree

Subset: Tree, Girl, Flower

Subset: Boy, Dog, Bird

231. *Preferences for Color, Detail, Proportion, and Depth Cues*
a. Stimuli contrasting color, detail, and depth.
b. Stimuli contrasting color and proportion.

b.

detail was pitted against color, that is, when a detailed uncolored out-
line drawing was matched with a simpler but colored version, four-
year-olds chose the colored picture with the simpler design. A similar,
though somewhat attenuated, trend held for the five-year-olds. From
seven years on, detailed drawings were consistently preferred over
simpler ones, even when color was added to the less-detailed designs.

In order of significance, attention to size differences among objects
ranks next. At the four-year-old level, inconsistent responses regarding
sensitivity to the relative size of an object predominated and remained
high for the five-year-olds. If only the consistent responses are analyzed,
we note that four-year-olds mostly preferred a composition of same-size
figures, whereas five-year-olds were inclined to select groups of objects
that were more realistic in the depiction of size relations among diverse
items. This trend became dominant for the older children. However, as
with detail, when color was added to the same-size compositions, the
five-year-olds reverted to a preference for color over proportionality;
from seven years on proportionality, or attention to the relative size of
objects, wins out. Among the variables we tested, the three-dimensional
portrayal of an object attains its preferred status at a later time than de-
tail and proportionality. When two-dimensional drawings were pitted
against three-dimensional line drawings, four- and five-year olds re-
sponded with a high rate of inconsistency (that is, children were not
consistent in their individual choices over a set of drawings). When only
the consistent responses are considered (that is, responses for those
children who consistently preferred either the two- or the three-
dimensional drawings of a set), they appeared to favor the two-
dimensional representations. Inconsistent responses remained at a high
level for the seven-year-olds, although the consistent selections now fa-
vored three-dimensional portrayals, a tendency that became more
marked for the older children. Despite the trend to prefer three-dimen-
sional line drawings, inconsistent selections still comprised 25 percent
of the responses of 10- and 11-year-olds. When color was pitted against
spatial dimensions—that is, when a two-dimensional colored drawing
was paired with a three-dimensional uncolored outline drawing—seven-
year-olds preferred the two-dimensional colored one. Color maintained
its attractiveness for the 10-year-olds, who selected in equal proportion
two-dimensional colored and three-dimensional uncolored pictures.
Thus, color remained a highly potent and preferred attribute of a draw-
ing that, perhaps, short-circuited further analysis of the picture.

Overall, these findings demonstrate that the ability to discriminate
detail, proportion, and spatial dimension need not lead to stable pref-
erences, and that stability of preference does not guarantee its utiliza-
tion in the child's own drawing. This is most strikingly demonstrated
in the selection of drawings that employ three-dimensional cues. From
the age of seven years on, children who in their own artwork do not
use perspective cues and who portray their objects as flat two-
dimensional shapes, preferred the three-dimensional figures, a prefer-
ence not sustained when the three-dimensional outline figures were
pitted against two-dimensional colored ones. Although elementary-
school children tend to become more rule-oriented in their choices, as

indicated by their consistent preferences for detailed, proportional, and three-dimensional figures, color remains a potent variable that tends to take precedence on selection tasks. On the latter, multiple colors are consistently preferred over monochromatic outline drawings (Manale, 1982; Wandre-Sanel, 1982). On drawing tasks, however, form seems to take precedence over color, as 50 percent of the four-year-olds produced monochromatic drawings on specific themes such as the "Family" (Golomb, 1983a; see chapter 5).

The course of the selection principles examined in Manale's study suggests, that at first, selections are unsystematic, unstable, unreflective, and less likely to be included in the child's own drawing repertoire. However, even when a preference seems well established, as is the case with color, the data suggest that certain aspects of shape are deemed of primary importance to the child artist; he attempts to draw a theme as best he can, and this consideration often takes precedence over such responses as "color is pretty." Form elements are essential to drawing because they facilitate the translation of the child's intention into an actual representation. For example, the human with the outstretched arms—a drawing that maximizes the contrasting horizontal and vertical directions—states unambiguously that the person has arms. Although, by comparison, the child may not consider this the prettiest picture, he has successfully conveyed his message. If one compares the child's free drawings and his preferences, it appears that he is more conservative when drawing than when he makes a selection. Clearly, the understanding that is necessary for production differs from the child's enjoyment and appreciation when he inspects a set of ready-made pictures.

In summary, this study of preferences in selections documents the emergence of an ordered sequence of representational rules. At first color is singled out for attention, next detail, proportions, and finally a preference for three-dimensional over two-dimensional line drawings becomes established. Children favor good two-dimensional drawings until ages seven or eight years, at which time a new conception of distance and of the multiple sides of an object tip the balance in favor of a three-dimensional depiction. The order in which these preferences emerge is quite similar to the one we found in the development of children's drawings (see chapter 3 on differentiation). From approximately six or seven years on, and at times even earlier, children's preferences seem to be one or two steps ahead of what they do in their own drawings. This suggests that preferences are not arbitrary nor are they totally determined by externally imposed cultural norms. Children's preferences relate in a fundamental way to their artistic conceptions and practices.

Compositional Preferences

The next study examines the child's judgment of art works produced by other children, and thus of drawings that are similar to her own. Drawing on my own collection, I selected sets of children's drawings on two themes. The drawing in each set represented developmental levels

that differed in terms of figural differentiation and compositional skill. They also served as models for two sets of pictures Judy Helmund and I designed (Golomb & Helmund, 1987; Helmund, 1987) We chose this approach over spontaneously produced drawings in order to control for significant variables. When I speak about similarity between the child's own work and the drawings we presented him with, I refer to drawings the child has made somewhat earlier, is currently making, or

232. *Drawing Sets on Themes of Family, Birthday, Lake, and Village*
a–d. Each set comprises items that vary in graphic differentiation and compositional arrangement.

may make in the near future. With these sets of drawings, we set out to probe the child's conception of child art and to sample his likes and dislikes of typical examples of children's drawings.

Our participants were children enrolled in kindergarten, first, and second grades. Each child was presented with five sets of drawings, two on the theme of the Family, and one each on themes of a Birthday Party, a Boat on a Lake, and a Village (see ills. 232 *a–d*). Each set

c.

d.

233. *Scenes that Vary in Representational Complexity*

comprised four drawings that varied in terms of figural differentiation—for example, from tadpoles to fully differentiated figures drawn in side view—and in terms of compositional characteristics from free-floating figures to coherently organized groupings. The drawings are quite typical of the work of four- to 10- or 11-year-old children. The drawings of the Family and Birthday Party are based on examples selected from my collection of children's drawings. They are direct copies of child art, closely imitating the style, drawing system, figural differentiation, and compositional arrangement of the originals. The remaining two sets (Boat and Village) were designed by Judy Helmund; they exhibit similar developmental principles. Within each set, the number of items and color use was kept constant. A series of relatively open-ended questions probed the child's judgment about the age and skill of the artist, subject matter, preferences, and his own judgments of what constitutes a good picture.

Two sets of questions yielded consistent responses from all children, independent of age. Nearly all children preferred the picture drawn by the oldest child and chose it as the best picture. When asked to identify the ages of the artists and to indicate which of the drawings was most like their own work, most children overestimated the similarity of their own work to that of the preferred drawing, seemingly underestimating the difficulty in attaining the figural and compositional complexity depicted in these drawings.

The question that asked the child to indicate if there were any drawings he might dislike elicited few critical responses. Mostly, the drawings were identified by the presumed age of the artist and considered adequate for the children producing it. The work was always identified as the product of children and quite accurately identified as made by younger or older children. Although these youngsters were reluctant to criticize the drawings, their responses to the question "how pictures are alike and how they are different" indicated their ability to make competent discriminations and revealed their reliance on certain representational principles. This was the case even for the kindergarteners. The children commented on the faulty orientation of figures (for example, "they are all tippy," or "the houses are all falling down") and criticized the undifferentiated size of the family members. Apparently, size discrimination, by their standards, is important for the theme of the family, an indication that they are sensitive to compositional arrangements. Most children, independent of grade level, noticed detail in a picture and commented favorably on the most complex compositional arrangement of items that gave the clearest indication of the meaning of the event.

A difference that distinguishes the attitude of the younger from the older children appeared in the more personal self-referential associations of the kindergarteners. Typical comments in response to a question that inquired into the reason for liking a picture included such statements as: "I could make one like this," or "It reminds me of my birthday." The older children were more apt to mention "objective" criteria like detail and realism. They showed some awareness of pictorial depth cues (for example, changes in size with distance and

the role of partial occlusion) and they displayed a more critical orientation vis-à-vis the early and undifferentiated levels of representation.

In summary, even kindergarteners possess the ability to apply emerging representational standards to the work of their peers. These standards apply to the differentiation of figures, to their orientation, and to the compositional arrangement. Their approximately correct identification of the ages of the artists indicates that they are aware of the developmental aspects of the artistic endeavor and that they make allowances for the age and experience of the artist. These youngsters are quite able to "read" the subject matter, even when the compositional arrangement is quite primitive. Their ability to read primitive drawings may have been helped by the more advanced pictures in this array, which depict the same subject.

The question of compositional complexity was further examined in a study jointly conducted with Thea Wandre-Sanel (Golomb, 1983a; Wandre-Sanel,1982). We studied children's preferences by varying the drawing system in which a scene is depicted. A street scene consisting of a house, garage, car, trees, and flowers was varied from a predominantly frontal presentation that avoids overlap (see ills. 233 a) to representations that use partial occlusion (ills. 233 b), decreasing object sizes, and a single vanishing point to suggest depth (ills. 233 c). This set of three drawings was presented to children ranging in age from four to nine years. In the simplest drawing, figures were aligned in a single plane, on a horizontal base, in frontal view, without any overlap of shapes. The next drawing also aligns its figures on one baseline, but adds a second streetline and some partial occlusion of adjacent objects, which suggests such spatial relations as side-by-side, in front, and behind. The third drawing introduces multiple overlap, a single vanishing point, and objects diminishing in size, all of which foster the illusion of depth. Before the actual presentation of this set, the children were asked to draw a picture that would incorporate the above mentioned items. This enabled us to compare a child's drawing with her selection of the scene she liked best. The results are as follows. Most children whose performance on the drawing task fell below the complexity levels illustrated in our set either insisted that they liked *all* three drawings of the set, or they liked at least two out of the three equally well. Such multiple choices were typical of the four-year-olds and declined somewhat in the five-year-olds. The high incidence of multiple choices suggests that these children do not clearly differentiate between the three drawings on the same theme, and that they are inattentive to the meaning of partial occlusion and to the other pictorial depth cues. One four-year-old, when pressured to make a selection, turned to the game of "eenie, meenie, minie, mo" to determine her choice. The older children, whose own drawings corresponded to one of the first two complexity levels (see ills. 233 a or b), showed a clear preference for a drawing more complex than their own. Although none of the children used perspective cues in their drawings, the picture that displayed multiple overlap, diminishing sizes, and a single vanishing point was, from the age of six years on, frequently selected as the one best liked. Approximately 50 percent of

the six- and seven-year-olds and 69 percent of the eight- and nine-year-olds selected this drawing. We tried to assess their ability to differentiate between the three scenes and questioned the children regarding the differences they perceived. All age groups noted, quite literally, differences in the size and placement of the figures. They listed items in the following manner: "A large car, a small car, a big house, a small house, a straight road, a curved line." Only a few of the oldest children mentioned that the most complex drawing (see ills. 233 c) looked more "real." Even to such a specific question as "Why is the road of a different width?" [reference to the converging lines] only a few children answered that "things further away look smaller."

In summary, the youngest children, whose own level of graphic differentiation was inferior to the simplest level of our test drawings (see ills. 233 a), failed to make a distinctive selection. Most children whose drawings had reached the simplest level preferred drawings above their own level, a finding that also held true for those who had reached the intermediate level (ills. 233 b). Not a single child performed in his own work at the most complex level (ills. 233 c), even though from the age of six years on this picture was frequently chosen. Despite this preference for the most complex drawing, which is easily identified in a set consisting of only three drawings, few children could explain the differences in representational style. They did not refer to stylistic properties of drawings, and the absence of explanations suggests that they had a limited understanding of the pictorial devices that create the illusion of pictorial realism.

Support for this interpretation comes from a second study, in which Kate Sullivan and I extended our series by adding two drawings of very simple design to our set of street scenes. In this set, the simplest drawing ignores the relative size and proportion of the objects; they are drawn in uniform size, in frontal view, and side-by-side alignment. The next drawing in this series also adheres to a strictly frontal view of the objects but differentiates size in the manner depicted in ills. 233 a. Altogether, the new set comprises five drawings, beginning with the simplest depiction of the theme and ending with the perspective drawing. Children ranging in age from six to nine years were asked to select the most- and the least-liked drawing of this set. The unsystematic selections made by the six-year-olds reveal little awareness of the differences between drawing systems. Although 50 percent favored the perspective drawing, 30 percent identified the same drawing as the least-liked one! A similar result was obtained on an indoors theme, also comprising five different representational levels. The preferences of the six-year-olds tend to be based on personal associations reminiscent of what Michael Parsons (1987) describes as "favoritism"—for example, "This one is the most black, and black is a good color," "They are too close together" or "Too far apart," "I don't like cobblestones, too hard to ride my bike," and "I like the cat next to the couch [indoors scene], can reach for the cat." More consistent preferences emerged among the seven-year-olds, who chose as their best-liked picture the drawing that employed partial occlusion, size

and form differentiation, and some grouping of items (ills. 233 *b*), a result that closely mirrored the findings for the indoors scene. Such drawings are based on the object's true shape rather than on its perspective deformation, and they avoid extremes in the depiction of size. They employ principles that enhance the elementary readability of the composition and render a pictorial statement that appeals to the seven-year-olds. From eight years on, a clear-cut preference emerges for perspective drawings. Some children now state that these drawings look more "real," more "natural," ("it looks like it is popping out," "like one is farther away and smaller") that they show an artist who is "highly skilled," and that they like diagonal streets. Unlike the children in the previous study, these youngsters, who have had more exposure to art, have become discerning observers of pictures and are aware of the information that a drawing in perspective can convey. One might say that these children have attained some degree of pictorial literacy in Western styles of representational art.

These data once again confirm our previous findings; namely, that the child's criteria for drawing versus for making a selection among ready-made pictures differ significantly, a finding also reported by Hilda Lewis (1963). Although selections require less command over the medium, little or no planning strategy, and only an intuitive and undifferentiated understanding of the spatial relations, they predict in a general way the direction the child will pursue in his evolving attitude toward pictorial representation.

Children's Attitudes Toward Their Own Work

In the next study, Judy Helmund and I (Golomb & Helmund 1987; Helmund 1987) examined kindergarteners' spontaneously produced artwork with paints, brushes, magic markers, pencils, and crayons. One of our major goals was to elicit the child's comments on his own work and to facilitate the articulation of his implicit assumptions about media and art.

Our participants were observed in their classroom, during the hour in which they had free access to a variety of materials. The study was conducted in three phases. First, the child's spontaneous choice of medium (paint and brushes versus pencils, markers, chalk, or crayons) was noted. Next, the child was asked to produce a work in the missing mode, either working with paints or crayons/markers. Thus, for each child we collected a set of drawings and paintings that used at least two different sorts of implements. During both phases, we took notes on the child's behavior and verbalizations. Finally, each child was seen individually, and an inquiry was conducted that probed his thoughts and feelings about the activity, the medium, and the mode of representation.

The great majority of these kindergarteners created nonrepresentational work with paints and brushes and representational drawings with markers and crayons. Our inquiry reveals that for these children,

painting was the most attractive and enthusiastically produced activity. Regardless of the medium used, children usually expressed satisfaction with their work. Their actions and comments indicate that each medium served a different purpose; crayons and markers for making something "real," paints and brushes for creating colorfield mixtures. The idea of changing something in their work seemed quite foreign to these children, and most showed surprise when questioned about such a possibility. In response to the question, "Is there anything you could do to make it better?" only a few children suggested that they could add something to a representational drawing or fix a drippy area in their painting. Similar results were obtained by Kate Sullivan with six- and-seven-year-olds who stated, almost unanimously, that even if they disliked something they would not make changes in their drawings. When pictorial techniques are better understood, the child also contemplates revising his drawings. Usually, it is at this point in his development that he can consider how his work may appear to a nonprivileged outsider (see also Korzenik, 1972).

The marked disinclination of the younger child to revise her drawings or paintings should not only be viewed in terms of her cognitive egocentricity. Unlike the ease with which children change roles in symbolic or dramatic play, a fluidity that might be viewed as whimsical and even a sign of immaturity, a drawing can be seen as a record of one's creative efforts, and thus of more enduring value. There is merit to the relative permanence of the child's drawing style in that it can be understood and personally affirmed. Young children tend to repeat the graphic schemas that have proven successful and satisfying and to perfect them in the process.

Answers to the question of what the child liked about his work provide an insight into his distinctive orientation toward paints and markers. Markers were liked because they could make things that looked "real," which was the purpose of a drawing. Children's comments about the good shapes they could make with markers, shapes that looked "real," indicate that the term "real" or "realistic" refers mostly to a detailed and differentiated rather than perspective drawing. Paints were chosen because they were "smooth" or "slippery" or "all mixy"; children's behavior, both verbal and nonverbal, indicated a sensuous pleasure in the use of paint and its properties. Pencils, markers, and crayons were enjoyed because they made "good, fast and tight lines" or "they went where I wanted a line." These comments give but a glimpse of the child's enthusiastic involvement with art-making, an engagement both spontaneous and sincere.

Overall, the responses made either spontaneously or to our questions indicate that these kindergarteners differentiated between the media and the uses to which they could or should be put. Their criteria for making representational and abstract works varied sharply, and their appreciation of the different implements was quite distinct, depending on what one could do with each one of them. There was evident pleasure in the control of pencil and marker, with special attention paid to the function of line, namely, that it can be jaggedy,

smooth or curvy, fast and tight. In the case of painting, the pleasure was of a more sensuous nature and in the spirit of an adventure.

Taken together, the results indicate that these kindergarteners showed sensitivity to some of the properties of the medium, a sensuous and perception-based response suggestive of other than purely cognitive-symbolic variables. Evidently, their pleasure in the colors and shapes they produce is not totally dependent on representing or denoting an object. They derived very different sorts of satisfaction from their representational and nonrepresentational work, and their preferences depended on what they wished to do with the media.

The Child's Conception of the Arts

So far I have focused on children's preferences and judgments regarding their own work and that of other children. But what is their understanding of "pictures" and of the relationship between the artist, the artwork, and the viewer?

Children's conception of "art" and of what qualifies as a "picture" is to a large extent culture-bound, depending on the availability of images on a two-dimensional surface such as paper, bark, walls, slate, canvas, clothing, pottery, and, of course, the TV screen. Studies that examine English children's conception of pictures in a society where pictures are abundant suggest that preschoolers hold a very broad, somewhat undifferentiated view of pictures that includes numbers, letters, words, abstract designs, and nonsense figures. Children seem to apply a rule of intentionality: it is a picture if it has been intentionally created. However, the dual nature of pictures as a thing in itself and as representing a referent may present a difficulty for some children up to the age of four years, and their apparent facility with pictures may perhaps mask a conceptual misunderstanding about them (Nye, Thomas & Robinson, 1995).

Between the ages of six and eight years, recognizable subject matter constrains the earlier broad classification, and by the age of 10 years the subject matter of a picture needs to be recognizable and meaningful (Thomas, Nye & Robinson, 1994; Thomas, Nye, Rowley & Robinson, 2001). Thus, for example, a nonsense picture composed of two incompatible parts, even though recognizable, no longer qualifies as a picture.

The child's emerging understanding of the nature of pictures or paintings has recently been linked to his or her evolving theory of mind (that is, an understanding of mental processes in self and others). Norman Freeman proposes to view the child's growing mental resources for becoming an art critic within this theoretical framework (1995). Thus, the acquisition of an *intentional theory of pictures* is closely associated with the child's emergent theory of mind as it applies to pictures. In the process of constructing his theory of mind, the child comes to see that pictures communicate the artist's thoughts to the beholder (the audience), thoughts that refer to an aspect of the real or imagined world. Between the ages of five to seven years there

is a beginning shift in the child's approach to mental events with an emerging view of the mind as an interpretive organ. From assuming that a happy artist paints a happy picture, that beauty is an objective attribute of an object and that a beautiful object will yield a beautiful picture (see Parsons' stage one and two of cognitive-aesthetic development), there is a dawning awareness that a happy artist can create a sad portrait, and that beauty is related to the artist's skill level and to the viewer's feelings. Between the ages of 7 and 11 children also show an awareness of the viewer's contribution to her judgment of a picture, and that this interpretation depends on her knowledge and personal inclinations. It is indeed a long route from the novice's approach to pictures to the sophisticated understanding of art as a socio historical phenomenon that provides a social commentary.

Applying an adult conception of the arts to the work of children may come at the risk of misinterpreting their intentions and underestimating their competence. In the framework of "the child's theory of mind," psychologists tend to assign representational status only to those mental activities that can be verbally articulated and that explicitly refer to the thoughts and intentions of the protagonist. A child who cannot explain the relationship that exists between the mental state of the artist, the viewer (audience), and the real world is seen as deficient in his or her understanding of the nature of a picture or drawing (Freeman, 1995; Thomas et al., 2001; see also Reith's account that relates theory of mind to Piaget's cognitive operations, 1997). In many domains of mental activity, the distinction between explicit and implicit knowledge signals different levels of understanding with verbally stated explicit knowledge reflecting a higher order of conceptual reasoning. However, in the domain of the visual arts, the verbal articulation of young talented children, autistic savants, and retarded adult artists called on to explain the intent and meaning of their artwork often falls short of the level of their graphic articulation, which appears also to be the case for some normal adult artists. Not all artistic activities lend themselves equally well to verbal articulation; this, however, needs not signal a lack of intelligent-representational understanding. The child who draws his mother as a tadpole figure with earrings does not mistake this portrait for a crippled or disfigured mommy, even though he cannot articulate his theory of pictures; namely, that the artist has the freedom to select simple lines and forms to stand for the intended object. The child may say, "This is the best I can or will do," at the same time that she lists additional features of the figure that are not graphically represented.

Acknowledging the child's surprising representational understanding of the nature of image-making is not to deny that there is a genuine development in the understanding of the arts and that this development is real, extensive, and prolonged (Parsons, 1987). With cognitive development comes a potentially deeper understanding of the cultural heritage in the arts, an appreciation of tradition and innovation, a more sophisticated understanding of the complex relations that exist between the picture (his own or that of another artist), the viewer or beholder, and the object or scene that inspired the drawing,

and that all three stand in a dynamic relation in which the viewer constructs and reconstructs the artist's intentions and evaluates the outcome.

Summary

The data from the different domains I have surveyed demonstrate that the child's own drawings are not a simple predictor of her completion or selection. Taken together, the different tasks of drawing and of preferences when she judges the work of others provide a more comprehensive view of the child's understanding of the pictorial medium. The finding that her preferences do not coincide with her own drawings indicate that the tasks are indeed very different ones. Detail and the use of color appeal greatly to the preschool and elementary-school child. Although he cannot yet master the former in his own productions without risking the clarity of the presentation, he is challenged by complex pictures that provide more information than he can convey. Likewise, although color by itself cannot serve the communicative goal that the drawing child sets himself, and at first serves only a subsidiary function in his drawings, it seems to have an immediate appeal to the child. Drawing best exemplifies the child's understanding of graphic relations when he is called upon to articulate that knowledge in the most compelling and visually meaningful way he can muster. In this sense, drawing is privileged and presents an accomplishment that far exceeds whatever he might do on completion and selection tasks or when called upon to explain his theory of pictures. However, the child is challenged by what is beyond his own productive efforts and, much like the ordinary unschooled adult, is able to enjoy complexities that are as yet beyond his creative powers.

The child's preferences for pictures, although not identical with his productions, are to some extent prophetic and point to the order in which his own work is most likely to progress. There is an overall synchrony between the order in which the child attends to form, proportion, and dimension in his own drawings, and the sequence in which preferences become differentiated and begin to determine the child's judgments. In his pictorial preferences, the child is one or two steps ahead of his own drawing achievements, suggesting an intimate link between production and aesthetic judgments.

10

Reflections on Cultural Variables

Since the "discovery" of child art in the late nineteenth century, many educators, artists, and art historians have pondered the presumed similarity between children's drawings and so-called primitive art. In their quest for innovation, the modern artists of the early 20th century turned to child art as an original and unspoiled pictorial language that inspired their experimentation with the simplification of unmodeled forms, the flatness of pictorial space, and the use of primary colors (Fineberg, 1997; Goldwater, 1986; Golomb, 2002). Comparisons of the artwork of preliterate societies and child art seemed to suggest that both are products of an early, cognitively naive but authentic stage in human development. In the domain of psychology, the notion of drawings as culture-free products of the child's mind, a conception that is quite compatible with this view of primitive art, motivated Florence Goodenough to construct her well-known Draw-a-Man test (1926).

Most students of child art have focused on certain uniform stylistic features that characterize children's drawings across different historical periods (Andersen, 1961–1962; Arnheim, 1974; Britsch, 1926; Cizek, 1936; Freeman, 1980; Goodenough, 1926; Kellogg, 1969; Lowenfeld, 1939; Lowenfeld & Lambert-Brittain, 1970; Luquet, 1927; Piaget, 1928; Piaget & Inhelder, 1956; Schaefer-Simmern, 1948; Viiola, 1936). Although their views of the determinants that underlie drawing development differ in major ways, they share, in broad outlines, the conception of a relatively invariant succession of stages or phases. The most articulate spokesman for a position that stresses the internal logic of representational development as a meaningful problem-solving mental activity has been Rudolf Arnheim. As the previous chapters have indicated, his approach to child art embodies a universalist orientation to developmental phenomena and looks for general principles that cut across time and space. In its search for general principles that underlie the artistic process, this approach is quite compatible with Noam Chomsky's linguistic theory (1957) and James Gibson's stress on perceptual invariants (1966, 1979).

At the other end of the spectrum, we find the notion that artforms are social conventions, arbitrary signs that do not stand in any compelling relationship either to the subject of the drawing, that is, to the phenomenal object, or to the organizational principles underlying human perception. The most extreme position in this camp is that of the philosopher Nelson Goodman (1968, 1978), and a somewhat modified version can be found in the writings of Brent and Marjory Wilson (1977, 1982a, 1982b, 1984, 1985). Because the Wilsons have become outspoken proponents for a developmental version of cultural relativism in art, their position deserves closer analysis.

Unlike Arnheim's representational theory, which stresses the artist's search for equivalences of form that will do justice to the object, the Wilsons maintain that a drawing is merely composed of configurational signs. In their view, when drawing, children are not concerned with the observation of objects in the real world; they learn to make signs by observing others at work and by studying the graphic models available in the culture. The graphic language of art, like the verbal one, consists of artificial signs that are mere convention. No intrinsic link exists between such a sign and the appearance of the object. A drawing of a cloud, for example, does not represent a cloud any more than the word *cloud*, and learning to draw configurational signs is similar to learning verbal signs. However, unlike the highly structured verbal syntax, graphic signs are loosely structured and permit many alterations. The Wilsons reject the notion of an autonomously guided development in the arts and view imitation of existing models as the major vehicle for the acquisition of graphic skills. They issue a radical challenge to theories that stress organismic variables and conceive of artistic growth in terms of self-directed processes.

This account of graphic development is tempered by an appeal to "innate" factors, which makes for an uneasy relationship between the concepts of cultural relativism and nativism, a position that is not quite consistent within itself. The Wilsons distinguish between the early childhood years, approximately up to ages seven or eight, and the later ones. In the early years, so-called innate factors determine such graphic tendencies as, for example, a preference for simple forms, for right-angular relations, and the avoidance of overlap. From the middle childhood years on, children attempt to overcome these innate "biases" by imitating the popular graphic models. The Wilsons point to Japanese comic books, avidly read by Japanese of all ages, which are visual narratives that tell a story over 30 or more frames and use words sparingly. They provide a powerful graphic model for Japanese children and are seen as the major source for their highly advanced childhood drawings. With this division into early and later developmental periods, the Wilsons seem to acknowledge certain robust tendencies in the art-making of children that are not easily explained in terms of imitation of cultural prototypes. They point, however, to very early social and cultural influences that affect even the drawings of three- and four-year-olds, and perhaps even younger ones (Wilson & Wilson, 1982a).

The question of cultural variability and of developmental malleability is, of course, not merely of academic interest but has educational implications. Depending on one's conception of artistic development and of the course that facilitates its growth, one might design different educational opportunities and strategies of intervention. No one can deny the importance of the sociocultural environment, its impact on the creation of pervasive styles, and the shaping of artistic taste. There is widespread acceptance of the view that art-making is a uniquely human phenomenon that serves a vital communal function. However, depending on one's theoretical orientation, different sets of questions will be addressed. If one considers drawing as a naturally evolving language, one inquires into the impact of the culture in terms of "when," "where," and "how." If, however, drawing systems are seen as the product of cultural conventions, one must ask whether the impact of cultural models transmitted by peers, siblings, and picture book illustrations can adequately account for the cross-cultural regularities that seem to characterize drawing development.

At a more fundamental level of analysis, we are considering whether representational development can best be described in qualitative terms, as a stagelike progression, in which case it is seen as an orderly, meaningful, and relatively self-guided process. In this view, children generate rule systems that reflect their understanding of the medium and guide the actual process of graphic representation. Such a view of a universal language of art, at least in early phases of development, can be contrasted with the notion that all forms of drawings, including the early ones, are the products of cultural influences. In the latter case, the early drawings reflect, perhaps unsuccessfully, the pictorial models available to the child and are the product of imitation and training. Such a conception has no place for stagelike constraints, and no specific sequence can be predicted.

In the previous chapters, I have presented detailed evidence to support my view of the origins and course of graphic differentiation. Most of the data, however, were collected in Western-style societies. To assess the influence of cultural variables, we need to extend the scope of our inquiry and examine cross-cultural studies that may shed light on the question of universals in graphic development. This is by no means a simple enterprise. Considering the wide individual variability in drawing skills documented so far, it is important to keep in mind a distinction made earlier between competence and performance. Variability in performance does not preclude the existence of a universal rule system. At every phase in development, performance can and does vary, and an informed search for universal tendencies in the way the human mind organizes graphic images has to be based on broadly conceived invariances and equivalences rather than on a literal reading of differences and identities. In this context it is also helpful to draw attention to John Flavell and Jack Wohlwill's (1969) distinction between strong and weak sequential invariance, which Pierre Dasen (1981) extends by analogy to "strong" and "weak" universals. A sequence is strongly invariant if it is universally present,

that is, present in all individuals of the species, and appears in a universally fixed temporal order in the childhood of undamaged human beings. A sequence is only weakly invariant if, when present, it appears in the universally fixed order (see also Feldman, 1980). The formulation of a weak universal in conjunction with the concept of representational equivalents will guide our review of studies of children's drawings collected in diverse cultural settings.

In the following section, I shall review cross-cultural studies conducted in the Goodenough tradition of human figure drawings, and report on the drawings of both preliterate and school children in non-Western societies.

Studies in the Goodenough Tradition

Since its publication in 1926, the Goodenough Draw-a-Man test has become a widely used screening device for the quick assessment of a child's cognitive level. The test was originally standardized on an American sample and documents a developmental progression in the drawn human figure. During the period from 5 to 10 years, drawings become increasingly detailed and realistic in their proportions, and improvements can be noted in the quality of line, shape, and overall organization of the figure.

To determine whether Goodenough's test is indeed a culture-free instrument of cognitive development, investigators have collected drawings from different regions of the world and compared the results for non-Western societies with those obtained by Goodenough's American sample. Overall, the results have not borne out Goodenough's hope for a universally valid, culture-free instrument of cognitive assessment. Findings vary significantly across cultures, even for children attending Western-type schools (Anastasi & Foley, 1936; Harris, 1963). In some cultures, drawings of the human figure attain IQ scores that are far in excess of Goodenough's norms, whereas in others scores are significantly lower. An example of the former is reported by Robert Havighurst, Minna Gunther, and Inez Pratt (1946), who found that 6-to-11-year-old American Indian children performed on the Draw-a-Man test at significantly higher levels than their white counterparts, with the drawings of boys surpassing those of girls. The opposite finding is reported by Wayne Dennis (1957) who studied human figure drawings of 5-to-10-year-old Near Eastern children. His participants were school children from Port Said in Egypt, and Sidon and Beirut in Lebanon. With only one exception, Dennis found a significant decline in IQ scores with age. Although scores at ages five and six years were comparable to those obtained from Western samples, they declined thereafter. This was also the case for children enrolled in a private Armenian school in Beirut where, apparently, little emphasis was placed on drawing and graphic illustrations were rarely used for instruction. Only in the school associated with the University of Beirut were students exposed to graphic materials comparable to

REFLECTIONS ON CULTURAL VARIABLES

those used in the West. This was also the only school where the Goodenough scores did not decline. A study of Nepalese children conducted by N. Sundberg and T. Ballinger (1968) replicates Dennis' finding of declining IQ scores from age seven years on. That the Goodenough test does not predict functional intelligence in non-Western groups can be seen in a study of the drawings of illiterate Bedouin children, adolescents, and adults living in a remote region in Syria. On the basis of their drawings, these normally functioning individuals received a mean IQ score of 55, which would place them in the retarded range (Dennis, 1960). Clearly, the norms of realism on which Goodenough's scale is based, and the notion that the development of human figure drawing naturally tends toward a realistic endpoint, are not supported by these and other studies (Anastasi & Foley, 1936, 1938). Goodenough's elementaristic conception and her method of quantification seem to be of limited use in addressing the question of cross-cultural variability and universals.

If one adopts a more qualitative approach to drawing and conceives of image-making as a representational process, different kinds of questions and data can be considered. From the outset, however, we have to acknowledge that a "pure" test of the culture versus universal grammar hypotheses cannot be made. Very few communities are preliterate in the sense of not having any contact with sources of images prevalent in the major cultural centers, whether East or West, and most have representational or ornamental traditions into which children are initiated. Even in the case of preliterate societies, the anthropologist who offers paper and pencil and requests a drawing introduces factors that affect the drawing outcome in ways that are difficult to specify. Once children attend schools, pictorial models and teachers' standards will exert their influence on children's drawings. Because we can't engage in experiments patterned on the Julia Hochberg and Victoria Brooks (1962) model, in which a child was raised for the first 18 months of his life in an artifically controlled environment devoid of pictorial materials, an absolute answer to the culture versus universal grammar kind of question cannot be given. What one can do is more limited in scope, namely, to compare the drawings of relatively naive, preliterate children with those produced in literate societies of varied graphic heritage.

Drawings of Children in Preliterate Societies

An often-quoted study in the controversy over the relative importance of cultural factors is the report of G. W. Paget (1932), who examined some 60,000 drawings, mostly of children. These drawings were collected by his correspondents throughout the non-Western world. No doubt, with so many investigators involved in the collection of the data, no strict controls could be exerted over the conditions under which the drawings were made. With this reservation in mind, let us consider the results for two of the requested four items, the drawings of a man and a woman. The artists ranged in age from 5 to 34 years.

Two findings strike me in particular: the great variability in the graphic models illustrated by Paget, and his identification of styles that appeared to be characteristic of certain ethnic groups of children (see ills. 234).

Among the most interesting examples provided by Paget are illustrations of drawings obtained in a single session that document how quickly experimentation with lines and shapes can lead to a fully representational figure. The child's problem-solving approach to drawing

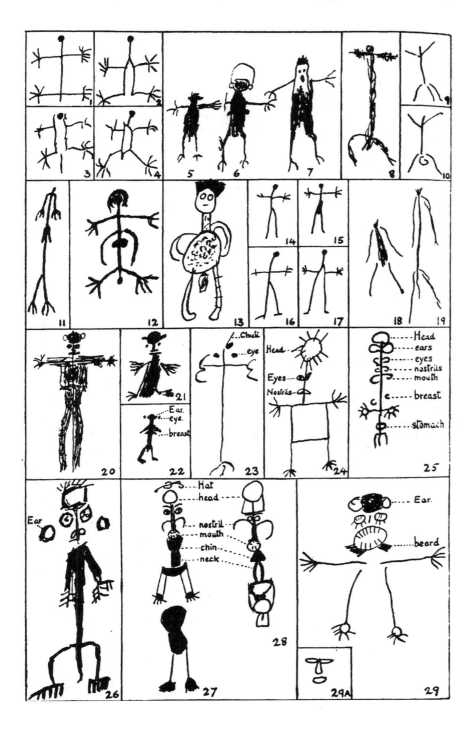

234. *Human Figure Drawings from Diverse Cross-Cultural Sources*
From the collection of G. W. Paget, *Journal of the Royal Anthropological Institute*, 1932. Reprinted with permission.

that Paget notes is similar to what I have observed in my own work (see chapters 2 and 3). He reports, for example, on the drawings of a seven-year-old Rhodesian girl whose explorations over a few trials led from a simple stick figure to one with a two-dimensional trunk. On the basis of his vast collection he notes that the outline figures of four- and five-year-olds are always tadpoles, that is, trunkless figures, whereas their stick figures include the torso, an impression enhanced by the genitals drawn between the legs. According to Paget, the legs of the tadpoles serve the double function of depicting legs as well as the sides of the body. He takes issue with those who consider drawings of contourless facial features indicative of a cognitive deficit. According to one of his correspondents, such a drawing was obtained from the brightest child this investigator had come across, and thus could not be taken as a sign of cognitive deficiency! Among the different graphic models in Paget's collection are contourless faces, as well as features drawn outside a contour in the outer space of what appears to him as a "cavity." He also comments on the large number of profile faces relative to the incidence for European children, a finding particularly common among New Zealand's Maori tribes. Despite the high incidence of profile drawings among Maori children, the mixed or two-eyed profile was not often seen. Although in general head size is exaggerated, he found a few exceptional cases in five or six of his 200 collections. In these cases, all from Africa, heads are reduced to pinpoint size and bodies are elongated. Paget also comments on the universal difficulty children have when they portray arms, a graphic problem that yields the spread-eagled arms drawn at right angles to the body, arms inserted in the back, or extended from the chest.

Observing both the diversity of naive children's drawing style as well as stylistic regularities, Paget was puzzled by what he terms "local conventions" that appear among groups of children living in widely separated regions. In West Africa, for example, children tend to use a triangle to depict the trunk, a form that, though it appears frequently in the ornamental designs made by adults, does not represent their elders' convention for the human body. Another example of a common graphic convention found in black children living in such diverse regions as West Africa, British Guiana, and Jamaica can be seen in the drawing of noses. Paget refers to a unique pattern that depicts nose and eyebrows with a continuous line resembling the shape of the letter "W." A similar finding, but for Nepalese children, was reported by Sundberg and Ballinger (1968). What are the likely sources for these graphic conventions? According to Paget, whereas imitation of an adult model may occur, it is the exception rather than the rule. He holds that graphic symbols are either spontaneously invented by the child or learned from the practices of the peer group. Concerning the wide variety of graphic symbols children use for the human body, he considers all of them as problem-solving efforts that successfully represent their object. Paget thus holds to a two-factor theory: he stresses the invention of representally equivalent forms, and he also considers the possibility that local child art traditions are transmitted

from one generation of children to the next one, independently of adult models.

Paget's illustrations demonstrate the diversity of graphic models that can be found among preliterate children: stick figures; pin-heads; contourless heads and bodies; detached parts aligned vertically; square, oval, and scribble trunks; hourglass triangular trunks; and concave featureless profiles (see ills. 234). Examining this array of graphic models, my overall impression is that these models are the typical examples of child art that I discussed at length in the previous chapters. The diversity of models can be assumed to be generated by the same underlying graphic logic. No single model truly represents child art at a particular developmental phase. Rather, within a certain structural range, graphic solutions are tried out and models are perfected, transformed, or discarded. In spite of what one could call the phenotypical variety of the actual specimens, the constraints on early child art, with which we have become familiar, find full expression in these examples, which attest to basic structural principles that underlie the visual logic of graphic development. Likewise, the child's daily experiences, which are embedded in a sociocultural context, also find expression in the child's drawings. For example, the depiction of penis, vulva, and breasts in African children's drawings reflect their direct perception of the sexual organs that differentiate between the status of a male and a female and define their role in society. In these drawings, sexual organs are as revealing of basic cultural influences as is their omission in the child art of Western children.

Unlike Paget's data, which were collected by multiple individuals from diverse settings, Meyer Fortes provides us with drawings of Tallensi children that he and his wife collected during the years 1934 to 1937 (Fortes, 1940, 1981). In collaboration with his wife, Fortes studied children and adolescents who had never drawn with paper and pencils. The youngsters were 12 illiterate bush children from Northern Ghana, ages 6 to 16 years. Fortes describes his procedure as follows: he invited the youngsters to his house, sat down in their midst, and, using a colored pencil, drew an animal on a sheet of paper. Next he offered a pencil to one of the older boys, a 12-year-old, who produced small shapes consisting of open and closed lines and distributed them all over the paper. The other children followed suit, making similar scribbles. During the first session, one of the boys produced a stick figure that became the standard configuration for most of the children (see ills. 235). Most commonly, the stick figure was placed vertically, in the middle of the page, while scribbles filled in the rest of the paper. Male figures were drawn with a penis, women with breasts. On the second day, the youngsters continued to fill the whole paper space with scribbles, interspersing them with human and animal stick figures. The propensity to fill the whole page persisted. While most figures were spindly matchstick models with pinheads, variations of this model consisted in the form of a filled-in body, a thickening of the lines to represent its volume. When adults were given paper and pencil, they too used the same graphic model

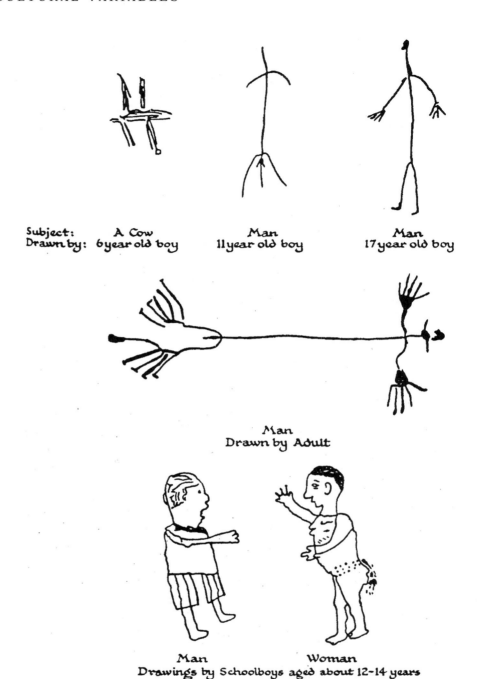

235. *Fortes' Drawings by Unschooled and Schooled Tallensi Children and Adults. Africa, 1940.*
Reprinted with permission.

developed by the children with the addition of radial hands and feet. Essentially, the same graphic model was used by both children and adults whose culture, according to Fortes, was completely devoid of representational graphic art.

Interestingly, the graphic model of the Tallensi children from Ghana was unlike their three-dimensional clay figures of people and animals, which were made spontaneously and figured prominently in their games. In contrast to their drawings, these sculptures were quite realistic in shape and proportion. A similar finding has been reported

by Sven and Ingrid Andersson on the drawings and sculptures of illiterate Namibian adolescents (Andersson & Andersson, 1997; Golomb, 2002).

Fortes compared the stick figures produced by the illiterate bush children with drawings solicited from school children, boarders at a middle school who came from the same tribe. Their drawing style followed the conventions typical of younger Western children. Several decades later, in 1970, Fortes once again collected drawings from Tallensi school children who were enrolled in a local primary school. Their figures were two-dimensional profile drawings, in the style of what Fortes describes as the Western graphic tradition. The three groups of Tallensi children differed also in their use of color. The bush children picked colors randomly, and the boarders chose colors according to a set of personal preferences, whereas the last group chose colors in a more conventional manner, adhering more closely to the object's true characteristics.

Fortes interprets his findings in terms that stress drawing as a culture-dependent convention, a view shared by Jan Deregowsky (1978). If, however, we take note of the fact that the stick figure is a model young Western children invent spontaneously, both in two- and three-dimensional media, then the notion of the stick figure as merely an arbitrary convention, passed on via cultural models, is no longer tenable. In cultures where children have ample access to paper and pencils and where they can experiment at length, this stick figure model is usually transformed into a two-dimensional representation until it reappears, at a later time, as an abbreviated formula that is useful for narrative accounts. The fact that children as well as Tallensi adults used the same graphic model suggests that it is an easily recognized and meaningful figure for which there is general approval. Such drawings are found in many different times, places, and cultures; they are, for example, quite similar to mesolithic rock paintings of battle scenes in Castellon, Spain, to rock carvings found on the islands of Hawaii and in the Camunian valley of Northern Italy, and they are akin to a more recently produced first drawing of a five-year-old child from the island of Ponape in Micronesia (Alland, 1983, p. 86).

The appearance of the stick figure among widely diverse cultural groupings indicates that it is not an arbitrary graphic convention, but ought to be seen as one of a number of early representational equivalencies for the human figure. No doubt cultural factors codetermine whether such a graphic model can serve a communicative function, whether it continues to be used in its original form or undergoes a radical transformation. Examples from preliterate Bedouins in the Sinai peninsula demonstrate how a general representational model that emerges spontaneously can be modified to capture the child's unique experiences. When children were provided with paper and pencils, a first in their lives, five- and six-year-olds progressed in a single session from scribbles to a radial shape, followed by a human with an oval trunk (M. Haas, April 9, 1978). Once this generic model of a human had evolved and children tried to capture the characteristic appearance of people in their tribe, they tended to draw the female

figure in a triangular shape whose contour, with the exception of a slit in the top part for the eyes, was filled in. Such drawings represent the traditional garb of Moslem women who expose neither bodies nor faces to the eyes of strangers. Perhaps, the emerging dominance of triangular shapes in this group of children is multidetermined and conceivably relates also to the mountain ridges that are prominent in this region and to the centrality of the camel with its triangular hump. Such findings are quite compatible with Dennis' (1960) report on the drawings of illiterate Syrian Bedouins. In their human figure drawings, they often omit the facial features, shade the facial area, or draw it very small, a rare occurrence among American children.

The interaction between what we might term organismic factors and the sociocultural environment finds further documentation in the work of Elsbeth Court and the Anderssons.

Court has done extensive research on the development of drawing in Kenyan children and documented both the general forms this development takes and some of the quite specific characteristics of the cultures she has studied. In an early study (1982) she reports on preliterate Kenyan children and adults who produced on first trials, and within the same drawing, circles and zigzag patterns that developed into simple humans, cows, and houses. The familiar drawing patterns evolved very quickly, without prior experience with paper and pencil. In a later study that specifically addressed the impact of the sociocultural milieu, Court examined the drawings of Kenyan schoolchildren from three different rural cultures: the Kamba, Luo, and Samburu. These communities have distinct traditions in the visual arts, but none include drawing on paper. The participants in this study were 699 school attending children, ages 6 to 18 years, most of whom are the first in their families to attend school. Since 1985, drawing is a required subject that is taught in all grades, and teacher certification requires some competence in this field. The drawing tasks were group administered and included the following topics: Cow, Person, House; Myself Eating; a Table with Some Items; Free Choice of Drawing. Court focuses her preliminary report (1989) on two major findings: the role of the person (self) in relation to others, and the drawing of tables. On the first task, the Cow, Person, House drawing, animals and houses are prominently displayed, whereas humans are either absent or play a subordinate role, a finding that seems also to characterize the Free Choice drawing. On the latter assignment only 25 percent of the Luo and Samburu children depicted humans; the Luo who are fishermen emphasized boats and the Samburu who are herdsmen drew animals. The majority of the Kamba, who come from a farming community, drew people within a social setting, which was the case for all the children on the Myself Eating theme, where they drew themselves in the company of others seated at a table. Court remarks that the table symbolizes progress and wealth and does not always indicate the drawer's personal experience. The dwellings of the Samburu, for example, are too small to house a table, but their children depicted themselves eating seated at a table. Of equal interest is the

high percentage of tables drawn in inverted or divergent perspective in which lines diverge instead of receding and converging in the background. In all grades, with the exception of the first grade, approximately 20 percent of the tables were drawn in this format, which increased with school experience. This formula for tables is widespread in East Africa; it is regularly seen on chalkboards and word charts, and also in the depiction of buildings. It also functions as a test on teachers' exams. This projective drawing system, which does not correspond to a particular "view" and does not aim for photographic realism, provides a satisfying solution to the problem of displaying items on a table surface, and its model is transmitted as a culturally acceptable representation.

In a recent attempt to broaden the cross-cultural investigation of representational development, Sven and Ingrid Andersson (1997) requested drawings as well as sculptures from children and adolescents living in a remote area of Northern Namibia near Ruacana and the Epupa Falls at the Kunene River (Golomb, 2002). The youngsters, members of the Himba tribe, did not attend school, and had no previous access to paper and pencils. In a video that documents the actions of their subjects, we note that the young women wear their hair in an elaborate and highly ornamental style and adorn their neck and bare-breasted chest with decorative pendants and necklaces and their wrists with bracelets, evidence of a developed aesthetic sense. The video captures the behavior of the first group of subjects, comprised of eight youngsters, and documents the somewhat gingerly held pencil movements that leave a light imprint as the pencil creates small circles, wavelike patterns, and S shapes dispersed over the page, interspersed with single vertically placed lines with two sets of shorter lines drawn perpendicular to the vertical. Patiently and slowly the page fills up with these marks as well as shapes that might resemble a stick figure, a tree, or a flower, all composed of line and circle. Once the page is filled, Sven Andersson, with the help of an interpreter, queries the drawer on the meaning of the figures and their parts. Slowly and hesitatingly, the answers include cow, rat, flower, goat. As children and adolescents gather around the table, the next person, a male, begins his explorations with paper and pencil. Stick figures emerge that are later identified as man, crocodile, donkey, snake, and elephant. The figures are drawn in an inverted orientation to the drawer. Next, in response to Andersson's request that he draw himself, he begins with an elongated oblong shape (body), adds one-dimensional arms and legs, and finally a head with two eyes. A two-dimensional drawing of an animal's head and body with one-dimensional legs comes next, followed by a two-dimensional homestead, lizard, and crocodile, all drawn in an inverted orientation to the drawer's position. Others take their turn with paper and pencil, creating stick figures; tadpoles; open-trunk figures; two-dimensional closed-trunk figures with or without arms; circular enclosures for house and animal shed; and even a head drawn in profile. Most participants draw with intense concentration, taking their time as they

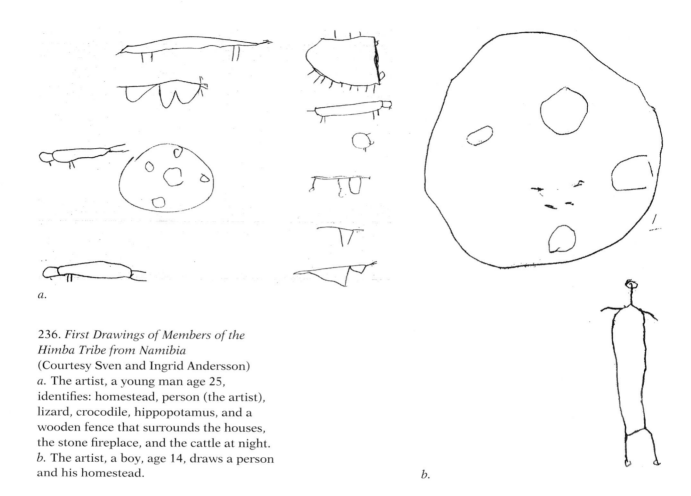

a.

236. *First Drawings of Members of the*
Himba Tribe from Namibia
(Courtesy Sven and Ingrid Andersson)
a. The artist, a young man age 25,
identifies: homestead, person (the artist),
lizard, crocodile, hippopotamus, and a
wooden fence that surrounds the houses,
the stone fireplace, and the cattle at night.
b. The artist, a boy, age 14, draws a person
and his homestead.

b.

create the simple variants of the basic human and animal figures we
have come across in children's drawings as well as in the drawings of
other preliterate societies (see ills. 236 *a, b*).

The findings reviewed so far on the graphic development of un-
schooled, preliterate children point to a rather limited range of basic
representational models that fall within the child art style. Where de-
velopmental progressions can be observed, either in a single session
or over a period of several trials, it follows in broad outlines the gen-
eral principles of differentiation. The progression is from simple
forms, right-angular relations, and frontal views (or undifferentiated
frontality) to more detailed and complex representations. Although
cultural variability exists, it consists of a limited set of variations on a
common underlying structure, indicating that the same rules can gen-
erate alternative models that are representationally equivalent. The
child's immediate experience of highly significant and perceptually
salient attributes finds expression in the drawings. For example, if nu-
dity is common until puberty and the sexual organs are covered only
minimally thereafter, as is the case among the Tallensi, such conspic-
uously visible organs that identify maleness and femaleness and de-
fine the individual's social and biological status will appear early in
the child's representation of people.

Cultural Variability and Group Models

The Wilsons have taken up Paget's interesting suggestion regarding the peer group's impact on children's drawing style. They have scanned the available literature for evidence that culturally determined models can be passed on from one generation of children to the next. Unlike Paget, however, they draw upon the work of children from literate, though culturally diverse, societies. They have identified examples of child art that have long been considered stage-specific phenomena and have challenged their presumed universal status. Their strongest case is the two-eyed profile, at times also called the mixed profile (Wilson & Wilson, 1982a). It is a profile drawing of a human head, but instead of respecting the side view by drawing a single eye, this profile boasts two eyes. It has often been described as a transitional phenomenon that appears when children, used to drawing the frontal face, try their luck with a side view while still intent on maintaining the symmetry of the two eyes. Early publications offered numerous examples of the two-eyed profile, and anecdotal accounts of contemporary adults confirm that it once existed as a transitional phase from the strictly frontal view to a side view. The Wilsons' search revealed that this once-common graphic model has practically vanished from the drawings of Western children. How to account for the disappearance of a, presumably, stage-linked graphic schema? Their answer involves the culture of the peer group and its influence on the graphic conventions of younger children who are just initiated into the art of sign-making. Although the Wilsons do not know from whence the two-eyed profile came, they contend that once it became a prototypical, stock-in-trade character in the figural arsenal of children's drawings, it was passed on through successive generations of youngsters. In earlier times, when paper was sparse and expensive, children frequently drew on walls, with the older ones occupying the heights and the younger and shorter ones the lower tiers, a phenomenon noticed by an early writer on child art who commented on the graffiti of Roman children (Ricci, 1887). According to the Wilsons, it was quite simple for the younger children to imitate the models of the older ones. Such a hypothesized transmission of graphic models via peer contact would be analogous to the transmission of games described by Iona and Peter Opie (1969). Where the model originated and why it vanished remains something of a mystery. However, for as long as it existed, it was perpetuated through interlocking cycles of local child art. Although this account is appealing in its simplicity, it leaves many questions unanswered. Why, for example, did the two-eyed profile of humans vanish but not the version used in animal drawings (see ills. 67 e and 70 b)? Why did Victor Lowenfeld's D.H., a near-blind child who drew with his head bent closely over the paper, adopt this schema (Lowenfeld, 1939)? It is not an intuitively convincing argument to state that a near-blind, visually severely impaired child would be influenced by the graphic models of his equally handicapped peers. Although I do not have a good answer to the riddle, the conditions of art-making for contemporary Western children have

radically changed since cheap paper and crayons have become widely accessible. Perhaps, with the greater freedom allowed children and a more tolerant attitude toward their work children stay longer with the frontal view than in former times, when teachers encouraged and even enforced the side view. When contemporary children draw a profile—for example, when they depict an action such as chasing—they frequently adopt a simple form consisting of an oval-circle with a sideways mouth and eye, and perhaps a separately attached nose. This type of profile drawing is easier than the more difficult strategy of producing a contour that weaves its way around indentations for nose, mouth, and chin. Perhaps drawing has also become a more solitary activity than the communal picture-making on walls and sidewalks. Above all, I would like to draw attention to the visual logic that underlies the two-eyed profile and continues to find expression in children's animal drawings and in the mixtures of frontal and side views. The two-eyed profile presents a point of transition between a frontal and a side view; it is a reasonable solution and not an arbitrarily imposed one. Its disappearance suggests the fluidity of transitional phases.

These reflections are not intended to deny the potential influence of peer models. Jane Belo's examples of the profile drawings of Balinese children in the 1930s come to mind. An early study by Belo (1937/1955) of unschooled children from the island of Bali illustrates both the general developmental principles of the emergence and differentiation of early forms and the impact of peers and of cultural models. She describes the rich cultural artistic traditions of the Balinese, who celebrate their temple festivals with dramatic performances. She especially notes the shadow-play performances that children enthusiastically attend. The shadow play is a form of visual storytelling; it takes place at night and, behind a white screen illuminated from behind by an oil burning lamp, puppet figures appear as shadows on the screen and enact the play. The highly stylized figures represent the heroes of Hindu mythology and the children who routinely attend many performances learn to distinguish between the different characters, demons, spirits, and heroes. With this background, Belo selected a group of 20 children who never before had access to paper and pencils. The children, who ranged in age from 3 to 10 years, came to her house for a period of three months where they drew in the company of other children. On the walls, Belo displayed drawings made by different-aged children. These drawings showed the impact of the traditional style of Balinese artists who represent the well-known mythological themes portrayed in the performance of puppets in a shadow play. Belo reports that the youngest, the three- and four-year-olds, drew round heads and lumpy bodies with stick legs, which are typical examples of early child art. However, between the ages of five to seven years a marked change could be observed as children began to draw in the culturally dictated manner of a head in profile, with the characteristically long nose and slanting eye of the wayang puppet shadow play. She notes that the children in her study

did not copy adult graphic models; they were interested in each other's work and learned new techniques demonstrated by their more experienced peers. Belo comments on the reciprocal influences between the children that produced a "style" to which new members of the group tended to conform. Lacking access to paper and pencils, the children drew on walls with charcoal, apparently gaining extensive experience with the culturally appropriate models. These findings illustrate both the early rule governed beginnings of pictorial representation and its deliberate transformation along cultural conventional forms. That many children could master the appearance, posture, gesture, and movement of the shadow puppets attests to the power of their motivation, their intense practice, and the talent to go beyond the early generic forms to the artistic formats of their community.

The Wilsons (1979, 1984, 1985) provide additional evidence for the cultural influences in stylistic features that tend to be passed on from one generation of children to the next. They highlight characteristics that differentiate between the drawings of Egyptian village youngsters and their urban peers. They point to drawings of school-age children in an Egyptian village and compared the drawings with those made by their urban, middle-class counterparts. Among these two groups of Egyptian children they found significant differences in the depiction of the head, the facial features, and the trunk, a difference they attribute to a locally intact and unchallenged child art tradition that, in the case of the village children, is less affected by Western models than are the drawings of the urban children (Wilson & Wilson, 1984, 1985). They find among the village children a larger number of horizontal-oval heads, a smaller number of vertical-oval heads, and a fairly high proportion of what they term "moonfaces." The latter refer to awkwardly drawn profiles whose contour-line looks somewhat like an inverted numeral 3, a model practically absent from the drawings of the city children.

Both groups of children employ a model in which the upper torso figures prominently and is drawn with a continuous outline that extends from the neck to the waist. The Wilsons identify this graphic model as the "Islamic torso," an "ideal" type that children strive to attain. Other models for the body consist of triangular and trapezoidal shapes, which are more frequently seen in the drawings of village children. Such phenomena as Islamic torsos, bottle-bodies, moonfaces, and back-mounted arms comprise the Egyptian child art style. The Wilsons base their conception of art as a conventional language on these kinds of data, which suggest to them that graphic models are learned as younger children imitate older ones. In their words: "Like some tribal art, the children's art owed at least some of its stylistic character to conventionalizations of intrinsically biased images. The resulting configurations are relatively few in number, relatively stable, and passed from one graphic producer to another" (Wilson & Wilson, 1984, p. 24). Although they subscribe to the two-factor theory of universally innate biases and cultural influences to which I referred in the beginning of this chapter, they clearly view the first factor in a

negative light. The innate patterns are to be overcome by imitating the models made available through the peer groups and later by other societal sources.

No doubt the Wilsons have isolated stylistic features that characterize the drawings of these Egyptian village children. Apparently, in a small community in which children have little exposure to graphic materials and limited opportunity to explore representational strategies, the range of variations on a common theme appears to be limited. But the most significant aspect of the study seems to me to be the finding that the Egyptian children's drawings are but variants of the typical child art style. When we consult such comprehensive older sources as Georg Kerschensteiner (1905), we see many examples of Wilsons' moon-faces in riders drawn in profile. Likewise, one finds many examples of the so-called Islamic torso with or without a neck, triangular or bottle-bodies, and arms drawn from the back. These models, like countless other illustrations from early and more recent publications, indicate experimentation with diverse graphic solutions, a diversity that consists of variations on an underlying theme. Clearly children are not impermeable to their experiences with real objects or their graphic representations. They are open to influences, but they do not skip from globals, whether contour or stick figure, to naturalistic representations.

The only study that seems to challenge the notion of an orderly progression from simple to more complex representations is a study by Schubert (1930). She reports on the drawings of seven youngsters, ages 10 to 21 years, members of a Siberian hunting tribe who, when given paper and pencil, drew animals in a naturalistic style. They had received little schooling, and only the oldest among them could read and write slightly. Given the small sample size, the wide age range, and the fact that they did receive some schooling, one cannot assume that they lacked all representational experience. Although they may not have had much access to paper, we cannot preclude other forms of practice, for example, with sand, rocks, clay, stone, or wood. Although in talented children progress in representational skill can be very rapid, some practice seems necessary even in the case of such gifted children as Eytan, Yani, and Nadia (see chapter 7).

The Wilsons have justly drawn our attention to sociocultural factors that can appear early in a child's development, and their critique of a rigid stage conception of graphic development has found a receptive audience. However, their emphasis on "innate" factors or biases is problematical and might be mistaken for an outdated model of human development in which universally present tendencies are attributed to specific hereditary patterns. We are not likely to discover a set of genes that predispose children and naive adults to the making of tadpoles, open-trunk figures, and right-angular relations. Such an approach might trivialize the nature of the problem-solving enterprise and underestimates the value that drawing as a record of visual thinking can provide to the student of child art. There is logic to the manner in which an inexperienced individual, child or adult, conceives of

graphic or plastic representations. The conceptual framework that I have outlined allows for a process of self-regulation that does not specify a single graphic model as the defining characteristics of a child's drawing at the hypothetical stages of his development. At each of the numerous steps in the developmental process, observation of nature and experimentation with the medium of representation open new possibilities. The variability of lines, shapes, sizes, and color expresses the child's individual conceptions. Both organismic factors and the availability of models that are within reach of the child affect the outcome. The drawings of young children are as different one from another as are fingerprints, yet they can be classified.

The impact of cultural models on children's drawings and the extent to which they modify the graphic schemas that are characteristic of the young is well illustrated in the artwork of Japanese children. In Japan, artistic education starts early in the preschool years with the teacher specifying theme, color, and size of paper and demonstrating procedures that the children follow. From the elementary-school grades on, art is a required subject for grades one through nine, and the instruction is based on a nationwide art curriculum.

In the preschools, under the teacher's guidance, children begin with a crayon drawing over which watercolor is applied, a technique taught in all preschools. Children often have a portfolio of drawings made during the school year, most commonly representing assigned themes. The artistic conception and convention on which this teaching method is based tends to encourage sensitivity to the medium, especially in terms of color use. Even at this young age, one can discern certain stylistic features that characterize Japanese children's drawings of humans and animals and one can identify certain commonalities in the manner heads are drawn in the style of popular Japanese cartoons called *manga*. However, overall, their work stays within the idiom of child art and its constraints (see ills. 237 *a, b*) and figural differentiation and compositional strategies are very similar to those of Western children ages three to five years.

Studies that examine the drawings of older children enrolled in elementary and middle schools and that compare the drawings of Japanese, American, and English youngsters, generally note the greater graphic skills of the Japanese children and the marked influence of the *manga* cartoon models on the drawings of boys and girls (Cox et al., 2001; Toku, 2002). A comparison of the drawings of Japanese and American children indicates that by the first grade the spatial representation of the Japanese children is already more advanced than that of their American peers, an advantage that is maintained by the older children. Especially noteworthy in Masami Toku's study are the exaggerated "views" and the bird's-eye perspective of the Japanese youngsters who model their drawings on the familiar schemas derived from the *manga* cartoons. The cartoons are favorite reading materials and the pictorial characters of their heroes and stars are avidly consumed and imitated. The *manga* influence can be seen in the drawings of Japanese girls who draw their female figures

a.

b.

237. *Drawings of Japanese Preschool Children*
a-b. Drawings of four-year-olds.
c–d. Drawings of five-year-olds.

with large eyes, a near-invisible nose, and skinny bodies, whereas the boys endow their figures with muscular bodies depicted in exaggerated postures and movements (Toku, 2002).

In general, one can see that cultural models and teaching methods have a distinct impact on children's drawings and paintings, but they do not change the basic structural similarities of child art, which are easily detected despite changes in time and space.

The developmental studies reported in previous chapters and the cross-cultural research reviewed so far do not support a rigid version of stages into which children are inevitably locked. It is an abstraction that even the more orthodox adherents of stage theory such as Lowenfeld, Luquet, and Piaget did not apply in any literal sense. Likewise, the notion of extreme relativism and of drawing as learning a language composed of arbitrary signs is not tenable. Authors frequently refer to E. H. Gombrich's view of art as a form of illusion practiced by artists who study the graphic conventions of other artists rather than learning their trade by observing nature (Gombrich, 1960). This, however, is only a partial reading of Gombrich's position. He rejects Nelson Goodman's notion of graphic symbols as arbitrary conventions and insists that there are limits to perceptual relativism.

c.

d.

Accordingly, he maintains that what looks like a leaf to a modern Eu-
ropean must also have looked like a leaf to predators in distant geo-
logical epochs. The search for meaning and the ability to perceive
meaningful relations is part of our biological inheritance. The visual
environment, according to Gombrich, is not neutral; our survival is
dependent on the recognition of meaningful features that elicit ap-
proach responses or impel us to withdraw. Unlike words, the images
of nature are not conventional signs; they are a natural language de-
signed to apprehend meanings. Representations are meaningful state-
ments because they stand in a systematic relationship to the objects
of reality for which they create a graphic equivalent (Gombrich, 1973,
1982).

My analysis of several competing theories and of the available em-
pirical data has led me to a rejection of two extreme positions: an or-
thodox version of a stage theory and the notion that graphic develop-
ment is devoid of intrinsic meaning. In my view, development seems
to evolve across cultures in much the same way, with structurally sim-
ple forms and figures always preceding more complex ones. The rules
for representing the world appear to be the same even though specific
graphic models, variants of the same underlying visual conception,

may become a preferred pattern in ways we cannot fully trace. My view of graphic development as a universally ordered sequence and an intrinsically meaningful mental activity has found additional confirmation in these cross-cultural data. Because representation is concerned with the creation of equivalences for objects and events, different forms may represent their object equally well, which accounts for the range of individual variation we have observed. There are, however, distinct limits to the representational equivalences children create, and their drawings are constrained by their as-yet limited exploration of the medium and of the objects they wish to portray (Golomb, 1987b, 2002).

Having made the case for an intrinsically ordered sequence of graphic development, we still need to examine the role of social and cultural variables. To begin with, we need to acknowledge that the normally developing child is not just a prisoner of a biologically preset clock or impermeable to social influences. The normal child, from the very beginning, is a social being, interested in her environment and responsive to it; she is also endowed with certain perceptual preferences that sensitize her to specific features of her environment (Baillargeon, 1987; Bower, 1974; Fantz, 1965; Gelman, 1991; Leslie, 1984; Salapatek, 1975; Spelke, 1991). Observations of preschoolers indicate that they pay attention to what their peers and siblings can draw and that they may try to adapt the more advanced models of some of their peers to their own level of comprehension and of skill. Although, at times, an older child's drawing may inspire a younger one, children tend to adopt those aspects of the model that they can understand. The more advanced sibling may encourage exploration in a younger child, perhaps even speed up the process of discovery, but she is not likely to lead to a totally new graphic conception.

Certain narrative themes are particularly reflective of the child's social setting, its myth and folklore. Inspired by the rituals of holidays and other important events, we find in the United States drawings of witches and graveyards, ships and pirates, monsters and dragons, robots and aliens, rockets and spacecrafts, missiles and airplanes, sports contests, and the favorite TV and cartoon characters. Such themes also determine the form, garb, and actions of the characters as children try to capture the essence of the graphic images presented by the popular media. During their middle childhood years some children become absorbed in the adventures of imaginary creatures, giving them the power and status only fantasy can award. Plots of power, destruction, and victory appeal mostly to boys. Themes of the family and of social relations are more typical for girls whose compositions are less action-packed and, by comparison with boys' drawings, appear more tranquil. In girls' drawings, ambition may be expressed in themes that touch on stardom, fashion, beauty, fame, and popularity. Models can exert an influence on the drawing, provided they are relatively simple, and the youngster's motivation, talent, and willingness to practice is high. Popular graphic models seem to be especially influential for those youngsters who continue to favor drawing over other activities and who develop a special competence in this

medium. The majority of school-age children continue to elaborate their earlier, typically child art models for some time, and then abandon drawing altogether. Why the readily available pictorial models are not more successfully incorporated into the average child's repertoire poses a challenging question to the art educator.

We have come to the end of our story of the child's creation of a pictorial world. In the process of forging a graphic language, children create forms and discover how they can be used to represent people, animals, plants, machines, and other objects of interest to them. From the beginning we can discern a tension between the need to create simple forms that can state their message clearly and the desire to play more freely with lines, shapes, and colors. We note a tendency to embellish figures and decorate their background, but we also see deliberate efforts to simplify a structure and to reorder its elements in the service of greater clarity.

Throughout the child's development, and underlying the diversity of styles and of cultural conventions, there is a unity that characterizes representational thinking and motivates the search for those graphic solutions that best express the child's conception. As soon as she discovers the simple rules that generate the early representational models, she imposes her personal stamp on the general forms and expresses her individuality through her unique style. Within the broad constraints imposed by biology, culture, and cognitive understanding, the child's overriding aim is to create with simple means a pictorial world.

References

Alland, A., Jr. (1983). *Playing with form: Children draw in six cultures.* New York: Columbia University Press.

Allport, G. W. (1962). The general and the unique in psychological science. *Journal of Personality* 30: 405–421.

Alschuler, R. H. & L. B. W. Hattwick. (1947). *Painting and personality: A study of young children.* 2 vols. Chicago: University of Chicago Press.

Alschuler, R. H. & L. B. W. Hattwick. (1969). *Painting and personality: A study of young children.* Rev. and abr. ed. Chicago: University of Chicago Press.

Anastasi, A. & J. P. Foley, Jr. (1936). An analysis of spontaneous drawings by children of different cultures. *Journal of Applied Psychology* 20: 689–726.

Anastasi, A. & J. P. Foley, Jr. (1938). A study of animal drawings by Indian children of the North Pacific coast. *Journal of Social Psychology* 9: 363–374.

Andersen, W. V. (1961–1962). A neglected theory of art history. *Journal of Aesthetics and Art Criticism* 20: 389–404.

Andersson, I. & S. B. Andersson. (1997). Aesthetic representations among Himba people in Namibia. Unpublished manuscript, Linköping University, Sweden.

Andrews, J. F. (1989). Wang Yani and contemporary Chinese painting. In Wai-Ching Ho (Ed.), *Yani: The brush of innocence,* pp. 39–50. New York: Hudson Hills Press.

Arnheim, R. (1966). *Toward a psychology of art.* Berkeley: University of California Press.

Arnheim, R. (1969). *Visual thinking.* Berkeley: University of California Press.

Arnheim, R. (1974). *Art and visual perception.* Berkeley: University of California Press.

Arnheim, R. (1980). The puzzle of Nadia's drawings. *The Arts in Psychotherapy* 7: 79–85.

Arnheim, R. (1986). *New essays on the psychology of art.* Berkeley: University of California Press.

Arnheim, R. (1988). *The power of the center.* Rev. ed. Berkeley: University of California Press.

Arnheim, R. (1997a). *The split and the structure.* Berkeley: University of California Press.

Arnheim, R. (1997b). Ancient Chinese aesthetics and its modernity. *British Journal of Aesthetics* 37(2): 155–157.

Asch, S. E. (1952). *Social psychology.* Englewood Cliffs, NJ: Prentice Hall.

Bader, A. & L. Navratil. (1976). *Zwischen Wahn und Wirklichkeit.* Luzern: C. J. Bucher.

Balla, D. & E. Zigler. (1976). Pre-institutional social deprivation and responsiveness to social reinforcement in institutionalized retarded individuals: A six year follow-up study. *American Journal of Mental Deficiency* 80: 228–230.

Balla, D. & E. Zigler. (1980). Mental retardation. In A. E. Kazdin, A. S. Bellack & M. Hersen (eds.), *New perspectives in abnormal psychology.* New York: Oxford University Press.

Balla, D., E. Butterfield & E. Zigler. (1974). Effects of institutionalization on retarded children: A longitudinal cross-institutional investigation. *American Journal of Mental Deficiency* 78: 530–549.

Baillargeon, R. (1987). Young infants' reasoning about the physical and spatial characteristics of a hidden object. *Cognitive Development* 2: 179–200.

Ballard, P. B. (1912). What London children like to draw. *Journal of Experimental Pedagogy* 1(3): 185–197.

Barnhart, E. N. (1942). Developmental stages in compositional construction in children's drawings. *Journal of Experimental Education* 11: 156–184.

Barrett, M. & P. Light. (1976). Symbolism and intellectual realism in children's drawings. *British Journal of Educational Psychology* 46: 198–202.

Beck, W. (1928). *Romano Dazzi: Self development in drawing as interpreted by the genius of Romano Dazzi.* New York: G. P. Putnam's Sons, the Knickerbocker Press.

Becker, L. (1980). *With eyes wide open* [Film]. Austin: Texas: Creative Learning Environments.

Belo, J. (1955). Balinese children's drawings. In M. Mead and M. Wolfenstein Eds.) *Childhood in contemporary cultures.* Chicago: University of Chicago Press.

Bender, L. (1952). *Child psychiatric techniques.* Springfield, IL: Charles C. Thomas.

Bernheimer, R. (1961). *The nature of representation: A phenomenological inquiry.* New York: New York University Press.

Bertrand. J. & C. B. Mervis. (1996). Longitudinal analysis of drawings by children with Williams syndrome: preliminary results. *Visual Arts Research* 22(2): 19–34.

Betensky, M. (1973). *Self-discovery through self-expression.* Springfield, IL: Charles C. Thomas.

Bettelheim, B. (1967). *The empty fortress: Infantile autism and the birth of self.* New York: Free Press.

Biehler, R. F. (1953). An analysis of free painting procedures as used with preschool children. Ph.D. diss., University of Minnesota.

Blake, D. (1988). Roger's world. Unpublished document, University of Massachusetts at Boston.

Blank, P., C. Massey, H. Gardner & E. Winner. (1984). In R. Crozier & A. Chapman (Eds.), *Cognitive processes in the perception of art.* Amsterdam: North Holland Press.

Bloom, B. (Ed.). (1985). *Developing talent in young people.* New York: Ballantine Press.

Bower, T. G. R. (1966). The visual world of infants. *Scientific American* 215: 80–92.

Bower, T. G. R. (1974). *Development in infancy.* San Francisco: W. H. Freeman.

Bregman, J. D. & Hodapp, R. M. (1991). Current developments in the understanding of mental retardation. *Journal of the American Academy of Child and Adolescent Psychiatry* 30: 707–719.

Britsch, G. (1926). *Theorie der bildenden Kunst.* Ed. E. Kornmann. Munich: Bruckmann.

Buck, J. N. (1948). The H-T-P test. *Journal of Clinical Psychology* 4: 151–159.

Buck, L. (1991). Creativity in the retarded. *Empirical Studies of the Arts* 9: 75–95.

Buck, L., E. Kardeman & F. Goldstein. (1985). Artistic talent in "autistic" adolescents and young adults. *Empirical Studies of the Arts* 3: 81–104.

Buehler, K. (1930). *The mental development of the child.* London: Routledge and Kegan Paul.

Buerger-Prinz, M. (1932). Uber die kunstlerischen Arbeiten Schizophrener. In *Handbuch der Geisteskrankheiten,* vol. 9. Bumke. (Ed.) Berlin: Springer.

Bunim, M. S. (1940). *Space in medieval painting and the forerunners of perspective.* New York: AMS Press.

Burns, R. C. (1982). *Self-growth in families: Kinetic family drawings (K-F-D) research application.* New York: Brunner-Mazel.

Burns, R. C. & S. H. Kaufman. (1970). *Kinetic family drawings (K-F-D).* New York: Brunner-Mazel.

Burns, R. C. & S. H. Kaufman. (1972). *Actions, styles, and symbols in kinetic family drawing (K-F-D).* New York: Brunner-Mazel.

Burt, C. (1921). *Mental and scholastic tests.* London: P. S. King and Son.

Carothers, T. & H. Gardner. (1979). When children's drawings become art: The emergence of aesthetic production and perception. *Developmental Psychology* 15(5): 570–580.

Carter, J. L. (1973). Human figure drawing of mentally retarded, brain injured, and normal children. *Art Psychotherapy* 1(3–4); 307–308.

Case, C. & T. Dalley. (1990). *Working with children in art therapy.* London: Tavistock/Routledge.

Case, R. (1992a). *The mind's staircase.* Hillsdale, NJ: Erlbaum.

Case, R. (1992b). Neo-Piagetian theories of intellectual development. In H. Beilin & P. Pufall (Eds.), *Piaget's theory: Prospects and possibilities,* pp. 61–104. Hillsdale, NJ: Erlbaum.

Case, R., Y. Okamoto, S. Griffin, A. McKeough, C. Bleiker, B. Henderson & K. Stephenson. (1996). The role of central conceptual structures in the development of children's thought. *Monographs of the Society for Research in Child Development,* 61, serial number 246.

Chomsky, N. (1957). *Syntactic structures.* The Hague: Mouton.

Cizek, F. (1936). Cited in W. Viola, *Child art and Franz Cizek.* Vienna: Austrian Red Cross.

Clark, G. & E. Zimmerman. (1987). Tending the special spark: Accelerated and enriched curricula for highly talented art students. *Roeper Review* 10(1): 10–17.

Clements, W. & M. Barrett. (1994). The drawings of children and young people with Down's syndrome: A case of delay or difference? *British Journal of Developmental Psychology,* 64: 441–452.

Corcoran, A. (1954). Color usage in nursery school painting. *Child Development* 25(2): 107–113.

Court, E. (1982). The dual vision: Factors affecting the drawing characteristics of selected Kenyan children. Paper presented at the National Art Education Association Conference.

Court, E. (1989). Drawing on culture: The influence of culture on children's drawing performance in rural Kenya. *Journal of Art and Design Education* 8: 65–88.

Court, E. (1994). Researching social influences in the drawings of rural Kenyan children. In D. Thistelwood, S. Paine & E. Court (Eds.), *Drawing, art, and development,* pp. 219–260. London: Longmans.

Cox, M. (1981). One thing behind another: Problems of representation in children's drawings. *Educational Psychology* 1(4): 275–287.

Cox, M. (1992). *Children's drawings*. London: Penguin.

Cox, M. (1993). *Children's drawings of the human figure*. Hove, East Sussex, England: Erlbaum.

Cox, M. & C. Bragal. (1985). The representation of spatial relationships in the drawings of ESN (M) and normal children. *Educational Psychology* 5(3–4): 279–286.

Cox, M. & S. Maynard. (1998). The human figure drawings of children with Down's syndrome. *British Journal of Developmental Psychology* 16: 133–137.

Cox, M., M. Koyasu, H. Hiranuma & J. Perara. (2001). Children's human figure drawings in the UK and Japan: The effects of age, sex, and culture. *British Journal of Developmental Psychology* 19(2): 275–292.

Csikszentmihalyi, M. & J. Getzels. (1988). Creating and problem finding in art. In F.H. Farley & R. W. Neperud (Eds.), *The foundations of aesthetics, art, and education*, pp. 91–106. New York: Praeger.

Csikszentmihalyi, M., K. Rathunde & S. Whalen. (1993). *Talented teenagers: The roots of success and failure*. New York: Cambridge University Press.

D'Amico, V. (1953). *Creative teaching in art*. Scranton, PA: International Textbook Co.

Dasen, P. R. (1981). Strong and weak universals: S-M intelligence and concrete operations. In B. Lloyd & J. Gay (Eds.) *Universals of human thought*. Cambridge: Cambridge University Press.

Delbanco, D. H. (1989). Monkeys in Chinese art and culture. In W. C. Ho (Ed.), *Yani. The brush of innocence*, pp. 27–38. New York: Hudson Hill Press.

DeLoache, J. S., M. Strauss & J. Maynard. (1979). Picture perception in infancy. *Infant Behavior and Development* 2: 77–89.

Dennis, S. (1992). Stage and structure in the development of children's spatial representation. In R. Case (Ed.), *The mind's staircase*, pp. 229–245. Hillsdale, NJ: Erlbaum.

Dennis, W. (1957). Performance of Near-Eastern children on the Draw-a-Man test. *Child Development* 28(4): 427–430.

Dennis, W. (1960). The human figure drawings of Bedouins. *Journal of Social Psychology* 52: 209–219.

Deregowsky, J. B. (1978). On reexamining Fortes' data: Some implications of drawings made by children who have never drawn before. *Perception* 7: 479–484.

DiLeo, J. H. (1972). *Children's drawings as diagnostic aids*. New York: Brunner-Mazel.

DiLeo, J. H. (1983). *Interpreting children's drawings*. New York: Brunner/Mazel.

Dubery, F. & J. Willats. (1983). *Perspective and other drawing systems*. New York: Van Nostrand Reinhold.

Duncum, P. (1981). Children's spontaneous drawing and environmental influences. *Visual Arts Monographs* 1(3): 1–22.

Duncum, P. (1986). Middle childhood spontaneous drawing from a cultural perspective. Unpublished doctoral dissertation. The Flinders University of South Australia.

Eames, K. & M. Cox. (1994). Visual realism in the drawings of autistic, Down's syndrome, and normal children. *British Journal of Developmental Psychology* 12: 235–239.

Earl, C. J. C. (1933). The human figure drawing of feeble minded adults. *Proceedings of the American Association of Mental Deficiency* 38: 107–120.

Ellis, N. R. (1963). The stimulus trace and behavioral inadequacy. In N. R. Ellis (Ed.), *Handbook of mental deficiency*. New York: McGraw-Hill.

Ellis, N. R. (1970). Memory processes in retardates and normals. In N. R. Ellis (Ed.), *International review of research in mental retardation*, vol. 4. New York: Academic Press.

Eng, H. (1931). *The psychology of children's drawings*. London: Routledge & Kegan Paul.

Exner, J. E. (1974). *The Rorschach: A comprehensive system*, vol. 1. New York: Wiley.

Exner, J. E. (1978). *Current research and advanced interpretation*, vol. 2, New York: Wiley.

Fantz, R. L. (1965). Visual perception from birth as shown by pattern selectivity. *Annals of the New York Academy of Sciences* 118: 793–814.

Fein, S. (1984). *Heidi's horse*. Pleasant Hill, CA: Exelrod Press.

Feinburg, S. (1976). Combat in child art. In J. Bruner, A. Jolly & K. Sylva (Eds.), *Play: Its role in evolution and development*. New York: Basic Books.

Feldman, D. (1980). *Beyond universals in cognitive development*. Norwood, NJ: Ablex.

Feldman, D. & L. Goldsmith, (1986). *Nature's gambit: Child prodigies and the development of human potential*. New York: Basic Books.

Fineberg, J. (1997). *The innocent eye*. Princeton, NJ: Princeton University Press.

Fischer, K. W. (1980). A theory of cognitive development: The control and construction of hierarchies of skill. *Psychological Review* 87: 477–531.

Fisher, M. A. & D. Zeaman. (1973). An attention-retention theory of retardate discrimination learning. In N. R. Ellis (Ed.), *International review of research in mental retardation*, vol. 6. New York: Academic Press.

Flavell, J. & J. Wohlwill. (1969). Formal and functional aspects of cognitive development. In D. Elkind & J. H. Flavell (Eds.), *Studies in cognitive development*. Oxford: Oxford University Press.

Fortes, M. (1940). Children's drawings among the Tallensi. *Africa* 13(3): 293–295.

Fortes, M. (1981). Tallensi children's drawings. In B. Lloyd & J. Gay (Eds.). *Universals of human thought*. Cambridge: Cambridge University Press.

Freeman, N. H. (1980). *Strategies of representation in young children*. London: Academic Press.

Freeman, N. H. (1987). Current problems in the development of representational picture production. *Archives de Psychologie* 55: 127–152.

Freeman, N. H. (1995). The emergence of a framework theory of pictorial reasoning. In C. Lange-Kuettner & G. V. Thomas (Eds.), *Drawing and looking*. London: Harvester-Wheatsheaf.

Freeman, N. H. & M. Cox. (1985). *Visual Order*. London: Academic Press.

Freud, A. (1948). Techniques of child analysis. *Nervous Mental Disorder Monograph* 48.

Freud, S. (1900). *The interpretation of dreams*. Trans. J. Strachey. The Standard Edition, London, 1953, vols. 4 and 5.

Freud, S. (1910). *Leonardo da Vinci and a memory of his childhood*. Trans. J. Strachey. The Standard Edition, London, 1957, vol.11.

Fucigna, C. & D. Wolf. (1981). The earliest two-dimensional symbols: The onset of graphic representation. Paper presented at the Eleventh Annual Conference of the Jean Piaget Society, Philadelphia.

Gallo, F., C. Golomb & A. Barroso. (2003). Compositional strategies in drawing: The effects of two- and three-dimensional media. *Visual Arts Research*, 28(1): 2–23.

Gardner, H. (1972). The development of sensitivity to figural and stylistic aspects of paintings. *British Journal of Psychology* 63: 606–615.

Gardner, H. (1973). *The arts and human development*. New York: Wiley.

Gardner, H. (1974). The contributions of color and texture to the detection of painting styles. *Studies in Art Education* 15: 57–62.

Gardner, H. (1980). *Artful scribbles: The significance of children's drawings*. New York: Basic Books.

Gardner, H. (1982). *Art, mind and brain*. New York: Basic Books.

Gardner, H. (1983). *Frames of mind: The theory of multiple intelligences*. New York: Basic Books.

Gardner, H. (1990). *Art education and human development*. Los Angeles: The Getty Center for Education in the Arts.

Gardner, H. (1993). *Creating minds*. New York: Basic Books.

Gardner, H. & E. Winner. (1982). First intimations of artistry. In S. Strauss (Ed.), *U-shaped behavioral growth*. New York: Academic Press.

Gardner, H., E. Winner & M. Kircher. (1975). Children's conception of the arts. *Journal of Aesthetic Education* 9: 60–77.

Gelman, R. (1991). Epigenetic foundations of knowledge structures: Initial and transcendent constructions. In S. Carey & R. Gelman (Eds.), *The epigenesis of mind*, pp. 293–322. Hillsdale, NJ: Erlbaum.

Getzels, J. & M. Csikszentmihalyi. (1976). *The creative vision: A longitudinal study of problem finding in art*. New York: Wiley.

Gibson, J. (1966). *The senses considered as perceptual systems*. Boston: Houghton Mifflin.

Gibson, J. (1979). *The ecological approach to visual perception*. Boston: Houghton Muffin.

Ghent-Braine, L., L. Schauble, S. Kugelmass & A. Winter. (1993). Representation of depth by children: Spatial strategies and lateral biases. *Developmental Psychology* 29(3): 466–479.

Goldsmith, L. (1992). Wang Yani: Stylistic development of a Chinese painting prodigy. *Creativity Research Journal* 5(3); 281–293.

Goldsmith, L. (2000). Tracking trajectories of talent: Child prodigies growing up. In R. C. Friedman & B. M. Shore (Eds.), *Talents unfolding, cognition and development*. pp. 89–117. Washington: APA.

Goldsmith, L. & D. Feldman. (1989). Wang Yani: Gifts well given. In W. C. Ho (Ed.), *Yani: The brush of innocence*. New York: Hudson Hill Press.

Goldstein, K. (1942–1943). Concerning rigidity. *Character and Personality* 11: 209–226.

Goldwater, R. (1986). *Primitivism in modern art*. Cambridge, MA: Harvard University Press.

Golomb, A. (1987). Graphic strategies of emotionally disturbed children. *Visual Arts Research* 13(2): 68–79.

Golomb, A. (1988). Book review of R. C. Burns Kinetic-House-Tree-Person drawings: An interpretive manual. *Journal of Youth and Adolescence* 17(4): 373–376.

Golomb, C. (1969). The effects of models, media, and instructions on children's representation of the human figure. Ph.D. diss., Brandeis University. Ann Arbor: University Microfilms No. 69–16: 308.

Golomb, C. (1973). Children's representation of the human figure: The effects of models, media, and instructions. *Genetic Psychology Monographs* 87: 197–251.

Golomb, C. (1974). *Young children's sculpture and drawing: A study in representational development*. Cambridge, MA: Harvard University Press.

Golomb, C. (1977). Representational development of the human figure: A look at the neglected variables of SES, IQ, sex, and verbalization. *Journal of Genetic Psychology* 131: 297–322.

Golomb, C. (1981). Representation and reality: The origins and determinants of young children's drawings. *Review of Research in Visual Art Education* 14: 36–48.

Golomb, C. (1983a). On imaginary or real décalage in children's representations: Compositional trends in draw-

ing, completion and selection tasks. *Visual Art Research* 9(2): 71–81.

Golomb, C. (1983b). Young children's planning strategies and early principles of spatial organization in drawing. In J. Sloboda & D. Rogers (Eds.), *Acquisition of symbolic skills*, pp. 81–87. London: Plenum Press.

Golomb, C. (1987a). The development of compositional strategies in drawing. *Visual Arts Research* 13(2): 42–52.

Golomb, C. (1987b). Reflections on cultural variables and universals in young children's drawings. Paper presented at the symposium on Social and Cultural Influences on Children's Drawings, Biennial Meeting of the Society for Research in Child Development, Baltimore.

Golomb, C. (1992a). Eytan: The early development of a precociously gifted child artist. *Creativity Research Journal* 5(3): 265–279.

Golomb, C. (1992b). *The child's creation of a pictorial world.* Berkeley: University of California Press.

Golomb, C. (1993). Art and the young child: Another look at the developmental question. *Visual Arts Research* 19(1): 1–15.

Golomb, C. (1994). Drawing as representation: The child's acquisition of a meaningful graphic language. *Visual Arts Research* 20(2): 14–28.

Golomb, C. (1995). Eitan: The artistic development of a child prodigy. In C. Golomb (Ed.), *The development of artistically gifted children*, pp. 171–196. Hillsdale, NJ: Erlbaum.

Golomb, C. (1999). Art and the young: The many faces of representation. *Visual Arts Research* 25(1): 26–49.

Golomb, C. (2002). *Child art in context: A cultural and comparative perspective.* Washington, DC: APA Books.

Golomb, C. & T. Barr-Grossman. (1977). Representational development of the human figure in the familial retardate. *Genetic Psychology Monographs* 95: 247–266.

Golomb, C. & G. Dunnington. (1985). Compositional development in children's drawings. Paper presented at the Fifteenth Annual Conference of the Jean Piaget Society, Philadelphia.

Golomb, C. & D. Farmer. (1983). Children's graphic planning strategies and early principles of spatial organization in drawing. *Studies in Art Education* 24(2): 87–100.

Golomb, C. & M. Haas. (1995). Varda: The development of a young artist. In C. Golomb (Ed.), *The development of artistically gifted children*, pp. 71–100. Hillsdale, NJ: Erlbaum.

Golomb, C. & J. Helmund. (1987). A study of young children's aesthetic sensitivity to drawing and painting. Paper presented at the symposium on Facets of Artistic Development, Biennial Meeting of the Society for Research in Child Development, Baltimore.

Golomb, C. & J. Schmeling. (1996). Drawing development in autistic and mentally retarded children. Special issue, *Visual Arts Research* 22(2): 5–18.

Gombrich, E. H. (1960). *Art and illusion.* London: Phaidon Press.

Gombrich, E. H. (1973). Illusion and art. In R. L. Gregory & E. H. Gombrich (Eds.), *Illusion in nature and art.* New York: Charles Scribner's Sons.

Gombrich, E. H. (1982). *The image and the eye.* Oxford: Phaidon Press.

Goodenough, F. L. (1926). *Measurement of intelligence by drawings.* New York: Harcourt, Brace and World.

Goodenough, F. L. (1934). *Developmental psychology.* New York: Appleton Century.

Goodman, N. (1968). *Language of art.* Indianapolis: Bobbs-Merrill.

Goodman, N. (1978). *Ways of world making.* Indianapolis: Hackett.

Goodnow, J. (1977). *Children drawing.* Cambridge, MA: Harvard University Press.

Gregorian, V.S., A. Azarian, M. B. De Maria & L. D. McDonald. (1996). Colors of disaster: The psychology of the "Black Sun." *The Arts in Psychotherapy* 23: 1–14.

Gross, C. G., C. E. Rocha-Miranda & D. B. Bender. (1972). Visual properties of monkeys in the inferotemporal cortex of the macaque. *Journal of Neurophysiology* 35: 96–111.

Haas, M. (1984). *Children drawing.* Oranim, Israel: The Institute for Science Education and the Improvement of Teaching, School of Education of the Kibbutz Movement.

Haas, M. (1998). *Preschool children's exploration and expression with art material.* Haifa, Israel: Ach.

Haas, M. (2003). *I painted this on this: Toddlers early experimentation.* Haifa, Israel: Ach.

Haas, M. & Z. Gavich. (2000). *Toddlers experience art materials.* Haifa, Israel: Ach.

Haddon, A. C. (1904). Drawings by natives of British New Guinea. *Man* 4: 33–36.

Hagen, M. A. (1986). *The varieties of realism.* Cambridge: Cambridge University Press.

Halkiadakis, S. (1983). The effects of repeated experience with a single drawing theme. Unpublished document. The University of Massachusetts at Boston.

Hammer, E. F. (1980). *The clinical application of Projective drawings.* Springfield, IL: Charles C. Thomas.

Hammer, E. F. (1997). *Advances in Projective Drawing Interpretation.* Springfield, IL: Charles C. Thomas.

Hardiman, G. W. & T. Zernich. (1977). Influence of style and subject matter on the development of children's art preferences. *Studies in Art Education* 19(1): 29–35.

Hardiman, G. W. & T. Zernich. (1985). Discrimination of style in painting: A developmental study. *Studies in Art Education* 26(3): 157–162.

Harris, D. B. (1963). *Children's drawings as measures of intellectual maturity.* New York: Harcourt, Brace and World.

Harris, D. B. (1971). The case method in art education. In G. Kensler (Ed.), *A report on preconference education research training program for descriptive research in art education*, pp. 29–49., Restow, VA: National Art Education Association.

Havighurst, R. J., M. K. Gunther & I. E. Pratt. (1946). Environment and the Draw-a-Man test: The performance of Indian children. *Journal of Abnormal and Social Psychology* 41: 50–63.

Heber, R. (1970). *Epidemiology of mental retardation.* Springfield, IL: Charles C. Thomas.

Helmund, J. (1987). Children's aesthetic perception: A developmental study of judgments and attitudes concerning the drawings and paintings of children. Master's thesis, The University of Massachusetts at Boston.

Hermelin, B. (2001). *Bright splinters of the mind.* London: Jessica Kingsley.

Hermelin, B. & N. O'Connor. (1990). Art and accuracy: The drawing ability of idiot savants. *Journal of Child Psychology and Psychiatry* 31(2): 217–228.

Hermelin, B., L. Pring, M. Buhler, S. Wolff & P. Heaton. (1999). A visually impaired artist: Interacting perceptual and memory representations. *Journal of Child Psychology and Psychiatry* 40(7): 1129–1139.

Hildreth, G. (1941). *The child mind in evolution.* New York: Kings Crown Press.

Ho, W. C. (1989). The brush of innocence. In Wai-Ching Ho (Ed.), *Yani: The brush of innocence.* pp. 13–26. New York: Hudson Hill Press.

Hochberg, J. & V. Brooks. (1962). Pictorial recognition as an unlearned ability: A study of one child's performance. *American Journal of Psychology* 75: 624–628.

Hodapp, R. M., J. A. Burack & E. Ziegler. (1990). *Issues in the developmental approach to mental retardation.* New York: Cambridge University Press.

Inhelder, B. (1968). *The diagnosis of reasoning in the mentally retarded.* New York: Wiley.

Inhelder, B. & J. Piaget. (1964). *The early growth of logic in the child.* London: Routledge & Kegan Paul.

Israelite, J. (1936). A comparison of the difficulty of items for intellectually normal children and mental defectives on the Goodenough drawing test. *American Journal of Orthopsychiatry* 6: 494–503.

Ives, W. & J. Rovet. (1979). The role of graphic orientations in children's drawings of familiar and novel objects at rest and in motion. *Merrill Palmer Quarterly* 25(4): 281–292.

Jahoda, G. (1981). Pictorial perception and the problem of universals. In B. Lloyd and J. Gay (Eds.), *Universals of human thought.* Cambridge: Cambridge University Press.

Jamison, K. (1993). *Touched with fire: Manic-depressive illness and the artistic temperament.* New York: Free Press.

Kárpati, A. (1997). Detection and development of visual talent. *Journal of Asthetic Education,* 31(4): 79–92.

Kellman, J. (1996). Making sense of seeing: Autism and David Marr. *Visual Arts Research* 22(2): 76–89.

Kellogg, R. (1969). *Analyzing children's art.* Palo Alto, CA: National Press Books.

Kennedy, J. M. (1980). Blind people recognizing and making pictures. In M. A. Hagen (Ed.), *The perception of pictures.* New York: Academic Press.

Kennedy, J. M. (1983). What can we learn about pictures from the blind? *American Scientist* 71: 19–26.

Kennedy, J. M. (1984). Gombrich and Winner: Schema theories of perception in aesthetics. *Visual Arts Research* 10(3): 30–36.

Kennedy, J. M. (1993). *Drawing and the blind.* New Haven, CT: Yale University Press.

Kerschensteiner, G. (1905). *Die Entwicklung der zeichnerischen Begabung.* Munich: Gerber.

Kläger, M. (1987). Mentally handicapped men and women as artistically productive persons. In *Artists from Stetten. An exhibition by persons with a mental handicap.* Stuttgart, Germany: Konrad Wittwer.

Kläger, M. (1992). *Krampus. Die Bilderwelt des Willibald Lassenberger.* Hohengehren, Germany: Schneider Verlag.

Kläger, M. (1993). *Die Vielfalt der Bilder: Kunstwerke entwicklungsbehinderte Menschen.* Stuttgart, Germany: Konrad Wittwer.

Kläger, M. (1996). Two case studies of artistically gifted Down's syndrome persons. *Visual Arts Research* 22(2): 35–46.

Kläger, M. (2002). *Die Kunst des Christoph Eder in der Stiftung de La Tour.* Hohengehren, Germany: Schneider Verlag.

Klaue, K. (1992). The development of depth representation in children's drawings: Effects of graphic surface and visibility of the model. *British Journal of Developmental Psychology* 10: 71–83.

Klopfer, B. & D. Kelley. (1942). *The Rorschach technique.* Yonkers, NY: World Book.

Klopfer, W. G. & E. S. Taulbee. (1976). Projective tests. In M. R. Rosenzweig and L. W. Porter, (Eds.), *Annual Review of Psychology* 27: 542–576.

Koffka, K. (1935). *Principles of gestalt psychology.* New York: Harcourt, Brace.

Koppitz, E. M. (1968). *Psychological evaluation of children's human figure drawings.* New York: Grune and Stratton.

Koppitz, E. M. (1984). *Psychological evaluation of human figure drawings by middle school pupils.* New York: Grune and Stratton.

Korzenik, D. (1972). Children's drawings: Changes in representation between ages five and seven. Ph.D. diss., Harvard University.

Korzenik, D. (1977). Saying it with pictures. In D. Perkins and B. Leondar. (Eds.), *The arts and cognition.* Baltimore: Johns Hopkins University Press.

Korzenik, D. (1995). The changing concept of artistic giftedness. In C. Golomb (Ed.), *The development of artistically gifted children*, pp. 1–29.

Kounin, J. (1941). Experimental studies of rigidity: I. The measurement of rigidity in normal and feeble-minded persons. *Character and Personality* 9: 251–272.

Kramer, E. (1971). *Art as therapy with children.* New York: Schocken.

Kramer, E. (1993). *Art as therapy with children.* Chicago: Magnolia Street Publishers.

Kramer, E. (2000). *Art as therapy: Collected papers.* London: Jessica Kingsley.

Kris, E. (1952). *Psychoanalytic explorations in art.* New York: International Universities Press.

Lark-Horowitz, B., H. Lewis & M. Luca. (1967). *Understanding children's art for better teaching.* Columbus, OH: Charles E. Merrill.

Lane, A. (1981). *Charlotte: Life or theatre? An autobiographical play.* London: Penguin Books.

Laws, G. & L. Lawrence. (2001). Spatial representation in the drawings of children with Down's syndrome and its relationship to language and motor development: A preliminary investigation. *British Journal of Developmental Psychology* 19: 453–473.

Lee, M. & G. Bremner. (1987). The representation of depth in children's drawings of a table. *Quarterly Journal of Experimental Psychology*, 39A: 479–496.

Leslie, A. (1984). Spatiotemporal continuity and the perception of causality in infants. *Perception* 13: 287–305.

Lewin, K. A. (1935). *A dynamic theory of personality.* New York: McGraw-Hill.

Lewis, H. (1963). The relationship of picture preference to developmental status in drawing. *Journal of Educational Research* 57(1): 43–46.

Li, S. & C. Jiang. (1984). *Yani's monkeys.* Beijing, China: Foreign Languages Press.

Light, P. (1985). The development of view-specific representation considered from a socio-cognitive standpoint. In N. H. Freeman and M. Cox (Eds.), *Visual order*, pp. 214–230. Cambridge: Cambridge University Press.

Light, P. & J. Humphreys. (1981). Internal spatial relationships in young children's drawings. *Journal of Experimental Child Psychology* 31: 521–530.

Light, P. & E. MacIntosh. (1980). Depth relationships in young children's drawings. *Journal of Experimental Child Psychology* 30: 79–87.

Light, P. & B. Simmons. (1983). The effects of a communication task upon the representation of depth relationship in young children's drawings. *Journal of Experimental Child Psychology* 35: 81–92.

Lombroso, C. (1895). *The man of genius.* London: Scott.

Lovano-Kerr, J. & J. Rush. (1982). Project Zero: The evolution of visual arts research during the seventies. *Review of Research in Visual Arts Education* 15: 61–81.

Lowenfeld, V. (1939). *The nature of creative activity.* New York: Harcourt, Brace and World.

Lowenfeld, V. (1947). *Creative and mental growth.* New York: Macmillan.

Lowenfeld, V. & W. Lambert-Brittain. (1970). *Creative and mental growth.* 5th ed. New York: Macmillan.

Ludwig, A. M. (1995). *The price of greatness: Resolving the creativity and madness controversy.* New York: Guilford Press.

Lukens, H. (1896). A study of children's drawings in the early years. *Pedagogical Seminary* 4(1): 79–110.

Luquet, G. H. (1913). *Les dessins d'un enfant.* Paris: F. Alcan.

Luquet, G. H. (1927). *Le dessin enfantin.* Paris: F. Alcan.

Luria, A. R. (1961). *The role of speech in the regulation of normal and abnormal behavior.* New York: Liveright.

MacGregor, J. M. (1989). *The discovery of the art of the insane. Princeton, NJ: Princeton University Press.*

Machotka, P. (1966). Aesthetic criteria in childhood: justifications of preference. *Child Development* 37: 877–885.

Machover, K. (1949). *Personality projection in the drawing of the human figure.* Springfield, IL: Charles C. Thomas.

Machover, K. (1953). Human figure drawings of children. *Journal of Projective Techniques* 17(1): 85–91.

Manale, P. (1982). The relative effects of color, detail, perspective and proportion on children's drawing preference: An exploration of child aesthetics. Honors thesis, University of Massachusetts at Boston.

Matthews, J. (1984). Children drawing: Are young children really scribbling? *Early Child Development and Care*, 18: 1–39.

Matthews, J. (1994). Deep structures in children's art: Development and culture. *Visual Arts Research*, 20(2): 29–50.

Matthews, J. (1999). *The art of childhood and adolescence.* London: Falmer Press.

McCarthy, S. (1924). *Children's drawings: A study of interests and abilities.* Baltimore, MD: William and Wilkins.

McElwee, E. W. (1934). Profile drawings of normal and subnormal children. *Journal of Applied Psychology* 18: 599–603.

Merleau-Ponty, M. (1962). *The primacy of perception.* New York: Routledge & Kegan Paul.

Michelmore, M. C. (1985). Geometrical foundations of children's drawings. In N. Freeman & M. Cox (Eds.), *Visual order*, pp. 289–309. Cambridge: Cambridge University Press.

Milbrath, C. (1995). Germinal motifs in the work of a gifted child artist. In C. Golomb (Ed.), *The development of artistically gifted children*, pp. 101–134. Hillsdale, NJ: Erlbaum.

Milbrath, C. (1998). *Patterns of artistic development.* New York: Cambridge University Press.

Milbrath, C. & B. Siegel (1996). Perspective taking in the drawings of a talented autistic child. *Visual Arts Research* 22(2): 56–75.

Millais, J.G. (1849). *The life and letters of Sir John Everett Millais.* New York: Frederick A. Stokes.

Millar, S. (1975). Visual experience or translation rules? Drawing the human figure by blind and sighted children. *Perception* 4: 363–371.

Moore, B. (1973). A description of children's verbal responses to works of art in selected grades. *Studies in Art Education* 14: 27–34.

Moore, V. (1986). The use of a coloring task to elucidate children's drawings of a solid cube. *British Journal of Developmental Psychology* 4: 335–340.

Morgenthaler, W. (1921). *Ein Geisteskranker als Künstler.* Bern-Leipzig: Bircher.

Morishima, A. & L. F. Brown. (1977). A case report on the artistic talent of an autistic idiot savant. *Mental Retardation* 15(2): 33–36.

Morra, S. (1995). A neo-Piagetian approach to children's drawings. In C. Lange-Küttner & G. V. Thomas (Eds.), *Drawing and looking*, pp. 93–106. London: Harvester-Wheatsheaf.

Morra, S., C. Moizo & A. Scopesi. (1988). Working memory (or the M operator), and the planning of children's drawings. *Journal of Experimental Child Psychology* 46: 41–73.

Muller, J. M. (Ed.). (1984). *Children of Mercury: The education of artists of the sixteenth and seventeenth centuries.* Providence, RI: Brown University.

Mundy, P. & C. Kasari. (1990). The similar structure hypothesis and differential rate hypothesis in mental retardation. In R. M. Hodapp, J. A. Burack & E. Zigler (Eds.), *Issues in the developmental approach to mental retardation.* New York: Cambridge University Press.

Munro, T., B. Lark-Horowitz & E. N. Barnhart. (1942). Children's art abilities: Studies at the Cleveland Museum of Art. *Journal of Experimental Education* 11(2): 97–155.

Naumburg, M. (1950). *Schizophrenic art: Its meaning in psychotherapy.* New York: Grune and Stratton.

Naumburg, M. (1973). *An introduction to art therapy.* New York: Teachers College Press.

Nye, R., G. V. Thomas & E. Robinson. (1995). Children's understanding about pictures. In C. Lange-Küttner & G. V. Thomas (Eds.), *Drawing and looking*, pp. 123–134. London: Harvester-Wheatsheaf.

O'Connor, N. & B. Hermelin. (1959). Discrimination and reversal learning in imbeciles. *Journal of Abnormal and Social Psychology* 59: 409–413.

O'Connor, N. & B. Hermelin. (1987a). Visual memory and motor programmes: Their use by Idiot-savant artists and controls. *British Journal of Psychology* 78: 1–17.

O'Connor, N. & B. Hermelin. (1987b). Visual and graphic abilities of the Idiot-savant artist. *Psychological Medicine* 17: 79–90.

Olson, D. R. (1970). *Cognitive development: The child's acquisition of diagonality.* New York: Academic Press.

Opie, I. & P. Opie. (1969). *Children's games in street and playground.* Oxford: Oxford University Press.

Ormond, R. (1981). *Sir Edwin Landseer.* New York: Rizzoli.

Ostherrieth, Paul A. and Anne. Cambier. 1976. As quoted in N. Freeman, 1980. *Strategies of representation in young children.* London: Academic Press.

Paget, G. W. (1932). Some drawings of men and women made by children of certain non-European races. *Journal of the Royal Anthropological Institute* 62: 127–144.

Paine, S. (1981). *Six children draw.* London: Academic Press.

Pariser, D. (1979). Two methods of teaching drawing skills. *Studies in Art Education* 20(3): 30–42.

Pariser, D. (1981). Nadia's drawings: Theorizing about an autistic child's phenomenal ability. *Studies in Art Education* 22(2): 20–31.

Pariser, D. (1987). The juvenile drawings of Klee, Toulouse-Lautrec, and Picasso. *Visual Arts Research* 13(2): 53–67.

Pariser, D. (1995a). Lautrec—Gifted child artist and artistic monument: connections between juvenile and mature work. In C. Golomb (Ed.), *The development of artistically gifted children*, pp. 31–70. Hillsdale, NJ: Erlbaum.

Pariser, D. (1995b). Not under the lamppost: Piagetian and neo-Piagetian research in the arts. A review and critique. *Journal of Aesthetic Education,* 29(3): 94–108.

Pariser, D. (1997). Conceptions of children's artistic giftedness from modern and postmodern perspectives. *Journal of Aesthtic Education* 31(4): 35–47.

Pariser, D. & A. van den Berg (1997). The mind of the beholder: some provisional doubts about the U-curved aesthetic development thesis. *Studies in Art Education* 38(3): 158–178.

Park, E. & I. Bin. (1995). Children's representational systems in drawing three-dimensional objects. A review of empirical studies. *Visual Arts Research,* 21(2): 42–56.

Parsons, M. J. (1987). *How we understand art: A cognitive developmental account of aesthetic experience.* Cambridge: Cambridge University Press.

Parsons, M. J., M. Johnston & R. Durham. (1978). Developmental stages in children's aesthetic responses. *Journal of Aesthetic Education* 12: 83–104.

Pascual-Leone, J. (1988). Organismic processes for neo-Piagetian theories: A dialectical causal account of cognitive development. In A. Demetriou (Ed.), *The neo-Piagetian theories* of cognitive development: Toward an integration, pp. 531–570. Amsterdam: North Holland.

Pereira, O. G. (1972). A reinterpretation of schizophrenic graphic representation: The role of attention, set and interference. Ph.D. diss., Brandeis University.

Phillips, W., S. Hobbs, and F. Pratt. (1978). Intellectual realism in children's drawings of cubes. *Cognition* 6: 15–34.

Phillips, W. S., M. Inall & E. Lauder. (1985). On the discovery, storage, and use of graphic depiction. In N. H. Freeman & M. Cox (Eds.), *Visual order*, pp. 122–134. Cambridge: Cambridge University Press.

Piaget, J. (1928). *Judgment and reasoning in the child.* London: Routledge & Kegan Paul.

Piaget, J. (1950). *The psychology of intelligence.* New York: Harcourt, Brace.

Piaget, J. (1951). *Play, dreams, and imitation.* London: Routledge & Kegan Paul.

Piaget, J. (1954). *The construction of reality in the child.* New York: Basic Books.

Piaget, J. & B. Inhelder. (1956). *The child's conception of space.* London: Routledge & Kegan Paul.

Piaget, J. & B. Inhelder (1971). *Mental imagery in the child.* New York: Basic Books.

Piaget, J., B. Inhelder & A. Szeminska. (1960). *The child's conception of geometry.* London: Routledge & Kegan Paul.

Pickford, R. (1970). Psychiatric art. In H. Osborne (Ed.), *Oxford companion to art.* Oxford: Clarendon Press.

Pickford, R. (1982). Art and psychopathology. In D. O'Hare (Ed.), *Psychology and the arts.* London: Harvester.

Plokker, J. (1965). *Art from the mentally disturbed.* Boston: Little Brown.

Porath, M. (1997). A developmental model of artistic giftedness in middle childhood. *Journal for the Education of the Gifted,* 20: 201–223.

Pring, L. & B. Hermelin. (1993). Bottle, tulip, and wineglass: Semantic and structural picture processing by savant artists. *Journal of Child Psychology and Psychiatry,* 34(8): 1365–1385.

Pring, L., B. Hermelin & L. Heavey. (1995). Savants, segments, art, and autism. *Journal of Child Psychology and Psychiatry,* 36(6): 1065–1076.

Prinzhorn, H. (1972). *Bildnerei der Geisteskranken.* Bern: Huber.

Reith, E. (1990). Development of representational awareness and competence in drawing production. *Archives de Psychologie,* 58: 369–379.

Reith, E. (1997). Drawing development: The child's understanding of the dual reality of pictorial representations. In A. M. Kindler (Ed.), *Child development in art,* Reston, VA: NAEA

Reith, E. & D. Dominin. (1997). The development of children's ability to attend to the visual projection of objects. *British Journal of Developmental Psychology* 15: 177–196.

Reith, E. & C. H. Liu. (1995). What hinders accurate depiction of projective shape? *Perception* 24: 995–1010.

Reitman, F. (1951). *Psychotic art.* New York: International Universities Press.

Ricci, C. (1887). *The art of children.* Bologna, Italy: N. Zanichelli.

Roback, H. B. (1968). Human figure drawings: Their utility in the psychologist's armamentarium for personality assessment. *Psychological Bulletin* 70(1): 1–19.

Rorschach, H. (1954). *Psychodiagnostik.* Bern: Hans Huber.

Rosch, E. (1973). Natural categories. *Cognitive Psychology* 4: 328–350.

Rosch, E. (1975). Cognitive representations of semantic categories. *Journal of Experimental Psychology* 104: 192–233.

Rosenblatt, E. & E. Winner. (1988). Is superior visual memory a component of superior drawing ability? In L. Obler & D. Fein (Eds.), *The exceptional brain: the neuropsychology of talent and special abilities.* New York: Guilford Press.

Rosenstiehl, A. K., P. Morrison, J. Silverman & H. Gardner. (1978). Critical judgment: A developmental study. *Journal of Aesthetic Education* 12(4): 95–107.

Rouma, G. (1913). *Le langage graphique de l'enfant.* Bruxelles: Misch and Throw.

Rubin, E. (1921). *Visuell wahrgenommene Figuren.* Copenhagen: Gyldendaiske.

Rubin, L. (1984). First draft artistry: Children's drawings in the 16th and 17th centuries. In J. M. Muller (Ed.), *Children of Mercury: The education of artists in the sixteenth and seventeenth centuries.* Providence, RI: Brown University.

Rush, J. (1984). Bridging the gap between developmental psychology and art education: The view from an artist's perspective. *Visual Arts Research* 10(2): 9–14.

Sacks, O. (1993, Dec. 27). A neurologist's notebook: An anthropologist on Mars. *New Yorker,* 106–125.

Sacks, O. & R. Wasserman. (1987, Nov. 19). The case of the color blind painter. *New York Review of Books,* pp. 25–34.

Salapatek, P. (1975). Pattern perception in early infancy. In L. B. Cohen and P. Salapatek (Eds.), *Infant perception: From sensation to cognition,* vol.1. New York: Academic Press.

Sartre, J. P. (1962). *Sketch for a theory of the emotions.* London: Methuen.

Schaefer-Simmern, H. (1948). *The unfolding of artistic activity*. Berkeley: University of California Press

Schilder, P. (1935). *The image and appearance of the human body*. New York: International Universities Press.

Schubert, A. (1930). Drawings by Orotchen children and young people. *Journal of Genetic Psychology* 37: 232–243.

Selfe, L. (1977). *Nadia: A case of extraordinary drawing ability in an autistic child*. London: Academic Press.

Selfe, L. (1983). *Normal and anomalous representational drawing ability in children*. London: Academic Press.

Selfe, L. (1995). Nadia reconsidered. In C. Golomb (Ed.), *The development of artistically gifted children*, pp. 197–236. Hillsdale NJ: Erlbaum.

Simon, M. (1876). L'imagination dans la folie. *Annale Medico Psychologie* 16: 358–390.

Siren, O. (1963). *The Chinese on the art of painting*. New York: Schocken.

Smith, N. (1972). Developmental origins of graphic representation. Ph.D. diss., Harvard University. University Microfilms No. 179–9892, 1979.

Smith, N. (1983). *Experience and art*. New York: Teachers College Press.

Spelke, E. S. (1991). Physical knowledge in infancy: reflections on Piaget's theory. In S. Carey & R. Gelman (Eds.), *The epigenesis of mind: Essays on Biology and Cognition*, pp.133–170. Hillsdale, NJ: Erlbaum.

Spitz, H. H. (1973). The channel capacity of educable mental retardates. In D. K. Routh (Ed.), *The Experimental Psychology of Mental Retardation*. Chicago: Aldine.

Spoerl, D. (1940). The drawing ability of mentally retarded children. *Journal of Genetic Psychology* 57: 259–277.

Sulloway, F. (1996). *Born to rebel: Birth order, family dynamics, and creative lives*. New York: Pantheon.

Sully, J. (1901). *Studies of childhood*. London: Appleton.

Sully, J. (1910). *Studies of childhood*. Rev. ed. London: Appleton.

Sundberg, N. & T. Ballinger. (1968). Nepalese children's cognitive development as revealed by drawings of man, woman, and self. *Child Development* 39(3): 969–985.

Swensen, E. H. (1968). Empirical evaluations of human figure drawings; 1957–1966. *Psychological Bulletin* 70(1): 20–44.

Tan, L. (1993). A case study of an artistically gifted Chinese girl: Wang Yani. Unpublished Master's thesis, Concordia University, Montreal.

Tardieu, A. (1872). *Étude medico-legale sur la folie*. Paris: Bailliere.

Tarr, P. (1990). More than movement: Scribbling reassessed. *Visual Arts Research*, 16(1):46–59.

Taunton, M. (1982). Aesthetic responses of young children to the visual arts: A review of the literature. *Journal of Aesthetic Education*, 16: 93–107.

Taunton, M. (1984). Artistic and aesthetic development: Considerations for early childhood educators. *Childhood Education*, 81: 55–63.

Terman, L. (1916). *The measurement of intelligence*. Boston: Houghton Mifflin.

Thomas, G. V. & A. M. J. Silk. (1990). *An introduction to the psychology of children's drawings*. New York: New York University Press.

Thomas, G. V., R. Nye & E. J. Robinson. (1994). How children view pictures: Children's responses to pictures as things in themselves and as representation of something else. *Cognitive Development*, 9: 141–164.

Thomas, G. V., R. Nye, M. Rowley & E. J. Robinson. (2001). What is a picture? Children's conceptions of pictures. *British Journal of Developmental Psychology*, 19: 475–491.

Thorndike, E. L. (1913). The measurement of achievement in drawing. *Teachers College Record*, 14(5).

Toku, M. (2002). Cross-cultural analysis of artistic development: Drawing by Japanese and U.S. children. *Visual Arts Research*, 27(1): 46–59.

Treffert, D. A. 1989. *Extraordinary people: Understanding "idiot savants."* New York: Harper & Row.

Van Sommers, P. (1995). Observational, experimental, and neuropsychological studies of drawing. In C. Lange-Küttner & G. V. Thomas (Eds.), *Drawing and looking*, pp. 44–61. London: Harvester Wheatsheaf.

Vasari, G. (1979). *Artists of the Renaissance*. Trans. G. Bull. New York: Viking.

Viola, W. (1936). *Child art and Franz Cizek*. Vienna: Austria: Austrian Red Cross.

Walton, P. H. (1972). *The drawings of John Ruskin*. Oxford: Clarendon Press.

Wandre-Sanel, T. (1982). Children's aesthetic preferences for form and color. *Unpublished document*, University of Massachusetts.

Wang Shiqiang. (1987). *Wang Yani: Pictures by a young Chinese girl*. Munich: Prestel Verlag.

Warner, M. (1979). *Drawings of John Everett Millais*. Catalogue of an exhibition. Bolton Museum and Art Gallery, 7 July–August 4.

Warner, M. (1981). John Everett Millais, drawings from seven to eighteen years. In S. Paine (Ed.), *Six children draw*, pp. 9–22. London: Academic Press.

Webster's Third New International Dictionary. (1976). Springfield, MA: G&C Merriam Co.

Weiss, B., J. R. Weisz & R. Bromfield. (1986). Performance of retarded and non-retarded persons on information processing tasks: further tests of the similar structure hypothesis. *Psychological Bulletin* 100: 157–175.

Weisz, J. R. (1990). Cultural familial retardation: A developmental perspective on cognitive performance and "helpless" behavior. In R. M. Hodapp, J. A. Burack & E. Zigler (Eds.), *Issues in the Developmental Approach to Mental Retardation*. New York: Cambridge University Press.

Werner, H. (1948). *Comparative psychology of mental development*. New York: International Universities Press.

Werner, H. & B. Kaplan. (1963). *Symbol formation*. New York: Wiley.

Wertheimer, M. 1923. Untersuchungen zur Lehre von der Gestalt, II. *Psychologische Forschung*, 4: 301–350.

White, J. (1967). *The birth and rebirth of pictorial space*. Boston: Boston Book and Art Shop.

White, P. (1988). A comparative study of the drawing development of normal and emotionally disturbed children. Honors thesis, unpublished document, University of Massachusetts at Boston.

Willats, J. (1977). How children learn to draw realistic pictures. *Quarterly Journal of Experimental Psychology*. 29: 367–382.

Willats, J. (1981). What do the marks in the picture stand for? The child's acquisition of systems of transformation and denotation. *Review of Research in Visual Arts Education* 13: 18–33.

Willats, J. (1985). Drawing systems revisited: The complementary roles of projection systems and denotation systems in the analysis of children's drawings. In N. H. Freeman and M. V. Cox (Eds.), *Visual order: The nature and development of pictorial representation* pp. 78–100. Cambridge: Cambridge University Press.

Willats, J. (1997). *Art and representation*. Princeton, NJ: Princeton University Press.

Wilson, B. (1974). The super-heroes of J. C. Holz. *Art Education* 27(8): 2–9.

Wilson, B. (1976). Little Julian's impure drawings: Why children make art. *Studies in Art Education* 17(2): 45–61.

Wilson, B. & M. Wilson. (1976). Visual narrative and the artistically gifted. *The Gifted Child Quarterly* 20(4): 432–447.

Wilson, B. & M. Wilson. (1977). An inconoclastic view of the imagery' sources in the drawings of young people. *Art Education* 30(1): 5–11.

Wilson, B. & M. Wilson. (1979). Children's story drawings: reinventing worlds. *School Arts* 78(8): 6–11.

Wilson, B. & M. Wilson. (1982a). The case of the disappearing two-eyed profile: Or how little children influence the drawings of little children. *Review of Research in Visual Arts Education* 15: 19–32.

Wilson, B. & M. Wilson. (1982b). The persistence of the perpendicular principle: Why, when and where innate factors determine the nature of drawings. *Review of Research in Visual Arts Education* 15: 1–18.

Wilson, B. & M. Wilson. (1984). Children's drawings in Egypt: Cultural style acquisition as graphic development. *Visual Arts Research* 10(1), 13–26.

Wilson, B. & M. Wilson. (1985). The artistic tower of Babel: Inextricable links between culture and graphic development. *Visual Arts Research* 11(1): 90–104.

Wiltshire, S. (1987). *Drawings*. London: Dent.

Wiltshire, S. (1989). *Cities*. London: Dent.

Wiltshire, S. (1991). *Floating cities*. New York: Summit Books

Winner, E. (1982). *Invented worlds: The psychology of the arts*. Cambridge, MA: Harvard University Press.

Winner, E. (1996). *Gifted children: Myths and realities*. New York: Basic Books.

Winner, E. (2000). The origins and ends of giftedness. *American Psychologist* 55(1): 159–169.

Winner, E. & H. Gardner. (1981). The art in children's drawings. *Review of Research in Visual Arts Education* 14: 18–31.

Winner, E., P. Blank, C. Miller & H. Gardner. (1983). Children's sensitivity to aesthetic properties of line drawings. In D. Rogers & J. A. Sloboda (Eds.), *The acquisition of symbolic skills*, New York: Plenum Press.

Winner, E., E. Rosenblatt, G. Windmueller, L. Davidson & H. Gardner. (1986). Children's perception of 'aesthetic properties' of the arts: Domain specific or pan-artistic? *British Journal of Developmental Psychology* 4: 149–160.

Winner, E. & M. Casey. (1993). Cognitive profiles of artists. In G. Cupchik & J. Laszlo (Eds.), *Emerging visions: Contemporary approaches to the aesthetic process*, pp. 154–170. New York: Cambridge University Press.

Winston, A. S., B. Kenyon, J. Stewardson & T. Lepine. (1995). Children's sensitivity to expression of emotion in drawing. *Visual Arts Research*, 21(1): 1–14.

Wolf, D. P. & M. D. Perry. (1988). From endpoints to repertoires: Some new conclusions about drawing development. *Journal of Aesthetic Education* 22(1): 17–34.

Wolf, D. P. (1994). Development as the growth of repertoires. In M. B. Franklin & B. Kaplan (Eds.), *Development and the arts*, pp. 59–78. Hillsdale, NJ: Erlbaum.

Zeaman, D. & B. J. House. (1963). The role of attention in retardate discrimination learning. In N.R. Ellis (Ed.), *Handbook of mental deficiency*. New York: McGraw-Hill.

Zigler, E. (1969). Developmental versus difference theories of mental retardation and the problem of motivation. *American Journal of Mental Deficiency* 73(4): 536–556.

Zigler, E. & E. Butterfield. (1966). Rigidity in the retarded: A further test of the Lewin-Kounin formulation. *Journal of Abnormal Psychology* 71: 224–23 1.

Zimmerman, E. (1995). It was an incredible experience: The impact of educational opportunities on a talented student's art development. In C. Golomb (Ed.), *The development of artistically gifted children*, pp. 135–170. Hillsdale, NJ: Erlbaum.

Zsensum, Z & A. Low (1991). *A young painter: the life and paintings of Wang Yani—China's extraordinary young artist*. New York: Scholastic.

Author Index

Alland, A., Jr., 349, *363*
Allport, G. W., 320, *363*
Alschuler, R. H., 134, 281, *363*
Anastasi, A., 343, 344, *363*
Andersen, W. V., 54, 340, *363*
Andersson, I., 18, 25, 349, 351, *363*
Andersson, S. B., 18, 25, 349, 351, *363*
Andrews, J. F., 254, *363*
Arnheim, R., 11, 15, 26, 27, 30, 38, 54, 58, 66, 95, 99, 104, 166, 168, 178, 180, 197, 201, 202, 254, 268, 340, *363*
Asch, S. E., 166, *363*
Azarian, A., 157, 320, *367*

Bader, A., 280, *363*
Baillargeon, R., 360, *363*
Balla, D., 293, *363*
Ballard, P. B., 163, *363*
Ballinger, T., 344, 346, *372*
Barnhart, E. N., 8, 43, 70, 105, 110, 202, *363*, *370*
Barrett, M., 96, 296, *363*, *364*
Barr-Grossman, T., 271, 294, 296, *367*
Barroso, A., 128, 191, *366*
Beck, W., 273, *363*
Becker, L., 272, 273, *364*
Belo, J., 354, *364*
Bender, D. B., 36, *367*
Bender, L., 281, *364*
Bernheimer, R., 54, *364*
Bertrand, J., 297, *364*
Betensky, M., 320, *364*
Bettelheim, B., 320, *364*
Biehler, R. F., 135, *364*
Bin, I., 113, *370*
Blake, D., 161, *364*
Blank, P., 323, *364*, *373*
Bleiker, C., 126, 127, *364*
Bloom, B., 277, *364*

Bower, T. G. R., 16, 98, 360, *364*
Bragal, C., 271, 296, *365*
Bregman, J. D., 293, *364*
Bremner, G., 110, *369*
Britsch, G., 95, 340, *364*
Bromfield, R., *372*
Brooks, V., 16, 36, 344, *368*
Brown, L. F., 272, 273, *370*
Buck, J. N., 281, *364*
Buck, L., 272, *364*
Buehler, K., 268, *364*
Buerger-Prinz, M., *364*
Buhler, M., 273, *368*
Bunim, M. S., 99, *364*
Burack, J. A., 293, *368*
Burns, R. C., 281, 284, 287, *364*
Burt, C., 8, 52, 96, 197, 271, 281, 293, *364*
Butterfield, E., 293, *363*, *373*

Cambier, Anne, *370*
Carothers, T., 323, *364*
Carter, J. L., 294, *364*
Case, C., 320, *364*
Case, R., 126, 127, 129, 131, *364*
Casey, M., 277, *373*
Chomsky, N., 340, *364*
Cizek, F., 201, 340, *364*
Clark, G., *364*
Clements, W., 296, *364*
Corcoran, A., 135, *364*
Court, E., 16, 25, 350, *364*
Cox, M., 28, 105, 110, 113, 114, 271, 292, 296, 357, *364*, *365*, *366*
Csikszentmihalyi, M., 276, 277, *365*, *366*

D'Amico, V., 197, *365*
Dalley, T., 320, *364*
Dasen, P. R., 342, *365*
Davidson, L., 323, *373*
De Maria, M. B., 157, 320, *367*

Delbanco, D. H., 256, *365*
DeLoache, J. S., 16, 36, *365*
Dennis, S., 127, 131, *365*
Dennis, W., 343, 344, 350, *365*
Deregowsky, J. B., 349, *365*
DiLeo, J. H., 281, *365*
Dominin, D., 112, *371*
Dubery, F., 98, 99, *365*
Duncum, P., 160, 165, 205, *365*
Dunnington, G., 120, 170, 178, *367*
Durham, R., 323, *370*

Eames, K., 296, *365*
Earl, C. J. C., 294, *365*
Ellis, N. R., 293, *365*
Eng, H., 37, *365*
Exner, J. E., 133, *365*

Fantz, R. L., 360, *365*
Farmer, D., 43, 120, 136, 170, 178, *367*
Fein, S., 85, 86, 88, 163, 206, *365*
Feinburg, S., 161, *365*
Feldman, D., 254, 276, 343, *365*, *366*
Fineberg, J., 281, 340, *365*
Fischer, K. W., 126, *365*
Fisher, M. A., 293, *365*
Flavell, J., 342, *365*
Foley, J. P., Jr., 343, 344, *363*
Fortes, M., 347, 348, *365*, *366*
Freeman, N. H., 41, 56, 66, 70, 113, 114, 337, 338, 340, *366*
Freud, A., 320, *366*
Freud, S., 279, 291, *366*
Fucigna, C., 24, *366*

Gallo, F., 128, 191, *366*
Gardner, H., 136, 197, 201, 202, 270, 273, 277, 278, 319, 323, *364*, *366*, *371*, *373*
Gavich, Z., *367*

Gelman, R., 360, *366*
Getzels, J., 276, 277, *365, 366*
Ghent-Braine, L., 113, *366*
Gibson, J., 114, 166, 340, *366*
Goldsmith, L., 254, 255, 276, *365, 366*
Goldstein, F., 272, *364*
Goldstein, K., 293, *366*
Goldwater, R., 340, *366*
Golomb, A., *366*
Golomb, C., 12, 15, 18, 21, 22, 24, 25, 39, 43, 47, 48, 49, 54, 61, 65, 68, 77, 93, 94, 105, 106, 120, 128, 129, 136, 170, 178, 191, 205, 228, 245, 271, 274, 294, 296, 297, 300, 320, 325, 326, 329, 333, 335, 340, 349, 351, 360, *366, 367*
Gombrich, E. H., 54, 99, 124, 358, 359, *367*
Goodenough, F. L., 8, 28, 38, 56, 60, 203, 271, 281, 293, 340, *367*
Goodman, N., 54, 341, *367*
Goodnow, J., 99, 325, *367*
Gregorian, V. S., 157, 320, *367*
Griffin, S., 126, 127, *364*
Gross, C. G., 36, *367*
Gunther, M. K., 343, *368*

Haas, M., 9, 10, 93, 205, 228, 274, *367*
Haddon, A. C., *367*
Hagen, M. A., 99, *367*
Halkiadakis, S., 195, *367*
Hammer, E. F., 281, *367*
Hardiman, G. W., 323, *367*
Harris, D. B., 16, 25, 28, 38, 56, 60, 281, 343, *367, 368*
Hattwick, L. B. W., 134, 281, *363*
Havighurst, R. J., 343, *368*
Heaton, P., 273, *368*
Heavey, L., 273, 319, *371*
Heber, R., 293, *368*
Helmund, J., 93, 320, 330, 335, *367, 368*
Henderson, B., 126, 127, *364*
Hermelin, B., 273, 276, 293, 319, *368, 370, 371*
Hildreth, G., *368*
Hiranuma, H., 292, 357, *365*
Ho, W. C., 254, 256, *368*
Hobbs, S., *371*
Hochberg, J., 16, 36, 344, *368*
Hodapp, R. M., 293, *364, 368*

House, B. J., 293, *373*
Humphreys, J., 113, *369*

Inall, M., 110, 126, *371*
Inhelder, B., 8, 27, 37, 38, 54, 56, 104, 106, 109, 112, 129, 281, 293, 340, *368, 371*
Israelite, J., 294, *368*
Ives, W., 66, *368*

Jahoda, G., 36, *368*
Jamison, K., 281, *368*
Jiang, C., *369*
Johnston, M., 323, *370*

Kaplan, B., 11, 27, 166, *373*
Kardeman, E., 272, *364*
Kárpati, A., 205, *368*
Kasari, C., 293, *370*
Kaufman, S. H., 281, 284, 287, *364*
Kelley, D., 133, *368*
Kellman, J., *368*
Kellogg, R., 9, 12, 13, 61, 92, 340, *368*
Kennedy, J. M., 18, 25, 36, 166, *368*
Kenyon, B., 148, 323, *373*
Kerschensteiner, G., 38, 56, 61, 105, 110, 203, 204, 293, 356, *368*
Kircher, M., *366*
Kläger, M., 271, 296, 319, *368*
Klaue, K., 113, *368*
Klopfer, B., 133, *368*
Klopfer, W. G., 284, *368*
Koffka, K., 15, *368*
Koppitz, E. M., 60, 281, 284, 285, 287, *368*
Korzenik, D., 200, 336, *369*
Kounin, J., 293, *369*
Koyasu, M., 292, 357, *365*
Kramer, E., 320, *369*
Kris, E., 280, *369*
Kugelmass, S., 113, *366*

Lambert-Brittain, W., 159, 202, 340, *369*
Lane, A., 166, *369*
Lark-Horowitz, B., 8, 43, 70, 105, 110, 197, 202, 205, 323, *369, 370*
Lauder, E., 110, 126, *371*
Lawrence, L., 296, *369*
Laws, G., 296, *369*
Lee, M., 110, *369*
Lepine, T., 148, 323, *373*
Leslie, A., 360, *369*

Lewin, K. A., 283, *369*
Lewis, H., 70, 110, 197, 202, 205, 323, 335, *369*
Li, S., *369*
Light, P., 96, 113, 114, *363, 369*
Liu, C. H., 126, *371*
Lombroso, C., 279, *369*
Lovano-Kerr, J., 323, *369*
Low, A., *373*
Lowenfeld, V., 158, 159, 202, 340, 353, *369*
Luca, M., 70, 110, 197, 202, 205, 323, *369*
Ludwig, A. M., 281, *369*
Lukens, H., 24, *369*
Luquet, G. H., 8, 38, 56, 107, 281, 340, *369*
Luria, A. R., 293, *369*

MacGregor, J. M., 280, *369*
Machotka, P., 323, *369*
Machover, K., 281, 283, *369*
MacIntosh, E., 113, 114, *369*
Manale, P., 326, 329, *369*
Massey, C., 323, *364*
Matthews, J., 9, 11, 66, 275, *369*
Maynard, J., 16, 36, *365*
Maynard, S., 296, *365*
McCarthy, S., 163, *369*
McDonald, L. D., 157, 320, *367*
McElwee, E. W., 294, *369*
McKeough, A., 126, 127, *364*
Merleau-Ponty, M., 166, *369*
Mervis, C. B., 297, *364*
Michelmore, M. C., 126, *369*
Milbrath, C., 129, 205, *370*
Millais, J. G., *370*
Millar, S., 18, 25, *370*
Miller, C., 323, *373*
Moizo, C., 126, *370*
Moore, B., 323, *370*
Moore, V., 66, *370*
Morgenthaler, W., 279, *370*
Morishima, A., 272, 273, *370*
Morra, S., 126, 131, *370*
Morrison, P., 323, *371*
Muller, J. M., 205, *370*
Mundy, P., 293, *370*
Munro, T., 8, 43, 70, 105, 110, 202, *370*

Naumburg, M., 280, 320, *370*
Navratil, L., 280, *363*
Nye, R., 337, 338, *370, 372*

O'Connor, N., 273, 293, 319, *368, 370*
Okamoto, Y., 126, 127, *364*
Olson, D. R., 41, *370*
Opie, I., 353, *370*
Opie, P., 353, *370*
Ormond, R., 206, 273, *370*
Ostherrieth, P. A., *370*

Paget, G. W., 344, 345, *370*
Paine, S., *370*
Pariser, D., 105, 112, 201, 202, 268, 273, 274, *370*
Park, E., 113, *370*
Parsons, M. J., 323, 334, 338, *370*
Pascual-Leone, J., 126, *371*
Perara, J., 292, 357, *365*
Pereira, O. G., 280, *371*
Perry, M. D., *373*
Phillips, W. S., 110, 126, *371*
Piaget, J., 8, 27, 37, 38, 54, 56, 98, 104, 106, 109, 112, 129, 281, 340, *368, 371*
Pickford, R., 280, *371*
Plokker, J., 280, *371*
Porath, M., 127, 131, *371*
Pratt, F., *371*
Pratt, I. E., 343, *368*
Pring, L., 273, 319, *368, 371*
Prinzhorn, H., 279, 280, 281, *371*

Rathunde, K., 277, *365*
Reith, E., 112, 126, 129, 338, *371*
Reitman, F., 279, 280, *371*
Ricci, C., 353, *371*
Roback, H. B., 283, *371*
Robinson, E., 337, *370*
Robinson, E. J., 337, 338, *372*
Rocha-Miranda, C. E., 36, *367*
Rorschach, H., 133, *371*
Rosch, E., 30, *371*
Rosenblatt, E., 323, *371, 373*
Rosenstiehl, A. K., 323, *371*
Rouma, G., 294, *371*
Rovet, J., 66, *368*
Rowley, M., 337, 338, *372*

Rubin, E., 15, *371*
Rubin, L., 205, 320, *371*
Rush, J., 197, 323, *369, 371*

Sacks, O., 134, 272, *371*
Salapatek, P., 360, *371*
Sartre, J. P., 166, *371*
Schaefer-Simmern, H., 15, 54, 99, 189, 195, 201, 202, 271, 296, 325, 340, *372*
Schauble, L., 113, *366*
Schilder, P., 282, *372*
Schmeling, J., *367*
Schubert, A., 356, *372*
Scopesi, A., 126, *370*
Selfe, L., 96, 203, 268, 272, 273, 319, *372*
Siegel, B., *370*
Silk, A. M. J., 105, 110, *372*
Silverman, J., 323, *371*
Simmons, B., 113, 114, *369*
Simon, M., 279, *372*
Siren, O., 254, *372*
Smith, N., 9, 10, *372*
Spelke, E. S., 360, *372*
Spitz, H. H., 293, *372*
Spoerl, D., 294, *372*
Stephenson, K., 126, 127, *364*
Stewardson, J., 148, 323, *373*
Strauss, M., 16, 36, *365*
Sulloway, F., 277, *372*
Sully, J., 96, 271, 281, *372*
Sundberg, N., 344, 346, *372*
Swensen, E. H., 283, *372*
Szeminska, A., 106, *371*

Tan, L., 254, 256, *372*
Tardieu, A., 279, *372*
Tarr, P., 10, 26, *372*
Taulbee, E. S., 284, *368*
Taunton, M., 323, *372*
Terman, L., 281, *372*
Thomas, G. V., 105, 110, 337, 338, *370, 372*
Thorndike, E. L., 271, 281, *372*

Toku, M., 357, 358, *372*
Treffert, D. A., 272, 273, *372*

van den Berg, A., *370*
Van Sommers, P., 105, 110, *372*
Vasari, G., 205, *372*
Viola, W., 340, *372*

Walton, P. H., 206, *372*
Wandre-Sanel, T., 329, 333, *372*
Wang Shiqiang, 254, *372*
Warner, M., 206, 273, *372*
Wasserman, R., 134, *371*
Weiss, B., *372*
Weisz, J. R., 293, *372*
Werner, H., 11, 27, 166, *373*
Wertheimer, M., 171, *373*
Whalen, S., 277, *365*
White, J., 99, *373*
White, P., 318, *373*
Willats, J., 66, 98, 99, 101, 102, 103, 105, 106, *365, 373*
Wilson, B., 70, 125, 160, 165, 197, 201, 203, 205, 341, 353, 355, *373*
Wilson, M., 70, 125, 160, 165, 197, 201, 203, 205, 341, 353, 355, *373*
Wiltshire, S., 272, 273, *373*
Windmueller, G., 323, *373*
Winner, E., 136, 197, 201, 202, 205, 268, 272, 276, 277, 323, *364, 366, 371, 373*
Winston, A. S., 148, 323, *373*
Winter, A., 113, *366*
Wohlwill, J., 342, *365*
Wolf, D., 24, *366*
Wolf, D. P., *373*
Wolff, S., 273, *368*

Zeaman, D., 293, *365, 373*
Zernich, T., 323, *367*
Ziegler, E., 293, *363, 368, 373*
Zimmerman, E., 205, 275, *364, 373*
Zsensum, Z., *373*

Subject Index

Abstract designs, 92–97
Abstract line patterns, 26
Abstract properties, early graphic forms, 30
Action
 gifted child artists, 215, 223, 244, 248
 horse drawings, 86, 87
 human figure drawing, 65, 71–77
 verbalizations, 11
Action–in-progress, 11
Action–representation, 11
Action–symbolism, 11, 26
Adults, 37, 68, 72, 201, 349
Aerial views, 80, 81, see also Bird drawings
Aesthetics, 196–197, 209, 268
Affect
 color link and child's art, 133, 139–149
 expression in drawing, 157, 158–160
Age, 196–197, 305, 307
Aggregate, 14
Aggression, 162–163
Airplanes, 234, 236
Alignment strategies
 compositional strategies, 180–182, 183, 189
 compositional trends in development, 170–174
 drawings
 gifted children, 212, 234, 235
 emotionally disturbed versus normal children, 300, 301, 302, 304
Ambiguity, 61, 63, 103
American Indian, 343
American Indian Petroglyphs, 53
Anatomical correctness, 51
Anchoring, figures, 174
Anger, 139, 140, 141

Animals
 differentiation of form/graphic models, 77–85
 emotionally disturbed versus normal children, 310
 gifted children
 Amnon, 211, 213, 214
 Eytan, 232, 233, 234, 235, 246, 250
 Varda, 221, 222
 Yani, 255
 two-eyed profile, 353, 354
Anxiety, 288
Apple picking drawings, 120, 121, 186–187
Arbitrary color, 308, see also Color
Arm(s)
 choice of compositional strategy, 183, 187
 drawings by children in preliterate societies, 346, 355, 356
 location/orientation and figure completion, 324
 movement/action and human figure drawing, 72, 74
 portrayal of feelings, 141, 147
 tadpole figures, 47, 48, 50, 52, 55
Art
 as form of illusion, 358
 child's conception, 337–339
 diagnosis of mental illness, 280–281
Art critic, child as
 attitudes toward own work, 335–337
 color, detail, proportion, dimensions, 326–329
 compositional preferences, 329–335
 conception of the arts, 337–339

 figure completions and preferences, 324
 line overlap, 324–326
Art teachers, 284
Art therapy, 319–321
Artist, pursuit of careers, 276–277
Artistic development theory, 95
Artistic practices, 329
Artistic work, similarity to child's own, 330–331
Associationistic approach, 282–284, 291
Asymmetry, 178, see also Symmetry
Athletes, 246, 252
Attentional deficits, 305
Attitudes, child's, 26, 335–337
Attributes, early graphic forms, 27
Atypical–normal children, 292
Autism
 savant artists, 272, 273, 274, 276
 Nadia, 203, 262–271
Autistic savants, see Autism, savant artists
Autoplastic experience, 158–159
Awareness, 8, 25, 69

Background, 26, 219–220
Balance
 composition
 choice of strategy, 190–191, 192
 problems, 194–195
 trends in development, 177, 178
 drawings of gifted children, 246, 252
Bali, 354–355
Bang-dots, 10
Baseline, 189
Beak, 80, see also Bird drawings
Beatles, 251
Bedouins, 16
Biafra, 222, 223
Bias, 42, 114, 340, 356

Bigness, 49, *see also* Tadpole figure(s)
Bipolar affective disorder, 314, 315
Bird drawings
 age, 78, 80, 81, 83
 gifted children, 211, 212, 258
Birthday party
 child in role as art critic, 330, 332
 choice of compositional strategy, 187–188
 drawings of gifted children, 212
 emotionally disturbed versus normal children, 303, 306, 309, 310, 311, 312, 313, 314
 mentally retarded versus normal children, 293, 294
 spatial techniques, 121–122, 123
Bizarre features, 311, 312
Black children, 346
Boat, 232, 234
Body anxiety, 286
Body image, 1
 hypothesis, 282–283, 285, 291
Body length, 86, 87
Body parts
 origins of early graphic forms, 18–20, 24
 tadpole man, 41, 42, 43
Body posture, 223
Body proportion effect, 42, 49–56, *see also* Tadpole figure(s)
Borderline psychosis, 315–317
Bottle-bodies, 355, 356
Breath of life, 260
Brightness value, 138
British Guinea, 346
Brush, 9–10
 strokes, 254
Bubbles, 141–142
Building blocks, early graphic forms, 12, 13
Bunk, three-tiered, 153, 154
Burial, 153, 226, 228
Buses, 238, 239

Canonical orientation, 221
Career paths, artistically gifted children, 274–278
Caricatures, 215
Cars
 differentiation of form/graphic models, 90–91, 92
 drawings of gifted children, 231, 232, 234, 237, 242, 243, 246, 247

Cats, 80, 82
Cement mixer, 232, 234, 235, 243
Centering strategies, 174–177, 178, 183, 190, *see also* Composition
Central conceptual structure, 126–127, 128
Charcoal drawings, 355
Chase, depiction, 71
Chicken, 263, 265
Chinese artistic traditions, 254–258, 260, *see also* Gifted child artists
Circle(s)
 animal drawings, 77
 function and human figure drawings, 60, 63
 origins of early graphic forms, 15, 27
 –oblong, 30, 34
 plant drawings, 89
Circular forms, 90, 92
Circular whirls, 12
Cityscapes, 243, 246, 249, 251
Classification, mental retardation, 293
Clay models, 348–349
Closed-line shape, 15
Closure, 107
Cognitive deficit, 1, 54, 346
Cognitive development, 337
Cognitive skills, 25
Cognitive view, 106
Coherence, 293
Coherent space, 226
Color
 developmental trends, 134–138
 children in preliterate societies, 349
 emotionally disturbed versus normal children, 308, 318
 gifted child artists
 Amnon, 209, 213–214, 215
 Eytan, 231, 246, 250
 Varda, 219, 222, 223
 Yani, 254
 use, 259, 261
 portrayal of feelings in drawings, 133, 139, 146, 147, 150
 preference and child's role as art critic, 326–329
 projective approach to personality link to child's art, 281

Color/affect/expression
 child's expression of affective meaning, 158–160
 conveying meaning, 157–158
 drawings
 child with incurable illness, 149–151
 Holocaust, 155–156
 Terezin, 152–154
 motivation, 164–168
 narrative drawings, 160–164
Coloring in
 animal drawing, 80, 82
 completion tasks and composition, 194, 195
 drawings of gifted child artist, 209
 horse drawings, 86, 87
 human figure drawing, 67
Combine, 14
Common symbols, 288–289
Communication skills, 262
Competence
 development and differentiation of forms/graphic models, 58
 emotionally disturbed versus normal children, 305
 gifted child artists, 230, 255, 256
 portrayal of feelings in drawings, 147
 task demands, age, and choice of compositional strategy, 191
Completion tasks, 40, 192–194, 195
Complexity
 child's role as art critic, 324, 325, 326, 331–332
 compositional trends in development, 177
 development in drawings, 95
 differentiation of forms/graphic models, 59
 drawings of emotionally disturbed versus normal children, 301
 gifted child artists, 231, 235–237, 238, 249, 258
Compositional organization, 176
Compositional preferences, 329–335, *see also* Art critic, child as
Compositional strategies
 completion tasks and balance problems, 192–195

drawings of emotionally disturbed versus normal children, 299–305, 318
drawings of gifted child artists, 255
effects of repeated trials, 195–196
function of in visual arts, 169
neo-Piagetians approach to representational space, 129–130
Compositional trends, 170–180
Compressor drawings, 234, 238
Concentration camp, 152–154
Conceptual deficits, 203
Conceptual development, 289–290
Concrete-operational period, 109, 110, 125
Conduct disorders, 315, 316
Configurational signs, 340
Conflict, 51
 resolution, 160
Conflictual feelings, 313
Congenitally blind children, 18, 25
Conservative tendency, 63
Content analysis, 313–319
Continuities, 76, 107
Continuous outline, 69
Continuous rotations, 10
Contour marks, 15
Contourless faces, 346
Contourless model, 31, 33, 34
Contour-lines, 86, 87
Contrast, 214
 principles, 172
Control, objects, 164
Controlled shape, 24
Coordinated orientations, 118
Copyist notions, 54
Copyist version, 3
Courtship patterns, 133
Cow drawings, 232, 234, 235
Crayons, 336, see also Art critic, child as; Media
Criteria, serial-order hypothesis, 42
Critique, drawings, 332, see also Art critic, child as
Crossed-line patterns, 13
Cube, representations, 104, 105
Cubist method, 214
Cues, 43, see also Memory; Tadpole figure(s)
Culture
 images and portrayal of feelings in drawings, 148

influence on human figure drawing, 65, 70
standards and gifted child artists, 260
variables
 drawings of children in preliterate societies, 344–352
 group models, 353–361
 overview, 340–343
 studies in the Goodenough tradition, 343–344
Curved lines, 30
Czech Republic, 152–154

Dark–white contrasts, 255
Decentration, 117
Decoration, 209, 226, 246, 250, see also Gifted child artists
Defect hypothesis, 2, 39, 293, 294
Defective drawings, 56
Defensive mechanisms, 288
Deficits, representation of objects, 2
Demarcation, 63
Denotational system, 105, 106
Dense lines, 12, see also Line(s)
Depressing themes, 311, 314, 315
Depth cues, 114, 332
Design stage, 14
Designs, gifted child artists, 219, 226
Detail, see also Complexity; Gifted child artists
 child's role as art critic, 326–329, 332
 differentiation of forms/graphic models, 58
 horse drawings, 86, 88
 house/car drawings, 90, 91, 92
Development
 accelerated and drawings of Nadia, 269
 compositional trends in visual arts, 170–180
 differentiation of forms/graphic models, 58
 drawing systems and space, 101–106
 drawings by children in preliterate societies, 347
Developmental analysis, 284–287, 291, see also Personality, art link and diagnostics
Developmental hypothesis, 294, see also Mental retardation
Developmental patterns, 91

Developmental stages, 106, see also Drawing systems
Developmental trends, 134–138, see also Color
Diagonal alignment, 100, see also Alignment strategies
Diagonal directionality, 80
Diagrams, 13
Dictation method, 18–20
Differentiation
 animal drawing, 79
 compositional trends in development, 176
 drawings of emotionally disturbed versus normal children, 305–308
 forms/graphic models
 abstract designs, 92–97
 animal drawings, 77–88
 definition, 58
 houses and cars, 90–92
 human figure drawing, 60–77, see also Human figures
 plants, 88–90
 gifted child artists, 208, 209, 232, 233, 234
 paper and space, 117
 principles and drawings by children in preliterate societies, 352
 serial-order hypothesis, 47–48
Dimensionality, 59
Dimensions, preference, 326–329, see also Art critic, child as
Dinosaurs, 231
Directionality, 64
Directions of space, 100, see also Space
Discontinuities, 76
Dispersal, figures, 99
Disproportionality, 50, 51, 221, see also Proportionality; Tadpole figure(s)
Distance–height differentiation, 125
Distorted shapes, 104
Distorting assimilation, 38
Divergent perspective, 240
Doom, impending, 151
Dot-markings, 12
Down's syndrome, 271, 296
Draw-a-Man test, 273, 281, 282, 290, 343–344
Draw-a-person task, 40
Drawing, planning, 181, 183, 184

Drawing-model correspondence, 108
Drawing-on-dictation, 18–20
Drawing systems, space, 101–106
Dreams, 139, 141–142, 143, 144, 145, 319
Dungeons and Dragons, 251
Dynamic balance, *see* Balance

Easel paintings, 93, 134
East Africa, 351
Egypt, 343, 355, 356
Emotional depression, 319–320
Emotional disturbance
 children's drawings, 281
 drawings of children, 297–299
 color, 308
 composition, 299–305
 content analysis, 313–319
 figural and object differentiation, 305–308
 location and size of figures, 308–309
 personal and idiosyncratic features, 310–313
Emotional indicators, 285, 287
Emotions/feelings, 61
Empowerment themes, 319
Empty spaces, 10
Enclosed contours, 174–175
Encyclopedia Britannica, 231, 243
End-anchor bias, 48, *see also* Bias
End-junctions, 105
Environment, 134, *see also* Color
Equilibrium, dynamic, 178
Equivalence concept, 29–30, 34
Errors, 42, 55, 108
Ethnic groups, 345
Euclidean relations, 107, 109
Events, children's representation, 2
Evolution, drawings, 54, 226, 238
Execution drawings, 154
Experience, 16, 18, 25, 128
Explicit/implicit knowledge, 337
Exposure, to artists, 205
Eye control, 12
Eyebrows, 140
Eyelashes, 140, 141

Faceless figures, 226
Fairy theme, 221, 222, 223, *see also* Gifted child artists
Fairytale theme, 163–164, 220, *see also* Gifted child artists
Familial retardates, 293

Familiar objects, 16
Family
 aptitude, 218, 230
 arrangement of figures and spatial techniques, 118
 child's role as art critic, 330, 332
 compositional strategy and task demands, 180–182
 compositional trends in development, 172, 173
 drawings of emotionally disturbed versus normal children, 301, 305, 306, 309, 314, 315
 drawings of gifted child artists, 232, 233, 254
 tadpole figures
 body proportion effect, 52
 serial-order hypothesis, 47–48
Fantasy theme, 161, 165, *see also* Gifted child artists
Far–near relation, 113
Faults, tadpole figures, 37, *see also* Tadpole figure(s)
Favorite subjects, 27
Feelings, portrayal, 139–149
Felt media, 131
Female figure, 349–350, 352
Fifth graders
 movement/action and human figure drawing, 72, 73, 74, 75
 portrayal of feelings in drawings and dreams, 144, 145, 146
Figural differentiation
 emotionally disturbed versus normal children, 305–308
 human figure drawing, 60–66
Figural orientation, 66–68
Figural overlap, 111
Figure alignment, 99, *see also* Alignment strategies
Figure completions, 324
 task, 20
Figure construction, 69–70
Figure drawing, 285
Figure–ground relations, 15, 99, 124, 189
Figure location/size, 308–309
First graders
 child's role as art critic, 326, 331–332
 compositional trends in development, 172, 176

dreams and portrayal of feelings in drawings, 142, 143
movement/action and human figure drawing, 71, 72, 73
partial occlusion and spatial techniques, 115
Fish drawings
 child's age, 78, 80, 81, 83
 gifted child artists, 232, 233
Flat surface, 29
Flowers, 89, 90, 258
Fold-out drawings, 108
Folk art, 166
Foreshortening, 112, 243
Form, perceptual judgments, 133
Form overlap
 arrangement of figures and spatial techniques in drawing, 121
 gifted child artists, 215
 horse drawings, 86, 88
 human figure drawing, 67, 68
 partial and choice of compositional strategy, 189
 representation of space and drawing development, 110–111, 113
Form puzzles, 295
Formal education, art, 153, 218, 228, 230
Fourth graders
 dreams and portrayal of feelings in drawings, 144, 145, 146
 movement/action and human figure drawing, 72, 74, 75
Framing, 175, 180–181, 209
Free-drawing, 21, 22–23, 40, 93
Frequency, color use, 136–137, *see also* Color
Freud, S., 279–280
Frightening dream, *see* Dreams
Frontality
 gifted child artists, 209, 213–214, 221
 house drawings, 90, 92
 human figure drawing, 66–68, 70
 portrayal of feelings, 140
 spatial techniques, 115, 117
Front–behind relations, 112

Garden
 color selection by preschoolers, 137

compositional strategy, 188–189, 190
drawings of emotionally disturbed versus normal children, 302, 307, 309
spatial techniques, 120–121, 122
Gas chamber, 156
Gender, 65, 163–164
Geometric figures, 27
Gestural patterns, 9–10
Ghana, 347, 348
Ghosts, 146, 147
Gifted child artists
career paths, 274–278
diverse trajectories, 258–262
drawings
Amnon, 207–218
Eytan, 230–254
Nadia, 262–271
savant artists, 271–273
Varda, 218–230
Yani, 254–258
overview, 201–207
reassessment of current findings, 273–274
Giftedness, 201–202
Giraffe models, 78, 79, 80, 82
Global forms
body proportion effect and drawing of tadpole figures, 51, 52, 53
differentiation of forms/graphic models, 59
drawings of gifted child artists, 208, 219, 255
origins of early graphic forms, 28, 29, 31–32
Golomb's Revised Compositional Scale, 130
Goodenough, F. L., 343–344, see also Draw-a-Man test
Graphic conventions, 346
Graphic devices, 203
Graphic forms, origins of early
invention of representational system, 26–36
mark-making and scribble ventures, 9–14
transitions and discovery of shape, 15–26
Graphic illustrations, 98
Graphic logic, 38–39, 123, 290
Graphic meaning, 8
Graphic reasoning, 56

Graphic representational tasks, 293
Graphic rule system, 56
Graphic shapes, 2
Graphic simplicity, 52
Graphic symbols, 346
Graphic vocabulary
differentiation of forms/graphic models, 59
gifted child artists, 202, 221, 224
origins of early graphic forms, 12, 14
Gridlike spatial principles, 173, 178, 208
Grief, 226, 228
Ground identification, 99
Ground plane, 187, 208
Ground–sky distinction, 124
Group models, 353–361, see also Culture
Grouping principles
compositional strategy, 181, 184, 189
compositional trends in development, 174–177, 178

Hair, scribbly, 283
Halloween themes, 145
Handedness, 135, see also Color
Happy dream, see Dreams
Happy, 139, 140, 141
Harm, 145, 146
Head, 140
Helicopters, 232, 235, 238
Hidden lines, 111
Hidden shapes, 14
Hide and Seek game, 114–115, 116, 118
Hierarchical relations, 182
Himba tribe, 18, 351–352
Hindu mythology, 354
Holocaust, 155–156, 217
Horizontal alignment, 99, 100, 115, 118, 119, 120, 121, see also Alignment strategies
Horizontal arc, 9
Horizontal axis, 61, 124, 172
Horizontal interposition, 114, 115
Horizontal oblique projection, 236, 237, 240, see also Projective drawings
Horizontal orientation, 78

Horse drawings
differentiation of form/graphic models, 85–88
gifted child artists, 203–204
Nadia, 262, 263, 264, 265, 267
Hospitalized children, 152
House drawings, 90–91, 92, 211, 306
Human anatomy, 217, 246, 251
Human face, 54, 225, 246, see also Faceless figures
Human figures
differentiation of forms/graphic models, 60–66
drawings by children in preliterate societies, 344–345
drawings by normal versus mentally retarded children, 295
gifted child artists, 209, 210, 221, 222, 232, 233, 234, 260, 263, 266
origins of early graphic forms, 16, 27–29
Humor, 245
Hunters, 232, 234

Idiosyncratic features, 310–313, see also Emotional disturbance
Illness, incurable, 149–151
Imagery, spatially-ordered, 41, see also Tadpole figure(s)
Immature concept, 40, see also Tadpole figure(s)
Impulse control, 134, see also Color
Incidence, gifted child artists, 204–206
Indiscriminate color, 308, see also Color
Individual differences, 10
Information processing, 127, 129
Innate factors, culture concepts, 340, 356
Inner feelings, 320
Inner self, 1
Inscriptions, dreams, 147
Insects, 234, 236
Inside story, depiction, 66, 67
Instinctual desires, 280
Instructions, 39–41, 46, 47, see also Tadpole figure(s)
Intellectual realism, 107, 108, 109, 110

Intelligence quotient (IQ)
 artistic giftedness, 272
 correlation with drawings of
 human figures, 273
 drawings of emotionally
 disturbed versus normal
 children, 298, 305, 307, 319
 growth and Piaget's view of
 children's art, 1
 prediction by Draw-a-Man test,
 343, 344
Intention, 65
Intentionality theory of pictures, 337
Inter-/intraindividual differences,
 273
Interior scenes, 122
Interpretation, abstract designs, 93,
 94
Interpretive signs, 287–289
Interventions, 269–270
Intrinsic factors, 96
Intrinsic order, 31
Inventions, drawing systems, 103
Invisible movements, 10
IQ, see also Intelligence quotient
Islamic torso, 355, 356
Isometric projection, 238, 239, 240,
 242, 243, 245, see also Gifted
 child artists
Israel, 155

Jamaica, 346
Japan, 357
Jeep, 232, 235, see also Cars
Jerusalem, 243
Judgment tasks, 51

Kenya, 16, 350
K-F-D, see Kinetic family drawings
Kindergarteners, 325, 331–332, 335,
 336
Kinesthetic sensations, 159
Kinetic family drawings (K-F-D),
 287–292
Klee, P., 206
Kneeling, 74
Knowledge, –visual perception, 125
Koppitz, E. M., 284–287

Labeling, 49
Lake, 331, 332
Learning effects, 294
Left–right directionality, 100, 101
Legs, 72, 74, 141

Likeness, 14, 63, 164
Likes/dislikes, 196
Line-actions, 12
Line(s)
 animal drawing, 77, 85
 configurations, 10
 drawings by gifted child artists,
 215, 261
 origins of early graphic forms, 30
 overlap, 306, 324–326
 patterns and abstract designs, 93
 portrayal of feelings in drawings,
 139, 141, 147
 two-dimensional use and horse
 drawings, 85, 86
Local art traditions, 346–347
Local true color, 308
Localization skills, 24, 25
Location, figures, 99, 308–309
Logic, children's art, 1
Longitudinal studies, 10, 93, 276
Lowenfeld, V., 158–160
Luo tribe, 350

Machover, K., 282–284, see also
 Projective drawings
Maleness, 352
Manga cartoon models, 357
Markers, 336
Mark-making, 9–14, 18
Maturity, 203, 228
Meaning, 11, 15, 27, 60, 157–158,
 see also Pictorial space,
 creation/meaning
 communication
Media
 choice and tadpole figures, 39–41
 color use, 138
 differentiation of forms/graphic
 models, 58
 gifted child artists, 213–215,
 224–226, 254
 mastery, 259
 neo-Piagetians approach to
 representational space, 129,
 130
Memory, 42–43, 27, 52, 231–232
Mental retardation
 drawings of children, 292–297
 drawings of savant artists, 271
 Nadia, 262–271
Metaphors, 148, 150
Millais, John Everett, 205–206
Missing dimension, 123

Mistakes, 37
Mixed profile, 86, 87
Mixed views, 108
Model effects, tadpole figures,
 39–41
Modifications
 differentiation of forms/graphic
 models, 58
 horse drawings, 86, 87
Monitoring, 191
Monkeys, 255–256
Monochromatic color, 308, see also
 Color
Mood state, 147, 222, 223
Moonfaces, 355, 356
Motion
 drawings of gifted child artists,
 217, 242, 263, 266, 267
 projective approach to
 personality link to child's art,
 288
Motivation, child's drawing
 emotionally disturbed versus
 normal children, 305
 expression, 164–168
 gifted artists, 261
 graphic development, 60
 human figure, 77
 portrayal of significant events,
 157
 representation of objects, 3
Motor activities, 8
Motor coordination, 230–231
Motorcycle, 242
Mouth, 139, 140, 147, 283
Movement, 71–77
Moving van, 237, 241–242
Multiple choices, 333
Multiple intelligences theory, 319

Naïve perspective, 102
Namibia, 349, 351–352
Narratives
 affect and child's expression,
 160–164
 repeated trials effect on
 composition, 197
 teacher reading task and choice
 of compositional strategy,
 184, 185
 visual and gifted child artists, 203
Native American, see American
 Indian
Nativism, 340

Natural elements, 53
Naturalism, 226, 227
Nature, 3, 255
Neo-Piagetians, 126–132
Nepal, 344, 346
Neural structures, 270
Nightmares, 320, *see also* Dreams; Events
Nightmarish events, 152–153
Nonpictorial patterns, 92
Nonpossessive attitude, 26
Non-Western societies, 343–344, *see also* Western societies
Nose, 283, 346

Object(s)
 child's concept, 40
 depiction, 38
 drawing by emotionally disturbed versus normal children, 305–308
 likeness and animal drawing, 83, 85
 origins of early graphic forms, 12, 25
 representation in drawing, 2
 transparency, 111
Oblique lines, 104
Observations, 261, *see also* Gifted child artists
Obstruction of view, 115
Occlusion
 drawings of gifted child artists, 214
 partial and choice of compositional strategy, 182, 189
 spatial techniques in drawing, 123
 technique and representation of space, 108, 113–114
Oil pastels, 214, 220
Openness, 107
Open-trunk figures, 61, 64
Oral emphasis, paranoia, 283
Ordering, parts, 107
Organic impairment, 293
Organization principles, 180, 213, 220, 245, 294
Orientation, body parts, 20
Originality, 219, 259
Ornamentation, 209, 211, 212, 226
Orthographic projections
 gifted child artists, 213, 232, 234, 236, 259

representation of space and drawing development, 110
space and drawing systems, 102
Outcomes, 128
Outer space, 161–163
Outline figures, 13, 15
Oval, 27
 –circle, 16
Overlap, 102, 182, 196

Painterly style, 224
 -impressionistic style, 260
Painting easel, 282
Paintings, 134–135, 323
Paints, 336
Paper-space, 174, 220
Parallelograms, 104
Paranoia, 283
Partial alignment, 171, 172, 180, 188, 301, *see also* Alignment strategies
Partial coordination, 116–117
Partial occlusion, 115, *see also* Occlusion
Pattern repetition, 178
Patterning process, 13
Peer group, 346, 353, 354–355
Pencil sketches, 225, 259, 336
Perception, 14, 29, 30, 38
Perceptual–motor control, 293
Perceptual relativism, 358–359
Perceptual–spatial systems, 180
Performance, 40, 42
Performance bias, 52, *see also* Bias
Personal features, 310–313
Personality, art link and diagnostics
 art therapy with children, 319–321
 drawings of emotionally disturbed children, 292–299
 color, 308
 composition, 299–305
 content analysis, 313–319
 figural and object differentiation, 305–308
 location and size of figures, 308–309
 personal and idiosyncratic features, 310–313
 projective approach to children's drawings, 281–292
Persons, portrayal, 37
Perspective
 child's role as art critic, 333–334, 335

drawings of gifted child artists, 215
projection, space, and drawing systems, 102, 103, 105
representation of space and drawing development, 109
Piaget
 drawing development, 106–114
 view of children's art, 1
Picasso, P., 206
Pictorial intelligence, 230
Pictorial plane, 99
Pictorial space, *see also* Space
 creation by children's drawing/painting, 98
 creation/meaning communication
 completion tasks and problem of balance, 192–195
 compositional trends in development, 170–180
 effects of repeated trials, 195–200
 task demands and choice of compositional strategy, 180–189
 drawings of gifted child artists, 208, 209, 213, 220, 224
Picture books, 231, 262
Picture plane, 318
Pincer grip, 10
Planning, drawings, 186–187, 189, 209, 219
Plant–child contact, 72, 73, 74
Planting, flower, 72–73
Plants, 88–90
Plasticine, 61
Play-Doh, 40, 61, 62
Playing, 121, 183–184, 309
Playing ball, 48, 120
Plexiglas board media, 128, 129, 130
Police car, 237
Postural differentiation, 141, 142, 147
Postures, 246, 247, 252
Power theme, 161
Practice
 composition
 effects of repeated trials, 196
 neo-Piagetians approach to representational space, 128
 trends in development, 177
 differentiation of forms/graphic models, 59
 origins of early graphic forms, 20, 21, 25

Preliterate societies
 comparisons of artwork with
 child's art, 340
 drawings by children, 344–352
Prerepresentational drawing, 20,
 22–23
Preschoolers
 animal drawing, 77–78
 body proportion effect and
 drawing of tadpole figures,
 52, 55
 color selection, 136–137
 composition, 172, 175, 181,
 184–185
 cultural variability and group
 models in Japan, 357, 358, 359
 line overlap and child's role as art
 critic, 324, 325, 326
 origins of early graphic forms,
 34
 projective approach to
 personality link to child's art,
 282
Presymbolic activity, 22
Primary colors, 136, see also Color
Primitive art, 340
Primitive mentality, 37
Primitive shapes, 311
Primitive unit-formation, 21–22
Primitivity, 293, 300, 304, 305
Primordial circularity, 20, 32, 61
Principle of differentiation, 31
Principle of gravity, 99
Principle of separation, 99
Printout hypothesis, 291
Problem solving
 choice of compositional strategy,
 186, 187, 191
 concrete–operational skills and
 planning a drawing, 131–132
 construction of tadpole figures,
 40
 drawings
 children in preliterate societies,
 346
 normal versus mentally
 retarded children, 295
Prodigy status, 274
Production errors, 42, 49
Profiles
 cultural variability and group
 models, 353–355
 face drawings in preliterate
 societies, 346

–head and human figure drawing,
 66, 67
horse and drawings by gifted
 child artists, 213
movement/action and figure
 drawing, 71–72
orientation and choice of
 compositional strategy, 183
Projection systems, 236, 237, 240,
 241, 242, 243
Projective drawings
 children drawings and
 psychological significance,
 281–292
 mastery and gifted child artists,
 259
 representation of space and
 drawing development, 107,
 109
Projective geometry system,
 101–106
Proportionality
 animal drawing, 82
 child's role as art critic,
 326–329
 differentiation of forms/graphic
 models, 59
 gifted child artists, 209, 214, 222,
 223
 normal versus mentally retarded
 children, 293
Prototypical humans, 209, 210
Proximity
 composition, 170, 171, 173, 184
 emotionally disturbed versus
 normal children, 301
 figures and children's drawing,
 99
 representation of space and
 drawing development, 107
Proximity principle, 189, 191–192
Psychological understanding, 226
Push-pull action, 9, 10

Racial identity, 67
Rainbows, 142
Random distribution, 170, 171
Reading off, 15
Realism
 child's role as art critic, 332
 drawing style, space, and child
 art, 124
 dream distinction and portrayal
 of feelings in drawings, 141

gifted child artists, 222, 223, 225,
 230, 251, 252, 261
milestone in drawing
 development, 131
projective approach to
 personality link to child's art,
 290–291
primitive deviations and
 representation of objects in
 drawing, 2
serial-order hypothesis and
 drawing of tadpole figure,
 42
use of color and age, 137, 138
Reasoning processes, 38
Rectangular shapes, 63, 64
Relationships, meaningful, 170,
 173, 189, 191–192
Relative position, 112–124
Relative size, 68
Repeated trials, 195–200
Repetition, 209, 245, 269
Replications, 38, 43
Representation
 abstract forms as starting point,
 95
 child's role as art critic, 332,
 333–334
 differentiation of forms/graphic
 models, 58
 equivalences and cross-cultural
 data, 360
 gifted child artists, 203, 259
 drawings of Amnon, 208, 209,
 211, 212
 drawings of Eytan, 232, 233
 drawings of Varda, 220, 221
 movement/action in human figure
 drawing, 71–72
 origins of early graphic forms, 12,
 15–16, 18
 invention, 26–36
 portrayal of feelings, 150
 space and stages of drawing
 development, 107
Representational figures, 20, 21, 25,
 78, 345
Representational function, 137,
 138, see also Color
Representational models, 318
Representational status, 37
Representational theory, 39, 340
Representational thinking, 295
Retinal image, 2

386 INDEX

Retinal projection, 104
Return upward, 43, 44
Reversible figure, 101
Right-angular configuration
 animal drawing, 80, 82
 arms and human figure drawing,
 64
 compositional strategy, 188
 cube, space, and drawing
 systems, 104
 origins of early graphic forms, 10,
 11
Roadways, 246
Rock caves, 349
Romancing, 24, 25, 35
Romans, graffiti, 353
Rooster, 263, 265
Rorschach test, 133
Rotational action, 11
Rubin, E., 101
Rules, 3, 29, 30–31, 33
Rural children, 355

Sadness, 139, 140, 141, 155
Samburu tribe, 350–351
Savant artists, 271–273
Scary dreams, see Dreams
Schematic vocabulary, 202
Science fiction theme, 161–163
Scribble-localization, 25
Scribble pictures
 drawings of gifted child artists,
 207–208, 219
 horse drawings, 85, 86
 origins of early graphic forms, 8,
 9, 10, 12, 13, 22
Sculpture, 228–229
Seasons, 255
Second graders
 child's role as art critic, 331–332
 dreams and portrayal of feelings
 in drawings, 144, 145
 movement/action and human
 figure drawing, 71, 72, 74
Seder, 154
Segmented approach, 70
Self-image, 283
Self-portraits, 320
Semantics, 26
Separation, 107, 173
Serial-order hypothesis, 41–49, see
 also Tadpole figure(s)
Sexual–anal references, 311, 314

Sexual difficulties, 283
Sexual organs, 347, 348
Shading
 animal drawing, 80
 drawings by gifted child artists,
 215, 246, 250
 horse drawings, 86, 87
 projective approach to
 personality and child's art,
 286
 plant drawings, 89
Shadow play, 354–355
Shadow puppets, 354–355
Shape
 discovery and origins of early
 graphic forms, 15–26
 drawings of gifted child artists,
 219, 242, 259
 horse and transformations in
 drawing, 87
 portrayal of feelings in drawings,
 139
 projective approach to
 personality and child's art,
 281
Siberia, 356
Side view, 70
Side-by-side arrangement, 117–118,
 see also Alignment strategies
Similarity principles, 172
Simple alignments, 172, 182, see
 also Alignment strategies
Single color, 136–138, see also
 Color
Single line, 110
Single-outline drawings, 80, 83
Sixth graders, 144, 145, 146
Size
 child's role as art critic, 328, 332
 compositional strategy, 181,
 184–185, 186, 187
 differentiation of forms, 59,
 68–69
 drawings of emotionally
 disturbed versus normal
 children, 308–309
 gifted child artists, 222, 223
 symbolic role and child's
 expression in drawing,
 159–160
Skylines, 172, 213
Snakes, 78, 81
Social reality, 318

Socially significant themes, 226
Sociocultural milieu, 350
Socioeconomic status, 275–276,
 298
Solidity, 80, 82, 112
Sophistication, 202, see also Gifted
 child artists
Space
 drawing systems, 101–106
 neo-Piagetian approach to
 children's drawing, 126–132
 Piaget's account of drawing
 development, 106–114
 task effects, 114–126
Spaceship, 247
Spatial concepts, 113
Spatial differentiation, 195, 99–100
Spatial–geometric concepts, 123,
 126
Spatial ordering, 30
Spatial organization, 172
Spatial principles, 99
Spatial problems, 66
Spatial relationships, 98, 147, 214,
 255
Spatial representational
 competence, 128
Spatial–representational
 intelligence, 109
Spatial–temporal patterns, 43
Spirit, life-like, 255
Sports events, 246, 252
Square outlines, 90, 92
Stability, 63–64
Stick figures, 61, 62, 347, 348, 349
Stooping, 74, 75
Story, 12, 184–186
Straight line, 60
Street scenes, 332–335
Structural relationships, 86, 87
Style
 child art across history, 340
 child's role as art critic, 323
 drawings of gifted child artist,
 220
 effects of repeated trials on
 composition, 196
 Egyptian village children, 355,
 356
Subject matter, color selection, 137
Subjective experience, 158–159
Suicidal/aggressive diagnosis, 314,
 315

Sunburst patterns, 60, 219
Symbolic domains, 1–2
Symbolic expression, 280
Symbolic meaning, 15–16, 211, 214, 223
Symbolism, 260, 295
Symbolization, 11, 14
Symbol–referent, 15–16
Symmetry
 compositional strategy, 183, 187, 188, 190, 191
 ordering of family, 181, 182
 solutions to completion tasks, 194, 195
 trends in development, 174–179
 gifted child artists, 209, 220
 drawings of emotionally disturbed versus normal children, 303, 304, 306
 origins of early graphic forms, 27, 31, 11
 portrayal of feelings in drawings, 148
Synthetic incapacity, 107, 108
Syrian Bedouins, 350

Tables, 101, 102, 306
Tadpole figure(s)
 animal drawing by preschoolers, 77, 78, 80
 body proportion effect, 49–56
 completions and child's role as art critic, 324
 differentiation and human figure drawing, 60–61
 drawings by children in preliterate societies, 346
 drawings of gifted child artists, 232, 233
 emotionally disturbed versus normal children, 306
 horse drawings, 85, 86
 origins of early graphic forms, 32, 33
 models, media, and instruction, 39–41
 serial-order hypothesis, 41–49
Tallensi, 347, 348
Task demands
 choice of compositional strategy, 180–192, see also Pictorial space, creation/meaning communication

compositional strategies, 128, 170
drawings by normal versus mentally retarded children, 295
movement/action and human figure drawing, 74, 76
relative positions and spatial techniques in drawing, 123
Task effects, 114–126
Task specificity, 47, 48
Teacher, 47, 48
 –pupils, 118, 119
Tears, 140, 145
Techniques, mastery, 254–255, 256
Tension, resolution, 167
Terezin, 152–154
Terrorist attack, 149
Texture, 220
Thematic complexity, 173
Thematic ordering, 172
Thematic unity, 301, 303
Theme complexity, 100
Themes
 color selection and age, 137, 138
 drawings of gifted child artists, 254, 239
 portrayal of feelings in drawings by children, 142–145, 148, 155
Thick lines, 70
Thing–empty space, 28–29
Thingness, 27, 33
Third graders, 72, 74, 75, 144, 145
Threat, dreams, 145, 146
Three-dimensional qualities, 66, 67, 105
Three-dimensional space
 dealing with by gifted child artists, 202, 238
 –two-dimensional drawings and child's role as art critic, 328–329
T-junctions, 105
Toddlers, 8, see also Preschoolers
Toilet training, 135
Topics, interest, 205
Topological geometry, 104
Topological representation, 27
Toulouse-Lautrec, H. d., 206
Tractor, 232, 233, 234
Trains, 232, 234, 236, 263, 265
Transformations, 61, 63, 65, 78
Transition, 213, 221, 224

Transitional phase, 12
Transparencies, 67, 108, 110–111, 112
Trees, 89, 90, 306, see also Plants
Triangular arrangements, 118, 120
Triangular shapes, 63, 64, 355, 356
Trucks, 232, 234, 235
True shape, 104
Trunk
 depiction and tadpole figures, 52–53
 drawings by children in preliterate societies, 346
 human figure drawing, 61, 63, 65
 origins of early graphic forms, 32
 plant drawings, 89, 90
Tummy, 61
Two-dimensional plane, 11
Two-eyed profile, 353
Two-factor theory, 346–347, 355
Two-group approach, 293

Unidirectionality, 171
Unification, 69
Uniformity, 129
Universalist orientation, 340
Up/down orientation, 172, 188
 near-far dimension, 100, 124

Vehicles, 231–245
Verbal processes, 268
Verbal–graphic correspondence, 43
Verbalization, 32, 34–36, 94
Vertical arc, 9
Vertical axis, 61, 122, 124
Vertical oblique projection, 102, 103, 110, 187–188, 237, 240
Verticalization, 113
Village, 331, 332
Violence, 311, 313, 319
Visual analysis, gifted child artists, 261
Visual arts, sensitivity, 322–323
Visual attention, 12, 13
Visual concepts, inability to form, 269
Visual–graphic definition, 54
Visual guidance, 10
Visual inspections, 43, 44
Visual intelligence, 66
Visual likeness, 33, see also Likeness

Visual memories, 202, *see also* Memory

Visual narratives, 160, *see also* Narratives

Visual realism, 108, 109, *see also* Realism

Visual–motor control, 15, 24, 26

Visual–motor coordination, 69

Visual–spatial orientation, 10

Visual symbolization, 3

Vocalizations, 11

Volume, drawings of Eytan, 242

Volumentric properties, 232, 233, 243

War theme, 161

Wechsler Intelligence Scale for Children (WISC), 286

West Africa, 346

Western societies, 353–354

Willat's classification of drawing systems, 101–106

Williams syndrome, 296–297

Wings, 80, 81, *see also* Bird drawings

Working memory, 127, 129

World, perception, 134

X-ray pictures, 66, 67

Yom Kippur war, 226, 228